Dürer

Anja-Franziska Eichler

Albrecht
Dürer

1471–1528

KÖNEMANN

Frontispiece
1 *Adoration of the Trinity (Landauer Altar)*
Detail of ill. 79

Copyright © 1999 Könemann Verlagsgesellschaft mbH
Bonner Str. 126, D–50968 Cologne

Art Direction and Design: Peter Feierabend
Project Coordinator: Jeannette Fentroß
Layout: Bärbel Messmann
Production: Mark Voges
Reproductions: Omniascanners, Milan

Copyright © 1999 for this English edition
Könemann Verlagsgesellschaft mbH
Bonner Str. 126, D–50968 Cologne

Translation from German: Fiona Hulse
Editor of the English-language edition: Susan James
Project Coordinator: Kristin Zeier
Typesetting: Goodfellow & Egan, Cambridge
Production Manager: Detlev Schaper
Printing and Binding: Neue Stalling, Oldenburg

Printed in Germany
ISBN 3-8290-2587-4
10 9 8 7 6 5 4 3 2 1

Contents

The Genius of Albrecht Dürer — a Painter's Icon Throughout the Ages

2 *Self-Portrait in a Fur-Collared Robe*, detail of ill. 60

This self-portrait of Albrecht Dürer, which was created in 1500, became one of the most famous paintings in Western art history due to its unusual depiction of him in the manner of Christ. During the course of the centuries, it has repeatedly been adapted in varying ways, both in printing and painting.

Albrecht Dürer was the first German artist to emerge north of the Alps who achieved a highly developed artistic self-awareness based on the model of the Italian Renaissance, as well as a high degree of acceptance in society (ill. 2). Being German, he continued throughout his life to receive important artistic stimuli from the Netherlands and Italy. While Dürer was more strongly influenced by Flemish art during his early period, possibly a result of the Franconian workshop tradition of his master Michael Wolgemut (1434/37–1519), in the period after his journeys to Italy he mainly worked with ideas from the Italian Renaissance which enabled him to create new images.

Dürer's varied interest in nature and the environment, his study of the works of other masters, and his inspired ability to transform this innovatively, contributed to the important stimulus he gave to the historical development of art, starting north of the Alps, but eventually extending throughout Europe. For example, he was the first artist north of the Alps to paint a self-portrait, and his watercolors were the first autonomous landscape depictions that were freed from the context of Christian iconography.

He was able to take part as an equal in discussions held in circles of famous academics and humanists, and acquired humanist knowledge himself. Studies of the classical period, interpreted by the Italian Renaissance artists, left their mark on his work.

Dürer was perfectly adept at brilliantly applying the discovery of central perspective, Vitruvius' (born c. 84 B.C.) canon of human proportions and Leonardo da Vinci's (1452–1519) theory of the ideal proportions of the horse, to his own art and in particular to his prints. During his lifetime he had already ensured his lasting fame by, for example, having his prints sold abroad by commission agents. This process of choosing new methods of distribution as an independent entrepreneur was an example of the new self-awareness of an artist who gradually distanced himself from his Late Medieval status as a craftsman dependent on commission work.

After his death, Dürer remained one of the most highly regarded of artists for centuries. Even today, the term "Dürerzeit" (age of Dürer) represents the process of transition from the late Middle Ages to the Renaissance in Germany.

The quality and wide range of his works and themes, both in terms of content and formal aspects, are also astonishing. Dürer's woodcuts and copper engravings made him famous throughout Europe; today he is still regarded as the greatest master of his age in the field of printed graphics. On account of his abilities as a graphic artist and painter, his contemporaries called him a second Apelles, after one of the most famous classical painters who lived during the fourth century B.C. Though his paintings were normally produced as the result of a commission – his two main areas of focus were portrait painting and the creation of altar pieces and devotional pictures – Dürer enriched them with unusual pictorial solutions and adapted them to new functions.

His watercolors and drawings are impressive due to their thematic and technical diversity. They demonstrate both Dürer's careful method of working when preparing his paintings and his special interest in the surrounding nature.

Fortunately, and in contrast to other artists, many of his works still exist, enabling a comprehensive picture of his work to be created. In addition to 350 woodcuts and copper engravings, 60 paintings and about a thousand drawings and watercolors are known to exist.

During the course of the years Dürer achieved the status of icon, and examples of this recognition include the reception of his *Self-portrait in a Fur-Collared Robe* (ill. 2) and the way admiration of him was expressed in the 19th century by the erecting of monuments (ill. 4).

While from the 16th to the 19th centuries it was mainly artists and collectors who promoted the adoption and admiration of Dürer and his works, an academic reappraisal of his work, which was able to base itself on extensive source materials, began in the 19th century. Dürer's written legacy includes autobiographical writings, theoretical treatises and diary entries as well as poems and letters to clients and humanists who were among his friends. Dürer is the first German artist from whom such an extensive selection of private remarks and letters have survived,

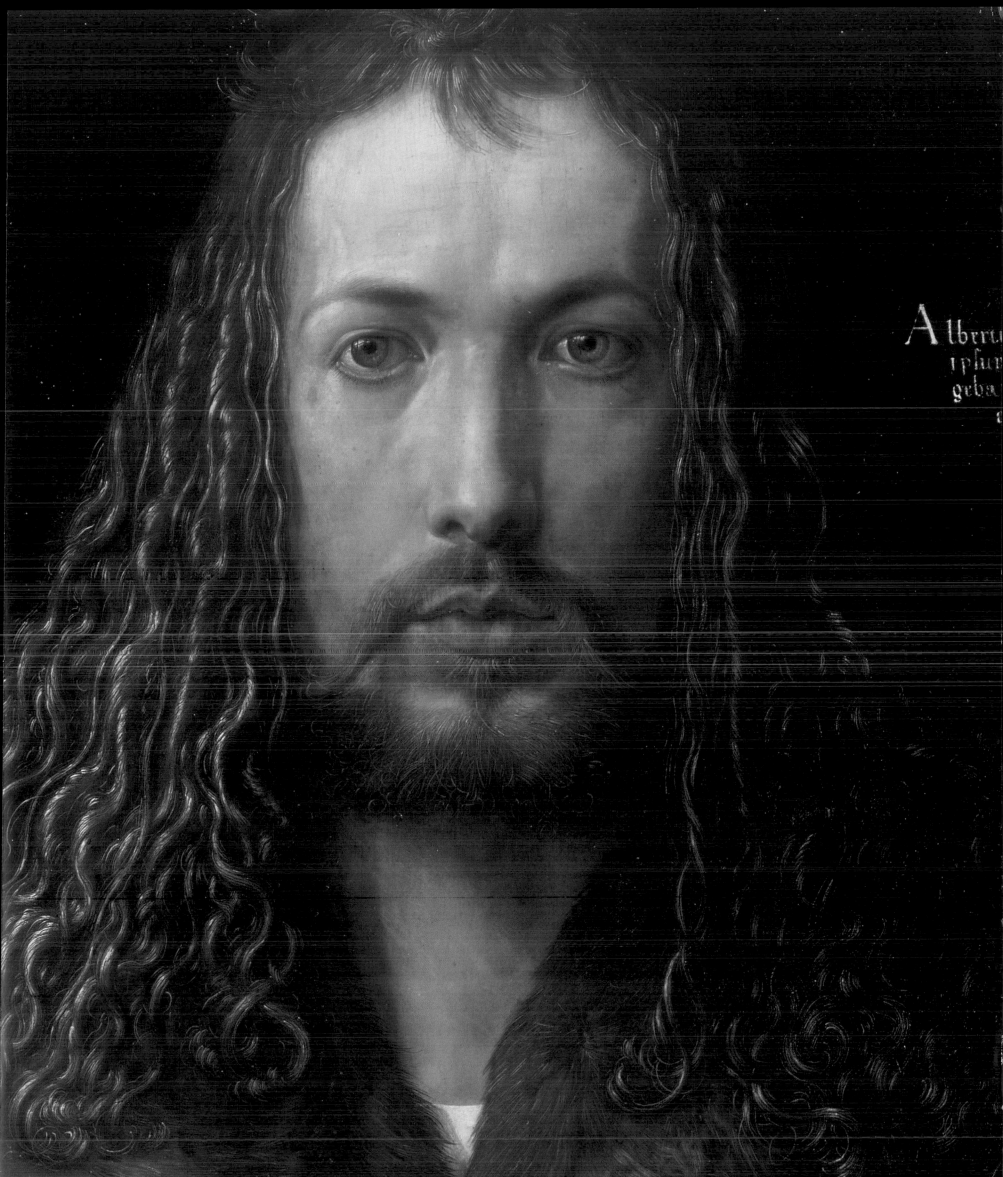

A lbrrt
i p̄ar
gebar

3 Georg Vischer, *Christ and the Adulteress*, 1637
Oil on panel, 70 x 109 cm
Alte Pinakothek, Bayerische Staatsgemäldesammlungen,
Munich

This painting is the earliest example of an interpretation of
the *Self-Portrait in a Fur-Collared Robe* (ill. 60) as a portrait
of Christ. The work was commissioned by the Bavarian
Duke Maximilian I, who was an ardent collector of
Dürer's works. The center of the composition is a precise
copy of the painting. Vischer also copied other famous
works by Dürer such as the side panels of the *Paumgartner
Altar* (ill. 53), and completed them in accordance with his
client's ideas.

permitting us to draw conclusions about the artist as a
person. Contemporaries such as the Nuremberg
patrician Christoph Scheurl (1481–1542) provide
further clues, as do famous artistic biographers such
as the Dutch Karel van Mander (1548–1606), the
German artist Joachim von Sandrart (1606–1688)
and the artist, architect and architectural theoretician
Giorgio Vasari (1511–1574). This extensive heritage
does not merely, however, make it possible to gain a
clearer picture of the character and figure of Dürer
than is possible for other artists of his age; his written
legacy enabled Dürer to take up a unique position in
his age, in which he also differs from his predecessors
and successors.

Dürer's theoretical treatises give us concrete informa-
tion regarding his methods of working, his didactic
abilities and the theoretical and scientific knowledge
which enabled him to write them. A good example of
this is Dürer's treatise on painting, called *Speis der*

maler knaben (Nourishment for Young Painters), in
which he explains the tasks and opportunities of
painting and their application to his students. During
recent decades, research on Dürer has progressed with
a flood of contributions. Matthias Mende's bibliog-
raphy, which appeared on the occasion of the 500th
anniversary of Dürer's birth, contains more than ten
thousand bibliographical references.

Every Dürer revival since the 16th century has
brought with it new views and insights. There are
countless statements from artists, collectors and
observers. The academic examination of the figure of
Albrecht Dürer and his works has continued, with
unbroken interest, right up to the present. Although
numerous research contributions appear every year on
this theme, the complexity of his works means that
researchers are constantly faced with new questions.
Even in the future, Dürer will remain a phenomenon
deserving of continuing attention.

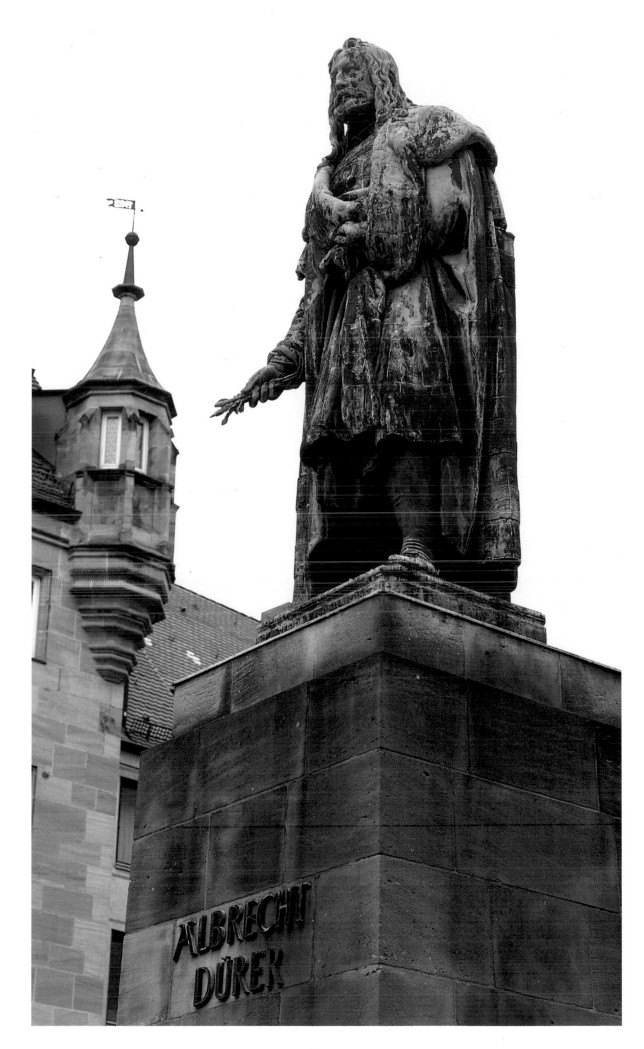

4 Christian Daniel Rauch, *Albrecht Dürer Monument*, 1826–1840
Bronze statue
Albrecht-Dürer-Platz, Nuremberg

Louis I of Bavaria (1786–1868) commissioned a life-size bronze statue of Dürer from the Berlin sculptor Christian Daniel Rauch, and it was erected as a monument on what is now the Albrecht-Dürer-Platz in Nuremberg. It is a prominent example of the Dürer Renaissance during the early 19th century and represents the way this artist was honored in numerous monuments during this time.

From Goldsmith to Painter

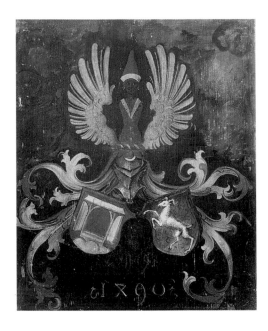

5 *Alliance Coat of Arms of the Dürer and Holper Families*,
1490, rear view of ill. 9
Oil on panel, 47 x 39 cm
Galleria degli Uffizi, Florence

The painted variant on the alliance coat of arms of the
Dürer and Holper families, a so-called speaking coat of
arms, is also depicted in a woodcut dating from 1523. It
forms the back side of Dürer's first portrait of his father
in 1490. The family's coat of arms depicts an open barn door
on the left, which was presumably a symbol of the family
name. The name means the same as "Türer," the German
translation of "Ajto," their place of origin Aijtos near
Gyula, the capital of the Bécéc district.

6 *Self-Portrait at 13*, 1484
Silver point on paper, 27.5 x 19.6 cm
Graphische Sammlung Albertina, Vienna

At the age of 13, Dürer created the earliest self-portrait of
an artist at so young an age. Using silver point, the features
of Dürer with which we are familiar from later self-
portraits, though still rather childlike here, are depicted
with gentle strokes. Like one of Martin Schongauer's Late
Gothic angels in depictions of the Annunciation, the boy
is also pointing to the right. His left hand is concealed
beneath his sleeve, thus suggesting that this self-portrait
was painted in front of a mirror.

Albrecht Dürer's immediate ancestors lived in Hungary.
His origins are confirmed by the occasionally patchy
family chronicle, much cited in academic works, that
Albrecht Dürer wrote later in life, on 25 December
1523, based on records kept by his father. Albrecht
Dürer the Elder (1427–1502) came from a small
Hungarian village called "Eytas" close to "a small town
called Jula." The place being described is now known as
Ajt, Dürer wrote later in life, on 25 December 1523,
based on records kept by his father. Even today it has
not been shown beyond doubt whether the Dürers
came from Hungary or Germany. It is possible that at
least a part of the family was of German origin, as
Albrecht Dürer the Elder's written German was excel-
lent, and his son also occasionally disassociated himself
from other nationalities using the term "Albertus
Durerus Germanicus." The family name is a translation
of the Hungarian "ajtos," "Tür" (door) in German, and
appears in writing as "Thürer" or "Türer." The coat of
arms on the back side of Dürer's earliest portrait of his
father shows a gateway with open doors (ill. 5), possibly
a barn door as an allusion to his ancestors' trade, for
they were cattle breeders.

His grandfather Anton Dürer had learned the craft
of the goldsmith, and his eldest son, Dürer's father,
was supposed to follow in his footsteps. The latter,
however, left his homeland at an early age and went off
on his travels. The imminent danger of a Turkish inva-
sion and the Hussite Wars in Bohemia were reason
enough to turn his back on Hungary. Albrecht Dürer
the Elder spent a short while in Nuremberg around 8
May 1444, but did not return to the Franconian city
until 1455 in order to work as an assistant in the work-
shop of the Nuremberg goldsmith Hieronymus Holper
(died 1476) after, so it was said, he had been "a long
time in the Netherlands with the great artists."

In 1467, after working as an assistant for twelve
years, he married Barbara Holper (1451–1514), the
15 year-old daughter of his master. Marrying a citizen
of Nuremberg enabled him to gain civil rights in the
city and in 1468, at the advanced age of 41, he quali-
fied as a master. At first the newly married couple lived
at the rear of the home of Dr. Johannes Pirckhamer
(died 1501), a Nuremberg patrician. This is where

Albrecht Dürer the Younger was born on 21 May
1471, their third child. Of his eighteen brothers and
sisters, only three brothers survived apart from him:
Hans the Elder (born 1478), Hans the Younger
(1490–1534/35 or 1538) and Endres (1484–1555).
Dürer spent his childhood and youth in the smart
Latin quarter of Nuremberg. The family lived in the
house "unter den Vesten" which Dürer's father had
bought in 1475 for 200 florins.

Both of Dürer's grandfathers, and his father, were
goldsmiths. It was intended that he should continue
this tradition. After he had "learned to write and read"
in school, his father started him as an apprentice in his
workshop. He was a bright student, but soon showed
greater interest in painting than in the goldsmith's
craft, so that according to his family chronicle his
father regretted "the lost time" that his son "had spent
learning gold work." This is the period from which
Dürer's first work dates, a drawing in silver point which
demonstrates his inherent ability to draw (ill. 6). At
the age of 13, before a mirror, he drew the earliest
remaining of the numerous self-portraits that were to
record his appearance at various points in his life.
Dürer noted in the inscription: "Daz hab jch aws eim
spiegell nach mir selbs kunterfet im 1484 jar, do ich
noch ein kint was" ("I drew this myself using a mirror
in the year of 1484, when I was still a child"). The
silver point drawing depicts the artist's characteristic,
childlike features in a style that is still Late Gothic and
somewhat angular, but already demonstrates an
assured hand. The young Dürer coped with playful
ease with the difficult silver point technique, which
cannot be corrected and requires a high degree of preci-
sion and stylistic confidence. It is the only existing
autonomous self-portrait of an artist at such an early
age. According to a source, an even earlier self-portrait
of Dürer at the age of eight was owned by the Bavarian
Elector. It was destroyed in the course of a palace fire.

It is probable that the father recognized his son's
talent, for in 1486 he finally gave in to his wishes and
sent him to become an apprentice in the workshop of
the respected Nuremberg painter and entrepreneur,
Michael Wolgemut. Christoph Scheurl, a humanist
and personal friend of Dürer's, reported that the artist

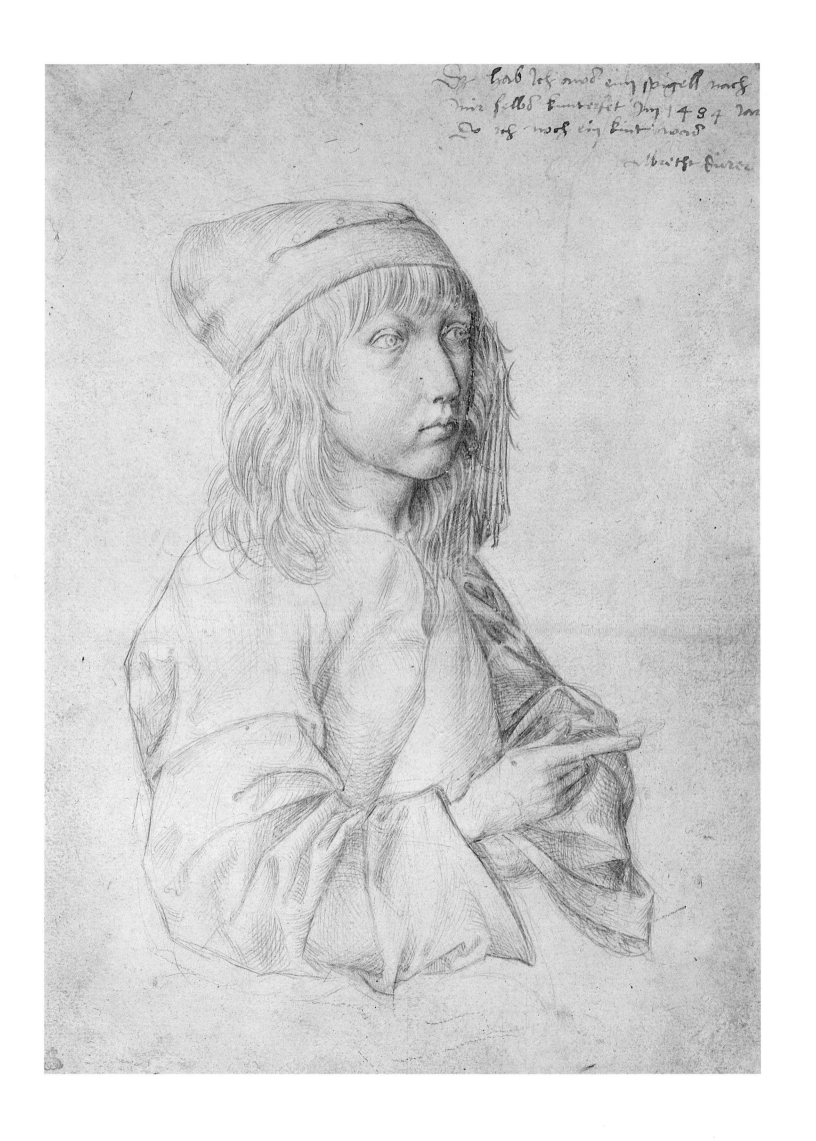

hie Veamefte
1 5 1 6 vñ
vnd hat g
zelt 1 5 1
an fant
fur

had informed him both verbally and in writing that his father wanted to apprentice him at the early age of fifteen to the famous, internationally renowned graphic artist Martin Schongauer (c. 1450–1491).

Schongauer, who was also the son of a goldsmith, produced copper engravings in larger editions than had previously been customary. This increased the familiarity of his works, which were soon so popular that they were also used by other artists of the late 15th century as models for their altars and panel paintings. During this time, selected masterly engravings by Schongauer could be found in many workshops and had a stylistic influence. In his *Lives of the Artists*, the artist and biographer Giorgio Vasari reports that even Michelangelo (1475–1564) had copied a copper engraving by Schongauer.

The question as to why Dürer's father finally decided in favor of Wolgemut as a master must remain open. It is possible that the Dürer family could not afford the expensive journey and living and apprenticeship costs. Perhaps the famous Schongauer also no longer wanted to take on any more apprentices.

It seems reasonable to assume that Dürer had already finished his apprenticeship as goldsmith with his father at this time. The knowledge of drawing which he had gained doing this was to prove useful later on when making precise preparations for paintings in the form of underpaintings and preliminary drawings. The years spent as an apprentice with Michael Wolgemut (ill. 7), whose style was still rooted in the Late Medieval craftsmen's tradition, were extremely useful for Dürer's artistic development, though they do not always appear to have been entirely easy from a human point of view. For example, at the age of 15 Dürer was the oldest apprentice in the workshop and had to "suffer much from [Wolgemut's] servants," as he himself wrote in his family chronicle.

In his master's workshop, Dürer learned the fundamental things necessary for his training as a painter's assistant. In addition to the basic requirements such as mixing colors, composition, pen and ink drawings and producing landscape backgrounds, there was also the intensive study and use of the technique of woodcuts. This is all the more remarkable as at that time Michael Wolgemut worked with the well-known publisher Anton Koberger (c. 1440/45–1513), who was Dürer's godfather, and employed wood block carvers to cut the preliminary drawings into the wood engraving block.

Woodcut illustrations from Michael Wolgemut's workshop were at the time some of the best in terms of technique that were available on the European market. New effects in their preparation, finer interior details and the suggestion of spatiality increased demand. The 645 illustrations for the *Nuremberg Chronicle* by the Nuremberg doctor and humanist Hartmann Schedel (1440–1514), which was published by Anton Koberger, became particularly famous. This work, which appeared in 1493, contained a total of 1809 woodcuts and, with its illustrations and descriptions based on the seven ages, was meant to represent a history of the world and its

peoples. The chronicle became internationally famous, and the 123 pictures of cities may have contributed considerably to its popularity. The largest depiction, a view of the then world and trade metropolis of Nuremberg, is a good example of the way city views were recorded in all their detail (ill. 13).

Repeated attempts have been made to stylistically prove Dürer's involvement in this book project by comparing it to his woodcuts of the Apocalypse. While there is no source material to confirm his collaboration, it can be assumed that he did so, as Dürer was working as an apprentice in Wolgemut's workshop at the time the *Nuremberg Chronicle* was produced.

The intensive study of woodcut techniques and what were, for the time, exceptionally high technical standards in the Wolgemut workshop were important prerequisites for Dürer's inspired potential for development in this field, and for his methodical action in later years when he started to use printed graphics to a broadly commercial extent.

In 1490, after his painter's apprenticeship in Michael Wolgemut's workshop ended, Dürer left on four years of travels as a journeyman, and immediately before departing painted the two portraits of his parents (ills. 8, 9) which were originally connected in the manner of a diptych and were separated after 1588. While the portrait of his father came to be owned by Emperor Rudolph II in Prague, its counterpart remained with the Imhoff family in Nuremberg.

These first painted portraits by Dürer demonstrate the knowledge and abilities he had gained in the Wolgemut workshop.

The subjects appear before a dark background and are related to each other by their lines of sight. Their piety is expressed by the rosaries in their hands. The delicate detail of the features, in particular those of the father, is realistic to a degree which is unusual in contemporary portrait painting, and is reminiscent of Dutch portraits of the early 15th century. In the arrangement and opposite positions of the pendants, Dürer was following the traditional scheme of portraits of married couples. The woman is positioned to the right of the man, the lower ranking position. The folds of the garments, particularly in the mother's portrait, still show a Late Gothic hardness. Uncertainties in the modeling of the features suggest that the portraits must have been created immediately after Dürer's apprenticeship had ended.

The goal of an emerging artist when making a journey was to get to know other workshops, methods of work and styles, and to extend his own repertoire in terms of techniques and motifs. Artistically interesting motifs were recorded in sketch books which were used after the artist returned from his journey to help him find his own forms. Such sketches made by Dürer, taken out of a sketch book, still exist.

In his family chronicle, Dürer refers to his time as a journeyman with just one laconic sentence: "And as I had finished my apprenticeship, my father sent me away, and I stayed away for four years, until my father

7 (opposite)
Portrait of Michael Wolgemut, detail of ill. 106

From 30 November 1486 to the end of 1489, Albrecht Dürer was apprenticed to the renowned Nuremberg painter Michael Wolgemut. The portrait of his teacher – not a commissioned portrait – is the only one by Dürer and demonstrates his mature portrait painting skills in later years.

8 (page 14)
Portrait of Barbara Dürer, 1490
Oil on pine panel, 47 x 38 cm
Germanisches Nationalmuseum, Nuremberg

Shortly before his departure as a journeyman, Dürer painted the double portrait of his parents, his first painted portraits. The portrait of his mother acted as the counterpart to the portrait of his father, and is related to the latter in terms of line of sight and body posture. The portraits are closely matched to each other in terms of composition. The mother, with a white bonnet, appears as a married woman in a dark red garment. While the latter is recorded in a summary fashion, her physiognomy is depicted meticulously. His mother is holding a rosary in her hand as an expression of her piety, and this gesture is another way in which she is related to the depiction of his father.

9 (page 15)
Portrait of Albrecht Dürer the Elder, 1490
Oil on panel, 47 x 39 cm
Galleria degli Uffizi, Florence

In the first of his paintings that have survived, the double portrait of his parents, Dürer outdid everything that had been achieved up until then in German portrait painting. Although the type of portrait, a three-quarter view before a monochrome background, still corresponded to the Late Medieval workshop tradition, the fine naturalism with which Dürer characterized the face of his father went beyond the portraits made by his teacher Wolgemut. The rosary he is holding shows his father to be a pious, godfearing man.

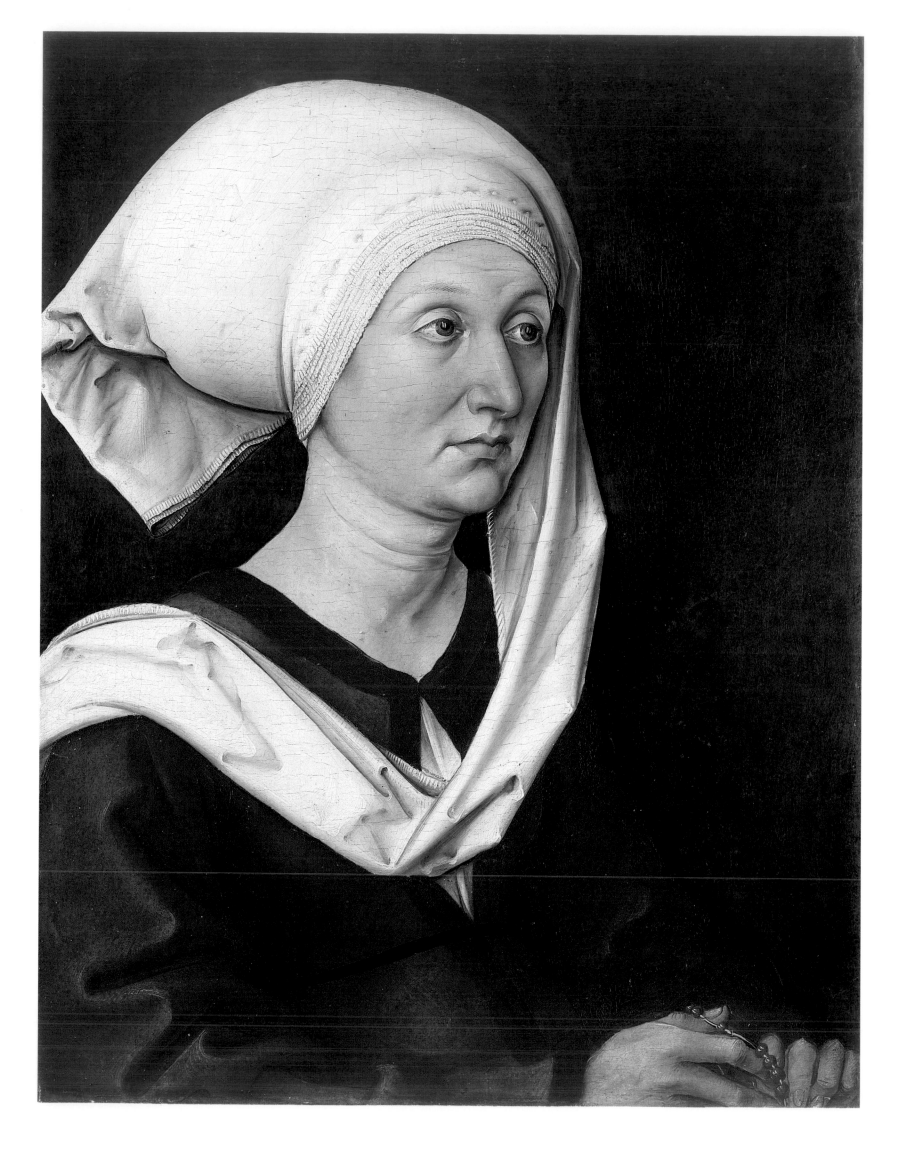

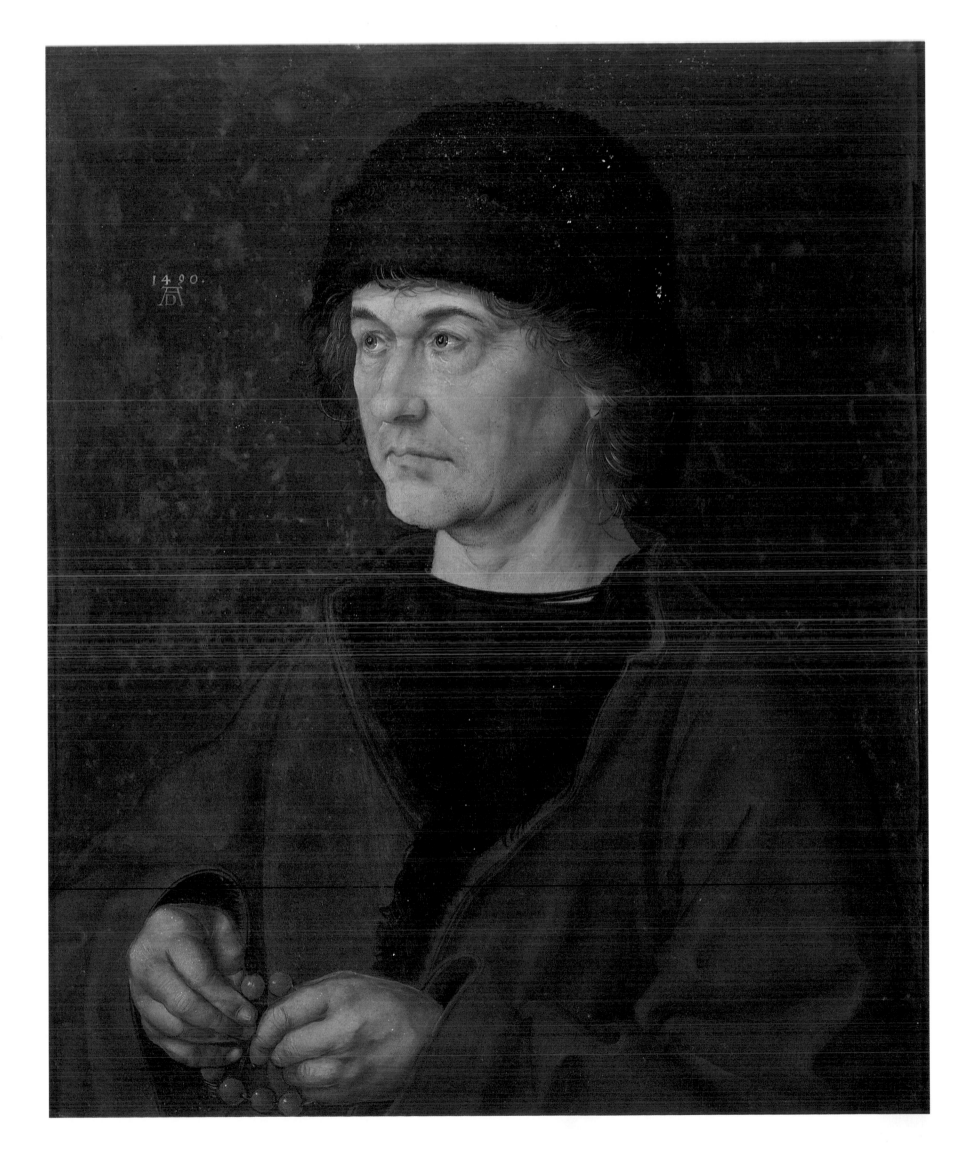

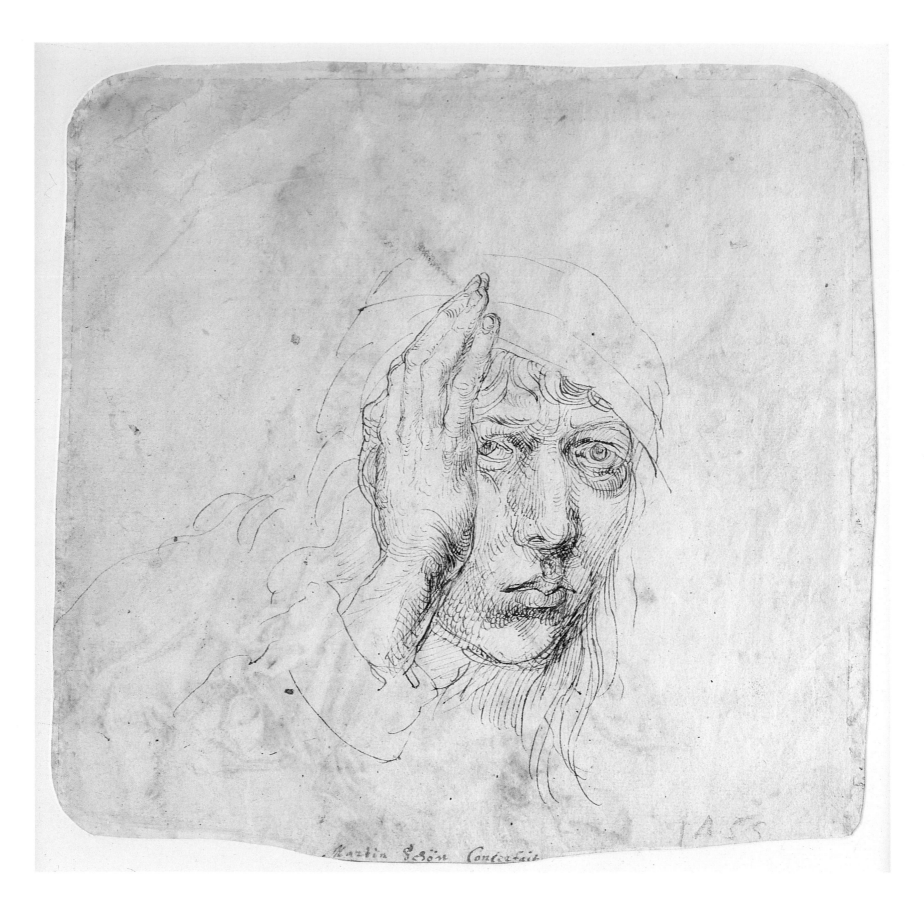

10 *Self-Portrait with a Bandage*, 1491/92
Pen drawing on paper, back side, 20.4 x 20.8 cm
Graphische Sammlung der Universitätsbibliothek, Erlangen-
Nuremberg, Erlangen

Dürer's self-portrait with a bandage presumably dates from the first
period of his journeys; it was sketched with rapid strokes, and
Dürer's face with his inquiring gaze stands out. The hand gesture is
reminiscent of the tradition of depictions of Christ suffering, of
melancholy and sleep. An interpretation of melancholy fits in most
readily with a self-portrait in this manner.

called for me again. And I left in 1490, after Easter, and returned again, in the year of 1494, after Whitsun."

Nothing is known about the places Dürer stayed at during the first two years of his journey, although portrait drawings such as the *Self-portrait with a Bandage* (ill. 10) presumably date from this time. The theory that Dürer possibly stayed in Haarlem in the Netherlands during this time cannot be proven, although it was suggested by the art historiographer and artist Karel van Mander in his lives of the artists *Het Schilder-Boeck*, which first appeared in 1604, by Joachim van Sandrart in his book *Teutschen Academie der Edlen Bau-, Bild- und Mahlerey-Künste*, and was assumed to be the case due to references to paintings by the Haarlem master Geertgen tot Sint Jans (c. 1460–1490). It is also called into question by a statement by the Nuremberg humanist Christoph Scheurl, a personal friend of Dürer's. In his work, *Vita reverendi patris domini Antoni Kressen Nürnberg*, dating from 24 July 1515 it says: "Then, after he had traveled back and forth in Germany, he came to Colmar in 1492 …".

More recent observations by Jane Campbell Hutchison assume that Dürer may have stopped off in Frankfurt, Mainz, and possibly Cologne, as he does not mention famous pieces of art that he could have seen during his first visit to the three cities in the otherwise so precisely written journal of his later journey to the Netherlands. The above-mentioned cities included attractions that a journeyman could scarcely turn his back on: Mainz was the center of book printing and was where the Dutch artist Erhard Reuwich (active from 1484 to c. 1500) lived, who had impressed Dürer with his popular woodcut illustrations narrating the pilgrimage made by Mainz Cathedral's dean, Bernhard von Breydenbach (died 1497) to the Holy Land. His woodcuts had been imitated in Wolgemut's workshop. Reuwich was the first artist to publish a book in his own printing works at full commercial risk to himself.

There were many things in Frankfurt to attract a journeyman. The trade fair there was Dürer's main goal in later years when he took his "wares" to market. Around 1490, Frankfurt was also the city where the so-called "Hausbuchmeister" or Master of the Housebook worked (active from about 1465/1470 – after 1505). This artist, known from a parchment manuscript with ink drawings in Wolfegg Castle, was the first artist apart from Martin Schongauer to create both paintings and printed graphics (ill. 36). His drypoint engravings appeared in small editions as the printing plates wore down very quickly. Early works by Dürer such as the copper engravings *The Walk* (ill. 37) and *Young Couple* reveal the influence of this master. It is possible that the journeyman from Nuremberg spent some time in the master's workshop and became acquainted with his works as originals.

We receive more precise information about the last two years of his journey from Dürer's friend Scheurl. From him we know that Dürer wanted to go to the famous Martin Schongauer in Colmar. That he could now go there as an assistant and not an apprentice had the advantage that he was in the position of being able

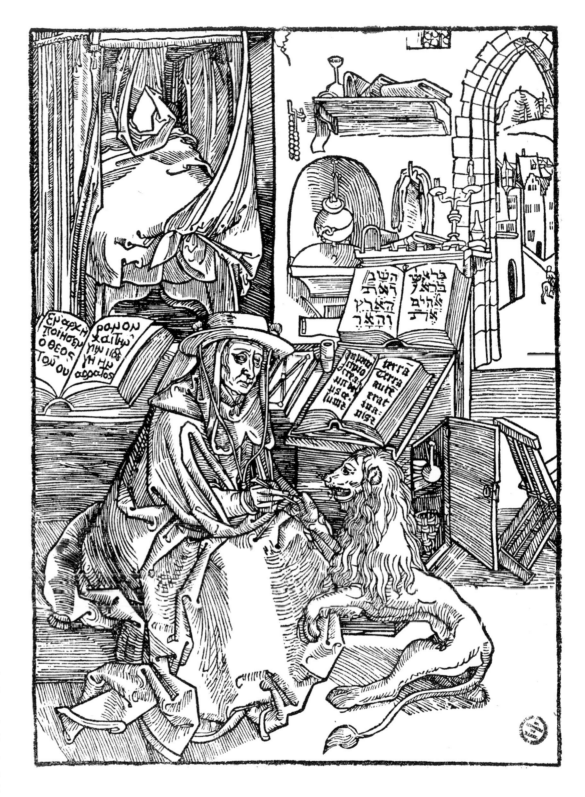

to earn his own living. As there were no great copper engravers in Germany at this time, staying in the workshop of Martin Schongauer, an outstanding teacher of this technique, would have been one of the main goals of his journey. Dürer arrived in Colmar in 1492. However, Martin Schongauer had died a short time previously, presumably of the Plague. His brothers welcomed the journeyman and allowed him to study the master's works thoroughly. During his early years, Schongauer's copper engravings were amongst Dürer's most important sources of inspiration and the starting point for his further development of the technique of copper engraving.

11 *St. Jerome*, 1492
Woodcut, 19 x 13.3 cm
Kupferstichkabinett, Kunstmuseum, Basle

This frontispiece for the second edition of the letters of the Father of the Church St. Jerome proves that Dürer spent some time in Basle as a journeyman. On the back of the wood engraving block, the following is written in Albrecht Dürer's hand: "Albrecht Dürer von nörmergk" (Albrecht Dürer from Nuremberg). This scene depicts St. Jerome pulling a thorn out of a lion's paw, from which point on the latter becomes his loyal companion. The Father of the Church's living room and study is adorned by open books and the everyday objects of the secular and spiritual worlds, realistic details which before this date were rarely depicted in woodcuts.

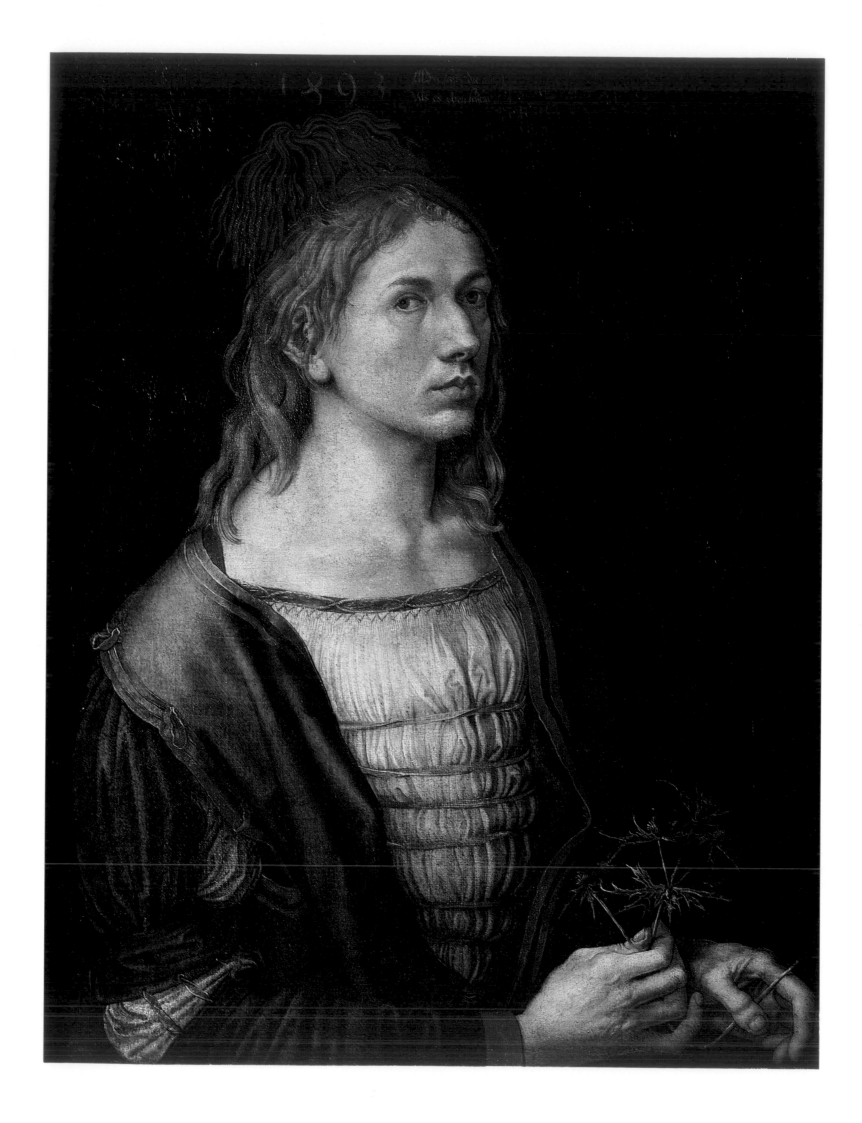

The next stage of the journey after Colmar was Basle. This city of publishers and printers had already developed into a center of humanism at the time. Dürer's stay there is proven by the signature "Albrecht Dürer von nörmergk" on the back side of a wood engraving block for the frontispiece of an edition of the letters of St. Jerome, printed by the publisher Nikolaus Kessler (active 1485–1509) in Basle (ill. 11). The knowledge that Dürer had gained during his apprenticeship with respect to woodcut illustrations was much in demand here, for after he had designed the above-mentioned frontispiece in 1492 he received a range of commissions. He created the woodcut models for the first German edition of the *Ritter vom Turm*, a collection of stories which had been compiled in France in the 14th century and had, by the end of the 15th century, become a popular folk book that had been translated into various languages. In addition, he produced 18 small woodcuts for a devotional book which was, in the end, not published, as well as preliminary drawings for wood engraving blocks of 140 illustrations on the *Comedies of Terence*. At the same time, Dürer was working on the 75 woodcuts for the popular *Ship of Fools*, published in 1494 in Basle (ill. 109), by the humanist and lawyer Sebastian Brant (1457/58–1521). This was an allegorical, satirical and moralizing poem in German which hit out at the foolish activities of mankind. Brant gained international renown through the book. Contemporaries compared him with famous poets such as Dante (1261–1321) and Petrarch (1304–1374). Dürer also illustrated a single-leaf print with a Latin poem composed by Brant in honor of his patron saint, St. Sebastian.

The woodcut illustrations for the *Ship of Fools* marked a decisive step on the way to a realistic method of depiction using woodcuts such as had not previously been known in this medium. The detailed reproduction of landscape backgrounds, the fine interior drawings and realistic conceptions already anticipate Dürer's later developments in woodcut techniques (ill. 109).

The last stage of Dürer's journey, Strasbourg, is confirmed by the mention of the lost double portrait of a Strasbourg master and his wife in an inventory list belonging to Willibald Imhoff (1519–1580), the grandson of Dürer's friend and humanist Willibald Pirckheimer (1470–1530). It is likely, during his stay in Strasbourg, that Dürer worked in this master's workshop and that it was on this occasion that he painted the two portraits. According to the information in the inventory, the portraits were painted on parchment, a medium which Dürer also used for his first painted *Self-portrait at 22* (ill. 12) dating from 1493, now in the Louvre. Due to the material and year of production, it is assumed that it was produced in the same workshop as the two lost portraits.

This first painted, autonomous self-portrait in Western art history illustrates Dürer's lifelong interest in self-examination, which manifested itself, to various extents, in numerous drawings and three paintings.

Dürer did without a preliminary drawing and transferred the painting in the mirror directly onto parchment. This is confirmed by the right hand, completed at a later time. The portrayed artist is gazing towards the observer, dressed smartly and with a red cap at a jaunty angle on his head. The portrait still follows a traditional scheme well-known in Nuremberg both in terms of composition, posture and line of sight, and the two-dimensional, dark background. In contrast to Dürer's first paintings, the double portrait of his parents before he started his journey, the manner of painting in the self-portrait is already more relaxed.

The rhyming couplet at the top edge of the self-portrait reads: "My sach die gat/Als es oben schtat" (My affairs follow the course allotted to them on high), a verse in the Alemanic dialect that was used along the upper Rhine. Fedja Anzelewsky considers the couplet to have been inspired by the Strasbourg mystic movement in the Grünenwörth monastery. These "friends of God" developed as a lay organization in parallel with the Dutch "Devotio moderna" and were influenced by Dominican mysticism. It was their endeavor to submit humbly to the will of God.

The *eryngium*, a type of thistle, that the portrayed man is holding can mean several things. The thistle is also known as "Männertreu" (meaning conjugal fidelity) and is frequently found in engagement pictures. At the same time, however, it is also a reference to religious closeness with Christ, as it appears in traditional Christian iconography as a symbol of the Passion of, and Redemption by, Christ. This gives the early self-portrait the following double meaning: holding the thistle in his hand and dressed as a courtly lover, in imitation of the House Bookmaster's works, Dürer is both expressing his fear of God and, on the other hand, referring to his imminent marriage to Agnes Frey from Nuremberg (1475–1539), which had already been settled months before his return. The couplet expresses his submissiveness in the face of his fate. It has been assumed that Dürer sent the painting to Nuremberg in advance of his own arrival. There is, however, no proof of this.

12 *Self-Portrait at 22*, 1493
Oil on parchment, pasted on canvas
56.5 x 44.5 cm
Musée du Louvre, Paris

In 1493, presumably during his stay in Strasbourg, Dürer produced his first painted self-portrait. While his body posture, a three-quarter view in front of a unified dark background, still corresponds with traditional portrait schemes, the realistic depiction of details in the material and the self-confident, foppish dress and pose of the portrayed artist differ from the first painted portraits of Dürer's parents. Dürer is holding an *eryngium* in his hand, a thistle which may refer both to his imminent marriage and Christ's Passion. His courtly dress is reminiscent of pictures by the Master of the Housebook, with which Dürer probably became acquainted during his journey.

13 Hartmann Schedel, *Nuremberg Chronicle*, 1493
Page 100: *View of the city of Nuremberg*
Woodcut, folio
Bayerische Staatsbibliothek, Munich

Schedel's view of the city of Nuremberg depicts the city from the south, from which direction the hill with the castle is easily recognizable. The mass of houses rises above the double circle of the city walls. The two main churches, St. Sebald and St. Lorenz, are also emphasized by inscriptions. The sheet has frequently been copied.

"What a marvelous view this city presents! What splendor, what magnificent sights, what beauties, what culture, what an admirable government! … what clean streets and elegant houses." (Aeneus Silvius Piccolomini, 1405–1464)

From the 14th century, Nuremberg experienced an economic and cultural flowering which reached its zenith during Dürer's time (ill. 13). The city had already been the trade center of Europe for 200 years and played a leading role in the working of metal and textiles, building instruments, making paper and printing. As the secret "capital of the Holy Roman Empire of the German nation", as it was called in the Golden Bull in 1356, the city attracted numerous scholars and also became the center of humanism and the fine arts in Germany.

The famous astronomer and mathematician Regiomontanus (1436–1476) called Nuremberg the "center of Europe." No other city is named so frequently in sources dealing with the economic history of the late Middle Ages. Measures and weights as well as the Nuremberg coinage were points of comparison and reference, and quotes in the Nuremberg market were also used as a starting point for calculating prices in other cities. As an export and import trade center, Nuremberg was located on one of the two major crossroads of long-distance European trade: amber, salted fish and furs were imported in from the Baltic, the raw materials of the metalworking crafts such as gold, silver and copper from Hungary and Bohemia, valuable silks and luxury items from Venice, and expensive cloth from the Netherlands. Export goods from here such as metal implements and scientific instruments were traded as far afield as Portugal and Poland.

The city was a free imperial city directly subordinate to the Emperor, and enjoyed the privilege of being able to trade duty-free with 70 European cities. Due to its outstanding position in European trade, Nuremberg occupied a strategic position which was also of importance to the ruler. According to law, every new emperor had to hold his first Imperial Diet in Nuremberg. Apart from this, however, the rulers very rarely stayed there. The city council ruled in their absence.

The city's particular significance was further emphasized when, on 24 February 1424, the German king Sigismund brought the so-called "Heiltum" (holy relics, ill. 14), the imperial insignia, crown jewels and imperial collection of relics, together with a document dating from September 1423, for the city to keep in perpetuity. These holy and historical treasures were displayed once a year at the so-called "Heiltumsweisungen" on the main marketplace and strongly attracted the public. They were publicly displayed from a "Heiltumsstuhl," a chair-like wooden structure about seven meters high. From the Schopperhaus, the gallery with the "Heiltumsstuhl" could be approached via a footbridge. Private displays of the holy relics took place in the Hospital of the Holy Spirit and were restricted to high-ranking visitors.

As a medieval center of parchment manufacture, the city constantly provided a supply of fine paper to its workshops, publishers and printers. The first German paper mill was erected outside the gates of Nuremberg in 1390. In 1470, the printing trade moved in and was soon flourishing, limited only by the satisfactory supply of paper and metal. Anton Koberger's publishing works rapidly developed into the most important printing business.

Nuremberg occupied a position of supremacy in Europe in the field of metal working, for pioneering innovations in this field such as "Kupferseigerung," the recrystallizing of copper ore containing silver in lead to produce crude copper and silver, had been developed here. So-called "Seiger" commercial companies were set up which appointed factors for purchasing copper ore and selling crude copper and silver to all the important trade cities along the main trade routes. As early as the 14th century, the majority of the craftsmen located in Nuremberg were working in the metal industry. The main export goods, apart from all sorts of everyday tools and metal goods such as nails and needles, were weapons and armor.

Given its outstanding position as a humanist center, the city gradually gained a monopoly in the production of precision engineered instruments for use in scientific disciplines such as geography, astronomy, mathematics and physics. Nuremberg maps were used on pilgrimages to the holy sites and the cities with great trade fairs. Using instruments made in Nuremberg, Regiomontanus mapped the night sky and calculated the movement of the stars. Inventors such as the Nuremberg master locksmith Peter Henlein introduced devices such as a small portable clock in the shape of a can which chimed and ran for forty hours. Special pieces such as this clock were held in high regard and were ordered in advance by the city council to provide as valuable gifts for important personalities; in the end, they were mass-produced in advance.

During the course of the progressive discovery and conquest of the world, Nuremberg gradually lost its monopoly as the capital of European trade, for the geographical emphasis had shifted in favor of the western European seaports. The importance of the city diminished, in particular as Nuremberg merchants did not play a part in discovering and investing in the New World.

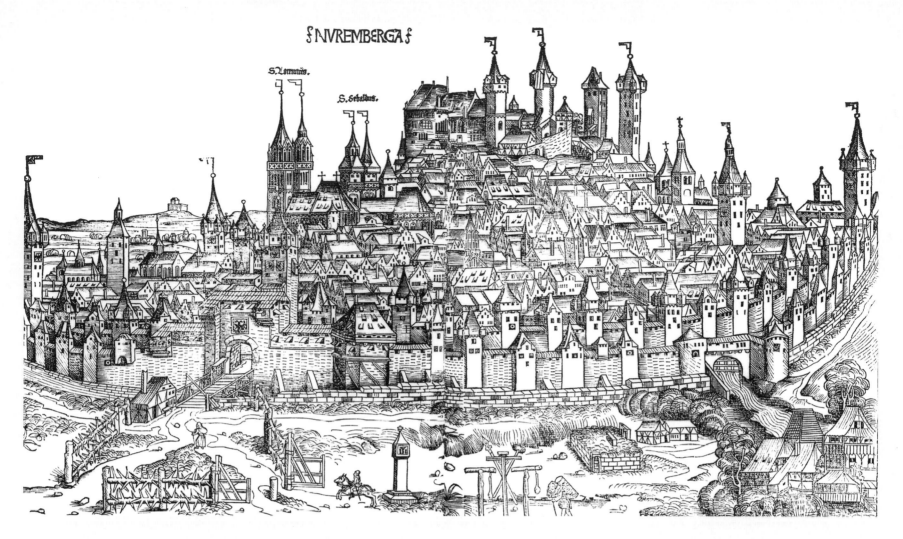

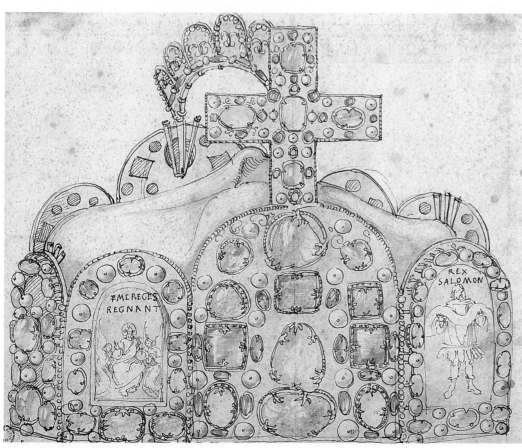

14 *The Imperial Crown*, c. 1510
Pen drawing with watercolor, 23.8 x 28.9 cm
Kupferstichkabinett, Germanisches Nationalmuseum,
Nuremberg

The pen drawing of the imperial crown is one of the
preliminary studies for the imperial portrait of
Charlemagne (ill. 85), who appears in his imperial regalia
complete with the imperial jewels. The imperial insignia,
the so-called regalia, together with the imperial relics,
formed the so-called "Heiltum" that was publicly
displayed once a year. Dürer produced the individual
studies directly from the originals. In contrast to the other
two preliminary drawings of the imperial sword and orb,
the crown is depicted in detail, from the shape and type of
precious stones and jewels right down to the small
inscribed plates with the figures of saints and scenes from
the Old and New Testaments.

Encounter with Proportion and Perspective. The First Italian Journey

15 *St. Anne*, St. Anne, detail of ill. 108

Some portrait sketches of Agnes Dürer at a young age exist. In later years, Dürer only painted her once in the form of St. Anne, a work preceded by several preliminary studies.

16 *"mein Agnes"*, c. 1494
Pen drawing in bistre on white paper, 15.6 x 9.8 cm
Graphische Sammlung Albertina, Vienna

Agnes Dürer, née Frey, was the daughter of the Nuremberg coppersmith Hans Frey and his wife Anna Rummel. Agnes, who still appears girlish, even childlike, here, is sitting at a table and supporting her head pensively on her right hand, her hair tied back. The intimacy of this everyday sketch is unusual, showing the depicted woman at a moment when she evidently thought herself to be unobserved.

At the end of May 1494 Dürer returned to Nuremberg where he married shortly afterwards on 7 July. The family chronicle provides the following information about this:

"And when I arrived home once more, Hans Frej negotiated with my father and gave me his daughter called Agnes with 200 florins and held the wedding. This was on the Monday before St. Margaret's in the year of 1494."

It was an arranged marriage, a "good catch" which Dürer's father had initiated for economic reasons. Hans Frey (1450–1532), Dürer's father-in-law, was a master craftsman, a smith from an old Nuremberg family who had specialized in air-driven fountains, machines and banqueting tables, was the site manager and landlord of the town hall, and was elected to the city council in 1496. His wife Anna, née Rummel (died in 1521), also came from a wealthy and respected family. One of her relatives was the wealthy financier Wilhelm Rummel, who worked mainly in Italy for the Emperor, the Curia and the Medicis.

At the time of her marriage to Dürer, Agnes Frey was about 18 or 19 years old (ill. 16). A pen drawing in the Albertina collection, bearing the caption "mein agnes" added by Dürer himself, shows her as she might appear when nobody was looking, as a childlike girl with her hair tied back. It is possible that this sketch was even produced before they were married, as Agnes appears without a bonnet, in accordance with the custom for unmarried women.

It can be clearly recognized from various letters from Dürer to Willibald Pirckheimer dating from the second Italian journey in 1506 that Dürer's marriage, which did not produce any children, was an unhappy one. This is confirmed in later years by the meticulous records in the Netherlands journal, from which it emerges that during the course of the one year trip, Dürer took most of his meals together with his numerous friends or alone, while his wife and maid were able "to cook and eat upstairs." Despite this he depicted his wife, who despite all personal differences was a competent business partner and traveled to the fairs and markets with his printed graphics, in numerous portraits. In later years she was his model in

the painting of *St. Anne* (ill. 108). It has been speculated at various times that Dürer was homosexual, based on a letter by the Nuremberg patrician Lorenz Behaim (died 1518) to Willibald Pirckheimer on 7 March 1507, in which "Dürer's boys" are spoken of. There is, however, no further evidence of this.

A few months after the wedding Dürer left on his first Italian journey. The only evidence of this trip is a mention in a letter written during his second period in Italy in 1506/07, in which Dürer tells Willibald Pirckheimer: "And the thing that I liked so much 11 years ago no longer pleases me now."

What is meant here is either a work of art that cannot be more closely identified, or the Italian style in general which may have made a deep impression on Dürer as a young journeyman on his first trip to Italy. By the time of his second Italian journey, however, he had already developed his own style and artistic ideas, for which reason he may have remained calm in the face of external influences.

The reason for Dürer's sudden departure for Italy in 1494 has frequently been thought to have been the outbreak of the Plague in Nuremberg, which during its worst phase killed over a hundred people every day. As early as 1483, in a report requested by the city council, the Nuremberg city doctors – in imitation of the Florentine doctor and philosopher Marsilio Ficino (1433–1499) – recommended that the most effective preventative measure against the plague was fleeing from the city. Respected Nuremberg citizens such as the artist Christoph Amberger (c. 1500–1561/62) and Dürer's godparent Anton Koberger withdrew to the country to escape the risk of infection.

The plague raging in Nuremberg was probably not the only reason Dürer left on so long a journey. This was frequently viewed as a sort of extended journeyman's travels. This later became decisive in Dürer's role as a mediator between the Italian Renaissance and Germany, breaking through his customary way of depicting things, marked by the Late Medieval workshop tradition, to reveal the "new" element in Italian art, the recollection of the classical world.

A decisive element in Dürer's interest in making this journey to Italy may have been the desire to learn from

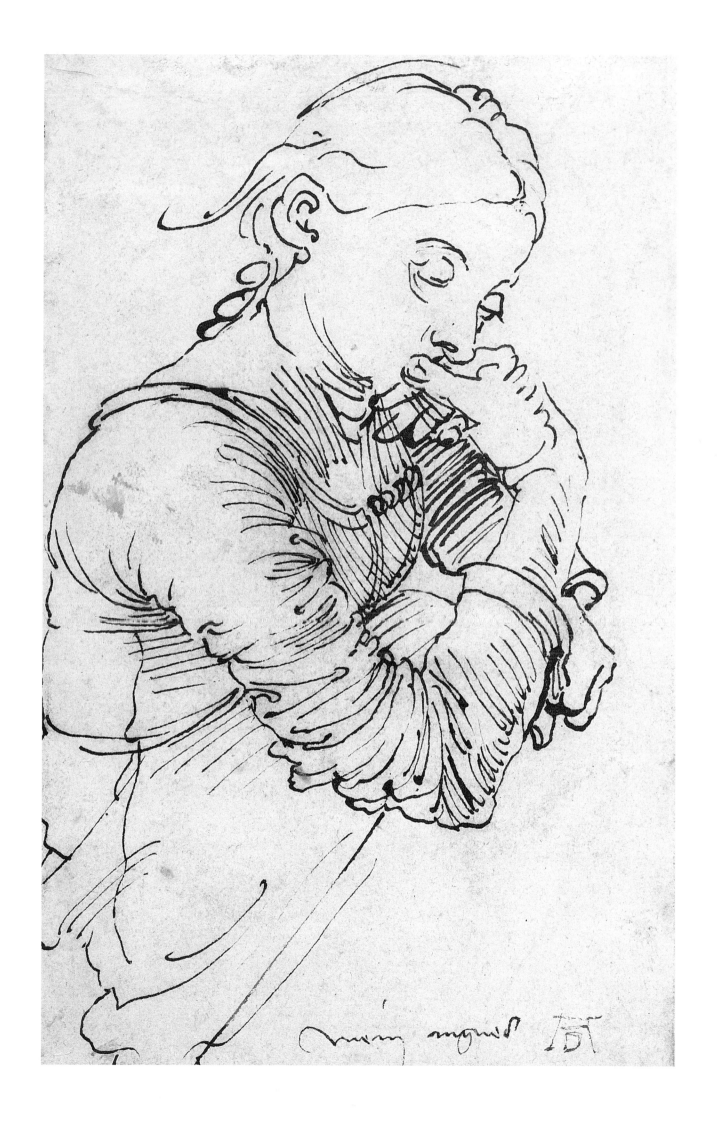

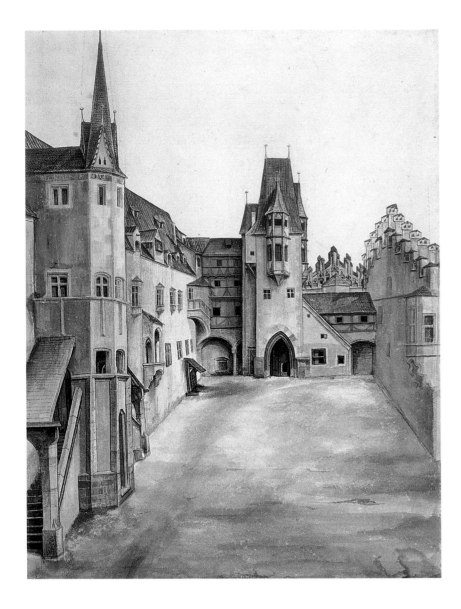

17 (above left) *The courtyard of the former castle in Innsbruck without clouds*, 1494
Watercolor on paper, 33.5 x 26.7 cm
Graphische Sammlung Albertina, Vienna

This watercolor, together with another view of a castle courtyard in the Tirol (ill. 18), was presumably created during Dürer's first Italian journey in about 1494. The location of the castle is still disputed. Together with the other sheet, we have two differing views of the same castle courtyard. They show an extended courtyard with various Gothic castle buildings grouped around it. The bay-like staircase on the left is at its front side opposite the gate tower from which the second view of the courtyard was produced.

18 (top right) *The courtyard of the former castle in Innsbruck with clouds*, 1494
Watercolor on paper, 33.5 x 26.7 cm
Graphische Sammlung Albertina, Vienna

The picture shows a second variation of the castle courtyard in the Tirol, with clouds. The courtyard of the Gothic building is seen from a different side than in the first view (ill. 17). Here Dürer chose the balcony in the gate tower as his viewpoint, while in the first sheet a window in the opposite transverse wing was his starting point. There is still some uncertainty in his application of perspective here. However, the variety of forms of the Late Gothic buildings are recorded in detail.

the sculptural and spatial conceptions of classical art and the Italian Renaissance artists and to understand the practice and theory of what the latter were striving for, the overlapping of the "image of man, perspective, proportion, the classical age, nature, mythology and philosophy." In this area, German art had remained stuck at a Late Medieval level.

Dürer probably first heard of the new trends in Italian art while he was in Basle. The first examples to reach the North were graphic sheets and devotional pictures. Drawn copies of a series of copper engravings by a master from Ferrara from about 1470 are some of the earliest proofs of northern interest in Italian Renaissance art. Copper engravings made by the Italian artist Andrea Mantegna (1431–1506) were in circulation in Germany even before Dürer's Italian journey. Dürer traced them directly from the original sheets, though it is uncertain whether he did this immediately before his journey or during his stay in Italy.

Dürer's first Italian journey is an important milestone in his artistic development. First of all, he was no longer familiar with southern art merely in the form of printed graphics, as was the case north of the Alps, but was able to see the works on the spot.

Basing their insights on the classical architectural theoretician Vitruvius, Italians were studying both the ideal proportions of the human body and the development of central perspective as a means to a more realistic depiction of space. Dürer was to learn about all these things from Italian artists such as Jacopo de Barbari (c. 1440/1450–1515) and Giovanni (1430–1516) and Gentile Bellini (1429–1507), with whom he may have become acquainted in Venice at the arrangement of Nuremberg merchants. There is, however, no evidence as to whether he ever sketched directly from antiques or whether he received his knowledge of classical forms solely from copying engravings made by Italian masters.

The route of Dürer's journey presumably first took him via Augsburg to Innsbruck, where he drew the two watercolors of the courtyard of Innsbruck Castle (ills. 17, 18). These are the first two in a series of landscape watercolors which were created during the journey. They were used as independent study material and private records. Later they were also incorporated into Dürer's printed graphics and the landscape backgrounds of his paintings. There are a total of 32 watercolors dating from the period between 1494 and shortly after 1500, most of which are connected with

Dürer's travels to Italy. None of the sheets is signed or dated. For this reason there is to date no agreement concerning their precise sequence. The watercolors are some of the most studied in Western art history. They can rightly be considered autonomous works and document an altered relationship with landscape painting, which had previously been the least regarded artistic genre, its function being entirely subservient to history paintings. A decisive factor in the new conception of landscape pictures is an individual concept of nature as well as an innovative technique in using watercolors, making it possible to produce the subtlest nuances by building up layers of glaze similar to the technique used in oil painting. While Dürer's early watercolors are still reminiscent of typical examples of topographical methods of depiction from the Franconian workshop tradition, such as the views of Bamberg from the workshop of Wolfgang Katzheimer (active from 1478–1508), in the later works their composition, color and painterly design becomes considerably more free. The atmospheric conception of landscape in these later watercolors has even led to their being compared to those of the impressionist, Paul Cézanne (1839–1906).

Dürer's watercolors can be divided into two groups. The early examples frequently include topographical studies which are the first autonomous colored landscapes to record particular locations in detail. They still contain some perspectival uncertainties, such as the depiction of the *Wire-drawing Mill* (ill. 19). Here, the artistic interest in producing a realistic picture is at the fore. This leads to all details being recorded additively with the same emphasis, and the color being softened very little. His knowledge about the influence of light and air on the appearance of color only becomes noticeable in later works. These move from a natural to an atmospheric and cosmic record of landscape, which becomes clear both in the overall composition and in the more relaxed use of color. The detailed record is now subordinate to the harmonious effect of the whole. A single motif that aroused Dürer's interest, such as a section of wall, a mass of roots in a quarry or a complex of buildings, may stand out from the otherwise summary picture, captured with a few brushstrokes and color surfaces. In later, mature watercolors such as the *Quarry* (ill. 21) dating from about 1506, a section is placed freely on the surface of the picture. Here, Dürer is experimenting with the technical

19 *Wire-drawing Mill*, c. 1494
Watercolor and gouache on paper, 28.6 x 42.6 cm
Kupferstichkabinett, Staatliche Museen zu Berlin – Preußischer Kulturbesitz, Berlin

From a raised vantage point, our gaze passes over the large and small mills in the meadows on the banks of the River Pegnitz belonging to the city of Nuremberg. On the left in the background the city with the Spittler Gate, town walls and gate tower is visible. Although the detailed composition of the sheet still accords with Late Medieval workshop tradition, the fine glazes, produced with considerably thinned watercolors, already herald the freer brushstrokes of later watercolors. In this respect the sheet can be called a milestone in Dürer's development of the technique of watercolor painting.

20 (above left) *Landscape near Segonzano in the Cembra Valley*, c. 1504/1507
Watercolor, 21 x 31.2 cm
Ashmolean Museum of Art and Archaeology, Oxford

Dürer called this landscape watercolor, which was created during his second Italian journey, "wehlsch pirg" (Italian hills). Its topographical location was long disputed. The most convincing suggestion is that this is a depiction of the Cembra Valley near Segonzano. The free manner in which the scene is captured, with the relaxed light brushstrokes in the foreground while the background is recorded with a naturalistic delicacy, makes it understandable why Dürer's watercolor technique at this time has been compared with that of Paul Cézanne.

21 (above right) *Quarry*, 1506
Watercolor and gouache on paper, 22.5 x 28.7 cm
The British Museum, London

The unusual depiction of a quarry, a masterpiece in watercolor, is generally dated to 1506. Dürer captured this section of a rock formation, and placed it centrally and independently on the sheet. The artist's main interest here was not merely to depict the subject of the picture and its bizarre appearance, but to put the possibilities of the watercolor technique to the test. Starting with precise miniature painting, via the glazes of light brushstrokes to broad sweeps of the brush, Dürer made virtuoso use of the entire spectrum of techniques offered by watercolor in this study sheet. The color range is based on brown tones with an incredible range of nuances, creating the impression that Dürer wanted to try out the entire scope of his ability in this small masterpiece.

opportunities of watercolor by allowing various brown tones to come into effect in numerous nuances and shades. The knowledge of perspective gained in Italy was already leaving its mark on watercolors such as the *Landscape near Segonzano in the Cembra Valley* (ill. 20), making them easier to date.

His road led on across the Brenner Pass and through the Eisack Valley to Venice. The likely route can partly be deduced from the watercolors, and partly from information about frequently used routes that has been handed down in the first map printed as a woodcut (ill. 30), complete with travel routes and distances, by the mathematician and doctor Erhard Etzlaub (c. 1460–1532). According to this, Albrecht Dürer's route would have taken him from Innsbruck on the road over the Brenner Pass, then to Bressanone (Brixen) and Chiusa (Klausen), where a watercolor of the Rabenstein near Weidbruck was created. According to the "Bolzano Chronicle" dating from 1494, the roads near Bolzano (Bozen) were flooded at the time of Dürer's journey. It is therefore likely that the artist made a detour through the Cembra Valley, which is confirmed by the watercolor. During his return trip, on the road to the Brenner, he probably created a view of Klausen in the Eisack Valley which has since been lost, though it was reworked in the copper engraving *Nemesis or Good Fortune* (ill. 63).

Dürer's stay in Venice, however, was characterized mainly by drawings produced from originals and from life. Throughout his life, Dürer expressed his enthusiasm for the variety of fauna and flora in numerous

drawn studies. During his stay in Venice, the large-format water study sheets with depictions of a *Sea Crab* and a *Lobster* (ill. 22) were created. Initially there was doubt about the authenticity of these sheets, but Winkler established that the lobster was a member of a species predominantly native to the Adriatic Sea. Studies of lions, reminiscent of Venice's heraldic animal, and mythological depictions have also survived. These sheets, like the watercolors, were independent studies not made in preparation for any concrete work.

In Venice, Dürer copied from works by Mantegna, Lorenzo di Credi (1456/1460–1537) and Antonio del Pollaiuolo (1430–1498), and here his interest in nudes was in the foreground. Studies such as the *Female Nude* (ill. 23) of 1493 provide evidence that Dürer had already considered the depiction of human proportions before his journey to Italy. A prominent example of drawn copies of Italian originals is the pen drawing of the *Death of Orpheus* (ill. 25) in the Hamburg Kunsthalle, which Dürer probably produced in imitation of a painting by Mantegna. The original is only known by a copper engraving which is also in the Kunsthalle in Hamburg. The pictorial theme was drawn from the eleventh chapter of Ovid's *Metamorphoses* (1–43): the classical hero and famous singer Orpheus is killed by two women during a feast of Bacchus in Thrace for having introduced homosexual love to Thrace. This early drawing already demonstrates something that was to become significant in Dürer's later graphic works: recording the human

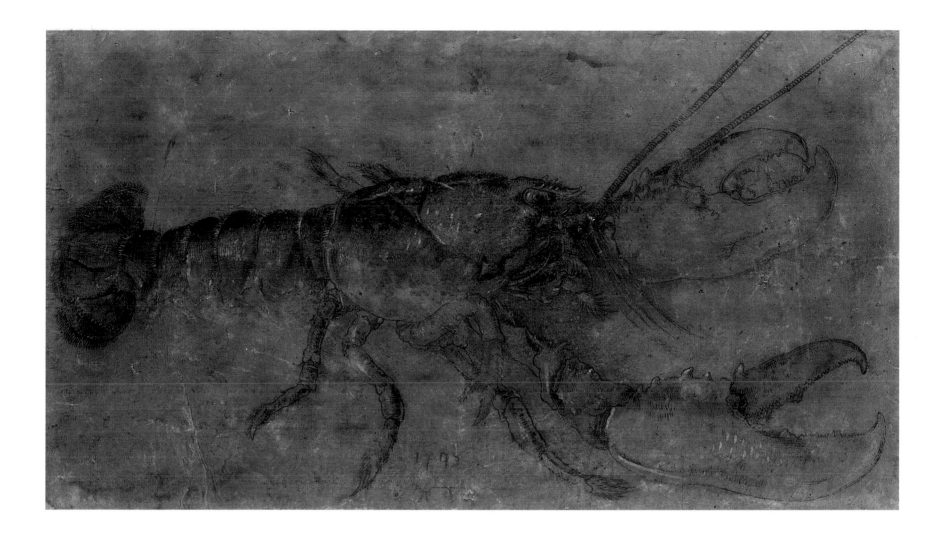

body in motion had priority over narrating the mythological theme. The sweeping gestures of the two Thracian women, both seen from the front and the back, form a counterweight to the movement of Orpheus' body. The study of human proportions and search for the ideal measurement were echoed in numerous other nudes such as the standing nude woman seen from the rear (ill. 24).

On repeated occasions, Dürer spontaneously recorded new impressions from life. This is also documented by the studies of Venetian women wearing the city dresses with very low necklines that were widely considered to be "indecent". In a pen drawing Dürer contrasts a Venetian with a Nuremberg woman (ill. 26), and the liberal Venetian dress clearly differs from the tight and modestly laced German costume.

In this connection, Erwin Panofsky compares Dürer with a modern art historian contrasting a Late Gothic town house and a Renaissance palazzo in a similar manner. Studies of traditional Venetian dress reappear in Dürer's printed works at a later date, such as in the drawing and woodcut of the *Martyrdom of St. Catherine* (ill. 27) and the depiction of the *Babylonian Whore* in the series of woodcuts for the book of the *Apocalypse*.

It has frequently been questioned how Dürer managed to finance this journey to Italy. It is possible that he was able to invest a portion of his wife's dowry, but it is likely that he kept his head above water by selling woodcuts, perhaps even by doing commissioned work. Researchers differ in their opinions about

Dürer's activities as a painter during his first journey to Italy, as there is no corresponding painting that can be definitely attributed to this period by means of a signature or sources.

The picture of the *Virgin and Child* (ill 29) that is now in a private collection but used to be in the Capuchin monastery of Bagnacavallo near Bologna is considered by Anzelewsky to be part of a group of four paintings which were possibly created during the first journey to Italy. There are other opinions, to the effect that Dürer possibly painted the picture after his return to Nuremberg and took it with him on his second Italian journey in order to sell it there. The work was not rediscovered until after the Second World War. Before this time it had been in Italy.

In this picture, the Late Gothic style is already combined with the first hints of the Italian Renaissance. The Virgin is enthroned before a gate arch which opens to one side, the Christ Child bedded on a cloth on her lap. In terms of composition, the group of figures is in the shape of a triangle. Mary and Jesus are related to each other by their postures. The mother is tenderly holding her son's hand and gazing at him both lovingly and mournfully, foreseeing his Passion to come. The strawberry twig in Mary's hand, a symbol of both Christ and Mary, is a sign both of motherhood and, because of its red color, of Christ's Passion. In the monumental and well-proportioned conception of the group of figures Dürer was following Italian models, in particular the Madonna paintings by Giovanni Bellini, though the spatial composition still

22 *Lobster,* 1495
Pen drawing on paper, 24.6 x 42.8 cm
Kupferstichkabinett, Staatliche Museen zu Berlin
Preußischer Kulturbesitz, Berlin

Even during Dürer's first Italian journey, a variety of animal studies documented his interest in all the unusual and exceptional features of nature. One example of this is the above pen drawing. The lobster is positioned to fill the entire page. It is entering the picture from the left. Its fixed gaze and large claws identify it as a predator of the Adriatic Sea, its main native territory. This sheet is one of the studies which Dürer used as independent rather than concrete study material.

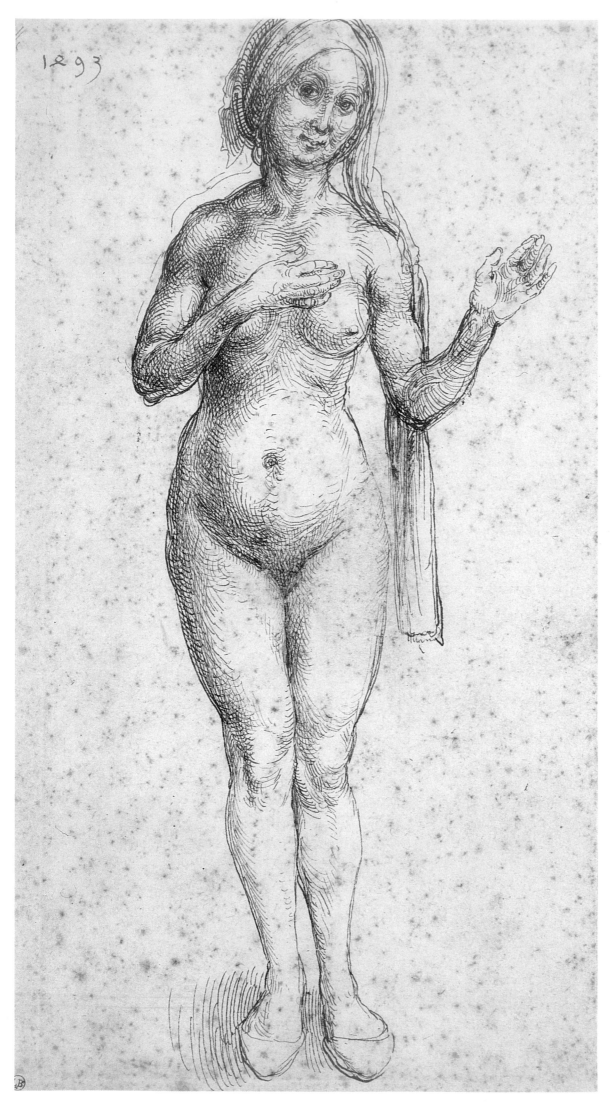

23 *Female Nude*, 1493
Pen drawing on paper, 27.3 x 14.7 cm
Musée Bonnat, Bayonne

This pen drawing demonstrates that Dürer was interested
in the shape of the human body at a very early point in
time. It is the earliest nude drawn from a living model
north of the Alps and anticipates the decades Dürer was to
spend studying the ideal human proportions. The woman,
shown in a frontal view, is smiling in embarrassment as
she modestly holds her right hand in front of her body.
There are still signs of uncertainty in the proportions of
individual sections such as the shoulders and neck.

24 *Female Nude from Behind*, 1495
Brush drawing on paper, 32 x 21 cm
Cabinet des Dessins, Musée du Louvre, Paris

This female nude seen from behind records Dürer's
interest in human proportions during his first Italian
journey. The attributes, staff and cloth, suggest that this
freely drawn nude study was created from a model. The
firmly sketched shape of her body forms a charming
contrast with the glazed, freely swinging cloth. The head
and cloth are executed with gentle brushstrokes and clearly
show a spatially plastic relationship between the figure and
pictorial space.

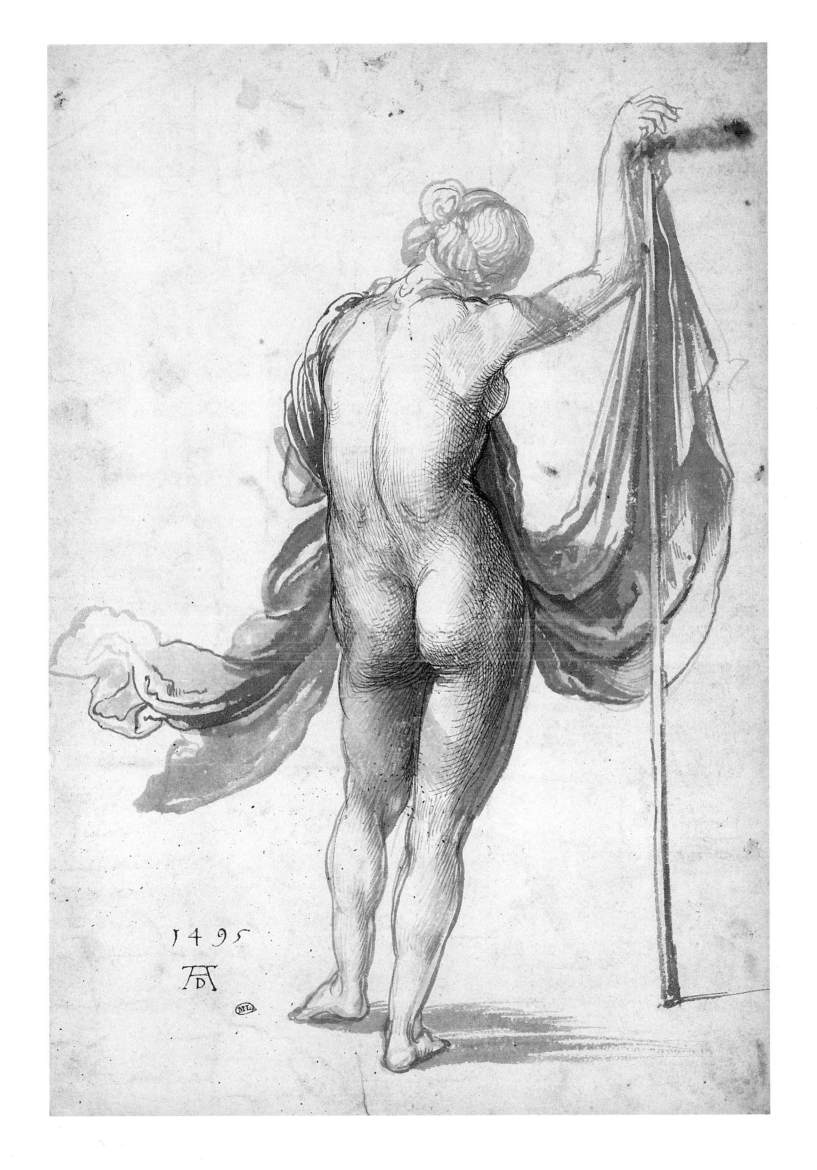

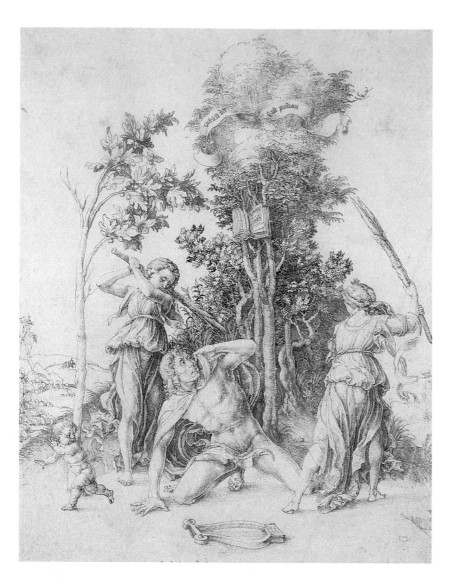

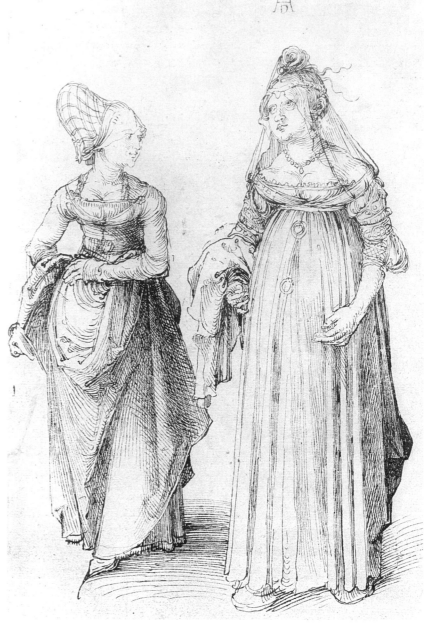

25 *Death of Orpheus*, 1494
Pen drawing, 28.9 x 22.5 cm
Kupferstichkabinett, Hamburger Kunsthalle, Hamburg

This drawing is probably derived from a painting by Andrea
Mantegna, whose printed graphics Dürer copied. The center of the
picture is the male nude in motion. According to the *Metamorphoses*
by the classical author Ovid (43 B.C.–17/18 A.D.), Orpheus
introduced homosexual love to Thrace and for that reason is beaten
to death by two Thracian women during a bacchanal. The group of
figures is placed before a central tree in which an open book with
music is hanging. The classical singer's lyre is lying at his feet.

26 *Nuremberg and Venetian Women*, 1496/97
Pen drawing on paper, 24.1 x 16 cm
Kupferstichkabinett, Städelsches Kunstinstitut, Frankfurt

This pen drawing is an eloquent example of Dürer's interest in
costumes, which he here places side by side comparatively. The two
women, one from Nuremberg and one from Venice, appear as if they
were taking a stroll together in Venice. The lavish ornamentation and
low neckline of the liberal, pretty Venetian costume contrasts with
the modest, simple dress of the Nuremberg woman.

27 *The Martyrdom of St. Catherine*, c. 1497/98
Woodcut, 38.7 x 28.4 cm
Kupferstichkabinett, Staatliche Kunsthalle, Karlsruhe

The woodcut confirms the function of costume studies as
independent source material, for here the saint appears in Venetian
costume. St. Catherine, an Alexandrian princess, suffered a martyr's
death during the reign of the heathen Roman emperor Maxentius, as
a result of her missionary work during the period when Christians
were being persecuted. She was condemned to be broken on the
wheel, but it collapsed at God's command and a rain of fire killed
many heathens. Here, this event is shown together with the
beheading of St. Catherine.

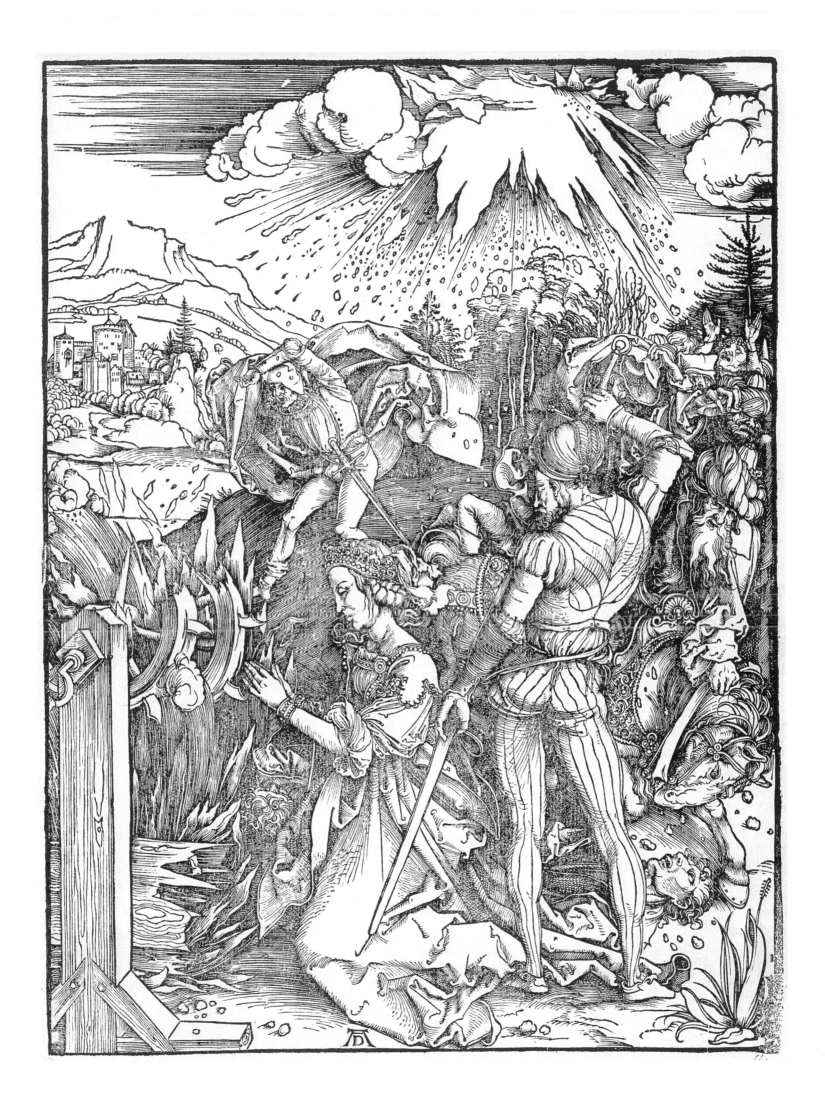

28 *Study of the Christ Child*, 1495
Pen drawing, 17.2 x 21.5 cm
Cabinet des Dessins, Musée du Louvre, Paris

Dürer's pen drawing of a Christ Child is based on a design
by the Florentine painter Lorenzo di Credi, which the
latter made use of in several works, and it may have
been used as a preliminary study for his *Virgin and Child*
(ill. 29). Although the body posture and gestures differ,
the types of faces of the two Infant Christs in the painting
and drawing are comparable.

owes much to the Late Gothic style as influenced by
Dutch painting. The physiognomy of the Christ Child
is reminiscent of Dürer's drawing of a reclining Christ
Child after Lorenzo di Credi (ill. 28). While this
drawing is not a concrete model, there are nonetheless
stylistic parallels.

During the following decades, the achievements of
Italian Renaissance art, as conveyed by both printed
graphics and the works and writings of Dürer, enabled
all genres of art north of the Alps to take a decisive
step forwards. Artists no longer went just to the
Netherlands in order to study the originals of great
masterpieces by painters such as Jan van Eyck
(c. 1390–1441) or Rogier van der Weyden (1399/
1400–1482), copy them and continue work on them
after they returned home; now they also allowed Italian

forms to leave their stylistic mark on their works. Many
German artists, however, merely fed on the indirect
influence of printed graphics and did not journey to
Italy themselves.

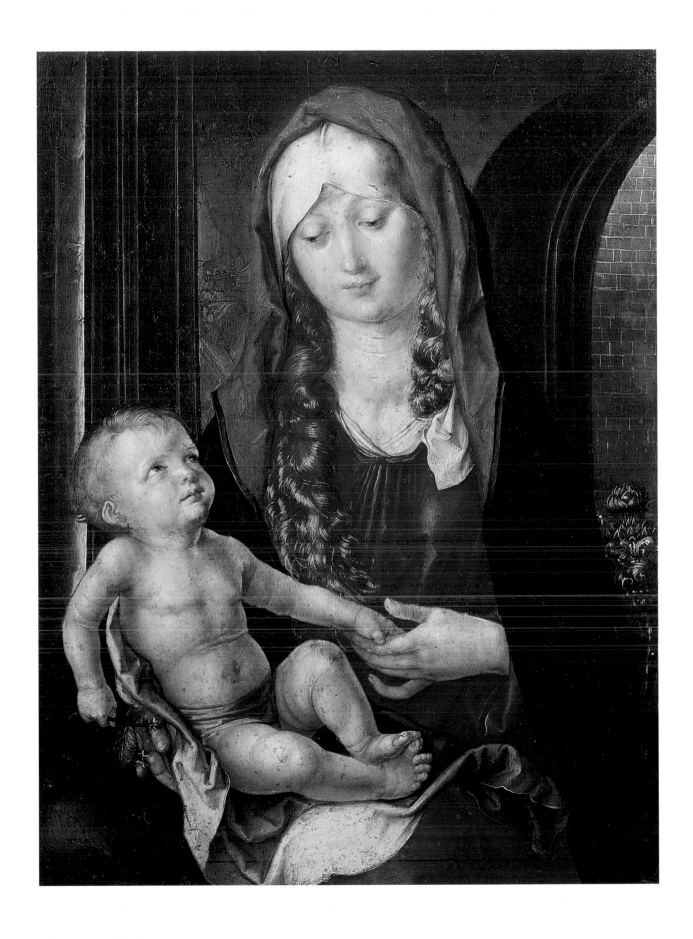

29 *Virgin and Child*, c. 1496
Oil on panel, 47.8 x 36 cm
Magnani Collection, Mamiano near Parma

Mary and the Christ Child sitting in her lap appear to be right in the foreground of a space which opens to one side onto a bordering interior courtyard. While the Madonna still owes much to the Late Gothic German type, the Christ Child is reminiscent of Italian models. Half-length figures such as this early picture of the Madonna were widespread in Italy and the Netherlands. The depiction of the space with the view to the side through an arch is reminiscent of Flemish models, but the figural conception and monumental triangular composition of the group of figures also relates to Italy, in particular to the Madonna paintings by Giovanni Bellini.

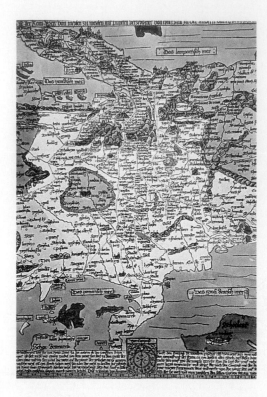

30 Erhard Etzlaub, *Map of the Route to Rome*, 1500
Colored woodcut, 41.3 x 29.4 cm
Bayerische Staatsbibliothek, Munich

Erhard Etzlaub's map of the route to Rome is the oldest
existing road map of central Europe. It was used as a guide
by pilgrims from all European countries and included
information relating to the shortest routes to the holy city,
the distances involved and the length of daylight. The then
metropolis and trade city of Nuremberg appeared in the
center of the map. The map of the route to Rome appeared
in three editions and contained an index compiled by
Hartmann Schedel.

Interest in exploring the world was growing towards the
end of the 15th century as a result of the first missionary
world journeys made by such as Marco Polo (1254–1324)
and pilgrimages to the Holy Land.

This included both journeys to unknown parts of the
world and the development of gauges to be used for more
detailed study and research in the fields of geography and
astronomy. The city of Nuremberg, with its blossoming
metal crafts, provided ideal opportunities for the de-
velopment of precision instruments, and astronomical
and geographical equipment. Albrecht Dürer was also
extremely interested in astronomy. He mixed with famous
geographers and cartographers such as Erhard Etzlaub
(1462–1532), Martin Behaim (1459–1507), Johannes
Stabius (died 1522) and Georg Hartmann, who were
investigating the new sciences for exploring the world.
Famous humanists such as Konrad Peutinger and Willibald
Pirckheimer were interested in travel, and collected and
published travel literature. Peutinger, for example, wrote a
Descriptio indiae which amongst other things mentions
the first arrival of a rhinoceros in Portugal (ill. 31).

Dürer himself had studied the construction of sun dials
in his theoretical work, the *Manual of Measurement*, and
this was the first printed treatise on this subject.

At the beginning of the 15th century, book printing had
also led to a development in cartography. The first two
page map of Germany and central Europe to appear in a
printed book is found at the end of the *Nuremberg
Chronicle* by the Nuremberg humanist and doctor,

Hartmann Schedel. The Nuremberg cosmographer and
doctor Hieronymus Münzer (died 1506) had designed it to
match the map of Germany by Nicolas van Cues (died c.
1439) and the first globe, produced in 1492, by Martin
Behaim. Behaim's globe corrected the misconception that
the earth was a disc, but did not yet take America and
Australia into account due to lack of geographical infor-
mation. Completed in the year that America was discov-
ered, it shows the picture of the Earth in accordance with
the writings of the Greek natural scientist Claudius
Ptolemy (c. 100–160) with the Indian Ocean as an inland
sea with a group of islands along its southern edge. The
polar regions are filled with fantastic forms, and the
southern hemisphere with the Nuremberg eagle.

Amongst the road maps by the cartographer Erhard
Etzlaub, published as single-leaf prints by the Nuremberg
wood block carver Jörg Glockendon, there are two maps
that should be mentioned, in addition to the road map of
Nuremberg and its surroundings, as outstanding examples
of the history of cartography: a map of Rome published in
1500 (ill. 30) as an aid to businessmen and diplomats trav-
eling there and a road map through the Holy Roman
Empire. These much-used maps had an enormously wide-
spread impact and influence on successors. The road maps
appeared in several editions. They were even used by
Martin Luther as a guide when planning his route to the
holy city of Rome.

Columbus' discovery of America in 1492 and the arrival
of foreign peoples in Europe led to a growth in ethno-

31 *Rhinoceros*, 1515
Pen drawing, 27.4 x 42 cm
The British Museum, London

In 1515 the first rhinoceros appeared in Portugal, a gift of
Sultan Muzafar of Kamboja in India to King Emanuel I.
Although he had not seen the animal with his own eyes,
Dürer produced a drawing and a woodcut based on the
sketch and description in a letter from a Nuremberg citizen
who lived in Lisbon, Valentin Ferdinand, to a merchant
who was a friend of Dürer's. The woodcut was also used to
make a leaflet which Dürer sold at markets. The rhinoceros
is standing in the foreground of the picture, filling its entire
format. The detailed depiction of his armor and skin
accords with the wording in the inscription below.

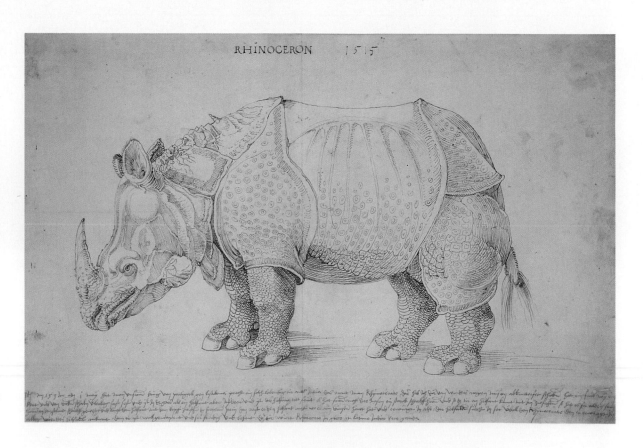

graphic interest which was to become evident mainly in printed depictions, though also in paintings north and south of the Alps.

Hence, for example, contemporary depictions of Turkish soldiers and officers are not merely a historical reflection of the advance of the Turks into Europe, but also reflect the contemporary curiosity about the unknown parts of the world. These notions about other peoples also meant that any gaps in information about them were filled in with fictional elements. The various peoples of the earth described and pictured in the opening section of Hartmann Schedel's *Nuremberg Chronicle* are pure figments of the imagination (ill. 32). All sorts of curiosities are illustrated here, from cephalopods to one-eyed people.

Travel descriptions exist from earlier centuries, but the first illustrated travel chronicle dates from the last third of the 15th century. The Dutch artist Erhard Reuwich accompanied the Mainz Cathedral dean Bernhard von Breydenbach on his pilgrimage to Jerusalem. He produced woodcuts from preliminary drawings made en route to illustrate Breydenbach's report on the journey, *Peregrinatio ad terram sanctam*. The woodcuts document the journey with six large views of cities which were, in part, adapted from the *Nuremberg Chronicle*.

The chronicle, which appeared in 1493 in a Latin and German edition, was a written and illustrated treatment of the events in the world between the Creation and the Last Judgment, divided into seven ages of the world. Michael Wolgemut and his stepson Wilhelm Pleydenwurff (died 1494) designed the illustrations based on the texts of Hartmann Schedel. Comprising 1,809 woodcuts printed with 645 wood engraving blocks, the chronicle was the largest book publishing venture of Dürer's time.

The views of cities were only partly drawn on the spot, being instead mainly drawn from existing models. The *Liber chronicarum* or *buch der Croniken vnd geschichten mit figuren vnd pildnussen von anbeginn der welt bis auf diese vnnsere Zeit* (Book of the chronicles and stories with figures and pictures from the beginning of the world to our own times), as the chronicle was called, had for example adopted the views of Heraklion, Crete, Rhodes and Jerusalem from Erhard Reuwich. For in order to be able to produce authentic depictions of the 32 cities in the *Nuremberg Chronicle*, Michael Wolgemut's assistants would have had to travel 1,500 kilometers on foot, horseback or by ship. Unknown cities were repeatedly replaced by already existing views of cities. Large format views such as that of Nuremberg helped the chronicle to become very famous, and were even still used during the 16th and 17th centuries as models for Sebastian Münster's (1488–1552) *Cosmographia* and the city views by Matthäus Merian (1593–1650).

The predecessors of the present-day travel guides, the first printed guides to Rome, date from the time of the *Nuremberg Chronicle*, and they provided practical information about the pilgrimage, such as places where pilgrims could acquire indulgences. As they were a handy size and could be bound, these books could easily be taken along on the lengthy pilgrimage.

32 Hartmann Schedel, *Nuremberg Chronicle*, 1493
Sheet 12: *Other Nations*
Woodcut, folio
Bayerische Staatsbibliothek, Munich

The *Nuremberg Chronicle* by Hartmann Schedel is divided into a history of the world in seven ages of the world. The second age of the world uses the descriptions of St. Augustine (354–430), the Roman Father of the Church and founder of the monastic order, and the classical author Pliny (23/24–79) and describes the peculiar people who apparently lived in India. In addition to cephalopods and curious hybrids, the woodcuts mainly show people lacking limbs. Scarcely a decade later the comical notions Europeans had about Indian nations would be refuted by the discovery of the sea route to India.

A Revolution in Printed Graphics and Painting

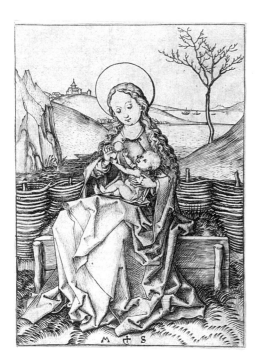

33 Martin Schongauer, *Madonna on the Turf Bench*
Copper engraving, 12.2 x 8.4 cm
Kupferstichkabinett, Staatliche Museen zu Berlin –
Preußischer Kulturbesitz, Berlin

The Madonna is sitting on a turf bench in front of a wickerwork fence which separates the foreground from an extensive landscape in the background, a world landscape. The engraving is an example of the effect Martin Schongauer's works had on Dürer's development of the technique of copper engraving. From a technical point of view, engravings such as this sheet differ in their simplicity from the already more mature works of Dürer.

34 *Virgin with the Dragonfly*, c. 1495
Copper engraving, 23.6 x 18 cm
Kupferstichkabinett, Staatliche Kunsthalle, Karlsruhe

Mary and the Christ Child are sitting on a turf bench in the foreground of the picture. To one side Joseph is leaning back, asleep, while God the Father appears in heaven with the dove of the Holy Spirit, giving his blessing. The dragonfly has also been interpreted as a praying mantis, and as such represents the eternal worship of God. The sheet is a direct successor to Martin Schongauer's work.

"But Dürer, however admirable in other respects – what cannot he express in monochrome, that is with black lines? Light, shade, splendor, the sublime, depths; and, although it has started from the position of a single object, the eye of the observer is offered much more than an aspect …" (Erasmus of Rotterdam, in *de recta Latini Graecique sermonis pronuntiatione*, 1528)

In 1495 Dürer returned to Nuremberg and started by putting the knowledge and ideas he had gained during his five year journey into practice in printed graphics, though a few years later he also applied them to paintings. The time after his journey can be termed the first high point in Dürer's creative work, during which, in a very short period, he perfected his abilities and revolutionized printed graphics and painting in terms of function, methods of depiction, themes and technical methods in a way no other artist of his age did. Between 1495 and 1500 about a dozen paintings and over sixty printed sheets were produced. The latter also comprise, in addition to almost the entire series of the *Great Passion* and the *Apocalypse*, seven large format single-leaf woodcuts and 25 engravings which he printed on his own printing press in the Nuremberg workshop he founded in 1495, and upon which his international fame was to be based.

In addition, Dürer was the first German artist to find new opportunities for production and distribution. Technical reproducibility, the possibility of reusing worked wood engraving blocks and copper plates as setting copies and printing high print runs, was something he used to a degree previously unknown. He was the first to introduce the production of printed graphics in his own publishing business on an equal footing with the running of a painter's workshop.

In contrast to his teacher Michael Wolgemut, Dürer produced his printed graphics in advance and not on commission. This meant that in this medium he was independent of the traditional iconography and of the prescriptions normally stipulated by paying customers when ordering works. At that time, the artist was still considered to be a craftsman, an agent who had to meet the client's requirements. Dürer's new method of using the medium of printed graphics made a considerable contribution towards changing artists' self-image

in Germany and raising their social acceptability. In this way the artist emancipated himself from being a simple craftsman to being the more self-determined "creator" of new themes or new artistic interpretations of existing themes. A sign of this increasing self-determination, independent of the traditional social understanding of artists, is the process of signing and dating printed graphics. The fact that Dürer's copyright was shamefully ignored suggests that the signature was an attempt to guard against abuse. Letters which Dürer wrote to Jakob Heller (c. 1460–1522) in 1507 clarify his endeavor to apply his ideas and knowledge independently of clients. This is probably also the reason why the emphasis of his work during the first five years after the foundation of his workshop was on the area of printed graphics. During this time he perfected his engraving technique and achieved his own style which has yet to be surpassed technically. Dürer also applied the experience he gained in this way to woodcuts, which he liberated from their Late Gothic stylistic forms. He enabled both techniques, which he treated equally in his work, to achieve new pioneering forms of expression.

In addition to the artistic, it was probably also the commercial possibilities of the new medium that proved decisive. As early as 1497 Dürer engaged his first art dealer, Conrad Swytzer, who was to offer the prints for sale at the highest possible prices – as established in the contract – by taking them "from one place to the next and from one town to the next." Nuremberg was the ideal place to produce and sell printed graphics. On the one hand, the city had been a center of parchment, and later of paper production since the Middle Ages, and on the other hand copper crafts were also widespread there, so that the workshops' demand for copper engraving plates could be met without difficulty. The numerous Nuremberg city festivities, fairs with shooting matches, funfairs and annual "Heiltumsfest" provided an outstanding sales opportunity.

Dürer's earliest monogrammed copper engravings date from the time immediately after his first Italian journey, and they are still influenced by Martin Schongauer, particularly as regards their figural

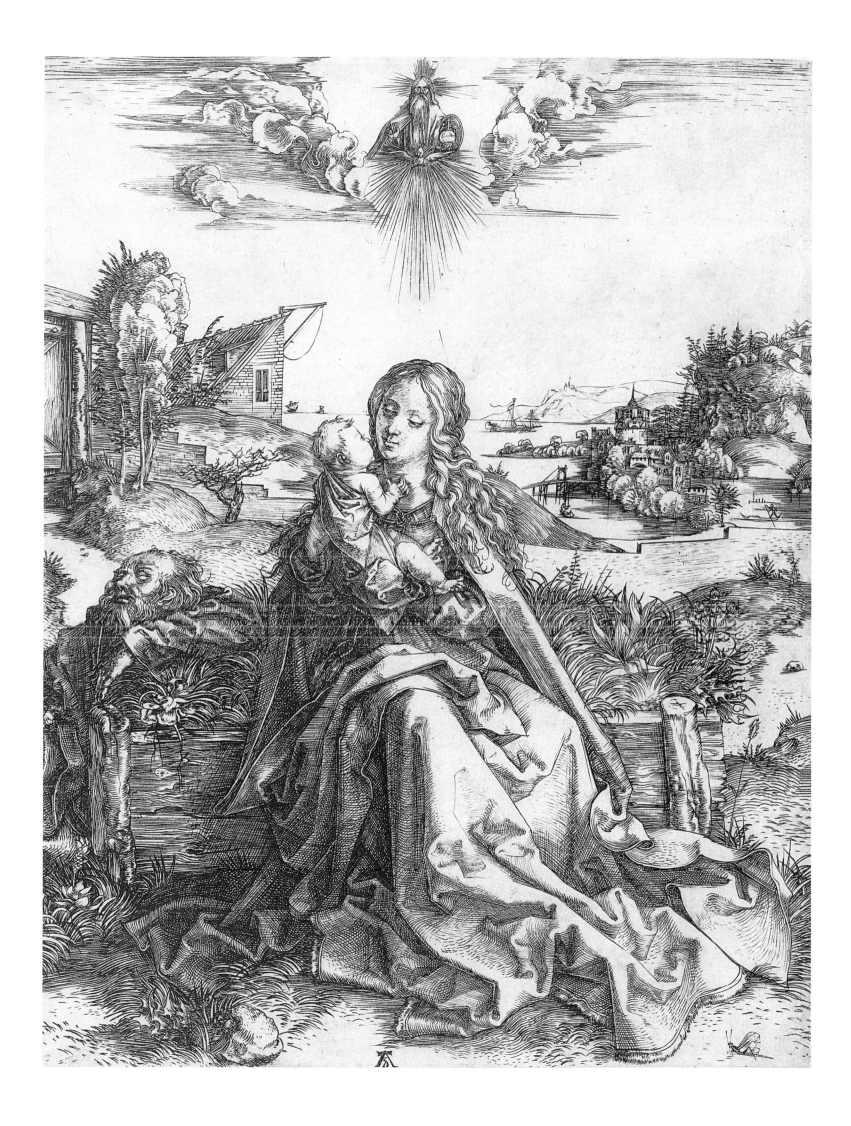

composition. There are about 30 engravings dating from this period. They are not dated at this point, something that Dürer started adding to his sheets from 1503 onwards.

The course of Dürer's artistic development in this technique can be followed in a sequence consisting of about 13 engravings. One can detect a gradual refinement of his use of lines which become continually more painterly and free.

The *Virgin with the Dragonfly* (ill. 34), Dürer's first signed copper engraving which is generally dated to about 1494/95, is one of the few early examples of this technique. The work, which is an adaptation of an earlier drawing by Dürer, reveals the influence of Martin Schongauer (ill. 33) in the Late Gothic formation of the garment folds and the composition of the figures. Here, his interwoven monogram can be seen in its earliest form, with the Late Gothic small letter of his surname within the capital letter of his Christian name. Some of the details of the group of figures, such as the cloak which falls stiffly on either sides and whose diagonal lines are emphasized, are reminiscent of Schongauer's altar painting *Madonna of the Rose Arbor* in Colmar. The overall composition, which fits in with a geometric basic scheme, and the conception of nature in the landscape in the background are drawn from experiences gained during Dürer's first Italian journey. The dragonfly has also been interpreted as a praying mantis, and as such would symbolize the eternal worship of God. Together with other copper engravings which were created immediately after Dürer's return to Nuremberg, the *Virgin with the Dragonfly* should be ascribed to the early period of Dürer's development of copper engraving. Here, Dürer was not yet revealing the three-dimensional values, depth, nuances and numerous intermediate tones so clearly by means of cross-hatching. In contrast to later sheets, he was also not yet making use of the opportunities provided by the "taille," the rising and fading line created by the burin.

In these first engravings Dürer was still combining the style and motifs of the Master of the Housebook with those of Martin Schongauer. Their influence was one he had to overcome in order, after a period of intense productivity, to be able to achieve his own style and technique shortly afterwards. The sheet of the *Violent Man* (ill. 35), dated 1495, also appears a little clumsy when compared to later works. The format and line techniques, in their nervous small scale, are reminiscent of works by the Master of the Housebook, the theme of whose works was also the transitoriness of earthly desires (ill. 36). *The Walk* (ill. 37), a copper engraving that can be dated between 1496 and 1498 and which is more free in its execution of lines, is also part of the tradition of moralizing pictures meant as a warning to the observer. A married woman, shown to be such by the bonnet she is wearing, is walking with her lover. Her costume consists of a mixture of Nuremberg and Venetian elements. The ostrich feathers on her gallant's hat are a sign of his bachelor status. The strolling couple in the foreground is being watched, almost undetectably from

behind a tree trunk, by Death who is holding a raised hour-glass in his hand. Here, love and sensuality were considered, as in so many pictures of the age, to be a metaphor for vanity, and they were confronted with the symbol of elapsing time.

The themes depended on the format of the paper. Several pictures were always printed on each sheet of paper. Hence, small formats mainly depicted scenes with secular and allegorical themes which were more traditional in terms of composition and motifs. Dürer used larger formats for religious and secular pictures to equal degrees. Sheets dating from the years from 1496 to 1498, such as *The Prodigal Son, Hercules at the Crossroads* and the *Madonna with the Monkey*, manifest his progressive liberation in terms of line and style from the models which still dominated his early period. *The Prodigal Son* (ill. 38) was already a prominent sheet during Dürer's time and displays his innovative treatment of themes. This subject, rediscovered by Dürer, soon became widespread and was copied by Italian 16th century engravers, faience painters and even by a Persian painter of miniatures. The Gospel of St. Luke tells us about a son who has his share of his father's inheritance paid out to him, fritters it away in the company of whores and in the end, when bankrupt, even envies the food the pigs are eating from the trough; he then returns penitent to his father and finds forgiveness (Luke 15, 11–32). Earlier woodcut illustrations normally depicted the prodigal son grieving out in the open while a servant knocks acorns off the trees for the swine.

Before this time, there was no known depiction of the moment of repentance. In Dürer's picture, the admission of repentance achieves a new emotional quality, the intensity of which is impressive. By falling to his knees, the prodigal son is lowering himself to the level of the swine and is praying for forgiveness while gazing heavenwards in desperation. By placing the scene in the inner yard of a farming settlement, Dürer departed from the precise text of the Bible. He transposed the events into the contemporary moment, making it comprehensible to the observer. The realistic portrayal of the everyday surroundings – the so-called "Himpelshof" to the west of Nuremberg is depicted – contrasts with the heartfelt attitude of the praying protagonist. The diagonal lines of composition of the surrounding roofs point to the prodigal son in the foreground and, hence, to the foreseeable happy ending: the mercy which the penitent sinner will find at his father's house. Dürer treated texts more freely if, as here, it served the overall statement of the composition. The heartfelt, genuine repentance of the prodigal son as the precondition for his reacceptance is a metaphor of God's mercy and the main motif of the copper engraving which contemporary observers found so fascinating. The separation of the figural and topographical depiction in the foreground and background leads to a compositional clarification which was also greatly admired.

The reformation of traditional methods of depiction is not the only significant element in Dürer's graphical works. There is also the invention of his own pictorial

35 *Violent Man*, c. 1494
Copper engraving, 11.4 x 10.2 cm
Kupferstichkabinett, Staatliche Kunsthalle, Karlsruhe

In the middle of the picture, on a turf bench, a wild wood gnome is attacking a young woman who defends herself angrily. While the lean, bony man is reminiscent of depictions of Death, the dead tree to the left of the turf bench is a symbol of vice and fated undoing. The original intention was to include a commentary, as is shown by the empty inscription cartouche above the scene. The most obvious interpretation is that made by Panofsky, who considered the small genre picture to be an allegory of death.

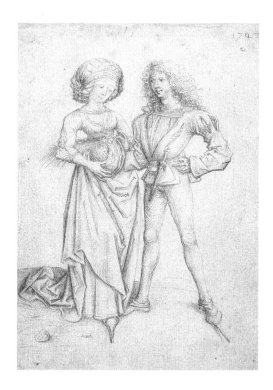

36 Master of the Housebook, *Standing Couple*, c. 1480
Drawing, 19.5 x 13.5 cm
Kupferstichkabinett, Staatliche Museen zu Berlin –
Preußischer Kulturbesitz, Berlin

This drawing was created by the so-called Master of the
Housebook a decade before Dürer's *The Walk* (ill. 37).
There are a large number of such gallant genre scenes that
were drawn by his hand. Dürer may have seen them in the
original during the years he spent traveling, and been
directly influenced by them.

37 *The Walk*, c. 1496/97
Copper engraving, 19.6 x 12.1 cm
Kupferstichkabinett, Staatliche Kunsthalle, Karlsruhe

The copper engraving showing a strolling couple is one of
the genre pictures which Dürer created in the tradition of
the Master of the Housebook (ill. 36) and Martin
Schongauer. As the gallant gazes at his companion
adoringly, he points ahead to the path. The ostrich feather
he is wearing in his hat is a sign of his bachelor status. The
fantastic costume worn by the woman combines elements
from both Nuremberg and Venetian fashion. Behind the
tree, unnoticed by the lovers, Death is holding up an hour-
glass. The picture can be interpreted as a moralizing
metaphor for the transitoriness of love and sensuality.

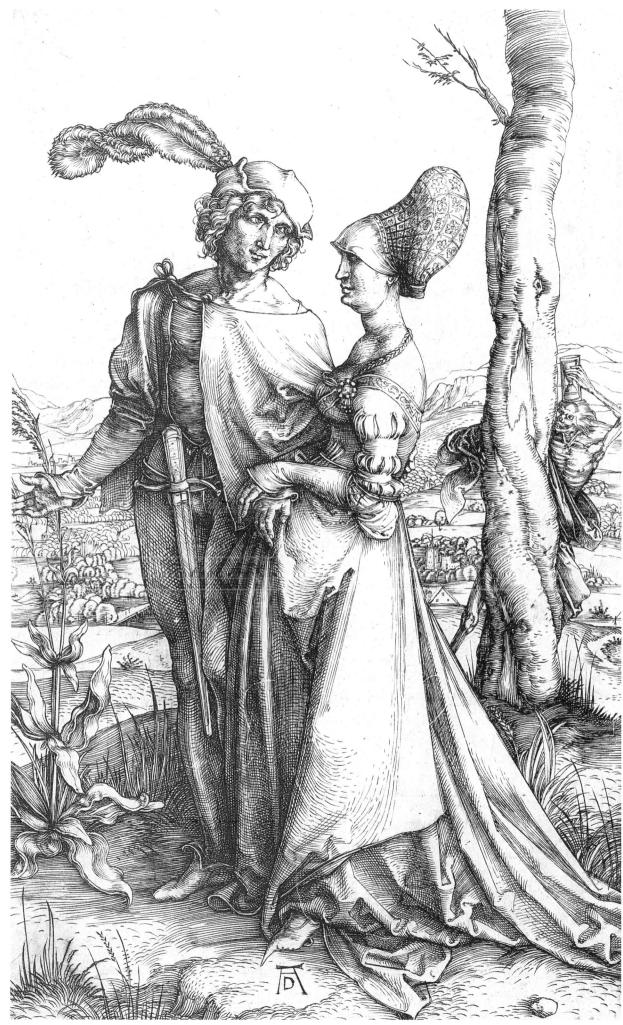

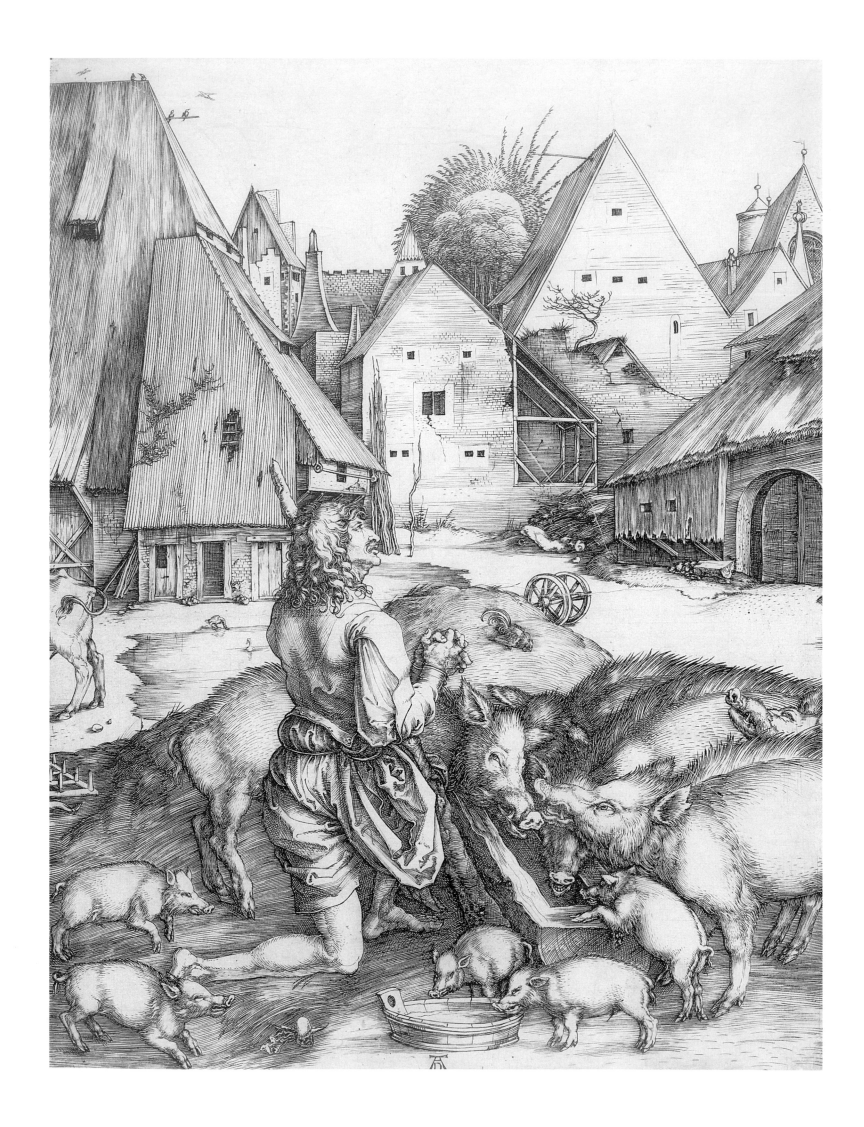

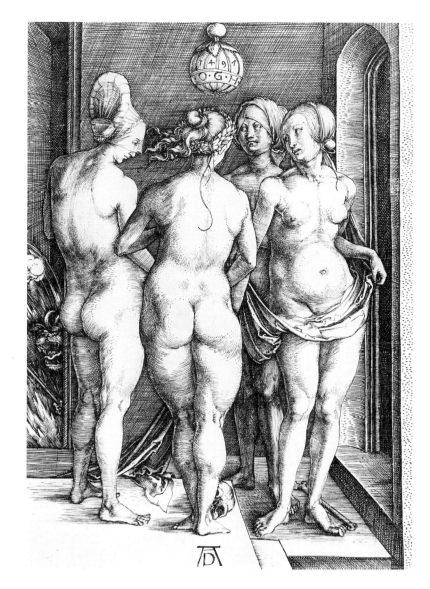

39 *The Four Witches*, 1497
Copper engraving, 19 x 13.1 cm
Germanischer Nationalmuseum, Nuremberg

This copper engraving is an example of the ambiguous
meaning of those Dürer's works that combine the heathen
and classical with the Renaissance ideals of thought. In a
small confined space, four female nudes are standing
together conspiratorially. The floor beneath their feet has
steps at different levels. The wall opens up to the left, and
the Devil in the shape of a horned monster is peering out.
The door opening to the right is shown by the skull and
bones lying on the floor to be the gateway to Death. The
group of women, which is derived formally from a classical
marble group of the Three Graces, have been interpreted in
different ways, amongst others as the three goddesses who
judged Paris together with the goddess of Discord, or as
four witches. The letters on the ceiling globe, "ODM,"
have been completed to read "Odium Generis Humani"
(repugnance of mankind). One possible interpretation
suggests that the engraving is a warning that disagreement,
disputes and quarrels inevitably lead to death.

38 (opposite) *The Prodigal Son*, c. 1496/97
Copper engraving, 26.1 x 20.2 cm
Kupferstichkabinett, Staatliche Kunsthalle, Karlsruhe

In the copper engraving of *The Prodigal Son*, Dürer
deviated considerably from earlier depictions of the theme.
Here, the scene is placed in the midst of a Franconian farm
and shows the prodigal son at the moment of his
repentance, kneeling in prayer on a pile of manure in the
foreground amongst the swine. The naturalism of the
picture was widely admired and contributed to the fame of
the copper engraving.

themes which were stimulated by the Nuremberg
circle of humanists and the mythological and allegor-
ical literature of the period. The interpretation of
sheets such as the *Four Witches* (ill. 39), the *Dream of
the Doctor* and *The Sea Miracle* has posed some difficul-
ties to researchers of art history and has led to contra-
dictory explanations, for Dürer frequently brought
together a variety of written sources. The complex
pictorial themes were intended for an educated circle
of humanist clients to whom the artist must at the
same time have owed suggestions for the content of his
pictures. His independent interpretation and reformu-
lation of traditional picture genres, however, indicates
Dürer's own extensive knowledge of humanist allegory
and classical mythology.

From 1496 Dürer's studies of human proportions
began to leave their mark on his work in printed
graphics. Woodcuts such as the *Men's Bathhouse* and the
copper engraving which Joachim von Sandrart called
The Four Witches because of the Devil who appears on
the left edge of the picture indicate that Dürer had
studied human proportions from a Vitruvian point of
view, presumably exclusively from copies of classical
sculptures. As a result, references have been made to the
classical group of the Three Graces with regard to the

overall composition of the copper engraving – it had
been excavated in Rome in 1460 – and Dürer added a
fourth figure to the group of three, the female nude
standing in the background (ill. 39).

While Dürer had considerably refined the tech-
nique of copper engraving during the first years after
his return from Italy, his next step was to devote
himself increasingly to woodcuts, and he revolution-
ized this in terms of form, content and technique.
The most immediately noticeable features are his
working of large formats and the adoption of fine
lines and hatching techniques that had not previously
been customary in woodcuts. These were the means
by which Dürer achieved an impressive range of
intermediate tones, from the deepest black to free
whites, in the modeling of interior details and
recording of materials. In their style, and in compar-
ison to earlier works, the woodcuts of the late
Nineties were so outstanding that they immediately
met with great success on both sides of the Rhine
and the Alps.

Large, single-leaf woodcuts by Dürer dating from
the years between 1496 and 1498 depicted both
secular and sacred themes. Pictures such as the *Men's
Bathhouse* show his increasing superb mastery of the

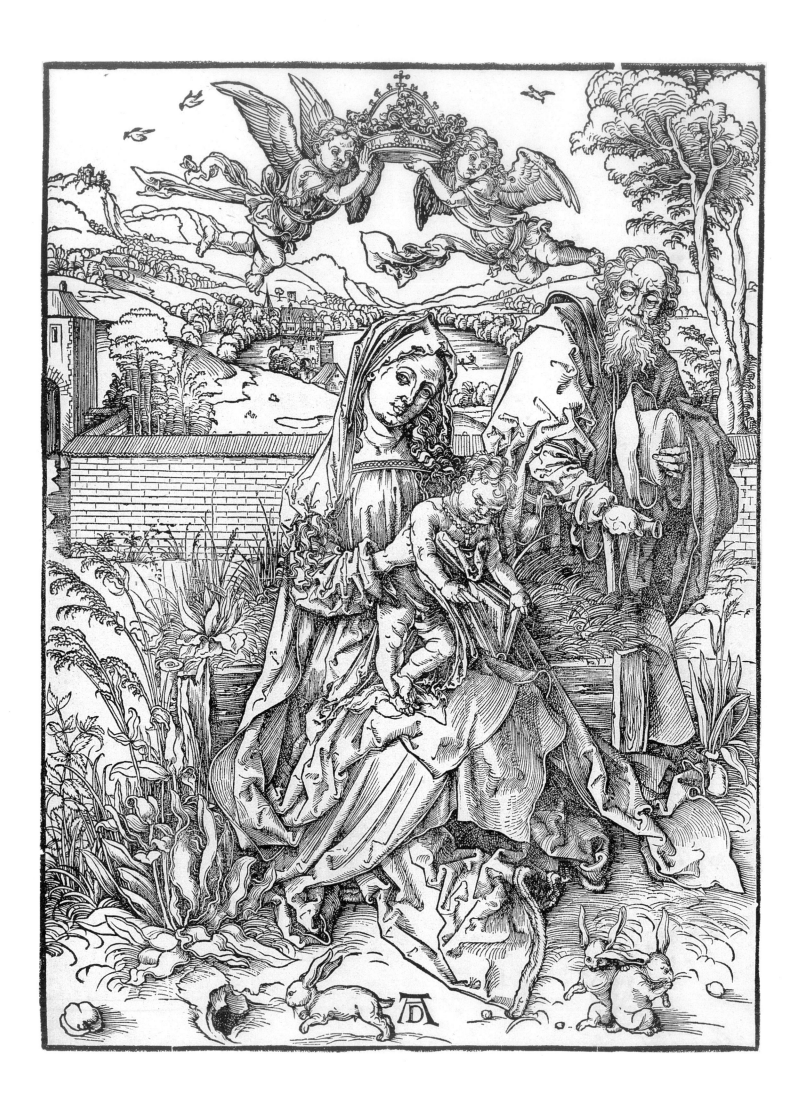

technique to an equal extent as in the *Holy Family with Three Hares* and *The Martyrdom of the Ten Thousand.*

The single-leaf woodcut of the *Holy Family with Three Hares* (ill. 40), dating from about 1497, is one of four religious single-leaf woodcuts which were created before 1500 and at the same time as the illustrations for the *Apocalypse.* The theme of the Holy Family in the "hortus conclusus" – an image of the remoteness of the heavenly paradise as opposed to the "worldly landscape" symbolizing the earthly world – is connected with a range of other themes. Here, for example, the Coronation of the Virgin is linked to the type of Madonna as seen in the picture on the turf bench, surrounded by numerous plants that are symbolically related to Christ and Mary. The three hares represent both the Holy Trinity and fertility. The variety of thematic references can be explained by the function of the sheet: the woodcut could be used – a feature new in the field of printed graphics – either as a devotional picture or as something religious to decorate the wall.

While the theme and the compositional conception may appear traditional, there are features in the linear execution that had previously been reserved for copper engraving: these include the delicate play of lines, the ornamental picture structure which is related to the surface, and the careful arrangement of sections of light and shade. A new feature is that the flow of the lines, as in copper engraving, appears free and descriptive and that nuances are created by means of cross-hatchings which interact to convey a sense of plasticity. The juxtaposition of black lines over a white base and white lines over a black base is also a well-calculated compositional method.

His innovative use of woodcut techniques suggests that Dürer did not use a wood block carver but prepared the wood engraving blocks himself.

The media-related function of printed graphics, such as their use in the form of leaflets, was adopted by Dürer whenever the theme moved him that way. The copper engraving of *The Deformed Landser Sow* (ill. 41) is connected with the reproduction of deformed animals and natural catastrophes before the turn of the century. This motif, which appears often in contemporary printed graphics and other sources, is recorded on several occasions in Dürer's work. News of such incidents, passed on by means of printed leaflets such as the two woodcuts by Sebastian Brant depicting the deformed piglets Dürer used as his models, was received fearfully by the population and interpreted as a sign of the imminent end of the world and possible judgment of God.

Dürer's famous fifteen-part series of woodcuts based on the Revelation of St. John must also be seen in connection with the expectation, shortly before 1500, that the last days had come. The last book in the New Testament, the Revelation of St. John, announces the coming Apocalypse. He wrote his visions down while in exile on the island of Patmos. They describe the Apocalypse, the last days of the world preceding the Last Judgment. The text, which is full of symbolism and difficult to interpret, narrates the events in chronological order.

Dürer created independent woodcut illustrations that have an unsurpassed expressive power and vivid dramaturgy. They are one of the high points in his work. The woodcuts are related to earlier prints on the same theme, but are more formally eventful and rich in detail than the latter. Dürer published an edition of the *Revelation of St. John* in his own printing works. The text runs continuously on the left page and only relates to the large format woodcuts arranged on the opposite page in two places in the book. For the print, Dürer chose a half sheet of paper in a vertical format. In the structure of the book he emancipated the illustration as a narrative medium of equal value to the text, and in terms of form and content surpassed his predecessor Erhard Reuwich, the only artist before Dürer to have published a book.

With the publication of the *Apocalypse*, Dürer created a new type of book that brought him great fame overnight. The volume appeared in 1498 in Nuremberg in a German and Latin edition simultaneously. It is not known how large the first print run was, but by 1511 a new edition of the Latin version was printed and by 1515/16 the first edition had already been reprinted three times. The text of the Latin version, titled *Apokalypsis cum figuris*, followed what was then the best known translation of the Bible, the Vulgate. It, like the Latin edition of the *Nuremberg Chronicle* by Hartmann Schedel, was printed using the types made by Anton Koberger's workshop. The formal models were the woodcuts of the so-called "Cologne Bible," which had appeared in Cologne in 1478 in a Dutch/Rhenish and Lower Saxonian edition, and which Koberger had used as a model for his German Bible published in 1483. Dürer largely followed this example when selecting the sections of text to be illustrated, but enriched the program by adding the scenes *St. John receives the Instruction from Heaven* and *Hymn of Praise of the Chosen*. Scenes, in contrast, which were combined in simultaneous scenes in previous illustrations were separated by Dürer into individual pictures.

The high artistic quality of the woodcuts, the dynamism and intensity must have appealed to the observer. They coincided with people's belief that the Apocalypse was to be expected by 1500 at the latest. In order to make the events even more topical, Dürer depicted his figures in contemporary costume. He produced scenes that were excitingly dramatic, in comparison to which his predecessors' illustrations, in block books composed of single-leaf woodcuts and printed bibles from the early 15th century, appeared dry and stereotyped. Scenes such as the *Four Horsemen of the Apocalypse* or *St. John swallows the Book* (ills. 42, 44) had a rousing effect on contemporary observers. The eschatological ending, the Last Judgment, is missing from the series. Instead, Dürer expresses both hope and faith in the redemption of the world in the last sheet, *The Angel with the Key to the Bottomless Pit* (ill. 43).

Dürer's *Apocalypse* has a cyclical structure both in overall and individual terms and, as recent research by Peter Krüger has confirmed, it returns to the narrative method of humanist literature. The composition of the individual scenes predetermines the sequence of the

40 *Holy Family with Three Hares*, 1497
Woodcut, 39. 5 x 28.5 cm
Kupferstichkabinett, Staatliche Kunsthalle, Karlsruhe

The large format woodcut combines the depiction of the Holy Family with the scene of the Coronation of the Virgin. In the *hortus conclusus*, a garden separated from the extensive landscape beyond by a wall, Mary is sitting on a turf bench while St. Joseph is gazing at her respectfully. The Christ Child is wearing a rosary around his neck and is about to open the Holy Scriptures in accordance with the Christian motto, "Jesus is the Word." Two angels with the magnificent crown of Heaven are floating above Mary, and the three hares symbolize fertility and the Holy Trinity. The free style of the lines, full of nuances, differs from earlier depictions of the scene.

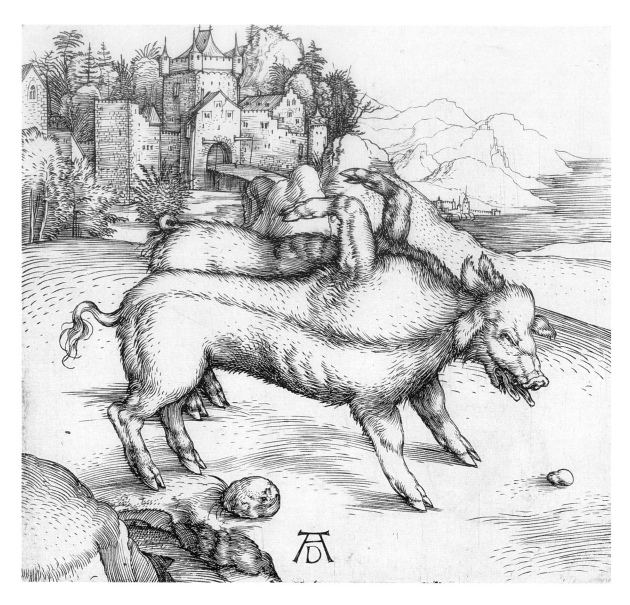

41 *The Deformed Landser Sow*, c. 1496
Copper engraving, 12.1 x 12.6 cm
Kupferstichkabinett, Staatliche Kunsthalle, Karlsruhe

A deformed pig is standing on a rise above a river landscape. Its body is divided towards the back. Two front legs are sticking up out of its back. The copper engraving was preceded by a leaflet by Sebastian Brant, which spread the news of the birth of a two bodied, eight legged, four eared and two tongued pig in Landser. Deformed animals such as these were interpreted as divine signs by the population, referring to the end of the world which was expected to take place in about 1500. In the course of the impending Turkish invasion, the leaflet and copper engraving have also been interpreted as heralding the imminent supremacy of the heathens over the Christians, or more generally the rule of the Antichrist.

contents for the observer, and the narrative structure of the entire cycle, with its built-in reversions and anticipations, is analogous to Aristotle's (384–322 B.C.) *Poetics*. Dürer presumably learned the classical theory of poetry in humanist circles during his first Italian journey. It has been proven by detailed analyses of the pictures that all the figures have a particular function in terms of the temporal and spatial sequence of the narrative. Dürer found artistic models for the importance of the relationship between the figure and its place in the scene in Giotto's fresco cycles and the pathos of the gestures of Donatello's (1386–1466) and Mantegna's works.

Some of the best known woodcuts have remained influential into the 20th century. The *Four Horsemen of the Apocalypse* (ill. 42), for example, played a key role in "My Name is Ivan," a 1962 film by Andrei Tarkovsky (1932-1986), in which the Apocalyptic Horsemen appear as a symbol of the German soldiers causing havoc in Russia.

The above-mentioned woodcut occupies a key position within the series, for it narrates, on the first of four occasions, how the judgment of God descends on mankind in the form of plague, war, hunger and death. It is based on the third vision of the Revelation of St. John (Rev. 6, 1–8). After four of the seven seals have been opened, four riders are sent out into the world in turn, galloping chronologically in an echelon that is slightly staggered towards the back: the first is riding with a drawn bow, the second with a raised sword, the third with a pair of balances and the fourth, finally, is Death followed by shapes from the underworld. The direction of reading leads out of the picture, creating the impression that the events cannot be contained by its edge. Even though the horses' hooves do not touch the ground, the forms lying on the ground are tumbling like ninepins, overpowered by this celestial vision. The last rider, who has been inconsistently interpreted as Death or as a secondary figure of "heavenly justice" related to the central rider, is followed by the jaws of Hell which swallow every sinner one by one. The figure of the "farmer" at the right, bottom edge of the picture makes the extent of the catastrophe clear. He has been seen as an identification figure for the observer, leading the events to the right beyond the edge of the picture, though still serving as a compositional counterbalance. Even as he falls – expressed by the peculiarly twisted position of his body – he is holding his hand protectively before

42 *Four Horsemen of the Apocalypse*, 1497/98
Woodcut, 39.9 x 28.6 cm
Kupferstichkabinett, Staatliche Kunsthalle, Karlsruhe

The *Four Horsemen of the Apocalypse* is the best known and most frequently referred to scene in the *Apocalypse*. After the opening of the first four seals (Rev. 6, 1–8), the Horsemen enter the world and bring plague, war, hunger and death to mankind. The group of riders, accompanied by an angel, thunders across mankind and does not appear to touch the ground. Finally, a hellish creature at the side of the Four Horsemen is swallowing everything in his enormous jaws that Death, the final rider, has passed.

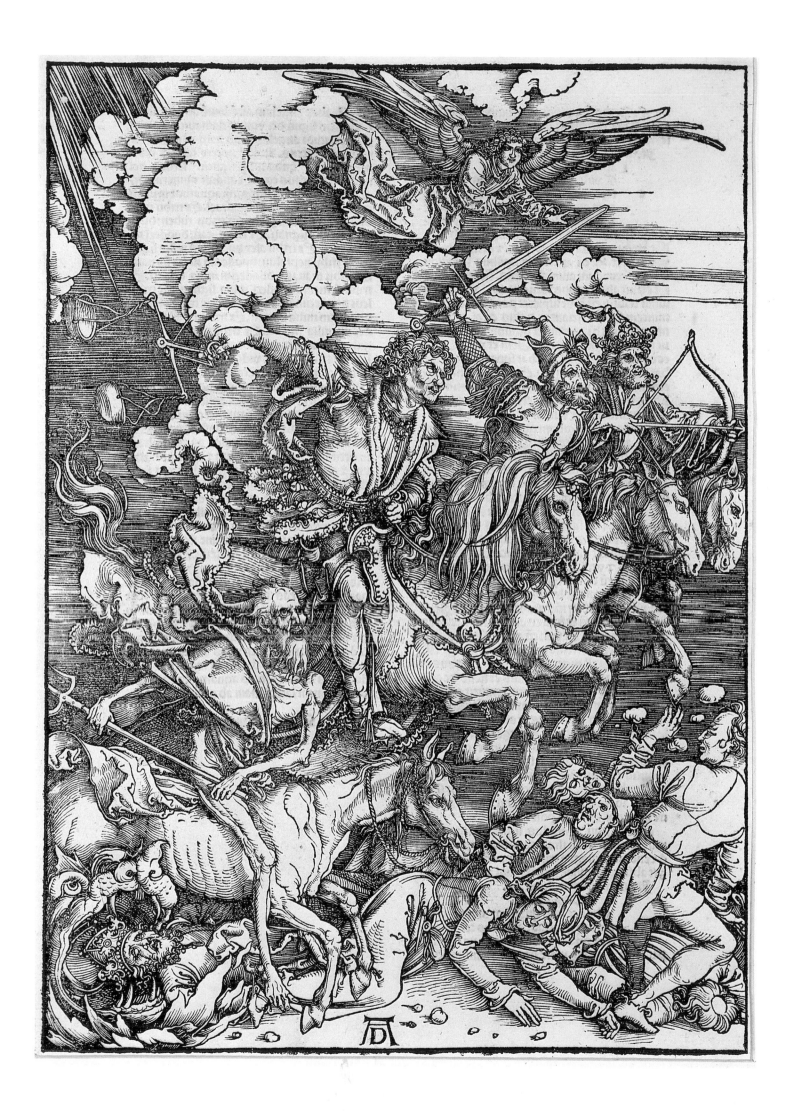

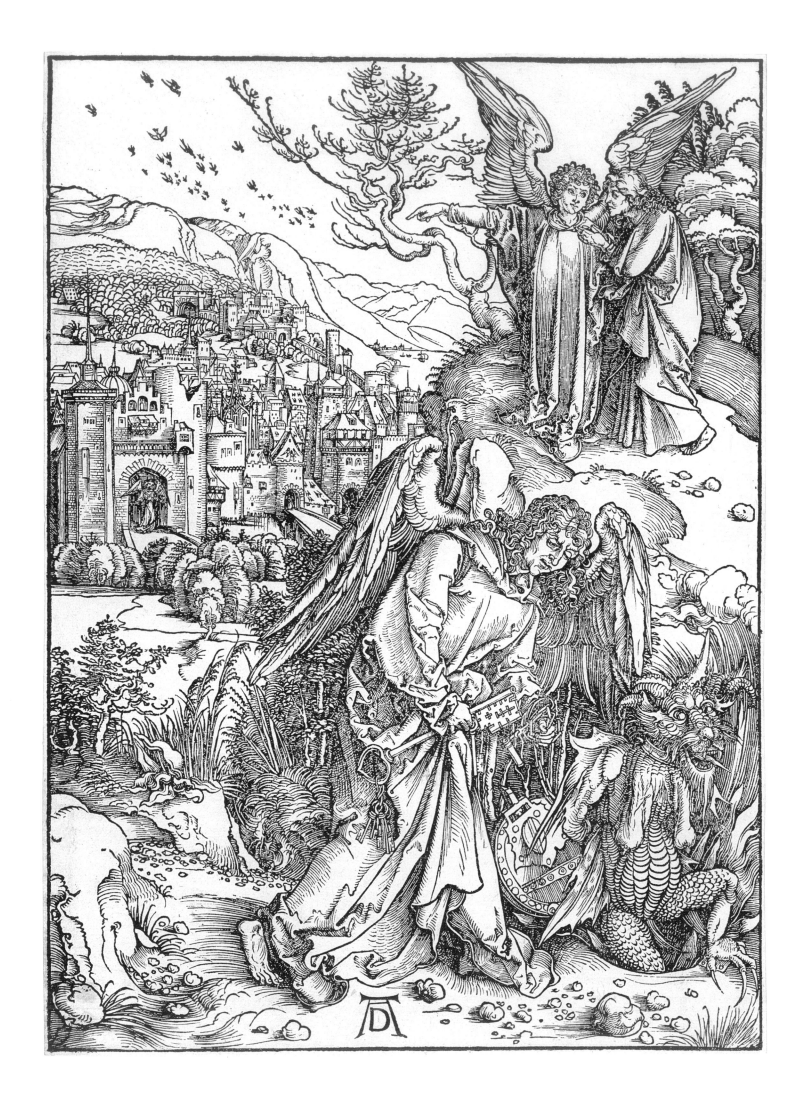

43 *The Angel with the Key to the Bottomless Pit*, 1497/98
Woodcut, 39.8 x 28.6 cm
Kupferstichkabinett, Staatliche Kunsthalle, Karlsruhe

In this last sheet of the *Apocalypse*, two events are
combined in one: the incarceration of Satan in the
foreground (Rev. 20, 1–3) and Jerusalem being pointed
out in the background (Rev. 21, 9–10). While Satan is
forced by an angel into a hole in the ground that is to be
closed up for ever, another angel is pointing the road out
to St. John in a scene behind them. He is supposed to
rebuild the abandoned, half ruined city that is being
guarded by angels – in the context of the general
expectation, in about 1500, that the last days had come,
this can be interpreted as a symbol of the Holy Roman
Empire. The flock of birds diving towards them is a
reference to the part of the text in which the angels order
the birds to gather to eat the bodies (Rev. 19, 17).

44 *St. John swallows the Book*, c. 1497/98
Woodcut, 39.8 x 28.9 cm
Kupferstichkabinett, Staatliche Kunsthalle, Karlsruhe

The tenth chapter of *Revelation* (Rev. 10, 1–9) describes
how a sun-like angel appears to St. John on Patmos, and
commands him to swallow a book that has been sent by
God. While this scene is depicted in the foreground,
putti are worshipping an altar in the heavens which is
surrounded by a rainbow. Dürer created his woodcuts for
the *Apocalypse* using a descriptive style of lines which was
highly admired by contemporaries and is particularly
evident in the detailed sections.

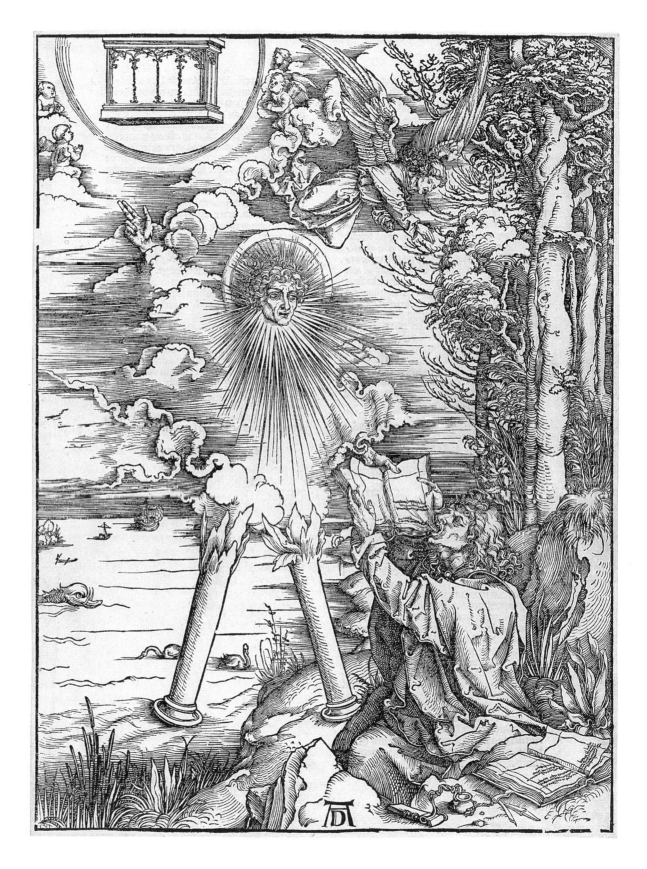

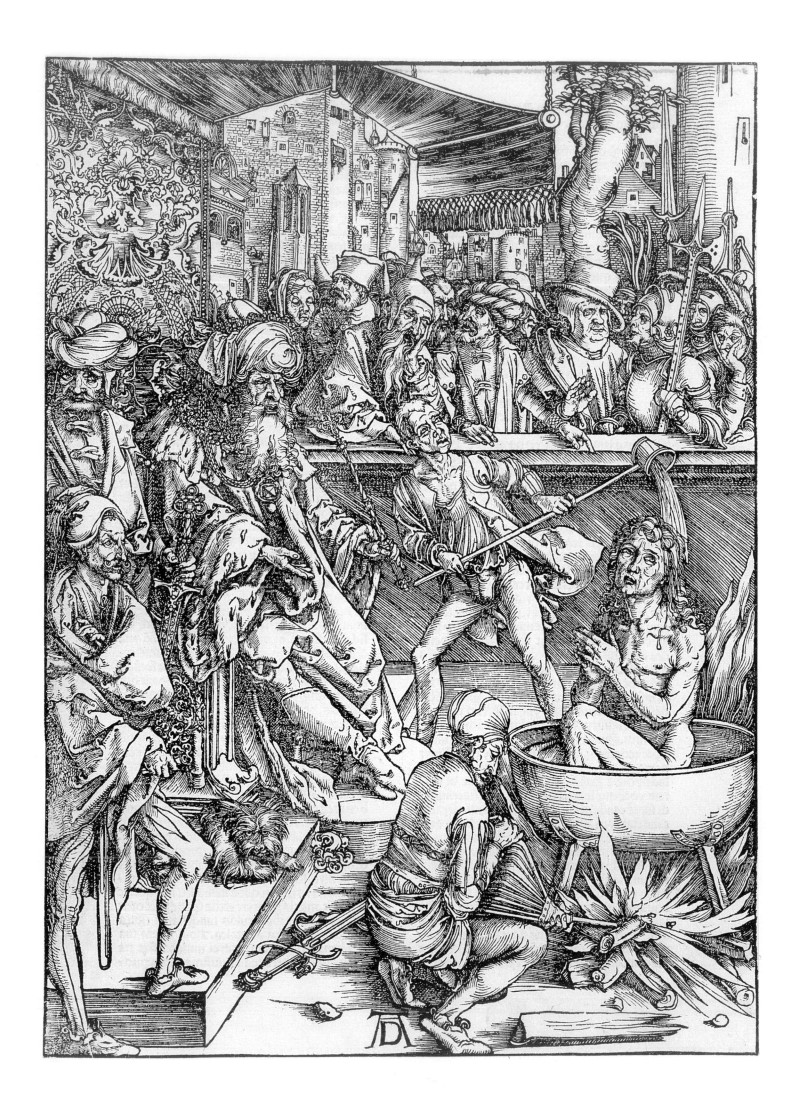

his face as the Horsemen thunder towards him, throwing up stones as they do so. The angel in heaven is blessing the events and with his hand also pointing to the next scene, where the martyrs are clothed and the stars of heaven fall.

In the concluding picture, *The Angel with the Key to the Bottomless Pit* (ill. 43), Dürer once more proved that he was interpreting the text of Revelation in his own manner. In this picture the events take place on the same level as the observer. It is a scene in which two of St. John's visions are combined: in the background the city is indicated, and in the foreground Satan is being incarcerated. A large angel who dominates the left foreground of the picture is forcing the chained Satan into the hole in the ground with supernatural force, ready to immediately lock the cover with the key (Rev. 20, 1–3); as he does so, another angel is pointing out the deserted city in the background to St. John, and more angels are posted by its gates. The diving flock of birds brings to mind the words in Revelation in which an angel commands the birds to eat the dead (Rev. 19, 17). The connection between the scenes is created by the small intermediate scene which diverges from the text. Perrig, who considers the entire series to be influenced by Dürer's anticlerical attitude on the eve of the Reformation, interpreted the group of figures on the hill as that of an angel urging St. John to rebuild the city, which he considered to be the devastated Holy Roman Empire of the German nation. St. John recoils from the size of this task, but the reconciliation of Heaven and Earth as the best precondition for the indicated path is expressed by the angel in the foreground triumphing over Satan, implying that Christ has triumphed over the Antichrist, and Heaven over Hell. This means that an epilogue in the form of an antithesis has been added to contrast with the prologue in the initial picture of the *Martyrdom of St. John* (ill. 45).

While Dürer was achieving new contents and forms in printed graphics, he was directing his main emphasis in painting elsewhere at this time.

In the preface to his uncompleted *Treatise on Painting*, he wrote: "The art of painting is used in the service of the Church and shows the suffering of Christ, and it also preserves the image of men after their death."

Here, he defined the two great topics of his painting: portraits and religious paintings for private and public devotion which he, insofar as the prescriptions of his clients made possible, extended both thematically and, above all, formally under the influence of the experiences he had gained in Italy.

His painted works during the period after his first Italian journey are mainly marked by high points in portrait art. He created painted portraits that record the character of those portrayed with considerable psychological sensitivity. Dürer received most of his commissions from the circle of Nuremberg merchants and patricians. One of the first was the Elector Frederick the Wise of Saxony (1463–1525, ill. 46). In 1496, he came to Nuremberg for four days and sat for Dürer to paint his portrait, and during this time

presumably also ordered the altar of the *Seven Sorrows of the Virgin* (ills. 51, 52). The portrait of the Elector was the first one that Dürer painted on canvas. As it employs the traditional portrait composition of placing the portrayed person in front of a monochrome background, this work is part of a series of pictures which includes the second *Portrait of Dürer's Father* dating from 1497 and the *Portrait of a Woman with her hair down*, 1496–98 (ill. 49).

In 1497, Dürer created the first paintings in which his models were shown in a clearly three-dimensional space. A window provides a landscape view in the background. The combination of portrait and landscape depiction was a form that had originated in the Netherlands; the way it was executed, however, testified to the influence of Italy. Dürer's second painted *Self-Portrait* of 1498 corresponds to this new style of portrait (ill. 47). In it, he appears as a young nobleman at the age of 26, dressed in smart Venetian fashion. The painting accords with the traditional portrait scheme in terms of the body posture and direction of the subject's gaze. His figure is emphasized by the window in the background and the vertical and horizontal compositional lines in the interior, a form which was also popular in Italian and Florentine portrait art. The fine reproduction of the alpine landscape, which has been located in a number of places by researchers, relates to the watercolor studies of his first Italian journey with regard to its ochre, russet, green and blue colors. Dürer's almost extravagant elegance, the "haarig partet maler" (painter with his hair parted) as he called himself, expresses an increased consciousness of the artistic status of the refined man, a "gentiluomo," who was dressed according to the most recent Venetian fashion. This reminds us that Dürer was already enjoying considerable success with his illustrations of the Apocalypse at this time. The inscription on the window frame emphasizes the artist's intention to record people according to their appearance at a particular point in their lives: "1498/I painted this from my appearance/I was twenty-six years old/Albrecht Dürer."

The *Portrait of a Woman with her hair up* (ill. 50), which was painted on canvas, is also part of the group of portraits created during these years, and comprises a diptych together with a second female portrait (ill. 49). The depicted women were presumably members of the Fürleger family, Nuremberg patricians, as the family's coat of arms appears on later copies of the two paintings. While the *Portrait of a Woman with her hair up* depicts a young woman about to become a bride, the *Portrait of a Woman with her hair down* shows a person who has decided in favor of life in a religious order. Both were painted in 1497 before they entered a new stage in their lives, and in each case the choice of a contrasting picture type coincides with the status of each portrayed woman.

In about 1499, the *Portrait of Oswolt Krel* (died 1534) was created. From 1495 to 1503 he worked as a factor for the "Große Ravensburger Handelsgesellschaft," a commercial company in Nuremberg (ill. 48). The portrait provides exemplary proof of Dürer's attempts –

45 *The Martyrdom of St. John*, c. 1497/98
Woodcut, 39.5 x 28.2 cm
Kupferstichkabinett, Staatliche Kunsthalle, Karlsruhe

The Martyrdom of St. John is Dürer's first illustration for the Apocalypse, although Revelation does not contain an account of it. There is, however, an account in the *Legenda aurea*. According to it, St. John refused to sacrifice to heathen Gods and was, therefore, condemned by the Roman Emperor Domitian to suffer a martyr's death in a bath of boiling oil. The Evangelist survived the intended martyrdom unscathed. He wrote down the visions that he had experienced during his martyrdom while in exile on the island of Patmos.
Dürer transposed the events into his own age and described the martyrdom in a very naturalistic manner. Domitian and his thugs appear as Turkish heathens in magnificent garments while members of various classes and nations are assembled in the pensive audience.

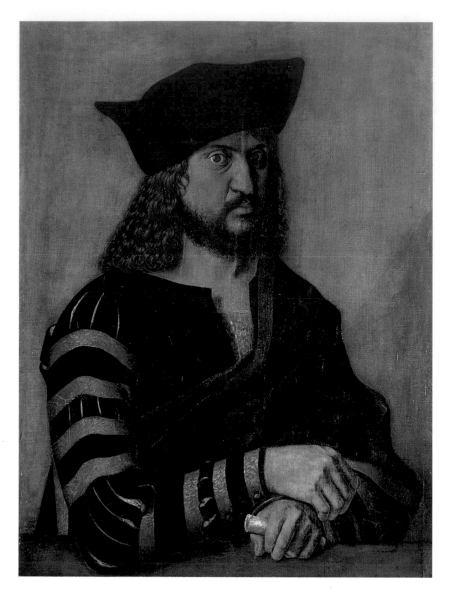

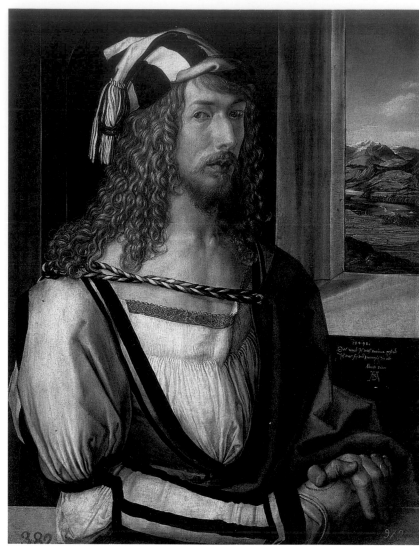

46 *Portrait of Elector Frederick the Wise of Saxony*, c. 1496
Tempera on canvas, 76 x 57 cm
Gemäldegalerie, Staatliche Museen zu Berlin – Preußischer
Kulturbesitz, Berlin

The portrait of the Elector was presumably created during his stay in
Nuremberg from the 14–18 April 1496. Here, for the first time,
Dürer used canvas as his picture medium together with watercolors
which were enriched only with an additive. They dry rapidly and
appear muted. The portrayed man is depicted in a vertical format in
front of a monochrome green background, and is gazing towards the
observer. The portrait stands out against the discreet background: the
striking face and large eyes of the Elector are particularly emphasized.
Although this is a traditional type of portrait, the posture and
expression of the portrayed man appear very lifelike and direct.

47 *Self-Portrait at 26*, 1498
Oil on panel, 52 x 41 cm
Museo del Prado, Madrid

In the same year that he was producing the illustrations of the
Apocalypse, Dürer painted himself as a refined and elegant
gentleman with artificially curled hair and dressed according to
Venetian fashion. As in other portraits of this time, Dürer is also
sitting in front of a breast-high wall, and on the right through the
window an alpine landscape is visible, the fine coloring of which
relates back to the landscape watercolors that were created during
his Italian journey. The dominance of horizontal and vertical lines
in the compositional structure of the panel refers to Florentine
portrait painting.

48 *Portrait of Oswolt Krel*, 1499
Oil on lime panel, 49.6 x 39 cm
Alte Pinakothek, Bayerische Staatsgemäldesammlungen, Munich

Oswolt Krel (c. 1475–1534) spent some time in Nuremberg at the
time the portrait was created as the chief accountant of the "Großer
Ravenburger Handelsgesellschaft," a commercial company. He was
known to be a pugnacious and impulsive person. Dürer
characterized him as such with the forceful expression on his face and
clenched fist. This impression is emphasized by the powerful red
color of the wall hanging and the composition in a tightly framed
vertical format. The delicacy of color and painted lightness of the
landscape on the left is reminiscent of the watercolors produced
during the first Italian journey.

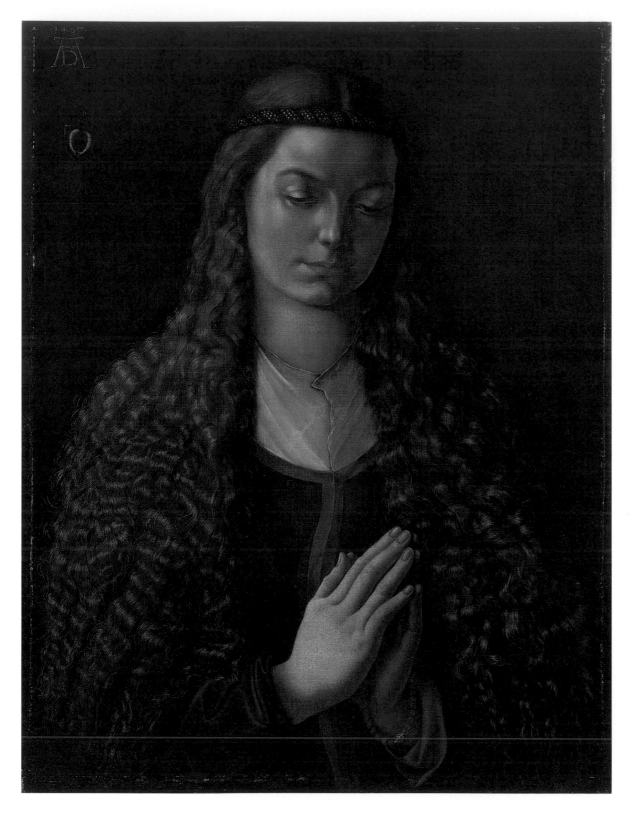

49 *Portrait of a Woman with her hair down*, 1496 – 98
Oil on canvas, 56. x 43 cm
Städelsches Kunstinstitut, Frankfurt

The portrait of a beautiful young woman with a superb
head of hair, whose gaze is modestly lowered deep in
prayer, is part of a diptych that was acquired by the art
trade in 1830 and divided (ill. 50). The portrayed woman
was presumably, as is suggested by the fact that her hair is
down and her attitude one of prayer, a person who had
decided to enter a religious order. For this reason the
depicted woman cannot be identical with the woman in
the second panel, something that has long been a topic of
discussion by researchers.

50 *Portrait of a Woman with her hair up*, 1496 – 98
Oil on canvas, 56.5 x 42.5 cm
Gemäldegalerie, Staatliche Museen zu Berlin –
Preußischer Kulturbesitz, Berlin

The portrait of a young woman aged 18 – her age is
recorded in the inscription above her – was, as Anzelewsky
proved, originally part of a diptych with a second female
portrait (ill. 49). It is part of the group of portraits created
at about the same time as Dürer's second self-portrait. The
eryngium, a type of thistle also known as "Männertreu"
(denoting conjugal fidelity) indicates, in conjunction with
the figure of a prophet in the background, that the
portrayed woman was a bride. The series of letters on the
border of her blouse have yet to be deciphered. If they were
not simply ornamental in function, they would have been
abbreviations of mottoes or epigrams.

51 *The Flight into Egypt*, c. 1496
Oil on pine panel, 63 x 45.5 cm
Staatliche Kunstsammlungen, Dresden

The Flight into Egypt is one of seven scenes from the Life of Christ which originally surrounded the large central panel of the *Mother of Sorrows* (ill. 52). In the Gospel of St. Matthew (Matt. 2, 13–14), the event is mentioned briefly, though narrated in more detail in the *Apocrypha*. King Herod ordered that all newborn sons should be killed once he had found out that a future king would be born in Judea. An angel conveys to Joseph God's message to leave the town. Thus the Holy Family fled to Egypt. The group of figures, with Mary riding and holding the Christ Child and Joseph leading the ass, is arranged parallel to the picture in the foreground, an arrangement which is repeated in the later woodcut in the *Life of the Virgin*. In the foreground the path is stony, and in the background a rocky landscape is visible. The rock is a sign of a safe place of refuge, but can also be interpreted as a mariological and christological symbol: "The stone which the builders rejected, the same is become the head of the corner" (Matt. 21, 42). Both the composition and method of painting still owe much to the Late Medieval workshop tradition.

the first artist apart from Leonardo da Vinci to do so – to reflect the portrayed person's character in his portraits. Oswolt Krel, a contemporary of Dürer's, was an impulsive and pugnacious person. Irrespective of his social position, he had just spent a short period in jail when the portrait was created, for having derided one of the city's citizens in a Shrovetide play. The angular shape of his face, the forceful expression and sharp gaze underline his temperamental nature. The overall composition, the vertical picture section and aggressive red color of the curtain behind him, support the powerful overall impression. Here also, the precisely recorded idyllic view onto a landscape reminds us of Dürer's watercolors. The morning or evening sunlight is shining atmospherically through the tops of the vertically soaring trees which underline the overall composition. Two small panels with wild men who are holding the coat of arms for the depicted man and his wife, Agathe von Esendorf, were probably used as protective covers for the painting.

The first major commissions with religious themes appear during the last years of the 15th century. The *Seven Sorrows of the Virgin* are still completely indebted to the Late Medieval tradition: seven Passion scenes are arranged around the large central picture of a monumental figure of Mary, the Mother of Sorrows, who is threatened by a sword (ills. 51, 52). The Passion scenes represent the pain that Mary had to endure because of the sufferings of her son. It was possible to prove that the central panel and Passion scenes, which are now in separate museums, belonged together when curators examined the edges and backs of the panels. The individual panels, painted in the traditional style, were co-ordinated with the central panel in terms of composition. Due to the sketchy sources available, their original function has yet to be explained. It is most likely that they would have been placed opposite an altar with a similar structure showing the Seven Joys of the Virgin. The *Seven Sorrows of the Virgin* was one of the devotional pictures derived from the worship of the Rosary. From the 14th century onwards, the Sorrows of Mary were worshipped in addition to the Stigmata of Christ. It was previously unknown to combine a large central picture of a standing saint with smaller narrative scenes arranged around it. Dürer probably first became acquainted with this shape of altar in Italy, where it had been used in Tuscany since the 13th century. This altar was presumably created after his first Italian journey, commissioned by Frederick the Wise for the castle and university chapel at his palace in Wittenberg.

His work for Elector Frederick the Wise led to the young Dürer receiving commissions for further altars from respected Nuremberg families such as the Paumgartners and the Hallers. The *Paumgartner Altar* (ills. 53 – 57) was created on the occasion of a pilgrimage made by Stephan Paumgartner (1462–1525) to Jerusalem in about 1498, and it was presumably intended as a memorial to his parents, the patrician Martin Paumgartner (died 1478) and his wife Barbara. Until 1613, it stood as a side altar on the east wall of the southern side aisle in the Nuremberg Dominican church of St. Catherine. Lukas and Stephan Paumgartner, the donors, were portrayed in the forms of St. Eustace and St. George (ills. 54, 55). The slightly under life-size, portrait-like depiction opened up new possibilities in the portrayal of standing figures of saints. Given the banners they carry, displaying the attributes of their legends, they could easily have been drawn from the tournaments of their time. They are related to the central picture, a *Nativity* (ill. 53, 57), by their position in the picture and the direction in which they gaze. Due to its progressive composition, which corresponds to the laws of central perspective, and the way the "production" of the holy scene takes place on a spatial stage, the central panel has been dated to after 1500, later than the outer wings. The box-like painted border around the scene is reminiscent of a shrine, a relic being guarded by the figures on either side. In this respect, the dominant depiction of the two donors as saints should not be considered blasphemous, but rather they should be viewed in terms of their function as guards of the devotional picture, as virtuous knights of Christ during the turbulent times when the invasion of the Turks was a constant threat. The central panel continues the subdivision into various planes of reality.

As Doris Kutschbach explained in detail, the Madonna contrasts with the kneeling Joseph in that the architectural frame around her makes her appear curiously removed, like a "picture within a picture." The figure of Joseph, with his back turned to the observer in the manner of a "repoussoir motif" leading us diagonally into the picture, has an appellative function. It invites the observer to worship. The small donor figures are in a similar proportional relationship to the holy events as spectators before a gigantic canvas; they are pious, respectful outside observers. As with the sculpturally conceived picture of the Mother of Sorrows amidst the seven scenes from the Passion, this altar is mainly creating an overall view of statuesque-sculptural and narrative-scenic elements. In a copper engraving created a few years later, Dürer returned to this composition and treated it in an even more unconventional manner, in which the tiny figural scene is dominated by the large spatial stage composed according to the laws of central perspective (ill. 67).

52 *The Seven Sorrows of the Virgin: Mother of Sorrows*, c. 1496
Oil on pine panel, 109.2 x 43.3 cm
Alte Pinakothek, Bayerische Staatsgemäldesammlungen, Munich

This panel is a monumental picture depicting Mary as the Mother of Sorrows. It was severely damaged in an attack when acid was thrown at it in 1988, and ten years have been spent restoring it. It is the central picture of the seven scenes from the Passion which are in the Gemäldegalerie in Dresden. The work was presumably ordered by Elector Frederick the Wise for the Wittenberg university chapel. Mary's arms are crossed and she is looking up in suffering, while a sword that is threateningly close to her heart is approaching, a symbol of her agonizing pain caused by the sufferings of Christ, narrated on either side in the scenes from the Passion. As a sign of her virginity, Mary is wearing a white cloth and a heavy blue garment, the color which refers to her status as the Queen of Heaven.

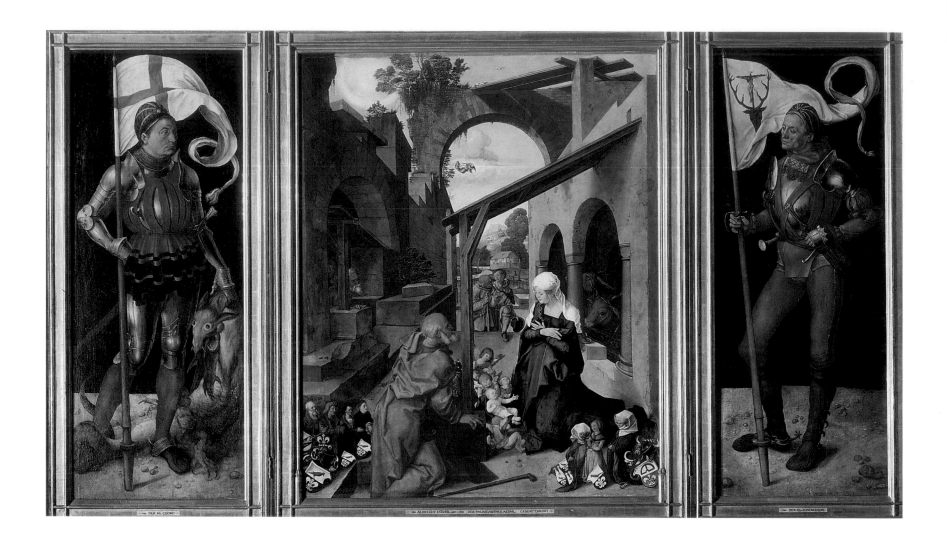

53 *Paumgartner Altar*, c. 1498
Oil on lime panel, 155 x 126.1 cm
Alte Pinakothek, Bayerische Staatsgemäldesammlungen, Munich

The winged altarpiece was created on the occasion of Stephan
Paumgartner's pilgrimage to the Holy Land, and commissioned
as a memorial to his parents, the Nuremberg patrician Martin
Paumgartner (died 1478) and his wife Barbara née Volckamer
(died 1494). The altar has the traditional shape of a winged
altarpiece. The outside, the weekday side, displays a workshop
production of an Annunciation and the former standing figures of
saints Catherine and Barbara. When opened, the magnificent colors
of the Nativity are visible, framed by saints George and Eustace.

54, 55 *Paumgartner Altar*, details of ill. 53
Saints George and Eustace

The side wings depict St. George on the left and St. Eustace on the
right, complete with their attributes on their banners as recorded in
the *Legenda aurea*. St. George was a crusader and had liberated the
Libyan town of Silena from the dragon, while the Crucified Christ
had appeared to St. Eustace in a forest in the antlers of a stag, thus
converting him to Christianity. The donors themselves appear in the
form of their personal saints. On the left, facing the central panel,
Stephan Paumgartner appears as St. George, and on the right Lukas
Paumgartner appears as St. Eustace. Both are wearing splendid
knightly armor. They are Christian knights, guards and protectors of
the holy shrine, the Nativity of Christ in the central panel where they
appear once more as part of the group of the donating family.

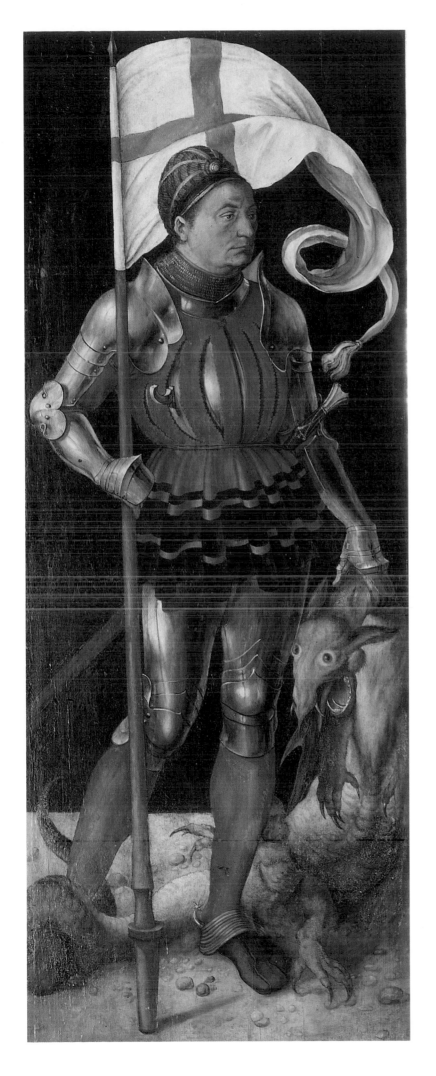
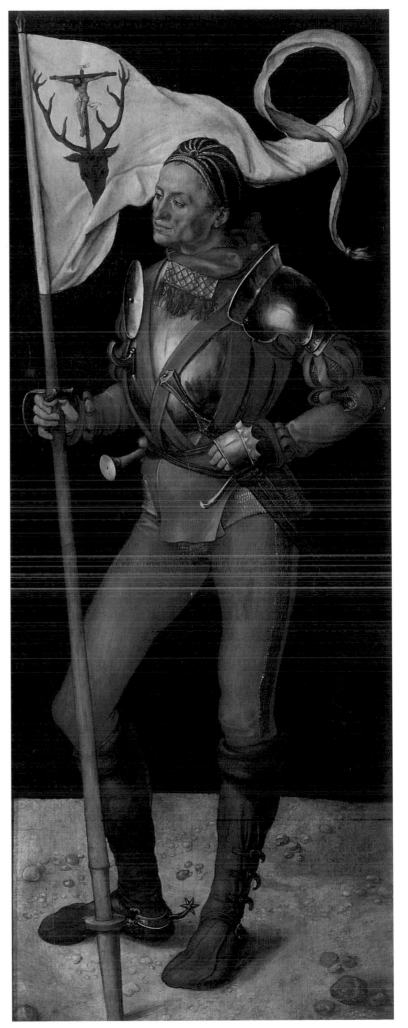

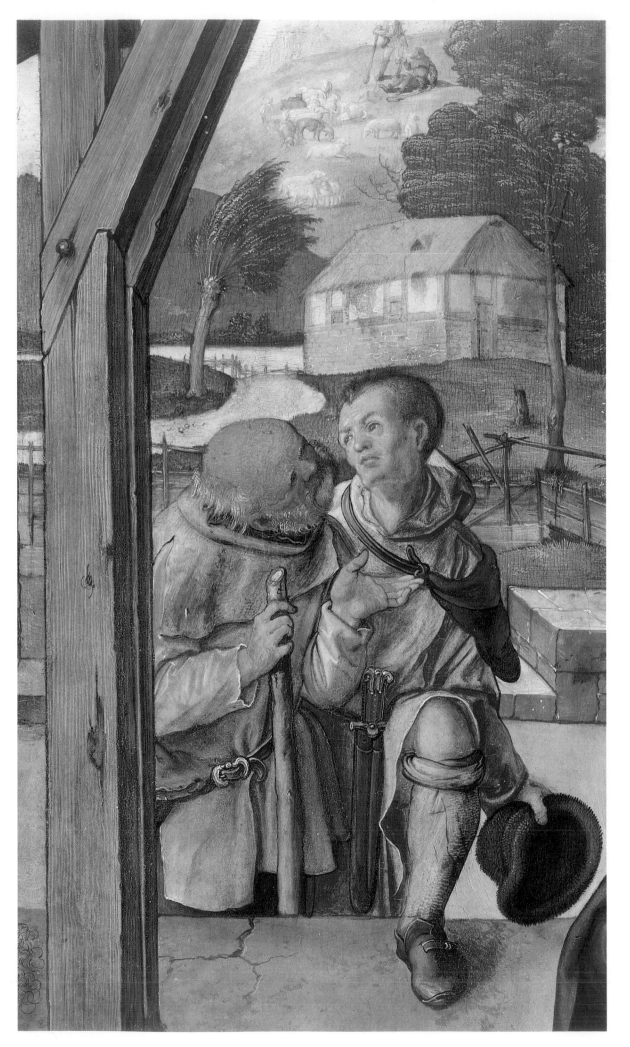

56 *Paumgartner Altar*, detail of ill. 53
Shepherds

In the background, an old and young shepherd, deep in conversation, are stepping up to the holy scene. As the old shepherd stretches out his hand in a rhetorical gesture, the other one turns towards him. The foreshortened frontal view of the young shepherd indicates Italian models such as Andrea Mantegna and others whose works Dürer had encountered during his first Italian journey.

57 *Paumgartner Altar*, detail of ill. 53
Nativity

Mary and Joseph are kneeling in the foreground of an architectural scene constructed according to the laws of central perspective, which opens out to the rear onto a broad landscape; next to them the numerous small figures of the donor family are kneeling before the newborn Christ Child. From the back, two shepherds seen in a perspectival foreshortening are climbing up to the place of Christ's birth, and on the left two more are watching the events. The center of the composition are Mary and the Christ Child, and they are additionally emphasized by the baldachin-like roof. The Star of Bethlehem is emblazoned in the sky, and in the background an angel is announcing the birth of the Savior to the shepherds.

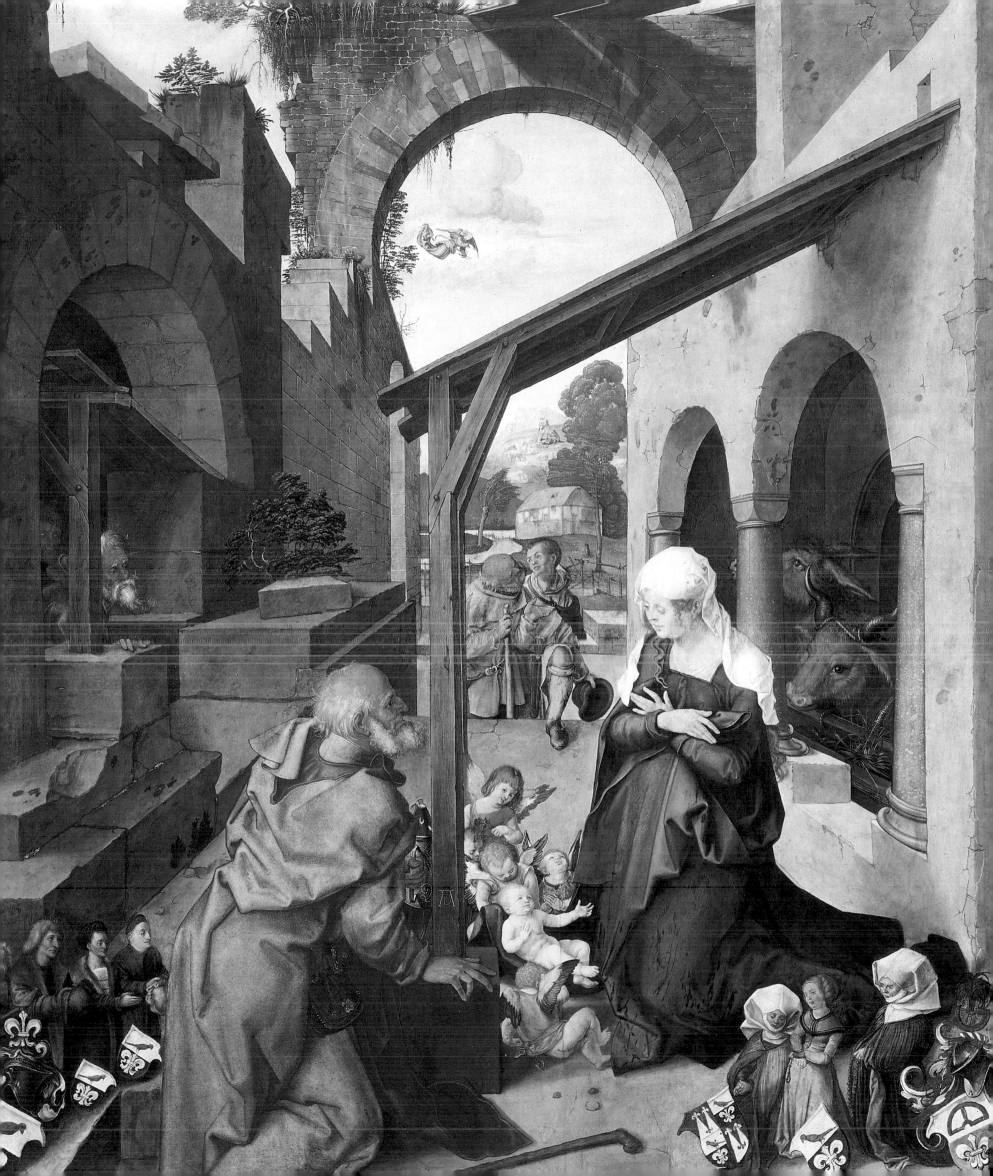

58 Anonymous,
Bearing of the Cross, c. 1400
Single-leaf woodcut, 26.9 x 39.9 cm
Graphische Sammlung Albertina, Vienna

The earliest single-leaf woodcuts to be produced
independently of books and printed texts were created in
about 1400. The *Bearing of the Cross* is an example of
the simple flow of the lines, lack of interior detail and
confinement to pure lines. However, the sheet displays a
clear composition that is focused on the central figure of
Christ.

The art of printed graphics was still young when Albrecht
Dürer was born. During the first third of the 15th century,
the engravings and ornamentation of the goldsmith's art
led to the development, before woodcuts, of copper
engravings which were still reproduced in relatively small
editions. Printed graphics were presumably created as a
result of the desire to be able to circulate pictorial ideas to a
wider group of observers and users. The increased demand
for religious pictures for private worship and as beneficent
decorations in houses was one reason for this, another was
the increasing range of secular uses during the second half
of the century: Playing cards, calendars and alphabets were
all sources of entertainment and education.

The origins of copper engraving can be seen in early
pictures in the reproduction of stamps such as are
known from goldsmith's art. The initial development of
the art in Germany was centered on the towns of
Constance and Strasbourg.

We do not know the earliest masters by name and they
are only referred to by their main works. Early sheets are
still rather simple in technique. The burin was used to
produce short points and hatchings, which disappeared
during the course of time, meaning that there was largely
a lack of interior detail and three-dimensional effect. Not
until after the middle of the century do we know that a
painter first used a burin; he was Martin Schongauer, the
son of a goldsmith. He worked the copper plates himself
and, by extending technical possibilities, opened up a
considerable range of previously unknown fields of expres-
sion. Engraving deeper lines in the copper plate meant
that at this point it was already possible to use lines and
hatchings to create a subtly differentiated, material repro-
duction and to depict light and shade. Schongauer's
copper engravings increasingly distinguish themselves by
their spatial and plastic clarity and their painterly effect
was admired and imitated by contemporary artists. It was
under their influence and the drypoint works of the Master
of the Housebook that Albrecht Dürer perfected the tech-
nique of copper engraving, which he finally enriched by
applying the "clair-obscur" technique and a dramatic use
of extreme lighting. Due to their easy transportability and
relatively high print runs, printed graphics made it possible
to exchange ideas between north and south, so that the
influence of the "new" Italian style was able to leave a
mark north of the Alps.

Both copper engravings and woodcuts achieved an
extremely widespread impact because of Dürer, and distin-
guished themselves by means of new, varied functions.
Higher print runs and Dürer's own methods of distribution,
which consisted of selling and exchanging them and
presenting them as gifts, meant that his name became
familiar in other regions. The commercial advantage which
printed graphics now provided could not be ignored by
contemporary artists. Copper engravings became popular
collectors' items in educated circles, and they were treated
as valuables by these people who had them decorated and
gilded, and copies made in the form of further engravings
and ivory reliefs.

The most decisive factor in the changing function of
printed graphics was the development of woodcuts. At
first it was mainly used as a method of illustrating books,
but it emancipated itself in two ways: First as an autono-
mous work of art (ill. 58) in the form of large format
single-leaf prints, and secondly, as a result of the technical
opportunities for reproducing the prints, the woodcut
became an important medium for passing on political and
social information. In addition to their religious function –
large format sheets were now even used for private
worship – they had become valuable in the areas of propa-
ganda and forming public opinion. The Reformation
picture propaganda manifested itself in new forms such as
the single-leaf print, the leaflet and the pamphlet which
combined pictures and text. The picture press played a
considerable role in making Martin Luther's ideas about
the Reformation popular.

However, the new medium could also be used to serve
the official needs of rulers governing in the manner of clas-
sical emperors. This explains why Emperor Maximilian I
ordered high print runs to be published of woodcuts such
as the *Triumphal Arch*, which an entire horde of artists
worked on and which led to new "secular and liturgical"
purposes. Throughout the entire Holy Roman Empire, for
example, ceremonies in homage to the emperor could be
performed beneath the almost ten meter high series of
woodcuts comprising the *Gate of Honor*. Ecclesiastical and
princely dignitaries such as Cardinal Albrecht of
Brandenburg and Elector Frederick the Wise ordered high
print runs and, for the purposes of propaganda, placed
their own copper engraved portraits as title pages at the
front of their own printed works.

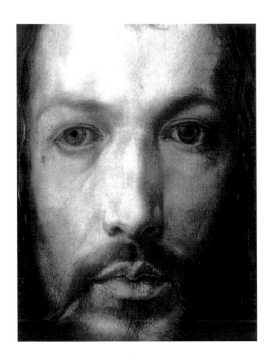

59 *Self-Portrait in a Fur-Collared Robe*, detail of ill. 60
Digital infrared reflectograph
Doerner Institut, Bayerische Staatsgemäldesammlungen, Munich

The precise underdrawing revealed by the digital infrared reflectograph shows how carefully Dürer prepared his self-portrait. The interior detail of the face is already completely laid out with gentle parallel and cross hatchings. The irregularly shaped nose which has been straightened in the painting shows the altered relationship between the preparatory underdrawing and the final painted version.

60 *Self-Portrait in a Fur-Collared Robe*, 1500
Oil on lime panel, 67.1 x 48.7 cm
Alte Pinakothek, Bayerische Staatsgemäldesammlungen, Munich

This self-portrait is Dürer's most famous and also the last of the three painted self-portraits. For the first and last time in Western art history, an artist was to portray himself in a Christ-like scheme. Given his idealized appearance – as the underdrawing shows, his nose was originally irregular in shape – Dürer is approaching us in "imitatio Christi", in imitation of Christ. The deceptive illusionism in which the picture is painted is also, however, a reference to the classical artistic legend about Apelles, with whom he had been compared by contemporary humanists.

The turn of the century marked a fundamental change in Dürer's style and view of the world. He studied the artistic theories of the Renaissance more intensively than ever, in particular the theory of the ideal proportions of the human body and central perspective. His interest in these themes is documented in numerous works. Printed graphics also provided him with undreamed of opportunities for experimentation free of the prescriptions relating to commissioned works.

For Dürer, the year of 1500, which was expected to signal the end of the world, started with the preparation of his *Self-Portrait in a Fur-Collared Robe* (ills. 59, 60), his last and most famous self-portrait which is now in the Alte Pinakothek in Munich. In it he included the sum of his artistic and humanist ideas and, at the same time, introduced a new period in his creative work. Since he gives his age as being 28 in the inscription, the painting must have been created before 21 May, Dürer's birthday. Karel van Mander reports that he saw the picture in Nuremberg in 1577 and held it in his hand. Dürer retained possession of the painting during his lifetime, but after his death it ended up in the "upper regimental chamber" of the Nuremberg town hall which was used as a sort of art gallery. In 1805 it was finally acquired by the royal collection in Munich. Without understanding the humanist content of the panel, one would assume from a modern perspective that Dürer's self-portrait had a provocative effect at the time, since for the first and last time in Western art history an artist was portraying himself in the same style, in terms of composition and type, as Christ. Such a strict frontal view had until then been reserved for depictions of Christ, and portraits traditionally made use of a half or three-quarter profile view. Dürer used the geometric scheme of proportions in his self-portrait on which depictions of Christ had been based, and which had been reserved for this purpose, since Byzantine art. This was the scheme by which pictures of Christ appeared to be "vera icon," true portraits of the Savior. It was in this sense that the form of the self-portrait was repeated a century later in Georg Vischer's painting of *Christ and the Adulteress*, which he created for the Bavarian Elector Maximilian I (ill. 3).

Although Dürer realistically reproduced his own physiognomic features such as his large nose and differently sized eyes, the fine, illusionistic manner of painting gives the self-portrait an idealizing glow. Dürer is clutching his smart fur coat (ill. 60) with one hand, the position of which is reminiscent of Christ's hand raised in blessing. The eye is particularly significant, being the painter's second "tool" after his hand. Hence, a small window is reflected in the portrayed artist's iris, and this should be viewed not as a naturalistic depiction of the workshop window, but as an expression of the classical topos "oculi fenestra animae," the eye as a window to the soul, which Dürer had presumably heard about from Konrad Celtis (1459–1508). The dark background helps us to concentrate on the figure of the artist. The inscription, "Albertus Durerus Noricus ipsum me propriis sic effingebam coloribus aetatis anno xxviii" (I, Albrecht Dürer of Nuremberg, painted myself thus in everlasting paints at the age of twenty-eight years), emphasizes his intention to create a portrait for eternity.

Five epigrams praising Dürer, written by the Nuremberg humanist Konrad Celtis, date from the same time; they are written in the same antiquated script as the inscription on the self-portrait and have a similar wording. In them, Celtis stressed Dürer's creative powers by comparing him to Apelles and Phidias (5th century B.C.), two of the most famous classical artists. He also did not shy away from comparing him to the medieval philosopher Albertus Magnus (c. 1206–1280) and emphasized that God had given both similar creative powers. These sources prove that Dürer, in his self-portrait, was expressing the God-given "natural" similarity of the artist to Christ brought about by his quality as a creator. We do not know for certain what the purpose of the portrait was. The fact that the painting remained Dürer's property for the rest of his life suggests that it had a didactic function as a teaching aid for his students and as a showpiece for his clients. The importance of the unity of "Harmonia" and "Symmetria" emphasized by classical authors such as Cicero (106–43 B.C.), Lucian (120–180 A.D.) and Vitruvius is clearly reflected in this portrait. The strict frontal view also reminds us that sight was the

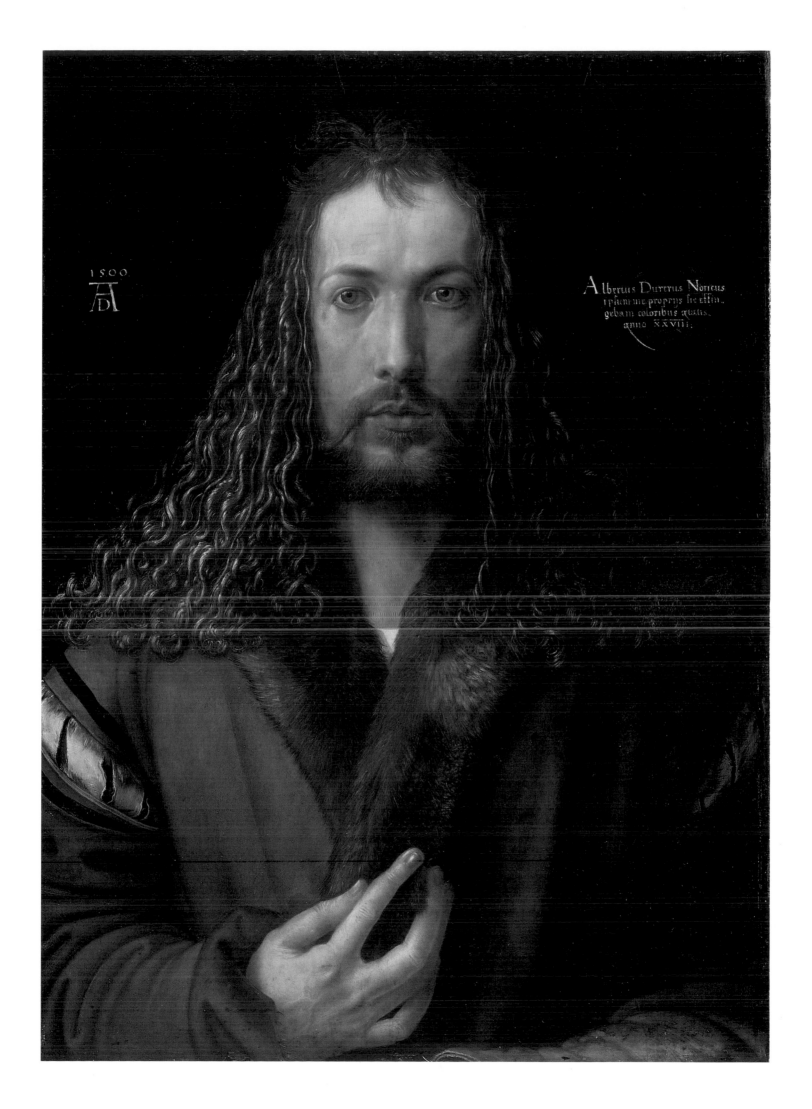

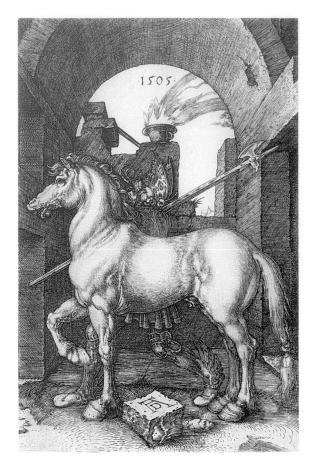

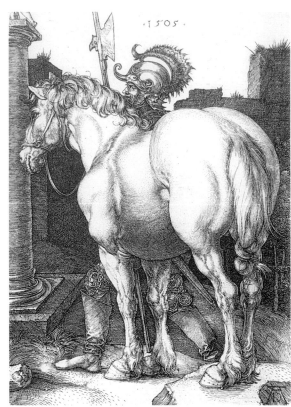

sense that Dürer valued the most highly, as can be deduced from the preface to his planned *Treatise on Painting* in 1512.

The color palette, limited to brown and gray tones, could possibly be an allusion to the writings of the classical author Pliny (23/24–79 A.D.), who reported that Apelles used a palette of four colors, and it was his masterly use of them that gave his paintings a special radiance. In this respect, Dürer appears here as the new Christian Apelles who sees himself as a creator in the service of God and as such takes up a forward-looking position. An earlier interpretation connected the similarity to Christ in the picture with the desire to imitate Christ as promoted in the *Imitation of Christ*, a book that was widely available in the late Middle Ages and written by the religious mystic Thomas à Kempis (1379/1380–1471).

The *Self-Portrait in a Fur-Collared Robe* of 1500 is both the climax and the conclusion to Dürer's three painted self-portraits.

This painting, produced at a turning point in his creative work, includes humanist ideas. Dürer was also attempting to place his other works of the period on a new footing in the sense of a reformation of art in imitation of classical artists. During the following four years, numerous studies on human proportions were produced, encouraged by his meeting with the Italian artist Jacopo de Barbari (c. 1440– c. 1515), who he met in Nuremberg in 1500 and who spurred him on to study the canon of ideal proportions according to Vitruvius. This theme was to occupy Dürer for the rest of his life and finally resulted in the *Four Books on*

Human Proportions which were published posthumously. This is the context within which his efforts to depict the ideal proportions of a horse should be seen, which manifests itself in various drawings and copper engravings such as the *Large Horse* and the *Small Horse* (ills. 61, 62) and reached perfection in Dürer's masterly engraving of *Knight, Death and the Devil* (ill. 94). In the third chapter of Vitruvius' famous treatise *de architectura*, he considers human proportions and central perspective. This, and the rediscovery of a classical statue of Apollo in Rome as well as Jacopo de Barbari's copper engraving of *Apollo and Diana,* exerted considerable influence on the so-called *Apollo Group* and other studies on male and female proportions in imitation of the classical era that were finally to culminate in his famous masterpiece, the engraving of *Adam and Eve* (ill. 64). Dürer believed that classical artists had possessed the secret that he spent his entire life trying to track down "with compass and spirit level." Both secular and sacred themes were a pretext for him to capture ideal depictions of nudes in printed graphics. An example of his studies of the proportions of the female body is the copper engraving that was created in about 1501 or 1502, *Nemesis or Good Fortune* (ill. 63). In technical terms, Dürer refined the unusually large copper engraving even further. The larger lines are subdivided two or three times, and the use of double cross-hatchings is further improved, giving the sheet a high degree of material density. The depicted theme is derived from a Latin poem by the Florentine humanist and Neoplatonist Politian (1454–1494), published in his book *Manto* which appeared in 1499 and with

61 *Small Horse*, 1505
Copper engraving, 16.4 x 10.9 cm
Kupferstichkabinett, Staatliche Kunsthalle, Karlsruhe

In this copper engraving, created in 1505, Dürer shows an equal degree of interest in spatial central perspective and the ideal proportions of a horse. A small, muscular horse is whinnying and nervously pawing with his forehoof in a barrel vaulted space. The animal is accompanied by a shouting groom in a fantastic costume. The winged helmet and shoes indicate that Mercury is being depicted. The group of figures appears to be confined within the walls, which are constructed according to the principles of central perspective. The burning vase in the background is an eternal fire alluding to human reason; as a result, the interpretation that has been generally accepted is that unbridled passion – in the form of the horse – has been tamed by the force of human reason – symbolized by Mercury and the eternal fire.

62 *Large Horse*, 1505
Copper engraving, 16.8 x 12 cm
Kupferstichkabinett, Staatliche Kunsthalle, Karlsruhe

The *Large Horse* dates from the same year as the *Small Horse*, and is also connected with Dürer's studies of proportion. The monumental size of his body, stable position and calm expression present us with a balanced temperament. The extreme foreshortening of the horse's body, the flat architectural backdrop in the background and the raised ground on which the animal is standing with its hind hooves all increase the impression of monumental size. While the horse is standing calmly and firmly on the ground, the warrior with him is depicted striding energetically. A drawing in the city library of Nuremberg indicates that the large horse was based on a proportional scheme.

63 *Nemesis or Good Fortune*, c. 1501–03
Copper engraving, 33.2 x 23.2 cm
Kupferstichkabinett, Staatliche Kunsthalle, Karlsruhe

This copper engraving was created between 1501 and 1503 and was one of Dürer's main large format engravings. The female figure is derived from the poem *Manto* by the Italian poet and humanist Politian, which Dürer presumably became acquainted with when studying in the library of his humanist friend, Willibald Pirckheimer. The poem combines the goddesses of Revenge and Fate. The female shape is floating along above the clouds on a globe and with eagle wings, holding a goblet in her right hand and bridle in her left. She is the result of Dürer's studies of Vitruvius' proportions.

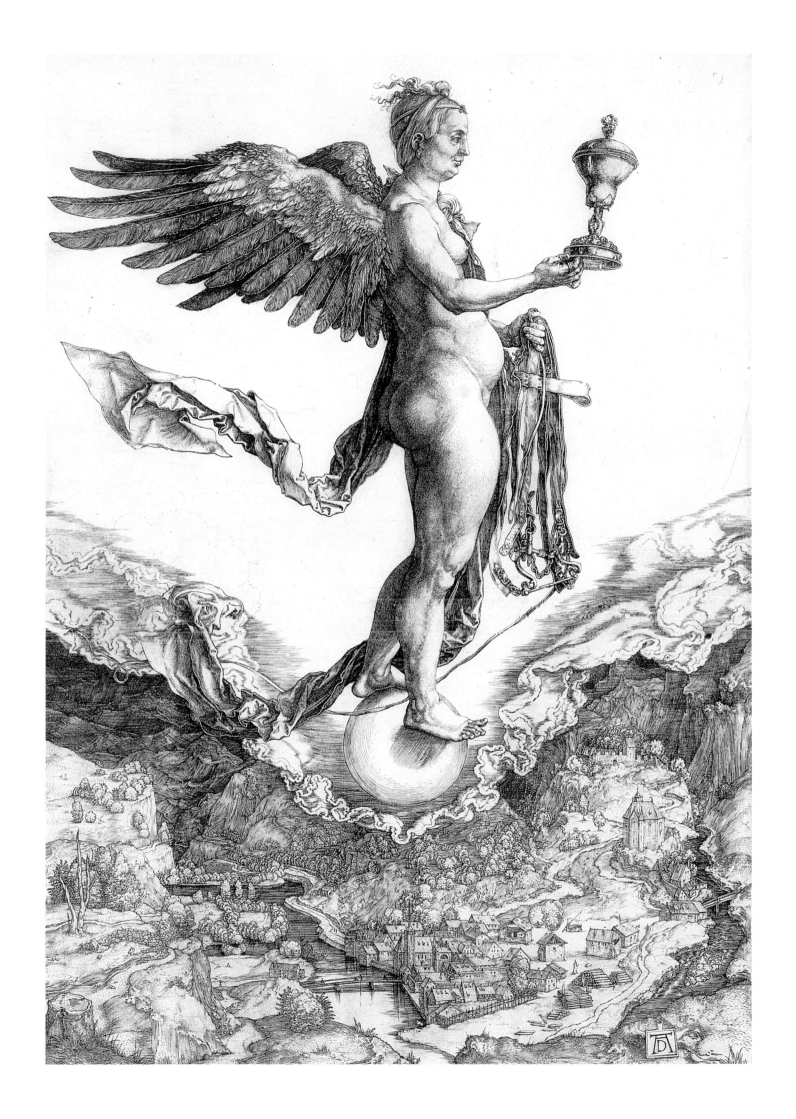

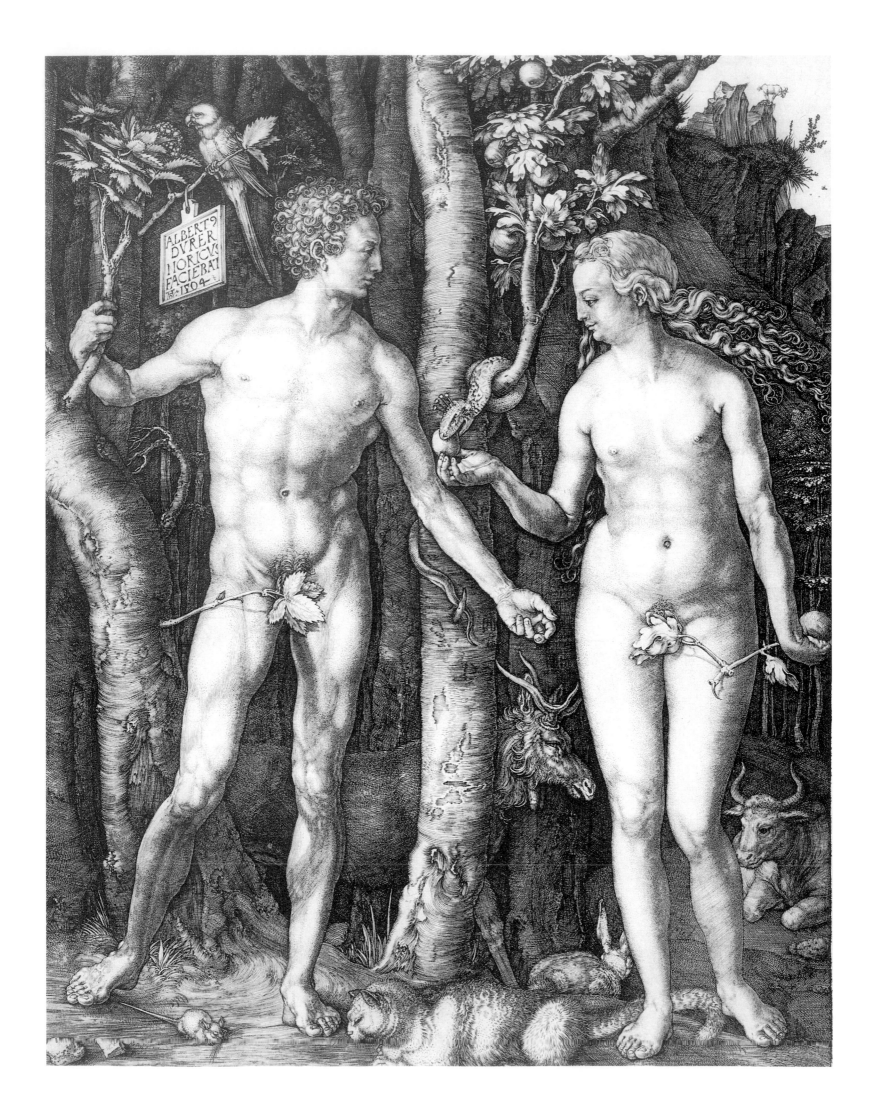

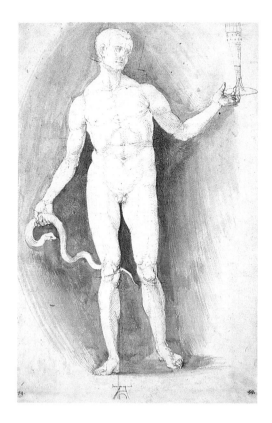

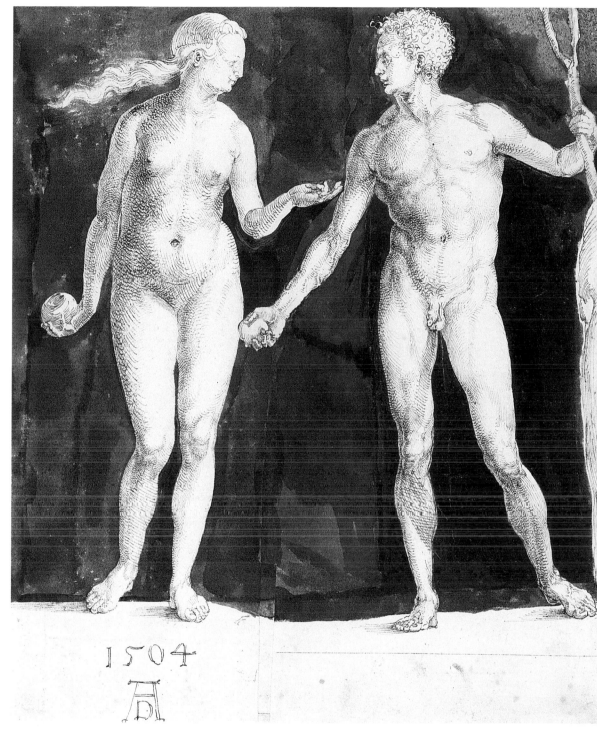

65 *Male Nude with a Glass and Snake*, so-called *Asclepius*,
c. 1500
Pen drawing, green ink, 32.5 x 20.5 cm
Kupferstichkabinett, Staatliche Museen zu Berlin –
Preußischer Kulturbesitz, Berlin

This pen drawing of the so-called *Asclepius*, the classical
god of medicine, is one of Dürer's earliest studies of
proportion. The design sketch proves that the figure was
originally laid out as a study of proportion. The muscular
detail of the body is similar to that of Adam in the copper
engraving dating from 1504.

64 (opposite) *Adam and Eve*, 1504
Copper engraving, 25.1 x 19.4 cm
Kupferstichkabinett, Staatliche Kunsthalle, Karlsruhe

This copper engraving is one of Dürer's most famous
engraved works. It draws on the sum of his four-year study
of the ideal proportions of the human body. His interest in
the biblical narrative is subordinate to his depiction of
Adam and Eve as ideal female and male nudes in imitation
of classical sculptures. The elk, hare, cat and ox symbolize
the four humors into which the human soul divided after
the Fall of Man. The contrasting cat and mouse embody
the tense relationship between the genders, the parrot
represents Mary as a second Eve and the ibex in the
background represents the infidels.

66 *Adam and Eve*, 1504
Pen drawing with watercolors, 24.2 x 20.1 cm
The Pierpont Morgan Library, New York

Dürer prepared his masterly engraving of *Adam and Eve*
(ill. 64) in numerous individual studies. This pen drawing
was created immediately before the copper engraving and
concentrates entirely on the depiction and three-
dimensional structure of the male and female nudes.
The body posture of the two figures shown here is already
identical down to the last detail with that of the copper
engraving.

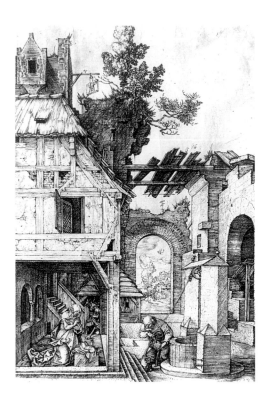

67 *Nativity*, 1504
Copper engraving, 18.3 x 12 cm
Germanisches Nationalmuseum, Nuremberg

The engraving imitates the central panel of the
Paumgartner Altar (ill. 57), created just a few years
previously. It dates from the same year as the masterly
engraving of *Adam and Eve* and displays Dürer's interest
in spatial central perspective, which here takes precedence
over the reproduction of the figural scene, the birth of
Christ. On the terrace of a partly ruined half-timbered
building, the Mother of God is kneeling in prayer before
the Christ Child. The form of a praying shepherd can be
seen behind, and Joseph, apparently unmoved by the holy
events, is fetching water from the well. While the ruin is a
sign of the Old Covenant, the sprouting plants and
newborn Christ Child are signs of the New Covenant. The
well and water jug refer to the virginity of Mary and the
sacrament of baptism.

68 *Green Passion: Christ before Caiaphas*, 1504
Pen drawing on green primed paper, 28.3 x 17.8 cm
Graphische Sammlung Albertina, Vienna

The *Green Passion*, so named after the green primed paper,
consists of twelve sheets, the purpose of which is not
known. It has been assumed that they were used as
preliminary sketches for stained glass windows. Like
the other pictures, the sheet of *Christ before Caiaphas*
distinguishes itself through its fine white highlights which
achieve a magical plasticity and dramatic lighting – as was
created by the "clair-obscur" technique – in their harmony
with the green base color of the scene. Christ and Pilate,
the two antagonists in the foreground, are positioned
opposite each other and emphasized both by the lighting
and the architecture.

which Dürer probably became acquainted in the
library of his friend Willibald Pirckheimer. The poem
combines Fortuna, the goddess of Fate, with Nemesis,
the goddess of Revenge.

In Dürer's depiction, a winged female figure is
floating on a globe high above the clouds. The land-
scape visible beneath is confirmed by one of Dürer's
watercolors that has since been lost. It is thought to be
the small town of Klausen in the Eisack Valley in the
Southern Tirol, Italy. The figure is holding a goblet and
bridle in her hands, symbols of good and bad fortune.
She appears to be standing still, only the fluttering
cloth and uncertain standing position reveal motion.
Panofsky put it very aptly: "The mighty figure is
depicted in a geometric side elevation, like a diagram in
a treatise on anthropometry."

This was the first figure to which Dürer had applied
Vitruvius' canon of proportions, in which individual
parts of the body are proportioned in a particular way
relative to the size of the body. Studies of proportions
confirm that Dürer started by inscribing a measure-
ment scheme on his figures which included all the
details of the body. The result, as is also the case here,
appears rather artificial.

The masterly engraving of *Adam and Eve* (ill. 64),
dating from 1504, must be considered the conclusion
to his studies of proportion. It is a famous engraving in
which his efforts to achieve the classical ideal of beauty
were combined with Old Testament, Christian themes.
The copper engraving was preceded by preparatory
studies (ill. 65). Adam and Eve appear to be two inde-
pendent studies of the ideal proportions of man and
woman. The classical pose is a result of Dürer's famil-
iarity with classical sculpture. The figure of Adam is
related to earlier dated drawings of *Apollo*, *Asclepius* and
Sol, and Eve to such as the *Medici Venus*. The first
human couple is standing before a dark forest. Their
bodies are lit by light falling from the left. The centrally
placed tree compositionally separates the couple who
are facing each other. The surrounding flora and fauna
symbolically emphasize the typological relationship
between the Old and New Testaments. The mountain
ash, the Tree of Life in front of which Adam is
positioned, stands opposite the Tree of Knowledge
which, complete with the diabolical serpent, is assigned
to Eve. The parrot appears as a symbol of Mary and sign
of the overcoming of sin by Mary, the second Eve. The
animals in the foreground are references, in keeping
with scholastic teachings, to the link between the Fall of
Man and the four humors. According to them, the
constitution and soul of Man before the Fall were in
perfect harmony, but afterwards illness, death and vice
entered his life. The soul was divided up into the four
humors, embodied by the four animals depicted here.

The elk represents the melancholy, the cat the
choleric, the ox the phlegmatic and the hare the
sanguine humor. The cat and mouse symbolize the
tense relationship between the genders, and the ibex
on the rocky peak in the background is a symbol
of the first human couple's disbelief when they
disobeyed God's law and sinned. Dürer self-confi-
dently signed the work with the Latin inscription
"Albertus Durerus Noricus faciebat 1504" (this was
created by Albrecht Dürer of Nuremberg in the year
of 1504) on the so-called "cartellino," a small plaque
hanging in the tree. This type of signature had already
been pioneered by the Italian artist Antonio
Pollaiuolo, as had the arrangement of various nudes
in front of a half shaded background.

The small copper engraving of the *Nativity* (ill. 67),
also created in 1504, was a reformulation of the
Paumgartner Altar produced shortly beforehand, and
the result of Dürer's study of spatial composition using
central perspective, again based on Italian models.

Mary is shown in an old half-timbered building
symbolizing the ruin of the Old Covenant, kneeling in
prayer before the Child who has come as a symbol of
the New Covenant to replace the old. Joseph, separated
from this scene, is fetching water from the well. In
contrast to the shepherd kneeling in the background,
he does not appear to have noticed the holy events. In
the background, in miniature, the Annunciation to the
shepherds can be seen. In this sheet, "the stage is almost
more important than the actors," as Panofsky stated,
and the events are subordinate to the struggle for
compositional unity in the sense that every detail has to
fit in to the perspective of converging lines.

At the same time the twelve drawings of the famous
Green Passion (ill. 68) in the Albertina in Vienna were
created, named after the olive green primed paper
medium. For the first time, Dürer used white high-
lights, creating dramatic lighting effects. The use of
black ink increased the effect. The sheets already antici-
pate Dürer's *Engraved Passion* (ill. 84), dating from just
a few years later. The drawings were presumably used as
sketches for twelve panels in the castle and university
chapel in Wittenberg, commissioned by Elector
Frederick the Wise.

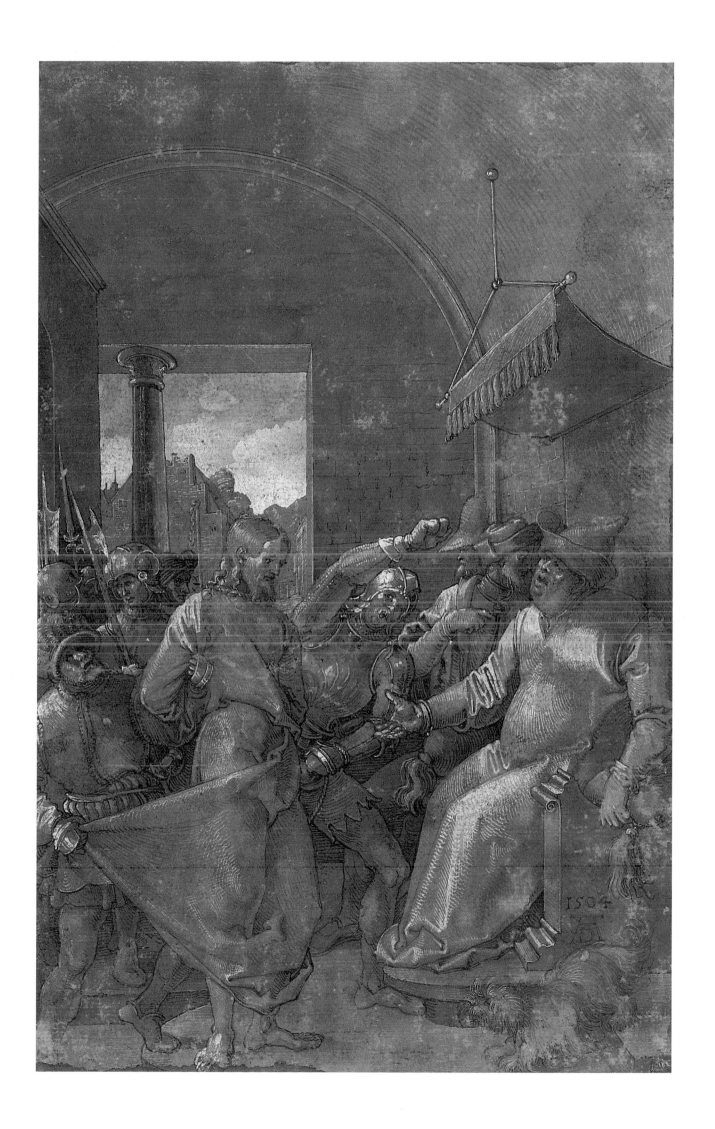

PRINCIPAL PAINTED WORKS.
THE SECOND ITALIAN JOURNEY

69 *Portrait of a Young Venetian Woman*, 1505
Oil on elm panel, 32.5 x 24.5 cm
Kunsthistorisches Museum, Vienna

The portrait of a young woman in Venetian costume is
not completely finished, as can be clearly seen in the bow
on her right shoulder. In warm shades of red which are
repeated in her hair and dress, the figure of the portrayed
woman, who has still not been identified, stands out
against the dark background. Dürer used gentle white
highlights to model the hair and face, thus giving the
portrayed woman a vivid expression.

"daz ding, daz mir vor eilff iore so woll hat gefallen, daz
gefelt mit jcz nüt mer." ("That which I liked so much
eleven years ago, I do not like any more;" Dürer to
Pirckheimer in a letter dated 7 February 1506)

In contrast to the first Italian journey, the only
evidence of which is the sentence dating from 1506
quoted above, Dürer's second period in Italy is docu-
mented in ten letters written to his friend Willibald
Pirckheimer, who also made the journey financially
possible. Eight of these letters were discovered in 1748,
when renovation work revealed a hollow wall in the
family chapel in the house belonging to Pirckheimer's
brother-in-law, Hans Imhoff (1488–1526). As the
first existing personal private letters from an artist to
his friend in the history of German art, they are
extremely significant. Other letters that no longer exist
and which Dürer wrote to his wife and mother are
mentioned in this correspondence.

It is thought that the reasons for Dürer's second
departure for Venice were partly due to the desire to
escape a new outbreak of the plague in Nuremberg,
and partly to do with matters of copyright, for
Giorgio Vasari mentions in his *Lives of the Artists* that
Dürer came to Venice in order to initiate proceedings
against the artist Marcantonio Raimondi (1480–1530).
Marcantonio had seen prints by Dürer on sale in St.
Mark's Square in Venice, and had been extremely
enthusiastic about them. Subsequently, he engraved
copper copies of Dürer's woodcuts and added his own
monogram to them. It was the first trial in German
art history to revolve around the protection of copy-
right. Dürer's achievement was that the Signoria, the
city government of Venice, forbade Marcantonio to
add his monogram to the copies. However, these
forgeries also prove just how highly regarded Dürer
was and internationally renowned at this time. In
Italy, Dürer's works were already being imitated in a
big way by painters, copper engravers and ceramists.
Copper engravings such as *The Prodigal Son* (ill. 38)
and the *Madonna with the Monkey* were frequently
used as models, particularly because of their
successful composition and finely executed, "natural"
background landscapes.

Dürer was mainly accepted by Italian artists as a
graphic artist, less so as a painter. The criticism leveled
at him was that he did not imitate the classical period
enough. But barely a year later, Dürer proudly reported
to Willibald Pirckheimer in a letter that he had silenced
those who did not think him a good painter in his
major commissioned work for the German commercial
brotherhood of San Bartolommeo, the *Feast of the Rose
Garlands* (ill. 70): "jch hab awch dy moler all gschilt,
dy do sagten, jm stechen wer ich gut, aber jm molen
west ich nit mit farben vm zw gen" (I have also silenced
all the painters who said, I was good at engraving, but I
did not know how to work with paints).

But his own artistic judgment also altered: Things
that had enthused him on his first visit to Italy now no
longer impressed him. Equally, his opinions about his
colleagues changed. Jacopo de Barbari, whom he had
previously respected so much, could now no longer
withstand his criticism. His judgment about the old
Giovanni Bellini, who he also mentioned in his letters
to Pirckheimer, was rather different. He and the old
master behaved with respect towards each other and
always praised each other in public.

All the paintings created during these years reveal
Dürer's endeavors to combine Italian feelings about
color and composition with his own pictorial ideas and
to develop his own personal style.

The *Portrait of a Young Venetian Woman* (ill. 69) in
the costume typical of the city is the first painting
that Dürer produced shortly after his arrival in
Venice in 1505. The figure of the young, unidenti-
fied woman stands out against the dark background.
She is wearing a bonnet interwoven with gold thread
on her reddish hair. Her face and hair are surrounded
by gentle white highlights. The emphasis in the
portrait is not on creating a picture of ideal beauty
but rather on depicting individuality. The full, irreg-
ular lips, the large nose and high forehead underline
the impression of personal proximity. The summary
execution of the dress indicates that Dürer did not
complete the portrait. The type of portrait, with the
depicted woman gazing to the right against a dark
background, is characteristic of portraits created
during this time.

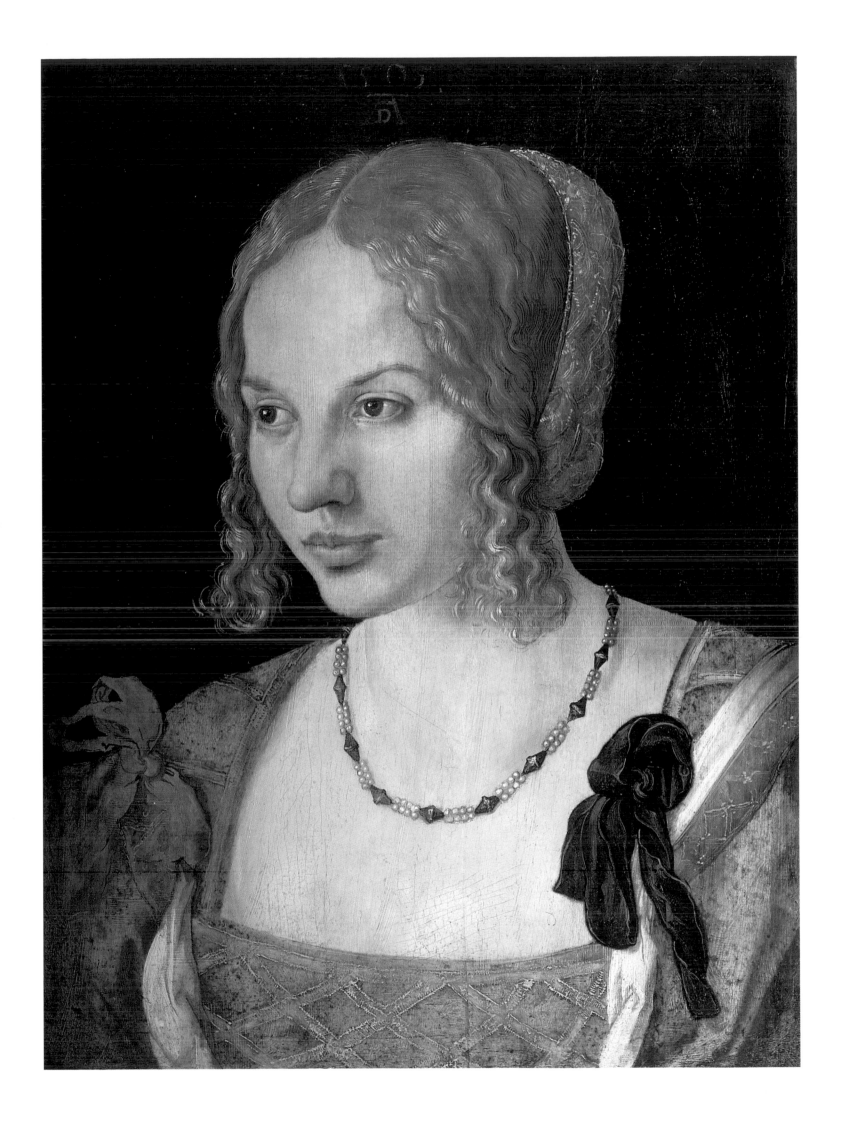

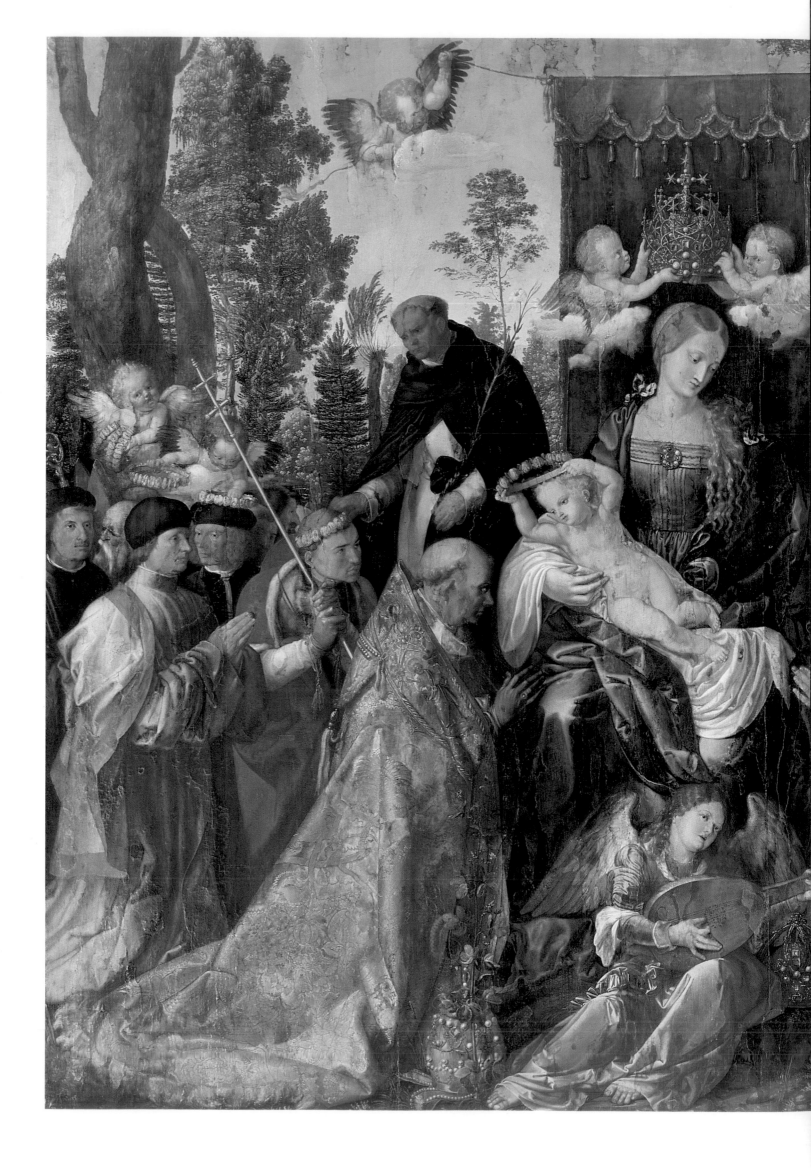

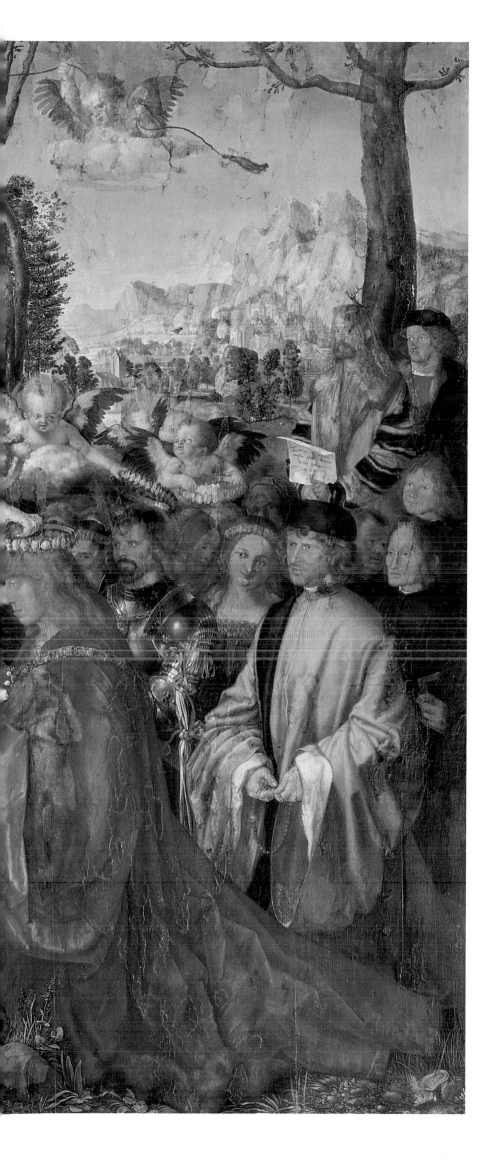

71 Jakob Sprenger, *Feast of the Rose Garlands*, 1476
Woodcut, 16.2 x 11.9 cm
Staatsbibliothek, Bamberg

In 1476 Jakob Sprenger's written work about the "revived brotherhood of the rose garlands" appeared with a woodcut which can, in the broadest sense, be considered a predecessor of Dürer's composition (ill. 70). Here, however, the ecclesiastical and secular believers are bringing rose garlands to the Madonna on her throne, rather than receiving them from her.

70 (left) *Feast of the Rose Garlands,* 1506
Oil on poplar panel, 162 x 194.5 cm
National Gallery, Prague

Mary as the Queen of Heaven on her throne, the Christ Child and St. Dominic to her right, and a crowd of putti are distributing rose garlands to the assembled ecclesiastical and secular ranks. The ecclesiastical dignitaries are led on the left by the Pope, and the lay worshippers on the right are following Emperor Maximilian I, who is kneeling directly at the Virgin's feet. In the crowd of believers Dürer combined real portraits which he prepared in studies with fictitious ones. In the *Feast of the Rose Garlands*, Dürer created his first single panel altar, though its compositional structure is like a triptych. On the right in the background, in front of an extensive alpine landscape, the artist is gazing towards the observer. He is dressed as a refined gentleman and in his hand is holding a sheet of paper with his signature and a Latin inscription.

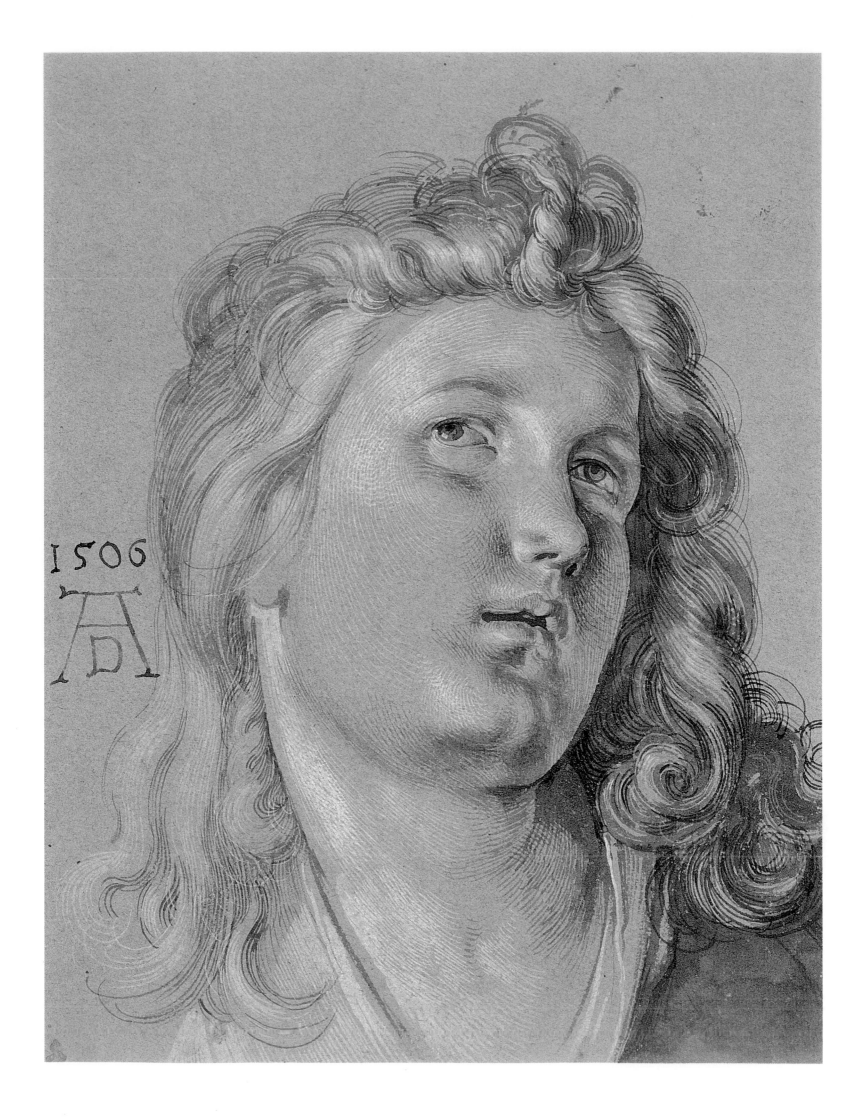

Dürer summed up his experiences with Italian Renaissance art in the composition and colors of his main work during these years, created in 1506 and known since the 19th century as the *Feast of the Rose Garlands*. The large community of German merchants living in the "Fondaco dei Tedeschi," the German warehouse by the Rialto, commissioned him to produce this panel. In a letter dated 6 January 1506, Dürer told Willibald Pirckheimer that he had been commissioned by the "Tewczschen" to paint an altarpiece for their church of San Bartolommeo. It has not been shown beyond doubt just who precisely was the donor and commissioner of the altar painting. It is probable that the artist was commissioned by the community of German merchants belonging to the German Brotherhood of the Rosary, founded in Venice in 1504 and attached to San Bartolommeo, a church in which sermons were given in German.

A fee of 110 Rhenish florins was agreed for the completion of the "Tewczsche thaffel," as Dürer always called the picture. The deadline had been fixed: the panel should "ein monett nach ostern awff dem altar stehen" (stand on the altar one month after Easter.)

Dürer prepared the picture very carefully in a large number of drawn studies, 22 in all (ill. 72). Each of these studies is an independent work of art of the highest level.

Dürer's altar painting is a brilliant conglomeration of German Dutch, Flemish and Italian stylistic features. The shape of the altarpiece, without wings, is derived from Venetian types of pictures and formats. These are also the source for the method of composition – the type known as *Sacra Conversazione* comes to mind – as well as the integration of the central group of figures into a triangle.

The influence of Bellini's rich and shining colors is evident here in the symmetrical composition; a concrete model is the votive picture of Doge Agostino Barbarigo (died 1571). The precise recording of materials is reminiscent of works by Flemish artists such as Jan van Eyck, and the crowd of figures of the German tradition of altars full of figures such as those painted by Stefan Lochner (1410–1451). However, the depicted theme reminds us that Dürer's teacher, Michael Wolgemut, had also created an altar for the Brotherhood of the Rosary in the Nuremberg Dominican church of St. Marien, and Dürer must certainly have been familiar with it.

The theme is part of the German pictorial tradition of the Brotherhoods of the Rosary: Mary, crowned by angels, the Christ Child and St. Dominic are handing out rose garlands to mankind, led by the pope and emperor. The objects of homage here were both Mary and the Rosary, and the secular and ecclesiastical authorities of the Germans.

The symmetrical composition is supported by framing trees on the right and left edges of the picture. Mary, enthroned in the center beneath a baldachin held by an angel, and dressed in Venetian costume, is crowning Emperor Maximilian on her left as the leader of the secular ranks. The Christ Child in her arms is about to put a rose garland on the pope, the head of the spiritual ranks. The events are being given a musical accompaniment by an angel at Mary's feet who is playing a lute. The counterpart to the coronation of the two highest representatives of the State and Church is the Coronation of the Virgin. Flying putti distribute rose garlands to the people gathered to the right and left of the throne. In preceding illustrations, such as a woodcut accompanying a written work about the Brotherhood of the Rosary written by the Dominican monk Jakob Sprenger (active from c. 1468 – c. 1494/1498, ill. 71), it was the faithful who brought rose garlands to the Madonna. Behind the pope, St. Dominic appears, dressed in his order's habit, and he is holding a white lily in his hand, the symbol of the virginity of Mary.

The execution of material details such as the crown meant for Mary, the brocade pluvial worn by the pope and other garments, and the depicted landscape are of such exquisiteness that it creates the impression that Dürer had gone out of his way to convince every single one of his critics.

The numerous portraits in the retinues accompanying the central group document the clients' intentions to have a piece of artistic evidence created of the community of German Christians in Italy. Some of the portraits, probably members of the German colony in Venice, can be identified with absolute certainty. But there are also a number of invented portraits amongst them. The portrayal of the pope, the original version of which has been handed down in a drawn study, cannot however be definitely identified as a portrait of Julius II. The pope and emperor are depicted traditionally in keeping with the theory of the two powers, temporal and spiritual, who were the heads of the *Civitas Dei*, the Christian community. The coronation of the emperor, whose features Dürer had previously only known from a drawing by the Augsburg master Hans Burgkmair (1473–1531), occupies a central position in the scene. Although Maximilian I was not yet emperor at the time the picture was created, he is already portrayed as such here. As Doris Kutschbach has recently expounded, this can be interpreted as a political intention, an appeal from the German merchants to the city of Venice not to block the emperor's coronation. This was because the French and Venetians were resisting Maximilian's plans to have the pope crown him emperor of Germany in Rome by forbidding him passage through their territories. The pope and emperor are joined by the various representatives of the ecclesiastical ranks, cardinals and bishops, priests and monks, and the secular ranks, knights and merchants, artists and craftsmen.

To the right of the picture, in front of a tree, the artist himself is depicted with a piece of paper in his hand (ill. 70). He is gazing directly at the observer. Dressed in a smart fur cloak with an alpine landscape behind him, he self-confidently identifies himself as the gentleman, which he was considered to be and treated as in Venice. The conspicuously displayed sheet in his hands bears the inscription "exegit

72 *Head of an Angel*, preliminary study for the *Feast of the Rose Garlands*, 1506
Brush drawing on blue Venetian paper, 27 x 20.8 cm
Graphische Sammlung Albertina, Vienna

There are a total of 22 preliminary studies, every one of which can be considered an autonomous work of art, in which Dürer prepared the *Feast of the Rose Garlands* (ill. 70). The head of the lute-playing angel by the Madonna's feet is a masterpiece of drawing. The technique of the brush drawing with white highlights on blue paper was one Dürer became acquainted with in Venice. The interplay of white and dark parallel and cross-hatchings which gently follow the curves of the face create the plastic effect of the light and dark shades.

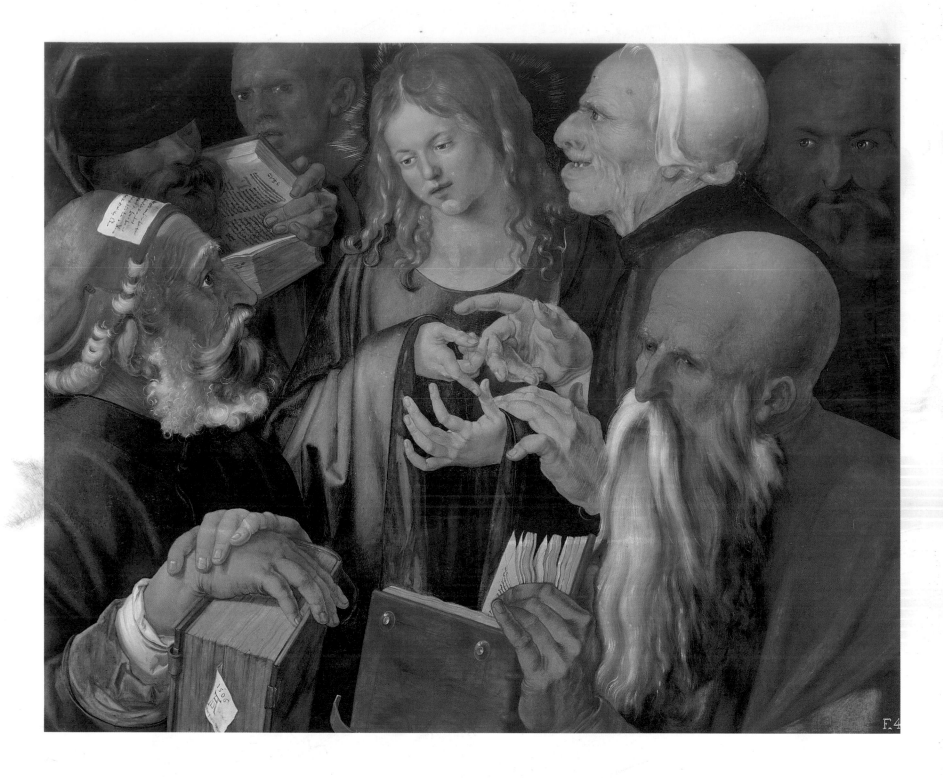

73 *Christ among the Doctors*, 1506
Oil on panel, 65 x 80 cm
Thyssen-Bornemisza Collection, Castagnola

At the same time as the *Feast of the Rose Garlands,* Dürer was working on the painting of *Christ among the Doctors.* The theme derives from the Gospel of St. Luke (Luke. 2, 41–52). During the feast of the Passover, Jesus answers the questions of the doctors in the outer court of the Temple. The beauty of the twelve year-old Jesus contrasts with the ugliness of the doctors surrounding him. The depiction concentrates on the heads, books and hand gestures. It is likely that Dürer already knew Leonardo da Vinci's caricatures at this time, and the latter's *Treatise on Painting* dealt, amongst other things, with the contrast between absolute beauty and ugliness.

quinque/mestri spatio Albertus/Durer Germanus/. M.D.VI." (Albrecht Dürer, A German, created this in the space of five months. 1506).

Next to Dürer, away from the main events, stands a man who is still proving difficult to identify due to a lack of preliminary sketches. It has been thought that this is the humanist Konrad Peutinger (1465–1547), who was an imperial advisor, as he also acted as an intermediary between the emperor and artists. Much of the original effect of the transparent paints and illusionistic recording of materials has probably been lost, for when the painting was moved from Venice it was badly damaged and was overpainted in many places.

The painting also played an important role for Dürer, as he had succeeded in disproving his opponents' opinions about his achievements in

painting. Even the Doge Leonardo Loredano (1431–1521) and Antonius of Surianus, the patriarch of Venice (died 1508) came in person in order to view the picture. Observers were particularly impressed by the careful application of the paint and the choice and harmony of the color values.

While the *Feast of the Rose Garlands* was a commissioned piece, during the following years Dürer also continued to develop his pictorial ideas in works independently of clients. In a letter dated 23 September 1506, he informed Willibald Pirckheimer that at the same he had completed "awch ein ander quar, des gleichen jch noch nie gemacht hab" – another one, the like of which I have not done before.

This text provides a link to another major work created at the same time, the painting of *Christ among*

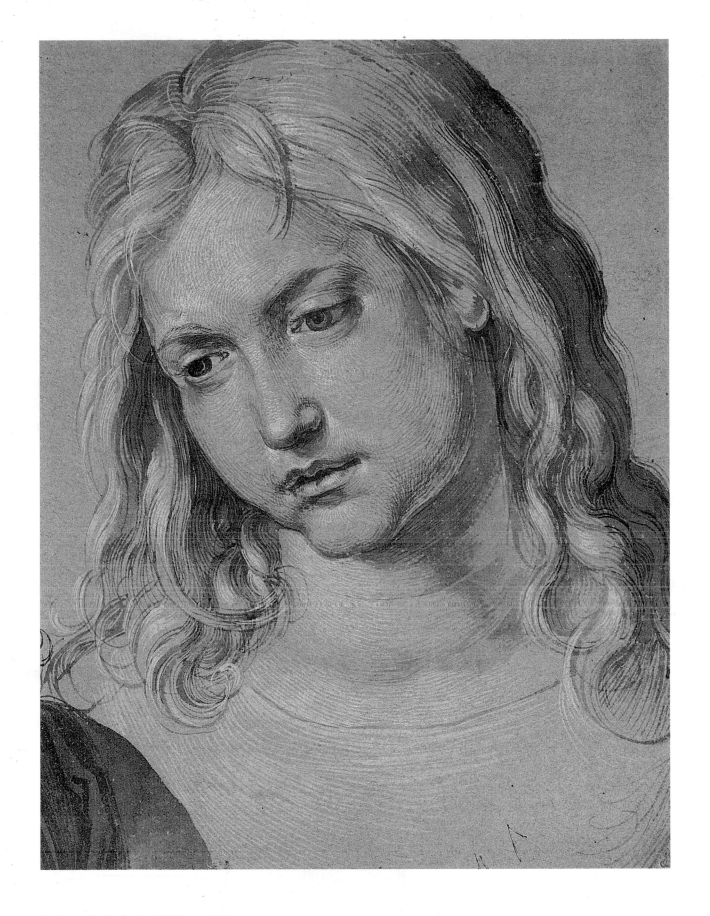

74 *Head of the Twelve Year Old Christ*, c. 1506
Brush drawing on blue Venetian paper, 27.5 x 21.1 cm
Graphische Sammlung Albertina, Vienna

The head study of the twelve year-old Jesus was originally drawn on
the same sheet, later separated, as the preliminary drawing of the
lute-playing angel in the *Feast of the Rose Garlands* (ill. 72). This is
confirmed by the fact that the two pictures were created at the same
time. In contrast to the preliminary drawing for the *Feast of the Rose
Garlands*, Dürer kept more rigidly to his preliminary study in the
painting of *Christ among the Doctors*, diverging only in details such as
the reproduction of the hair.

the _Doctors_ (ill. 73). The theme is derived from the Gospel of St. Luke (Luke 2, 41–52). When Christ accompanied his parents to the feast of the Passover at the age of twelve, he was separated from them and took part in lessons about the law in the outer court of the Temple. His questions and answers soon attracted the attention of the doctors. Dürer moves the group of figures, seen against a dark background, right to the foreground of the scene so that they fill the entire picture and the observer feels he is in their immediate presence. The young Christ stands in the center, his hair blonde and curly, and he is thoughtfully listing the reasons behind his argument with a rhetorical gesture. Jesus is mobbed by six caricature-like, overlapping old men, similar to the ugly thugs who formed part of the retinue behind depictions of the Bearing of the Cross, and they are holding or opening books. The picture concentrates entirely on the interplay of the character's heads, their gestures and the books they are holding in their hands, all of which contrasts with the gentle figure of Christ.

Dürer incorporated a variety of ideas in this picture. The gesture language of the hands is new, clarifying the dispute between Christ and the bad doctor standing directly next to him, and this is a method of depiction which is more frequently encountered in Italian pictures of debating doctors. This play of hands may have been inspired by Giovanni Bellini's painting _Lamentation over the Dead Christ_. The doctors seem to ignore Christ as they talk and look around just as much as they avoid visual contact with each other. Each of the figures has a different position of the head, and this produces a rhythmic overall image. Since the Middle Ages ugliness had been equated with wickedness. The exaggerated depiction reminds us that Dürer may already have been familiar, in Florence, with the caricatures produced by Leonardo da Vinci, the famous Italian artist, architect and natural scientist. His treatise on painting, the _Trattato della Pittura_, contains a rule recommending the contrast of absolute beauty and extreme ugliness.

The reproduction of rhetorical gestures and the arrangement of the figures in the picture reveals the influences of northern Italian half length portraits such as those by Andrea Mantegna, and a Venetian compositional scheme which shows Christ in the center of the picture surrounded by a group of half length figures. Dürer's signature appears on a bookmark sticking out of an open book, with the addition of "opus quinque dierum," a reference to the fact that the work was produced in the remarkably short time of five days.

Anzelewsky considers the wording of the inscription, which is no longer in its original condition and reads "1506/A.D./F.ROMAE/opus quinque dierum," to prove that Dürer stayed in Rome, but there are no other sources to support this.

A finely executed large sheet of paper that was later divided in the middle originally connected the two preliminary studies for the heads of the lute-playing angel in the _Feast of the Rose Garlands_ and that of the twelve year-old Christ (ill. 74). These brush drawings with white highlights were produced by Dürer on blue Venetian paper with white and black watercolors, and this gives the light and dark effects a particular impact. He had become familiar with the technique in Italy and perfected it to a degree that almost exceeded the ability of its inventor.

The _Madonna with the Siskin_ (ill. 75) was painted by Dürer at the same time as the _Feast of the Rose Garlands_ (ill. 70) and _Christ among the Doctors_ (ill. 73). It achieved considerable popularity due to its majestic type of composition and the shining colors which are interrelated with the picture's humanly natural and emotional values. The picture of the Madonna is part of the tradition of Giovanni Bellini's monumental paintings and, in terms of style, is directly connected to the _Feast of the Rose Garlands_. Mary, in Venetian costume and crowned by putti, is enthroned before a red curtain, to the side of which we can see out onto an alpine landscape.

In contrast to early depictions of the Madonna influenced by Schongauer, the group of figures is moved close to the front edge of the picture. The small St. John the Baptist, assisted by an angel who is holding the cross-shaped staff as a symbol of Christ's Passion, is offering Mary lily of the valley flowers, symbols of her virginity. Jesus, holding a pacifier in his right hand, is playfully balancing the siskin, a symbol of the sinful souls redeemed by Christ, on his elbow. The book on which Mary is leaning her arm is an allusion to the Mother of God as the "sedes sapientiae," the seat of eternal wisdom. The oak leaf crown above her head fits in with this subject. The piece of paper lying on the table bears Dürer's monogram and the inscription: "Albert(us) durer germanus/faciebat post virginis/partum 1506" (The German Albrecht Dürer made this after the Virgin gave birth 1506).

In terms of style and color, it is clear that the _Feast of the Rose Garlands_, _Christ among the Doctors_ and the _Madonna with the Siskin_ were all created at about the same time. They document Dürer's ability to combine Italian models with his own pictorial ideas.

75 _Madonna with the Siskin_, 1506
Oil on poplar panel, 91 x 76 cm
Gemäldegalerie, Staatliche Museen zu Berlin –
Preußischer Kulturbesitz, Berlin
The _Madonna with the Siskin_ was created at the same time as the _Feast of the Rose Garlands_ (ill. 70), and it was strongly influenced by Italian models, in particular the Madonna paintings by Giovanni Bellini. Moved right into the foreground of the scene, Mary and the Christ Child are enthroned, crowned by two putti. Jesus is carrying a siskin, the symbol of Christ's Salvation, on his arm and Mary is holding a book, the symbol of the "sedes sapientiae", the Mother of God as the seat of eternal wisdom. The small St. John the Baptist, accompanied by an angel and complete with his customary attributes of fur cloak and cross-shaped staff, is offering Mary two lilies of the valley – symbols of the Virgin. The picture radiates emotional warmth and immediacy by means of the shining harmonious colors and the human features of the Mother of God, and this may have contributed to its popularity.

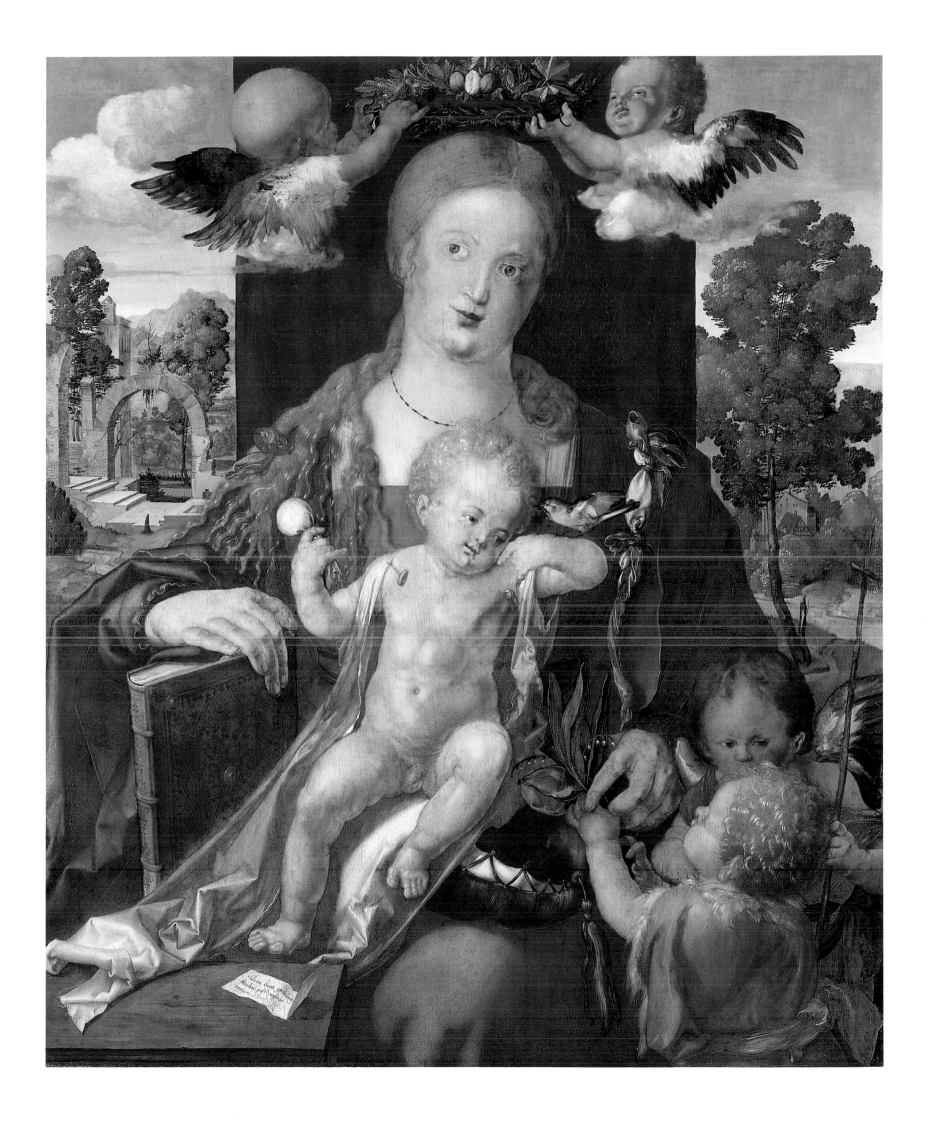

By the beginning of 1507, Dürer had probably already returned to Nuremberg. He was in a good financial position after his successful time in Venice, was able to pay off his debts to Pirckheimer and, from the heirs of the astronomer Bernhard Walter (c. 1430–1504) he bought the building by the Tiergärtner Gate that was to gain fame as Dürer's house (ill. 76).

The lack of theoretical treatises on the nature of painting caused Dürer, from 1508 onwards, to direct his attention to writing a book on painting which was given the interim title of "speis der maler knaben," but we only know of its planning from a few scattered notes. It was intended to be a textbook for his assistants and apprentices, and in addition to Dürer's own knowledge about geometry, perspective and color also provided advice on personal hygiene, morals and human problems.

During the ensuing years, the *Feast of the Rose Garlands*, Dürer's first major painted work, was followed by further masterpieces.

Shortly after his return from Italy, Dürer was commissioned to create a painting of the *Martyrdom of the Ten Thousand* (ill. 77) for his patron, the Elector Frederick the Wise. The work was meant for the chamber of relics in the Wittenberg castle chapel which housed a large collection of relics, including those of the 10,000 Christian martyrs. Dürer had already dealt with the theme in an earlier woodcut which was based on the same preliminary studies as the painting. In the preparatory drawing, Dürer still planned the picture to have a horizontal format. However, the choice of a vertical format, presumably a requirement on the part of the client, meant that in the end the composition and arrangement of the figures once more coincided with those of the woodcut. As in the painting of the first man and woman, Dürer added the word "alemanus" to his name: Albrecht Dürer the German. Numerous horrendous scenes of the martyrdom of the 10,000 Christian warriors and their leader Achatius on Mount Ararat are visible amidst a steep rocky landscape. The action develops horizontally in stepped picture strips. In addition to the powerful blue, the main colors are brown, red and green tones. The artist has depicted himself in the center of the picture, gazing

out at the observer (ill. 77). He is deep in conversation with the humanist Konrad Celtis, who was held in equally high esteem by the Elector. In the sense of platonic love in accordance with the notions of the Italian humanist Marsilio Ficino (1433–1499), they are intently watching the martyrs' sufferings. Their dark clothing distinguishes them from the rest of the event which is depicted in shining colors. While Dürer has been considered to be dressed in mourning in honor of the dead man, the robes of his companion have been interpreted as those of the professor of poetics at the University of Vienna. The little scene is interpreted as a recommendation for the soul of the dead humanist to the 10,000 martyrs. The panel fulfills two functions. On the one hand, it is a devotional picture relating to the relics belonging to the Elector, and on the other hand, it is a memorial picture commemorating dead humanist. There had been relations between the client, painter and humanist for some years, so that the Elector must have been aware of the double meaning of the picture. The painting was held in high esteem by Frederick the Wise and his nephew and successor Johann Frederick of Saxony (1503–1554). The latter is even supposed to have asked for it during his imprisonment in Brussels.

At the same time as the *Martyrdom of the Ten Thousand*, Dürer was working on an extensive altar for the wealthy Frankfurt cloth merchant Jacob Heller (c. 1460–1522), another important client who had heard of Dürer's outstanding achievement in the *Feast of the Rose Garlands* in Venice. He commissioned Dürer to produce a winged altar in three sections, meant to be dedicated to St. Thomas Aquinas, for the Dominican church in Frankfurt am Main. Nine existing letters document the difficult relationship between client and artist. The central altar picture was intended to be a new iconographical form of picture combining the Coronation of the Virgin with the Assumption, and the side wings were to depict scenes of martyrdom, donor portraits and standing saints. The central panel was completed by 1509. Matthias Grünewald (c. 1460/1480–1528) painted two additional outer side panels with standing saints in grisaille. As copies of the central panel and wings from Dürer's workshop prove,

76 Dürer's house in the former Zisselgasse, Nuremberg
Photographed before the Second World War

In 1509, after returning from his second Italian journey, Dürer bought the town house that was part of the estate of the Nuremberg merchant Bernhard Walther for 275 gold florins. In the same year, just a few months after the bill of sale was completed on 14 June, Dürer paid off the mortgage to the sum of 75 florins. In order to be able to pursue his astronomical studies better, Walther had had an open pergola built onto the top floor of the house, situated in the former Zisselgasse by the Tiergärtner Gate.

77 *Martyrdom of the Ten Thousand*, 1508
Oil on panel transferred to canvas, 99 x 87 cm
Kunsthistorisches Museum, Vienna

This picture was intended for the chamber of relics in the Wittenberg castle chapel, and was created as a result of the Saxonian Elector Frederick the Wise's worship of relics. In several horizontal picture fields, arranged parallel to each other, Dürer depicted the account in the *Legenda aurea* of how the Christian company of soldiers with Bishop Achatius, which had been converted to the Christian faith by a miracle, was executed on Mount Ararat. The Roman rulers Hadrian and Antoninus commissioned seven Oriental princes to carry out the execution, and they stand out here in their splendid turbans and robes.

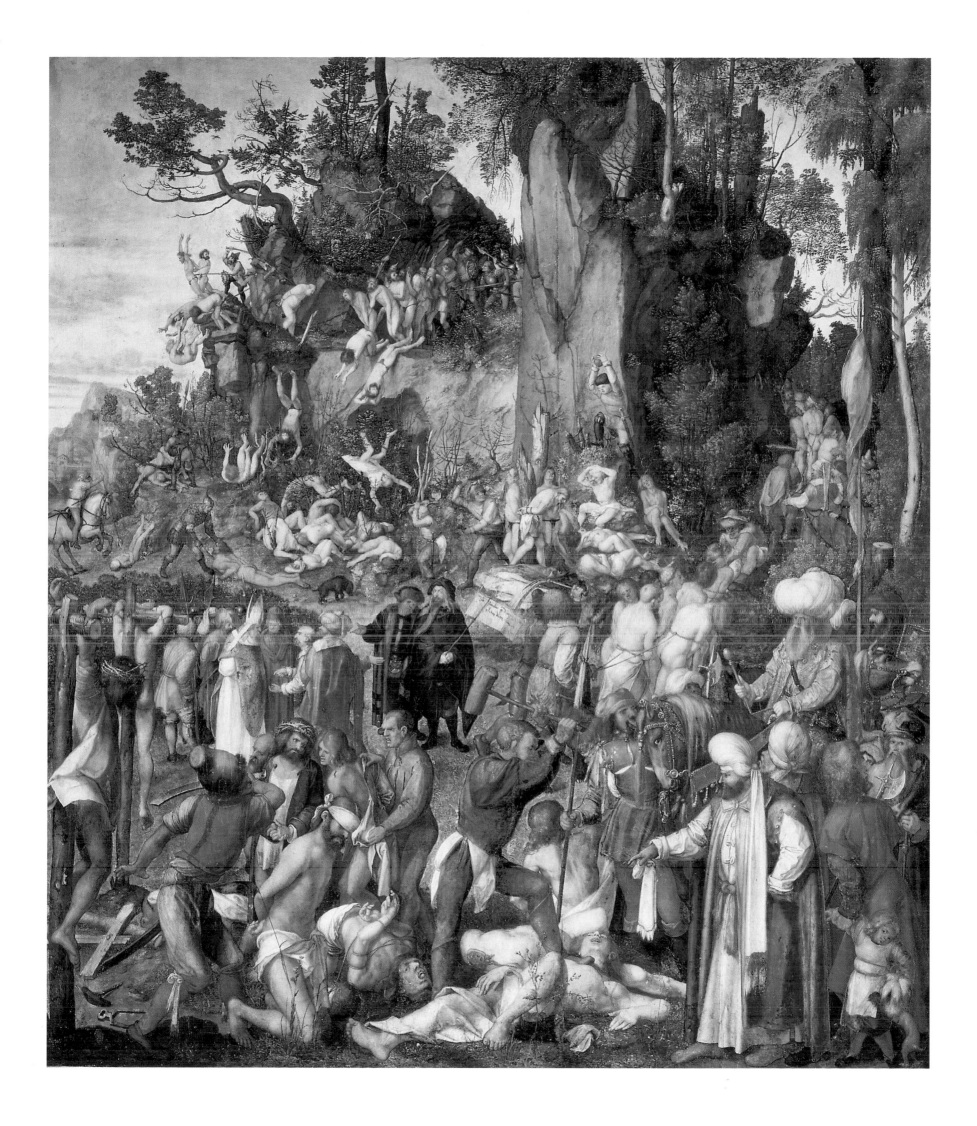

the *Heller Altar* was, together with the *Paumgartner Altar*, one of Dürer's most extensive altarpieces. In 1729 the central panel, a pale reflection of which is provided by a copy dating from 1614, was destroyed in a fire in the Munich residence. Eighteen preliminary studies, brush drawings on green, blue or gray primed paper which Dürer produced for this work influenced by Italian models, survived and convey an impression of what must have been a magnificent painting (ill. 78).

It was probably in 1508 that Dürer was commissioned to produce another altar painting, the *Adoration of the Trinity* (ill. 79), by Matthäus Landauer (died 1515), a Nuremberg metal dealer. The picture was intended for the Chapel of All Saints in the home that Landauer had founded for old craftsmen who had become impoverished through no fault of their own, and it was completed in 1511. Dürer designed the picture and frame as an artistic and iconographical whole. In keeping with Italian models, he chose a single panel, the relatively small size of which also differs from large altarpieces. At the request of the client, the work was carried out in a particularly lavish manner: the gold-colored sections were executed with real gold. A carved frame with Christ sitting in judgment and Mary and St. John in prayer opens up the view, in the manner of an eschatological prelude, of a heavenly vision comprising a gathering of all the saints around a depiction of the Holy Trinity. This vision heralds what is awaiting each individual after the Last Judgment in the City of God. In the earthly zone, an extensive river landscape, impossible to identify beyond doubt, is also a symbol of the real world. Dürer has depicted himself with considerable artistic self-confidence. He is holding

a plaque in his hands which bears the inscription: "ALBERTUS DVRER. NORICUS. FACIEBAT. ANNO A. VIRGINIS.PARTV. 1511" (Albrecht Dürer of Nuremberg made this in the year of 1511 after the Virgin gave birth).

All three altarpieces produced at the same time, after Dürer's second Italian journey, testify to his innovative approach to tradition and the influences of Italy. While the *Heller Altar* merged two different iconographical types in one, the *Martyrdom of the Ten Thousand* had an unusual double purpose as a devotional and memorial picture. The *Landauer Altar*, finally, differed from the earlier ones in the choice of a single panel picture and in the format and composition of traditional altar forms.

Dürer had never entirely abandoned his study of ideal human proportions during his second Italian journey, as is shown by various drawings. His efforts left their mark on the two pictures of *Adam and Eve* (ills. 80, 81) created in 1507. The two pictures, independent and nonetheless related to each other, were derived from preparatory studies and a copper engraving dating from 1504. The symbolical accessories are reduced to a minimum, and the recording of the nude figures and modeling of the bodies are at the fore. By using separate panels, Dürer created a new pictorial type for this theme which was frequently imitated. In his depiction of the first human couple, Dürer presumably was influenced by a wall painting by Masolino at the entrance to the Brancacci Chapel in the church of Santa Maria del Carmine in Florence. The pictures have motifs in common such as the Tree of Knowledge on the right edge of the picture. Dürer worked his knowledge of Venetian

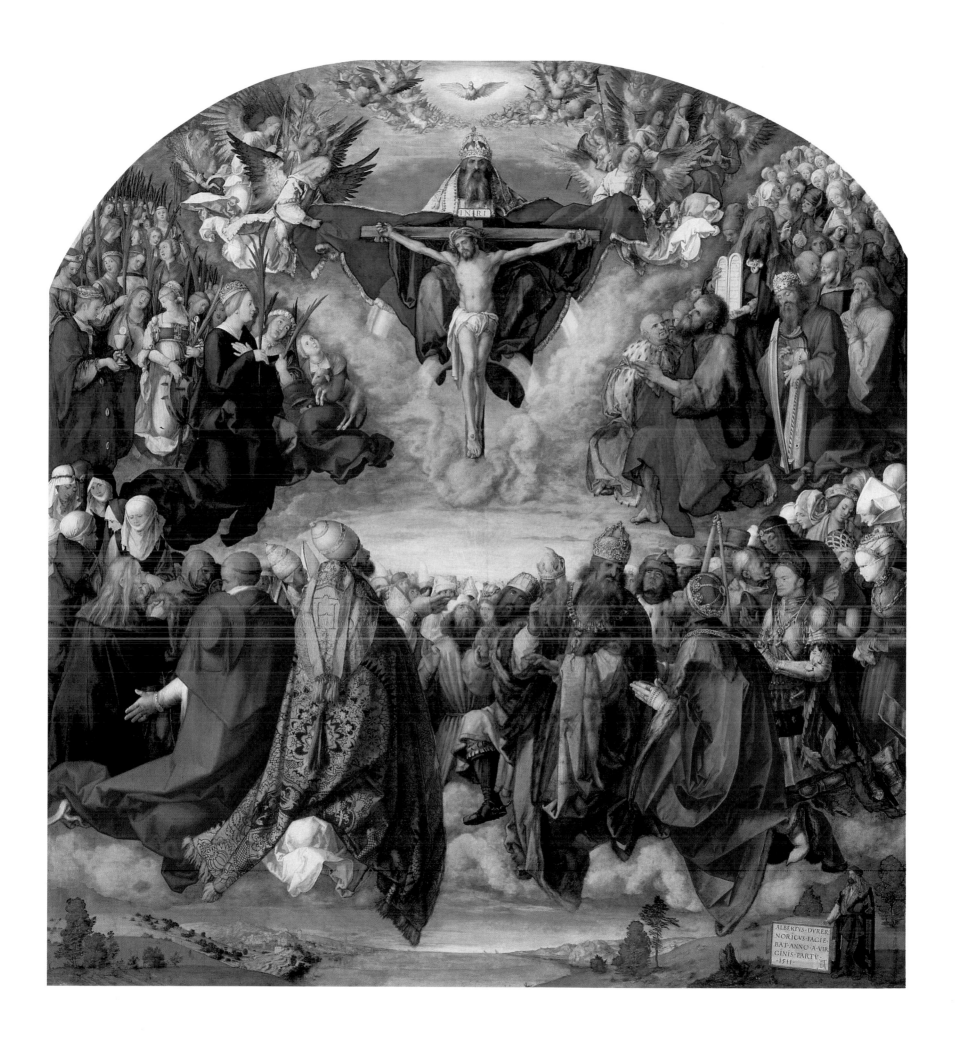

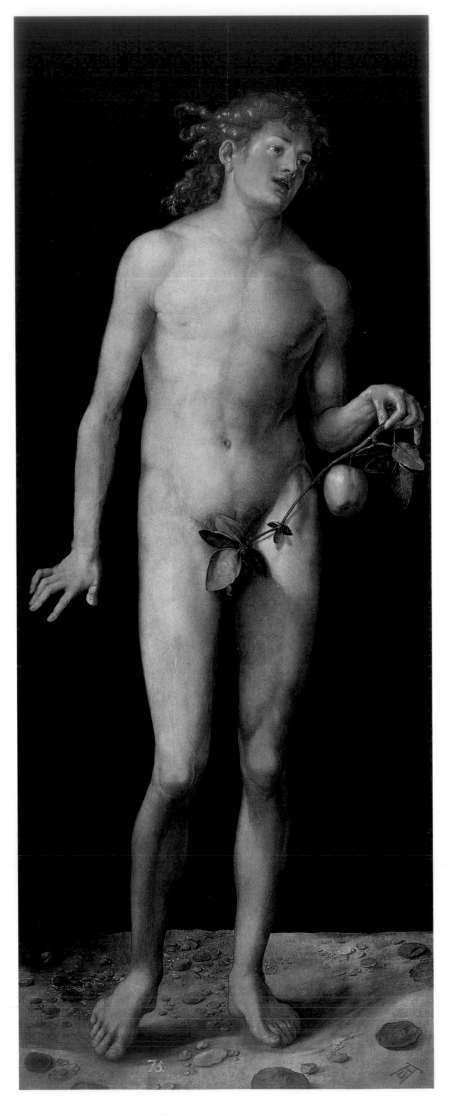

80 *Adam*, 1507
Oil on pine panel, 209 x 81 cm
Museo del Prado, Madrid

Following his copper engraving dating from 1504, Dürer
produced another painted version of the theme of the first
human couple three years later. The two pictures of Adam
and Eve (ill. 81) were painted as independent pendants
related to each other in their composition and the
movement of the figures' bodies. Adam, who is holding a
branch from the Tree of Knowledge in front of himself, is
turning yearningly towards Eve in the other panel. Like
Eve, he is depicted in motion, walking with his hair
blowing back.

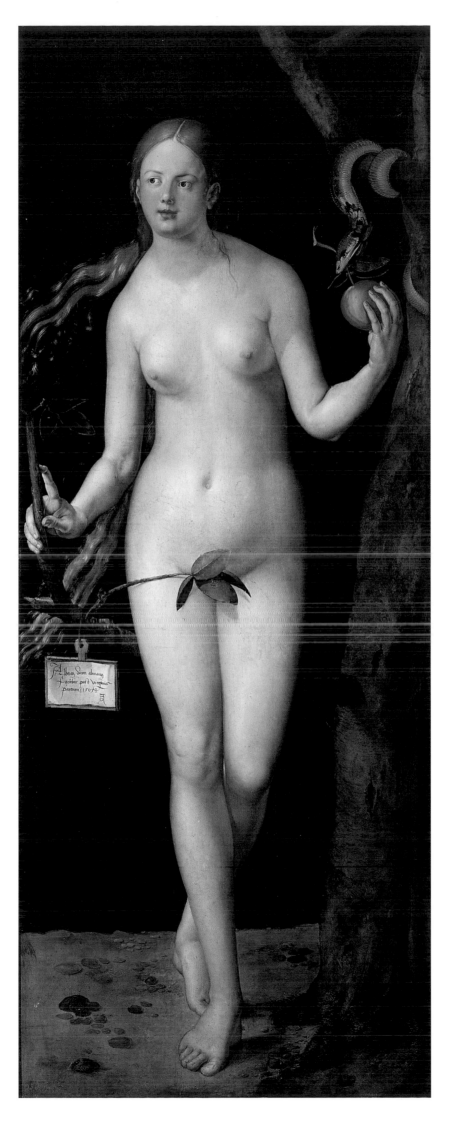

81 *Eve*, 1507
Oil on pine panel, 209 x 81 cm
Museo del Prado, Madrid

Like the depiction of Adam, that of Eve should also be considered in the context of the studies relating to the ideal proportions of the human body which Dürer had been making since his first Italian journey in 1496. The plastic values of the painting are toned down compared to those in the copper engraving, and the interior detail is gentler. Eve is gazing seductively across at Adam. In her left hand she is receiving the apple from the serpent, and in her right she is holding a branch from the Tree of Knowledge from which hangs a *cartellino*, a small inscribed plaque with the signature and phrase "Albertus Dürer alemanus faciebat post virginis partum 1507" (The German Albrecht Dürer made this after the Virgin gave birth 1507).

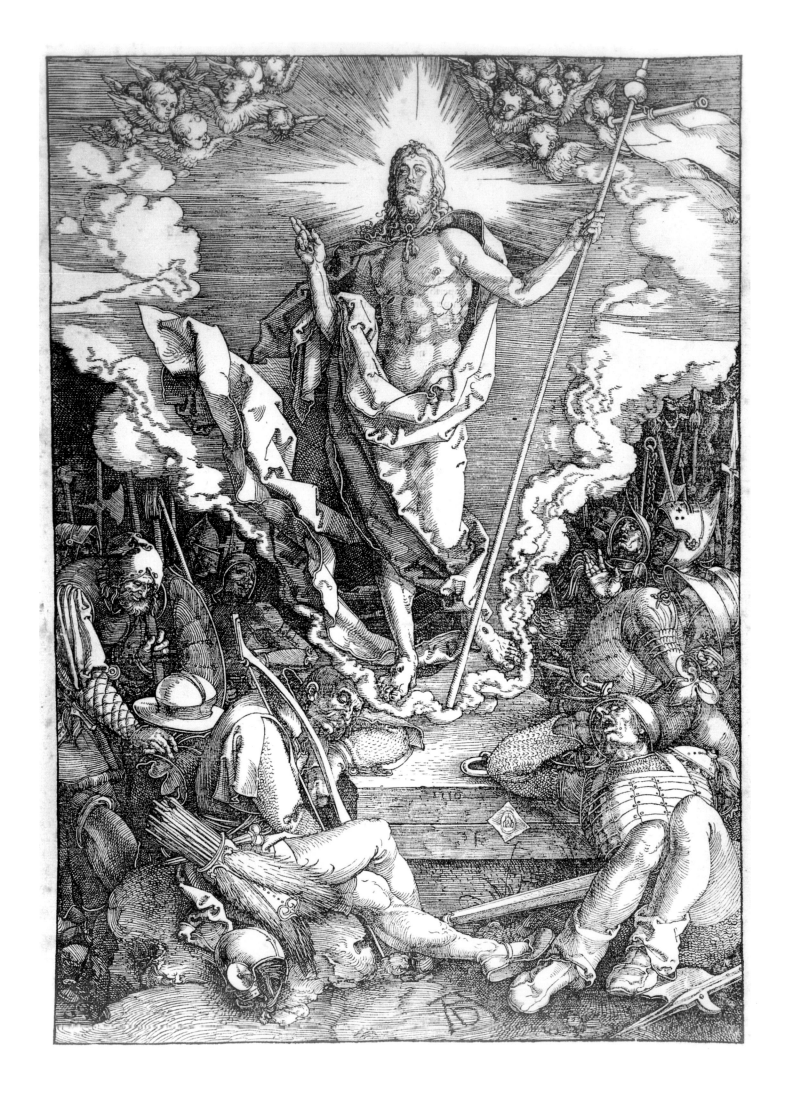

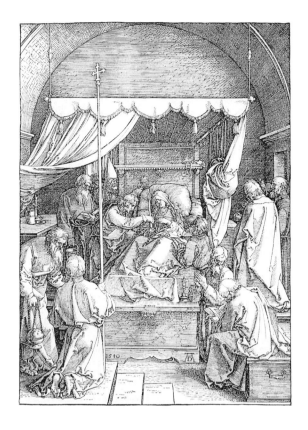

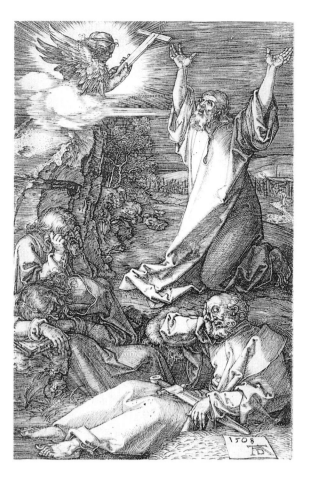

83 *Life of the Virgin: Death of Mary*, 1510
Woodcut, 29.3 x 20.6 cm
Kupferstichkabinett, Staatliche Kunsthalle, Karlsruhe

The canopied bed in which the Mother of God has just died is positioned centrally in a barrel vaulted room. The disciples are busy carrying out the medieval last rites. St. Peter, dressed as a bishop, is swinging the aspergillum containing incense while St. John presses the candle of death into the Mother of God's hands. Two of the disciples are reading funeral prayers, others are deep in prayer; in the foreground two figures are holding an incense burner and a crucifix which could be used to grant the deceased person an indulgence. The woodcut follows the tradition of the medieval *ars moriendi* depictions, and one model is a copper engraving of the same name by Martin Schongauer. The woodcut is part of a series of 19 sheets which make up the *Life of the Virgin*, which was published in book form in 1511.

84 *Engraved Passion: Christ on the Mount of Olives*, 1508
Copper engraving, 11.8 x 7.6 cm
Kupferstichkabinett, Staatliche Kunsthalle, Karlsruhe

The first sheet in the *Engraved Passion* is the scene of *Christ on the Mount of Olives*, one of four night scenes in the cycle. The compositional lines lead towards the figure of Christ who has cried out and brought his arms up just as the angel appears. His turbulent emotions are contrasted with the calm and sleeping innocence of the three disciples. These contrasts are heightened tremendously by the targeted use of dramatic lighting, and light and dark effects.

sculpture into the figure of *Adam*. After they were completed, the two panels came into the possession of Bishop Johann V of Breslau.

In 1511, Dürer returned to an increased study of printed graphics. Interactions between his paintings and graphics at this time as well as the experiences Dürer had gained on his second Italian journey are apparent in large-scale woodcuts such as the *Holy Trinity* and sheets from the *Life of the Virgin* (ill. 83). It is significant that Dürer turned to making series of woodcuts, such as the *Small Passion* and the *Great Passion* (ill. 82), the *Life of the Virgin* which Dürer published in 1511 in book form with poetry by the Benedictine monk Benedictus Chelidonius, and a new edition of the *Apocalypse*. In total, he produced nearly 90 woodcuts, some of which were very large in size, and these must have been very influential and ensured that the artist enjoyed a certain degree of financial independence from then on. At this time, Dürer's woodcuts were already on display everywhere as models in workshops. Therefore, it is surely no coincidence that Albrecht Altdorfer (c. 1480–1558) also started to carve his drawings in wood at this time. The printed graphics Dürer produced after his second Italian journey are distinguished by a novel use of the "clair-obscur" technique which had already been initiated in drawings such as the sheets of the *Green Passion* (ill. 68). In the *Small Passion* and *Engraved Passion*, Dürer succeeded in achieving an unprecedented dramatic effect by what was a novel use of light and dark effects in printed graphics.

The *Engraved Passion* (ill. 84) was conceived for a different target audience than the more popular *Small Passion*. It was created 30 years after Martin Schongauer's *Engraved Passion*, during the years between 1507 and 1513. In contrast to the *Small Passion*, which dates from the same period, the series was not intended to be a book for the edification of larger sections of the population, but was meant to be a piece for educated collectors. The engravings were very popular and were even treated as miniatures in the 16th century, illuminated with paints, highlighted with silver and gold leaf and mounted on sheets of parchment whose edges were decorated in accordance with Late Medieval tradition. Copies were owned by famous contemporaries such as Erasmus of Rotterdam (1469–1536). In contrast to the woodcuts of the *Great Passion* (ill. 82), the *Life of the Virgin* (ill. 83) and the *Apocalypse* (ills. 42–45), the engravings, which were also executed in considerably finer detail with regard to modeling and texture, appeared without a text. The picture detail is usually tightly spaced; the compressed groups of figures, positioned right in the foreground, frequently act in interiors or around a stage. Pictures such as *Christ on the Mount of Olives* (ill. 84) are among the first four nighttime scenes to underline the theatrical, oppressively emotional character of the scene by using special dramatic lighting against a dark background.

82 (opposite) *Great Passion: Resurrection*, 1510
Woodcut, 39.1 x 27.7 cm
Kupferstichkabinett, Kunstsammlungen der Veste Coburg, Coburg

This woodcut is the latest of twelve sheets in the *Great Passion*, named after the format of the series. In 1511 Dürer published the cycle, together with a title page and a poem by the Benedictine theologian and friend of Willibald Pirckheimer, Benedictus Chelidonius (died 1521). The pictures are distinguished by means of their strong emotions, naturalism and human treatment of the subject, thus distancing themselves from Late Gothic depictions of the Passion. In the figure of the Resurrected Christ, Dürer once more made use of classical models and the knowledge which he had gained through his study of ideal human proportions.

The Printed Graphics for Emperor Maximilian I

85 (opposite, left) *Emperor Charlemagne*, c. 1512
Oil on panel, 190 x 89 cm
Germanisches Nationalmuseum, Nuremberg

The idealized portrait of Emperor Charlemagne was intended for the "Heiltumskammer" in the Schoppersche House by the marketplace, together with the portrait of Emperor Sigismund of Poland (ill. 86). This was where the coronation insignia and relics were kept, which were put on display once a year at the so-called "Heiltumsweisungen." The physiognomy of Charlemagne, shown in the magnificent original coronation robes, is reminiscent of depictions of God the Father. The crown, sword and imperial orb were prepared by Dürer in sketches. The German imperial coat of arms and French coat of arms with the fleur-de-lis are emblazoned at the top.

86 (opposite, right) *Emperor Sigismund*, c. 1512
Oil on panel, 189 x 90 cm
Germanisches Nationalmuseum, Nuremberg

Dürer had originally planned the two imperial portraits of Charlemagne (ill. 85) and Sigismund to be a foldable diptych. In accordance with the prescriptions of the Nuremberg town council, who had commissioned the works, the two portraits were supposed to be based on the paintings which had previously decorated the "Heiltumskammer" in the Schoppersche House by the marketplace, where every year the state jewels were kept for a short time. Emperor Sigismund is turned towards Charlemagne. The portrait, which is rather wooden in appearance when compared to other portraits by Dürer, presumably was based on a miniature copy in a portrait book by Hieronimus Beck of Leopoldsdorf, which is in the Kunsthistorisches Museum in Vienna. The coats of arms of the German Empire, Bohemia, old Hungary, new Hungary and Luxembourg appear at the top of the painting.

"When a person dies, there is nothing to follow him apart from his work. If one does not create a memorial to oneself during one's lifetime, one will not be remembered after one's death, and such a person will be forgotten even as the bell tolls." (Maximilian I)

The years between 1512 and 1517 were shaped by commissions for Emperor Maximilian I (1459–1519) and Dürer's activities as a graphic artist.

Several imperial commissions were prompted by the portraits of the German emperors, Charlemagne and Sigismund (ills. 85, 86), who were portrayed in a manner which hovered between religious and secular iconography. The Nuremberg city council had commissioned Dürer to create these idealized, larger than life-size portraits, which were intended for the "Heiltumskammer" in the Schoppersche House by the marketplace and were presumably used as doors for the wall cupboard in which the "regalia" were kept. Charlemagne (724–814) was the first emperor of the Holy Roman Empire. He was canonized as early as 1165. Emperor Sigismund (1361–1437), in contrast, had brought the imperial insignia away from the Hussites, from Karlstein Castle in Bohemia, via Hungary to Nuremberg, and for that reason had played an important part in the history of the city. While the portrait of Charlemagne was a work of the imagination, though following a type of depiction that was common in the 15th century, the portrait of Sigismund was based on a model. In comparison to other portraits by Dürer, the pictures appear wooden. However, with the depicted state treasures and imperial jewels, objects from the "Heiltumskammer" in which they were mounted, they represented an ideal, if not an artificial, image of princely splendor. Due to the strangeness of the two panels in Dürer's works, it has been assumed that they were based on the two older panels in the "Heiltumskammer." For example, the hands of Emperor Sigismund, the blocky self-containedness of the figure and its bent posture may derive from the panel by a Nuremberg master dating from the period around 1430. When the Reformation came to Nuremberg in 1526, the panels lost their significance as sacred objects and were removed from the "Heiltumskammer" to the town hall as a result of a council decree dating from 6 October of that year.

In a letter written by Lazarus Spengler (1479–1534), the Nuremberg town clerk, on 30 November 1513, we can read of Maximilian I's admiration of the panels, in particular of the portrait of Charlemagne, whose beard was reminiscent of depictions of God the Father, and that the emperor intended to commission a range of works from Dürer. The emperor had recognized the opportunities that printed graphics provided for propaganda. During the following years, he endeavored to leave everlasting memorials to himself in the form of printed works and pieces of art. Amongst other things, he planned 33 books, seven of which were actually published. The literary fame the emperor wanted to achieve in this manner was to be spurred on by the embellishments provided by the staff of artists he commissioned. Apart from Dürer, who was in overall charge of the work on the series of woodcuts for the *Triumph of the Emperor*, numerous artists were involved in the projects, including Dürer's two students Hans Schäufelin (c. 1480/1485–1538/1540) and Hans Burgkmair, Albrecht Altdorfer and Maximilian I's court painter Jörg Kölderer (died 1540). However, the emperor's attitude to paying his staff left much to be desired. In a letter dated July 1515 and addressed to the imperial envoy in Nuremberg, Christoph Kress (1484–1535), Dürer complained that he had been in the service of the emperor for three years without pay and that he was "therefore asking his imperial majesty to pay him the hundred florins." In a reply dated 6 September, Emperor Maximilian granted an annual pension, but it was rarely paid by the city council.

In addition to his collaboration on the *Gate of Honor* (ill. 87) and the *Triumphal Procession*, Dürer also delivered two painted portraits to the emperor during these years, together with designs for a set of silver armor and 56 border illustrations for a prayer book which were used as preliminary drawings for the woodcut. The larger than life-size bronze statue of Albrecht von Habsburg (c. 1298–1358), which was created for the cycle of sculptures in Maximilian's sepulcher in Innsbruck by the Landshut sculptor Hans Leinberger

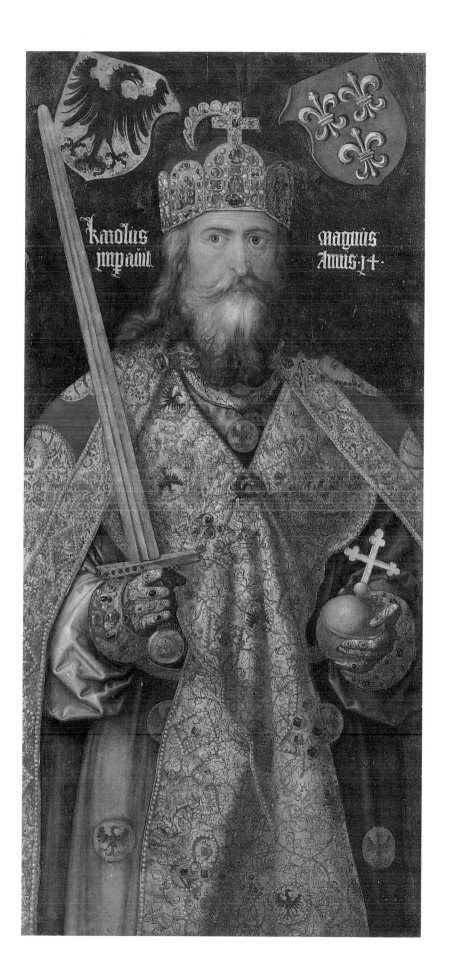

Karolus imperator magnus Annus LT·

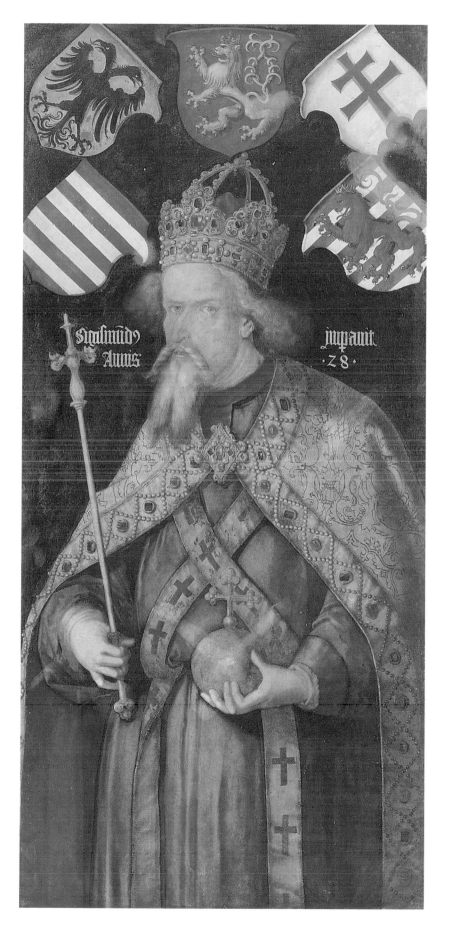

Sigismundus Annus imperavit Z8·

(c. 1480/ 1485 – after 1530), was also derived from a design created by Dürer.

The emperor was advised by a staff of court literati and historians when planning his triumphal and apotheotic printed works. The overall composition of the *Gate of Honor* (ill. 87), an important component of the glorious printed graphics, was created in close collaboration with the court writer and astronomer Johannes Stabius (died 1522). This printed triumphal arch was used formally to glorify the life and deeds of the emperor and his ancestors, and its type derives from classical triumphal arches and the narrative scenes in reliefs running along them, such as those on Trajan's Column in Rome. It combines classical ideas with contemporary forms. In its structure and architecture it is reminiscent of magnificent Renaissance palaces. Other artists apart from Dürer working on the monumental work, which was finished in 1515, were Wolf Traut (1480–1520), Hans Springinklee (c. 1495–1540?), Peter Flötner (1490/1495–1546) and Jörg Kölderer. Dürer was in charge of the design and the overall direction of the project. He enriched the architecture designed by Jörg Kölderer by adding the figural ornamentation. The 190 woodcuts of the *Gate of Honor*, produced by the wood block carver Hieronymus Andreae and finally pieced together, created an overall surface of almost ten square meters. Honorary ceremonies could be held beneath such a monumental scene. A high print run of 700 copies was meant to ensure that this gigantic woodcut work carried the emperor's fame to the far corners of his empire.

The *Triumphal Procession*, a series of 130 annotated woodcuts derived from the model of classical, imperial Roman triumphal processions, completed the *Gate of Honor*. Together they formed the *Triumph* with which the emperor intended to set a memorial to himself. When Maximilian died in 1519, many of the woodcuts and accompanying inscriptions and banderoles were not yet finished. Not until 1526 did Archduke Ferdinand (1503–1564), a grandson of Maximilian I's, posthumously publish the work.

For the *Triumphal Procession*, Dürer designed the eight pages of the *Triumphal Chariot* (ills. 88–91), which was to form the glorious conclusion of the procession. The woodcut was preceded by a colored design which the emperor probably still saw himself in 1518. In 1522 Dürer published the *Triumphal Chariot*, and in the next few decades it appeared in a total of seven German and Latin editions. The magnificent imperial chariot is pulled by a team of twelve horses, accompanied on either side by personifications of the Virtues, waving garlands of honor and identified by inscriptions. "Experience" (Experientia) and "Competence" (Solertia) are followed by "Boldness" (Avdatia), "Magnanimity" (Magnanimitas), "Vigor" (Acrimonia) and "Manly Strength" (Virilitas). Behind these walk "Speed" (Velocitas) and "Steadfastness" (Firmitvdo), followed by "Cheerfulness" (Alacritas) and "Expediency" (Oportunitas). The first pair of horses is led by "Foresight" (Providentia) and "Modesty" (Moderatio). The emperor is enthroned in

the chariot in his imperial robes, while the four Cardinal Virtues, "Temperance" (Temperantia), "Justice" (Justicia), "Fortitude" (Fortitudo) and "Prudence" (Prvdentia) dance around him, accompanied by "Victory" (Victoria) who is holding garlands of honor above him. The chariot is being driven by "Reason" (Ratio) together with "Nobility" (Nobilitas) and "Sovereignty" (Potentia), and its decorations, such as the imperial eagles inscribed on the wheels, are symbolic of the Holy Roman Empire. The wheels are turning as symbols of the empire's history, together with "Magnificence" (Magnificentia), "Dignity" (Dignitas), "Fame" (Gloria) and "Honor" (Honor). On the canopy is written: "Quod in caelis sol hoc in terra caesar est" (What the sun is in heaven, the emperor is on earth), and below it on a plaque: "Regis est in Manu Dei" (The ruler is in God's hands). "Greatness" (Gravitas), "Perseverance" (Perseverantia), "Confidence" (Fidentia) and "Reliability" (Secvritas) are constant companions.

The years of 1513 to 1514 can be called the high point in Dürer's work in printed graphics. These were the years during which three copper engravings were created, *Knight, Death and the Devil*, *Melencolia I* and *St. Jerome in his Study* (ills. 94, 95, 96). They are remarkable in having the same format and, due to their technical perfection, are considered the most masterly engravings in all Dürer's creative work. It is believed that the engravings of *St. Jerome in his Study* and *Melencolia I* were created as antithetical pendants, as Dürer handed them out in pairs on his journey to the Netherlands. Despite the lack of references by Dürer, the contextual connection between the three sheets was considered to be the thematic trio of the moral, theological and intellectual Virtues in scholastic teachings. *Knight, Death and the Devil*, for example, represents Christian, moral steadfastness, *St. Jerome in his Study* religious contemplation and *Melencolia I* the intellectual investigation of the divine order.

Knight, Death and the Devil was the first engraving to appear in 1513 (ill. 94). In an upright position with his halberd across his shoulder, an armored knight is riding along a narrow defile, unafraid of Death with the hourglass who is riding on an emaciated nag, and the Devil with goat's horns who is following him. The loyal dog, a symbol of faith, is following his master. The lizard is a symbol of religious zeal. The castle in the background could be the goal of the journey for the faithful. The "Reuter," as Dürer referred to the engraving in his journal during his Netherlands journey, has been given contradictory interpretations, from a robber baron to a respectable Christian knight. The latter appears likely because of the literary references, in particular the *Enchiridion militis christiani* written by the humanist Erasmus of Rotterdam in 1502. In it, Erasmus argued his conviction that every Christian had his own difficult path to follow as a soldier in the service of God. At the same time, the copper engraving can presumably be viewed as part of the large number of depictions of knights that were created between 1508 and 1510 and which were connected with Emperor Maximilian I,

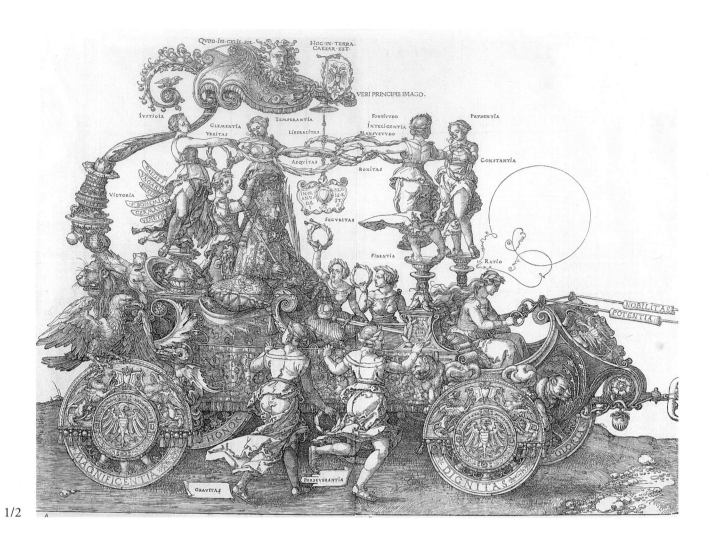

Deß gleychen greyfft Fortitudo mit der lincken handt in den khrantz Bonitatis/ darumb das ein rechte frümkeyt kein ware sterck seyn kan/ auff der selben vrsach ist auch der khrantz Equitatis/ vonn welcher Bonitas nit geschayden mag werden/ geflochten.

Mit der rechten handt helt Fortitudo Constantiam/ darumb wo die Bestendigkeyt nit ist/ mag Fortitudo nit stat haben. Vnnd ist Fortitudo darumb zäuorderst/ vnnd auff die rechte seyten gestelt. Die weyl menigklich vnuerporgen/ das treynlund Kayserliche May. hochlöblicher gedechtnuß/ mit rechter mañlicher sterck des leybs vnnd gemüts/ in Kriegßübungen vnnd widerwertigkeyten/ alle khönig vbertroffen hat.

Temperantia helt in der lincken hand den khrantz Liberalitatis/ mit die Keyserlich May. sonderlich begabt gewest/ als menigklich kundt ist der selb khrantz hecht an den mulen khrantz Mansuetudinis/ darumb das ir May. mit Sennfft mütigkeyt also gezimt gewest/ das auch sie sich in allen hendeln vil sachen wie ernstlich tapfer vñ groß die gewest/ gätzlich vnnd bescheyden gehandlet hat/ vnd alweg Mansuetudo/ als ein edle tochter Temperantie mit geloffen ist.

Gegen der Messikeyt vber steet Prudentia/ greyfft mit der lincken handt in den krantz Constantie/ welche Bestendigkeyt der Prudentie nit minder dañ der Fortitudini zusteet/ mit der gerechten handt helt sie den khrantz Intelligentie/ der sich in den krantz Mansuetudinis flicht/ darumb daß die vernufft zäuorderst den verstandt haben müß vnd weil.

Vnder dem schaden vnd obdach diser tugendt/ wirder billich der still Kayserlicher May. gesetzt/ als der so auff diser erden/ nit höher dañ allein mit tugenden geziert kan oder mag werden. vnd nach alter geworpheyt der Kriechen vnd Römer steet hinder Kayserlicher May. still ein Victoria/ die ihr May. in disem Triumphwagen mit dem krantz des siegs krönet/ in der selben fettich sind geschriben ettliche Victoria.

Neben disen wagen/ damit der nit wanck oder stuck/ sind geordnet vier tugent die ye halten. Nemlich/ Securitas: Fidentia/ Grauitas/ Perseuerantia. Darumb so die Sicherheyt mit Vertrawen vermischt wirder/ vnd da bey Tapfferkeyt sampt Verharrung mit laufft/ kañ es nit anders dañ eben vnd wol hynauß geen.

Firmitudo vnnd Velocitas füren die nachuolgenden zwenpferd/ darumb daß diser wagen/ so er mit schnelheyt gefürt wirdet/ darnoch steet sey/ vnd mit vestigkeyt gezogen werde.

Acrimonia vnnd Virilitas sinde den nachuolgenden pferden darumb zugeben/ daß der wagen mañlich vnnd mit einer tapffer kayt gefürt werde.

Diser nachuerzeychenter Eren oder Triumph wagen/ist dem allerdurchleuchtigisten Großmechtigisten herrn trey/ lund Keyser Maximilian/hochlöblicher gedechtnuß vnseren allergnädigisten herrn zů sonderen eren erfunden vnnd verordent/vnnd zů vnterthenigem gefallen dem großmechtigisten herr Regirenden Keyser Karolo ꝛc. durch Albrecht Dürer daselbst in das werck gepracht.

Erstlich/dieweyl ihr Keyserlich May. alle König vnnd herren mit glori/magnificentz/eer vnd wirdigkeyt vbertrifft/ so ist der selb wagen auff vier eren reder/darauff ihr Keyserlich May. solcher vberreflichkeyt halben billich empore gefürt werden soll gesetzt. Nemlich auff Gloriam/Magnificentiam/Dignitaten/vnnd Honorem.

Nachvolgent seind an den vier orten des wagens die vier angezeigten an ihrer vier seulen gesetzt. Nemlich Iusticia Fortitudo/Prudentia/Temperantia. Auß welchen all ander tugent iren anfang vnnd vrsprung haben/an die auch kein König oder herr volkumen seyn kan/oder mag. Dann wo die Gerechtigkeyt/Manlich sterck des gmüts/die Vernunfft/vnnd Bescheidenheyt mangelt/kan kein Reych bestendig seyn.

Nach dem Moderatio/vnnd Prouidentia der vernunfft am nächsten sind füren die selben zwo tugent die zwey nächsten pferd vor der vernufft/damit der wag mit rechtermaß vnnd fürsichtigkeyt seinen gang haben mag.

Dieweil auch dise vier tugend aneynander hangen/vnnd eine eneander nit gesondert werden mögen/also/wo eine der selben mangelt/das die ander nit volkumen seyn kan. So seind dise selben vier mit den anderen im anhangenden tugenden/so auß inen fliessen zůsamen gefaßt/vnnd ineinander verschlossen. Nemlich dieweyl Iustitia gepürt vnd haben muß Veritatem/so helt sie in der lincken handt den kranz der Warheyt. In den auch die Messigkeyt mit der rechten handt greifft/daß wo die Warheyt nit ist/kain die Gerechtigkeyt nit stat haben. Die Messigkeyt mag auch so sie von der Warheyt weycht/nit mer Messigkeyt genant werden.

Mit der rechten handt greifft Iustitia den kranz Clementi/das zaigt an/daß die Gerechtigkeyt nit gantz zů streng/sonder mit Miltigkeyt soll vermischt seyn. In disem kranz ist geflochten der vierier franz Equitatis/damit so wol als die Gerechtigkeyt nit zůscharpff/seyn/also soll sie auch nit alle mal/vnd in allen sachen zů vil sind oder darinn hertzig/sonder Equa vnd gleych seyn/on welche Gleychey die Gerechtigkeyt nit besten mag.

Die nachvolgende zwey pferd werden durch Alacritatem vnnd Oportunitatem gefürt. Darumb als wol sich gezimpt daß zu bequemer zeyt der wagen für sich gee/also gepürt sich auch/das sölchs frölich vnnd mit eyner freyheyt beschehe.

PROVIDENTIA ALACRITAS

MODERATIO OPORTVNITAS

Vnd damit diser wagen recht vnd wol gefürt ist Ratio zuuorderst an/für einen fürman vnd weglayter gesetzt/ darumb das alle bestendig ding mit vernufft geschehen söllen. Die selbig Ratio helt auch in zwayen sayhernnß Nobilitatis das ander Potentis/angezeigt daß die Keyser. May. alle König vn herrn mit adel vn macht vbertreffen hat.

Vnd auff daß die pferd so an den wagen gespant seind/nit als vnuernüfftige thieer auß dem wege der Verstendigkeyt lauffen/sonder besser statlicher durch Vernunfft regiert werden mögen/so hat ein yetlich pferd ein leytter vil halter/ damit es nit anders geen/noch lauffen mag/dañ wie sich auch eygenschafft der selben tugend gepürt.

Vnd wiewol alle menschen nach dem willen gottes regiert werden/noch daß sagen die treyen nit in sonderheyt das hertz des Königs in der handt gotes stee/der da nach seinem göttlichen wolgefallen wendt vnd thört/darumb so recht vor der Keyserlichen May. dise geschrifft. In manu dei Cor Regis est. Vnd für das wort Cor ist zů merer zierligkeyt ein hertz mit einer Laurea gemalet. Bedewt das edel hertz Keyserlicher May. so mit allen tugenden vmb vnd gekröner vnnd gezirt gewest ist.

Darnach geen zwey pferd die stetigs für sich begeren/werden durch Magnanimitatem vnnd Audaciam regiert.

Dieweyl auch mit ir zeytrehepe gesagt werden mag/daß weylund die Kayserliche May. mit irer zierd vil Clarheyt auff erdtrich eben daß das das scheinend Sun am himel gewest ist/so wirt ob irer May. dise schrifft gesetzt. Quod in terra Sol/hoc in terra Cęsar. Vnd ist für das wort Sol ein Sun gemalet/vnd für das wort Cęsar ein Adler.

Maximilian von Gottes gnaden
C. Römischen Kayser. ꝛc.

Ersamer lieber getrewer/wir haben den Triumphwagen mitsampt der Exposition/den du vns zu vnderthenigem gefallen zu zier vnsers Triumphs erdacht vnd gestelt. Auch durch Albrecht Dürer aufftreyssen lassen/vnnd bey zeyger diß brieffs zugestelt hat empfangen/den auch wolgefügklich vberschen vil tragen an sölchem deinem erfunden fleiß vil erbieten sonders gnädigs wolgefallen/sind deinegt das in sonderem gnaden gegen dir zu erkennen wöllen wir dir gnediger meynnung nit verhalen. Geben in vnser Stat Jnßbruck am Newnvnndzweintzigisten Martij. Anno. ꝛc. xviij. vnsers Reychs am. xxxij. jaren.

Per Regem per se.

Ad Mandatum Cesaree
Maiestatis proprium.
Westner.

Dem Ersamen vnserm Rat/vnd des Reychs lieben getrewen Wilboldem Pirckhaymer.

Damit die großmütigkeyt vnd keckheyt den wagen nit verfüren/so seind für die selben zuuorderst zway andere Roß gespandt/die werden durch Experieniam vnd Solertiam gemaystert. Daß wo die erfarnuß vnd fürrechtigkeyt nit ist/mag die Keckheyt vnd Großmütigkeyt leycht schade bringen.

Diser wagen ist zu Nürnberg erfunde gerissen vnnd gedruckt durch Albrechten Thürer/in jar. M.D.xxij.

Cum Gratia et Priuilegio Cesaree Maiestatis.

MAGNANIMITAS

AVDATIA EXPERIENTIA

SOLERTIA

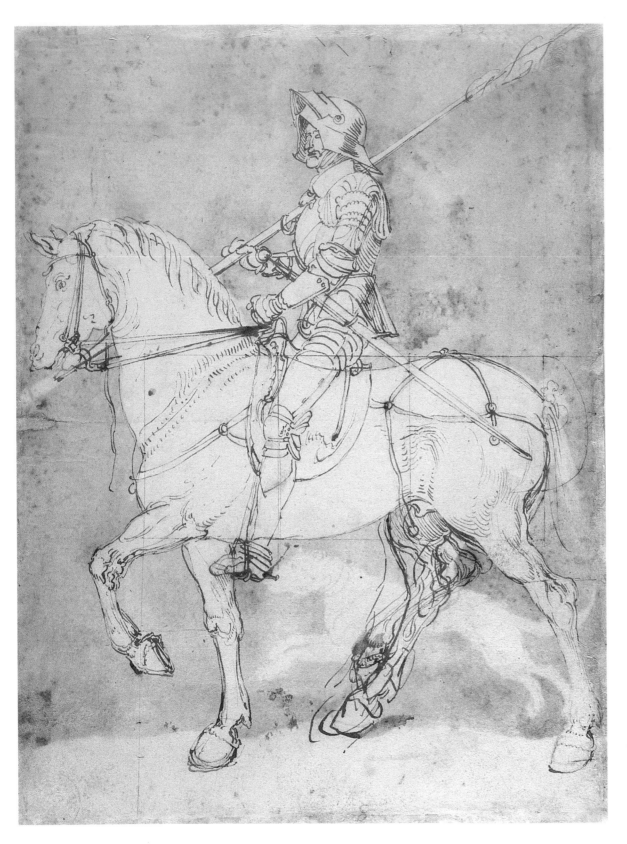

92 *Knight on Horseback*, c. 1512
Drawing, 23.9 x 17.3 cm
Biblioteca Pinacoteca Ambrosiana, Milan

A preliminary study, drawn on both sides of the paper, for the masterly engraving of the *Knight, Death and the Devil* (ill. 94) concentrates on the group comprising the horse and rider. From the proportional scheme drawn onto the sheet, it can be seen that Dürer precisely prepared the copper engraving in the same manner as his studies on the ideal proportions of the horse. While he did not change the depiction of the rider in the copper engravings, he altered details in the horse several times, for example correcting its right hind hoof both on the preliminary drawing and on the plate.

93 *St. Eustace*, c. 1500–1502
Copper engraving, 37.5 x 27.3 cm
Kupferstichkabinett, Staatliche Kunsthalle, Karlsruhe

This is Dürer's largest single-leaf copper engraving. The legend of St. Eustace is narrated in the *Legenda aurea* and is freely adapted in Dürer's picture. The Roman officer Placidus was converted to Christianity by a vision of a stag who spoke with the voice of Christ and carried a crucifix in its antlers, and he then took the name of Eustace. Here, the scene is taking place in the middle of a forest landscape, next to a pond. The statue-like depiction of the horse and the greyhounds, which are shown in five different body positions, shows that Dürer was more interested in reproducing proportions than in creating a precisely detailed account of the Christian legend.

who was called the "last Christian knight." The term "last Christian knight" was a reference to Maximilian's victories in tournaments and his worship of St. George. Hans Burgkmair (1475–1531) had already depicted the emperor as a knight in armor in 1508 in a "clair-obscur" woodcut.

The monument-like posture of Dürer's knight, and the walking pace of his horse, are references to equestrian monuments such as Andrea Verrocchio's (1436–1488) *Colleoni Monument* in Venice and Donatello's *Gattamelata* in Padua, which he would surely have known. The depiction of the horse had been preceded since 1500 by numerous studies on the ideal proportions of the horse, including the famous copper engravings of the *Small Horse* (ill. 61) and the *Large Horse* (ill. 62). Leonardo's treatise on the anatomy of the horse, which was later lost when Milan was sacked by the French, was perhaps known to Dürer. Dürer had certainly studied Leonardo's Sforza monument, and the proportional scheme developed

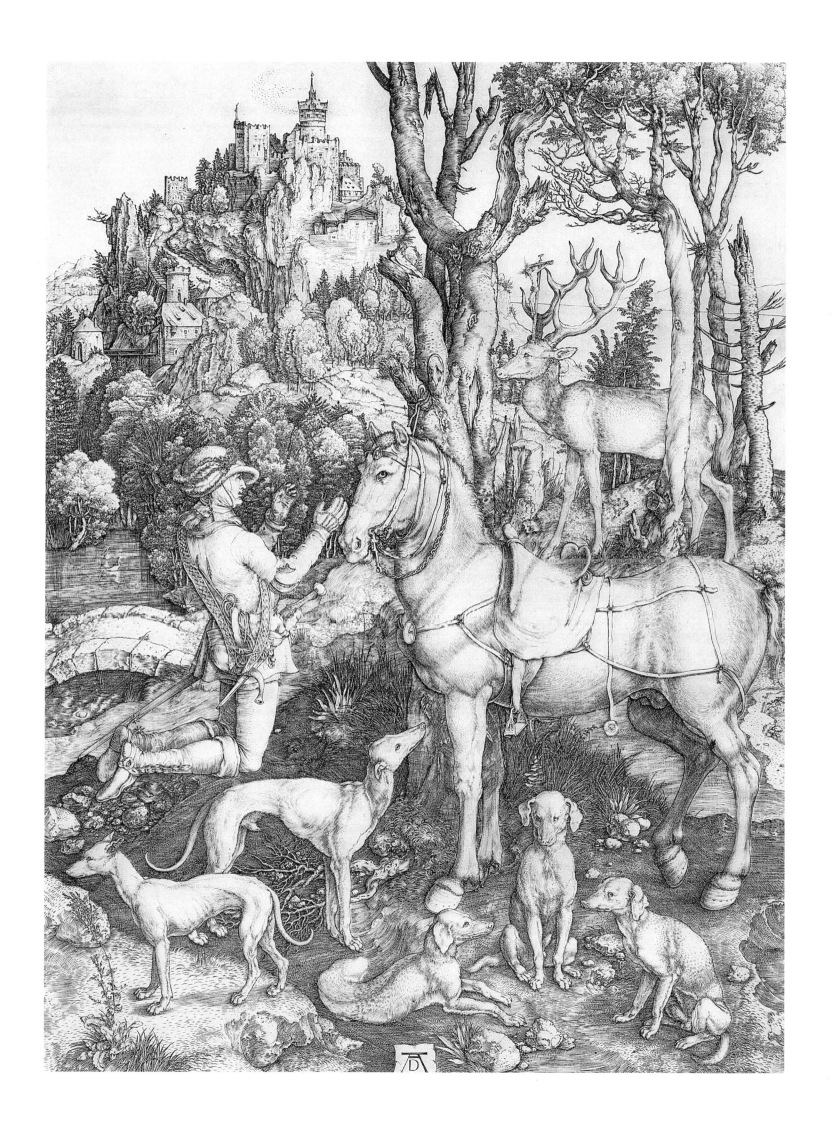

by him – possibly on the suggestion of Willibald Pirckheimer, who had become personally acquainted with Leonardo at the Milan court of Duke Ludovico Sforza (1452–1508) – and based his depictions of horses on it (ill. 92). The large format copper engraving of *St. Eustace* is, in this context, one of many examples of the way in which a religious theme could be subordinated to his interest in proportions (ill. 93).

The second and most famous copper engraving, *Melencolia I* (ill. 96) which was created in the year Dürer's mother died, has provided occasion for countless attempts at an interpretation due to its contradictory depiction and complex content. A winged figure of a woman is sitting, meditating somberly, on a flat stone step. She is leaning her garlanded head on her left hand, the traditional gesture of melancholy. In her right hand she is holding a compass. From her belt hang a bunch of keys and a money pouch. Melancholy is sitting in front of a building which has a bell, hourglass, set of balances and magical square mounted on it. The last three objects correspond to the principles of science: measurement, numbers and weight. In the case of the magical square, the sum of the vertical and horizontal strips, and the diagonal ones, is 34. Various objects are arranged around the female figure, such as a ladder, rhomboids, tools of the metal, wood and building trades, writing implements and a sphere. The personification is accompanied by a putto who is sitting on a millstone and drawing, and a sleeping greyhound. The landscape in the background on the left shows a comet and rainbow against a night sky. A squealing bat carries a banderole with the name of the copper engraving: "MELENCOLIA I."

The composition is well thought out: the back edge of the building marks the central line of the picture, and the comet and T-square point diagonally to the figure of Melancholy. There is a subtle differentiation of the materiality of the various substances. The most credible of the controversial interpretations of the sheet links the copper engraving with the other masterly engravings to form a trio of the virtues. The picture symbolizes mankind's intellectual path to salvation.

Panofsky, in contrast, was the first to suggest that the figure might be an embodiment of one of the four humors of scholastic teachings, namely Melancholy produced by the juice of the black gall, which was considered to be damaging to the human spirit. Hence, the figure has been interpreted in both negative and positive ways. Its ambiguity has led to the realization that Dürer was combining several types of pictures here; on the one hand the traditional personification of "Acedia," Lethargy, and on the other hand the "Typus Geometriae" which derived from depictions of the seven liberal arts represented by the tools and objects lying around. The Neoplatonist Marsilio Ficino and the classical philosopher Aristotle had emphasized that all outstanding people suffered from melancholy. The Neoplatonist philosophy, which in accordance with

Plato's theory linked melancholy with "divine madness," had possibly become familiar to Dürer through his humanist friend Willibald Pirckheimer. The rainbow and comet represent the planet Saturn, the initiator of melancholy. The bat, a creature of the night, and dog are also attributed to the saturnine melancholy. Its negative influence is counteracted by the healing powers of the magical square and the garland of aquatic plants on the head of the genius. According to the scholastic, theologian, philosopher and doctor Agrippa of Nettesheim (1486–1535), the number I signified the limitations of the human cognitive faculty, of *imaginatio*, compared to the divine order. More recent research by Peter-Klaus Schuster has implied that the engraving represents the sum of Dürer's humanist thought, a reference to moderation, dignity and piety in man as well as his attitude to God.

The copper engraving of *St. Jerome in his Study* (ill. 95) was considered to be the antithetical counterpart to *Melencolia I*. The learned Father of the Church, St. Jerome (347–419), was a model for contemporary humanists. Willibald Pirckheimer and Erasmus of Rotterdam considered him to be the ideal image of a Christian scholar. His translation of the Vulgate from the Greek and Hebrew into Latin was discussed in scholarly circles in many places.

St. Jerome is engrossed in his spiritual work at his desk in an old German study, with a bull's eyeglass through which the light – a symbol of divine revelation – is falling. He is surrounded by objects which relate as attributes to his legend and work. The compositional and converging lines in the room terminate in the space to the right of the figure of the saint, whose "enlightenment" is further indicated by a halo. The lion in the foreground, the crucifix on the desk and the cardinal's hat hanging on the wall are all direct attributes of the Father of the Church, and contrast with symbols of transitoriness such as the skull and hourglass. The bottle gourd hanging from the ceiling is a reference to the dispute about St. Jerome's translation, familiar to humanist circles, in which he translated the prophet Jonah's "gourd" as "ivy." The entire spatial interior of the study is depicted from the threshold, and testifies to Dürer's masterly implementation of his knowledge of central perspective gained from his Italian models. Due to the polished spatial composition, the subtly differentiated characterization of materials and the atmospheric reproduction of light and shade – there is not a single large white section on the sheet – this last of the three masterly engravings is considered to be the most perfect. Dürer had depicted St. Jerome a total of seven times, in various different ways, in his printed graphics and paintings.

94 *Knight, Death and the Devil*, 1513
Copper engraving, 24.5 x 18.8 cm
Kupferstichkabinett, Staatliche Kunsthalle, Karlsruhe

This copper engraving is the first in the group of three master engravings. Unflustered either by Death who is standing in front of him with his hour-glass, or by the Devil behind him, an armored knight is riding along a narrow defile, accompanied by his loyal hound. This represents the steady route of the faithful, through all of life's injustice, to God who is symbolized by the castle in the background. The dog symbolizes faith, and the lizard religious zeal. The horse and rider, like other preliminary studies made by Dürer, are derived from the canon of proportions drawn up by Leonardo da Vinci.

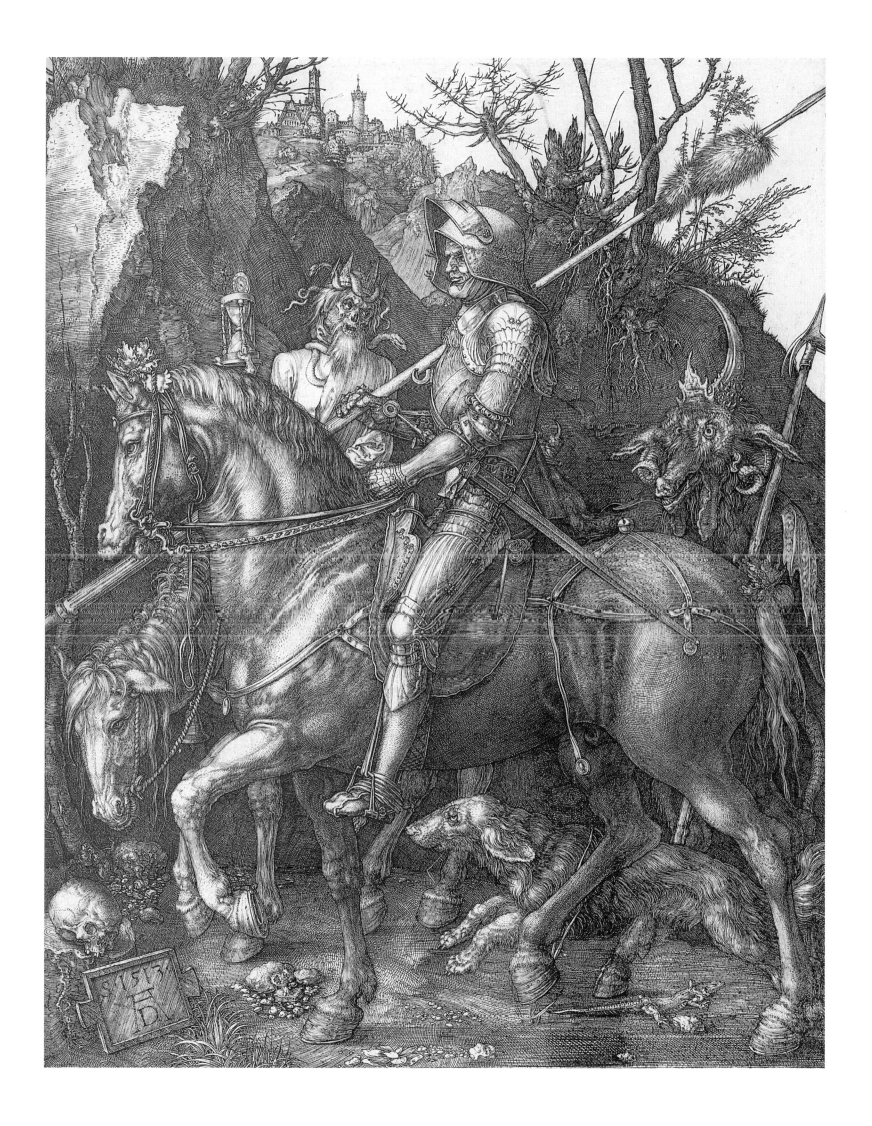

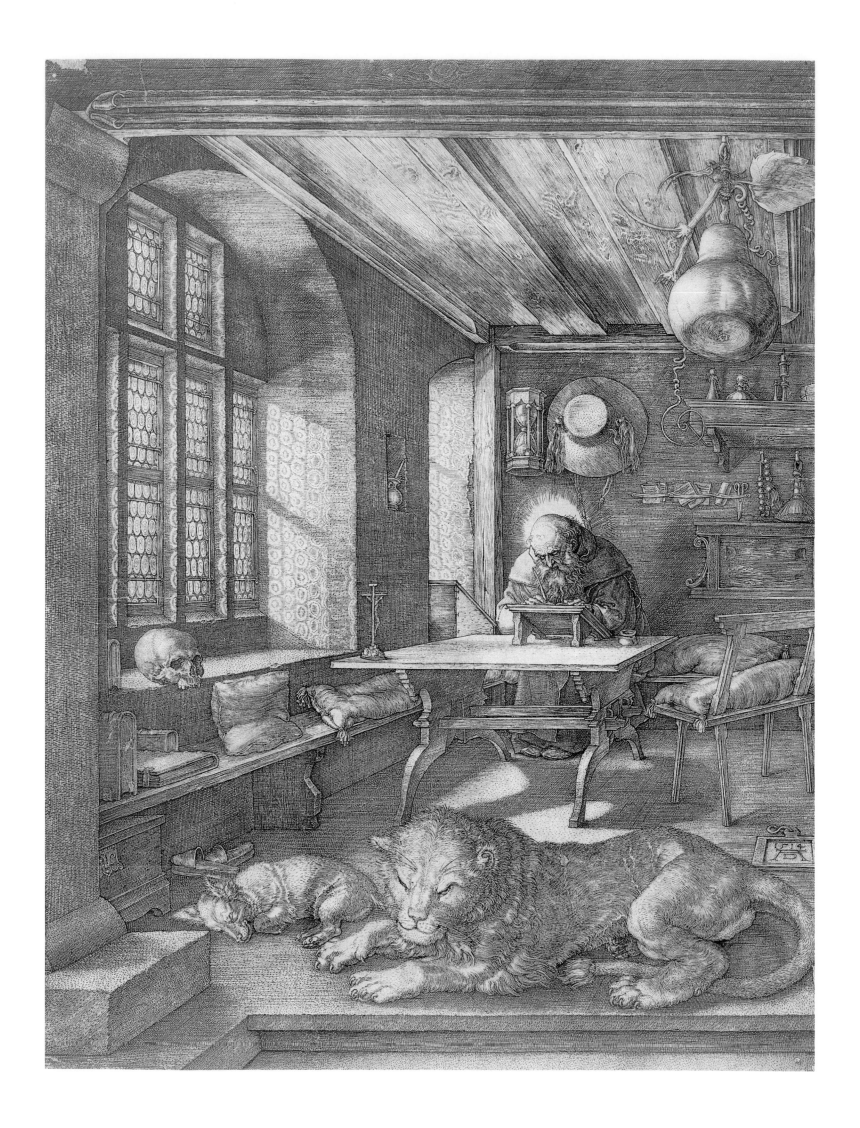

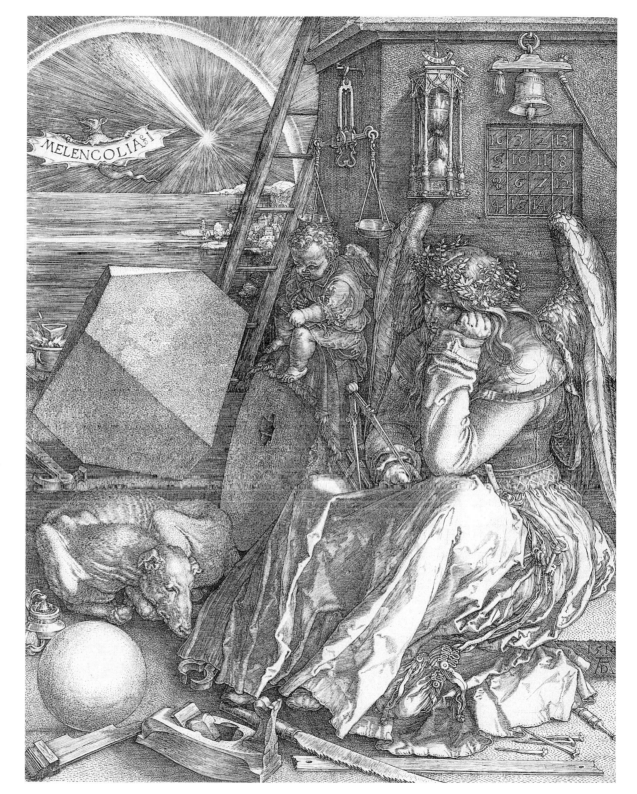

95 *St. Jerome in his Study*, 1514
Copper engraving, 25.9 x 20.1 cm
Kupferstichkabinett, Staatliche Kunsthalle, Karlsruhe

In the last of the three master engravings, Dürer placed
particular emphasis on the subtle differentiation of the
material qualities of the objects, and the depiction of the
interior according to the laws of central perspective, the
converging lines of which terminate in the space to the
right of the figure of the saint. St. Jerome, who was a
model for the humanists, appears as the translator of the
Holy Scriptures. The cardinal's hat on the wall and the lion
in the foreground are attributes referring to his legend.
The masterly engraving was presumably intended to be an
exemplary representation of the *vita contemplativa*, the
spiritual life, as a counterpart to the copper engraving of
the *Knight, Death and the Devil* (ill. 94), which was an
example of the *vita activa*, active life.

96 *Melencolia I*, 1514
Copper engraving, 31.8 x 26 cm
Kupferstichkabinett, Staatliche Kunsthalle, Karlsruhe

Melancholy is sitting as a winged genius with a compass
and book amidst various items of equipment and figures.
The tools are drawn from the field of measuring and
building, in other words, architecture. The rhomboid and
sphere represent geometry, the science of measurement
and numbers upon which all arts are based. The dog and
bat correspond to this melancholy humor. Melancholy was
considered to be both a negative and positive power of the
mind, as represented by the bat and writing putto. The "I"
in the inscription refers to the person who is affected by
melancholy here: according to contemporary views, artists
occupied the lowest level of the melancholy humor.

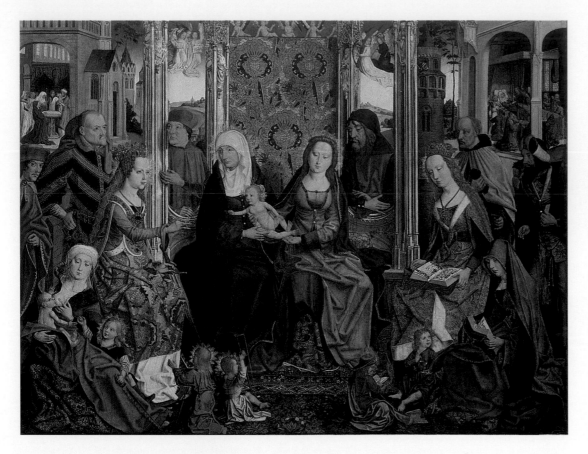

97 Master of the Holy Family, *Holy Family Altarpiece*,
c. 1500–1504
Oil on oak panel, central panel 141 x 186 cm, wings each
141 x 85 cm
Wallraf-Richartz-Museum, Cologne

This altar by the Master of the Holy Family, dating from
the years between 1500 and 1504, provides an example
that, during Dürer's time, artists in other places were still
working in accordance with the good old Late Medieval
craft traditions. In his conception of the figures and
composition, he is entirely indebted to Dutch models such
as Rogier van der Weyden and Hans Memling (c. 1433–
1494, ill. 98). At the same time, Dürer in Nuremberg had
long since liberated himself from this tradition.

98 Hans Memling, *Marriage of St. Catherine*, c. 1479
Central panel of the triptych with St. John the Baptist and
St. John the Evangelist
Oil on panel, 173.6 x 173.7 cm (unframed); 193.5 x
194.7 cm (framed)
Memling Museum, Sint Jans Hospital, Bruges

There are parallels here with the central panel of the altar
by the Master of the Holy Family (ill. 97) in terms of the
symmetrical composition, figural arrangement within the
magnificent throne architecture, and splendid execution
of the material qualities of the garments and jewellery;
they clarify in an exemplary manner the way in which
Dutch masterpieces were used as models by German
workshops throughout the 15th century.

In Germany, painting and sculpture had been viewed as
crafts for centuries, controlled by the craftsmen's guilds,
and differences depended on the workshop and regional
variations in style. Artists were not identified by means of a
signature, and within an altarpiece the only distinction
that can be made between the master and his assistants is
frequently one of quality.

Producing stylistic copies of major models was the defini-
tive way in which the workshops functioned. While, at the
beginning of the 15th century, influences from the French
International Gothic style were still making themselves felt
in the workshops of painters and sculptors, during the
following decades it was mainly the works of Dutch masters
that were studied. Paintings by Jan van Eyck, Rogier van der
Weyden and Hugo van der Goes had a direct influence on
their style (ill. 97). For example, the Bruges master Hans
Memling was born in Germany, but as a likely student of
Rogier's, he had such a perfect command of his style that his
works were used as models in Germany (ills. 97. 98).
Individual assistants were members of a community who
obeyed the rules of the guild, and they subordinated their
own artistic qualities to the style of the workshop.

As early as 1506, Dürer wrote from Venice to Willibald
Pirckheimer in order to clarify the difference in status of an
artist in German and Italian society: "hie bin ich ein her,
doheim ein Schmarotzer" (Here I am a gentleman, at
home a sponger).

The new intellectual trends emanating from Italy led to a
gradual alteration of the way artists saw themselves in
Germany. This change in perception and self-awareness of
the artist was particularly the result of knowledge about
Italian Renaissance art, and the close correlation between
the spiritual life, sciences and visual arts.

The development of printed graphics and increasing
closeness of European art meant that it was possible for
artists to no longer rely entirely on commissioned works,
and to put into effect new pictorial ideas gained in
exchanges with humanists and scientists.

The altered importance of the artist in Italian society was
reflected from the middle of the 15th century in the first
written accounts made by contemporary artists about their
colleagues. In the 16th century, these reports led to the
extensive biographies written by Vasari, the *Lives of the
Most Excellent Painters, Sculptors, and Architects*, which
remained the definitive text for a long time and is still
much in demand as a source text. In Germany, it was not
until the 17th century that the artist and biographer
Joachim von Sandrart published accounts of the lives of
artists based on Vasari's example.

Italian Renaissance artists were also the first to write
about their work and artistic philosophy. They demon-
strated the will to rise above the level of craftsmen by
means of study and erudition. In 1437, the painter Cennino
Cennini (active 1398) advised contemporary artists in his
book about art: "You should always behave in life as if you
are studying theology, philosophy and other sciences." This
is the first exhortation from an artist to his colleagues to act
with the same moderation and dignity as scholars.

A short time later, Lorenzo Ghiberti (1378–1455)
compiled his treatise on art, the *Commentarii*, which also
contains the first surviving autobiography of an artist.
Here, for the first time, a critical self-awareness, intellec-
tual pretensions and the growing awareness of the artist's
own creative powers are expressed, heralding a new type
of artist.

The Italian architectural theoretician, architect and artist
Leone Battista Alberti, who considered painting to be the
highest of all arts, stated in his treatise *On Painting*,
published in 1436, that an artist had to master composi-
tion, geometry, optics and perspective to an equal degree,
and be familiar with the movements of the body. A famil-
iarity with "poets, rhetoricians, and other similarly learned
and sensible figures" was a prerequisite of his composi-
tions. Overall, then, the status of master craftsman no
longer satisfied the demands which educated members of
society were making of artists. This was expressed in a new
educational ideal, and the goal of clients and artists of
incorporating painting, architecture and sculpture into the
seven liberal arts.

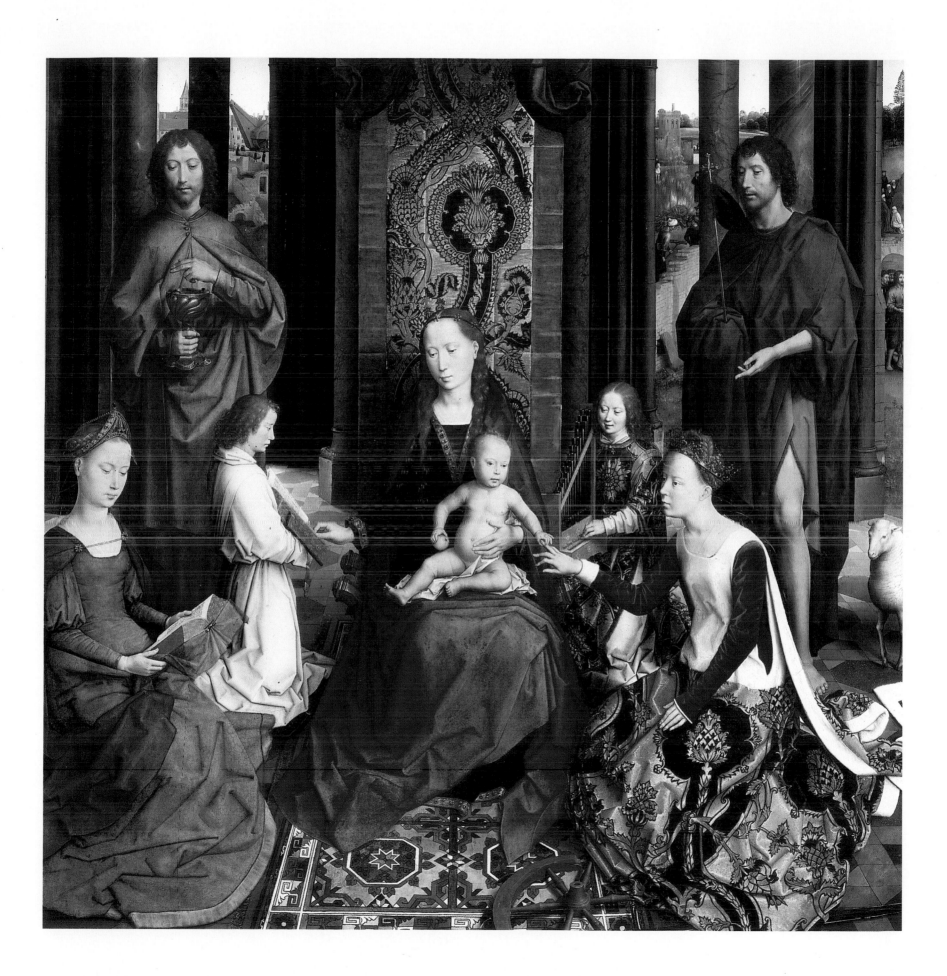

MANKIND AT THE CENTER.
NEW FORMS OF PORTRAITS

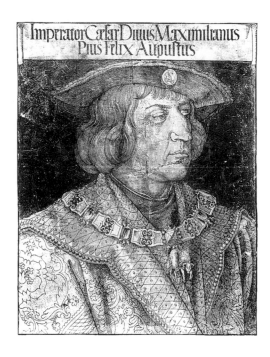

99 *Portrait of Emperor Maximilian I*, 1519
Colored woodcut, 42.6 x 32.1 cm
Staatsbibliothek, Bamberg

This woodcut portrait of Emperor Maximilian I was
created posthumously after a drawing that Dürer had
produced in 1518 during the Imperial Diet in Augsburg.
The emperor is dressed in a valuable brocade garment and
is wearing the chain of the order of the Knights of the
Golden Fleece around his neck. The addition of "divus" in
the inscription indicates that the woodcut was published
shortly after the emperor's death in 1519. The prints were
refined with gold and colors, which gave them the
appearance of paintings.

100 *Portrait of Emperor Maximilian I*, 1519
Oil on panel, 74 x 61.5 cm
Kunsthistorisches Museum, Vienna

The imperial portrait of Maximilian I in Vienna, which
was derived from a preliminary drawing made in 1518,
was exquisitely painted with delicate material qualities.
The emperor is wearing a magnificent fur coat over his
dark red silk cloak. As a sign of his imperial rule, he is
holding a pomegranate in his right hand. On the left,
above the portrayed man, the imperial coat of arms
appears with the Hapsburg escutcheon in the center,
surrounded by the links of the Order of the Golden Fleece
beneath the crown. The inscription at the top gives the
title and biographical dates of the emperor.

"Awch behelt daz gemell dy gestalt der menschen nach
jrem sterben." (Also, the painting retains the appear-
ance of people after they have died; Dürer in his *speis
der maler knaben*)

The years from 1507 to 1514 had unfolded almost
exclusively against a background of masterpieces in
printed graphics with both religious and secular
themes which Dürer brought to a climax in terms of
content and form. As early as the time of his second
visit to Italy, Dürer had become well-known as a
portrait painter due to the portraits in the *Feast of the
Rose Garlands* (ill. 70). However, ten years after his
Italian journey, his portrait style changed once more,
leading to new portrait types both in painting and in
printed graphics, a field in which portraits had not
been produced before Dürer.

In the years of 1518 and 1519, numerous painted
and printed portraits were commissioned and created.
Most official portraits of this period are a result of his
involvement in the Imperial Diet in Augsburg in 1518.
In 1509, Dürer had been elected to the Nuremberg
town council. He traveled to Augsburg to represent the
city of Nuremberg together with the Nuremberg coun-
cilor Kaspar Nützel (1471–1529) and the town clerk
Lazarus Spengler. Emperor Maximilian I was also
drawn by Dürer in his chambers in the bishop's palace.
This portrait sketch was used as a base for two painted
portraits and a large format woodcut (ills. 99, 100),
which, though they differ in technique, are not signifi-
cantly different in terms of the method of depiction.
The woodcut was repeatedly colored or given gold
highlights and, refined in this way, was meant for
members of the higher social circles. The magnificent
dress consists of a brocade cloak and the chain
denoting Maximilian I as the Grand Master, since his
marriage to Mary of Burgundy (1457–1482), of the
Burgundian order of the Knights of the Golden Fleece.
It shows the emperor to be a wealthy scholar. The term
"divus" in the inscription, meaning divine, is a sign
that the woodcut was created directly after the
emperor's death in 1519, as this title was not given to
the Roman emperors that Maximilian emulated until
after their deaths.

Starting with the woodcut which depicts Maximilian
and combines the portrait with an obvious inscription,
Dürer developed new types of portraits using printed
graphics. Building on the printed portraits that were
created on the occasion of the Imperial Diet in
Augsburg and which were thoroughly prepared in
drawings, Dürer created numerous portraits of spiri-
tual and secular leaders as well as contemporary
humanists during the following years. The printed
graphics were normally immediately preceded by char-
coal or silver point drawings. The method of depiction,
combined with an inscribed plaque of a classical type,
was suggested by epitaphs on Late Roman graves. The
busts of the portrayed people were depicted above a
plaque, and this gave them a monument-like distance
at a time when they were still alive. The inscriptions
beneath the pictures combined classical and Christian
bodies of thought and were obviously related to the
depicted person, as is shown by the copper engraving
portraying *Willibald Pirckheimer* (ill. 102). Dürer's
students continued using this form of engraved
portrait that the master had developed.

The portrait of Cardinal Albrecht of Brandenburg
(1490–1545) dates from 1519. The copper engraving,
which is known as the *Small Cardinal* (ill. 101) because
of its small format, was preceded by a drawing which
Dürer created during his stay in Augsburg for the
Imperial Diet. At that time, Albrecht had just been
named a cardinal. He was one of the most powerful
representatives of the Church in the Roman Catholic
world. When he was elected archbishop of Mainz in
1514, the Curia in Rome was provided with an oppor-
tunity to grant an indulgence throughout the empire.
When Albrecht of Brandenburg was applying to be
made a cardinal in 1517, he had to pay a tax of 50,000
florins to the Roman Curia, and to do so took out a
loan with the Fugger bankers. Half of the resulting
debts could, with the permission of the papal Curia, be
paid off using income earned from the Sermon of St.
Peter indulgence. The granting and promotion of the
sale of indulgences, and the methods of some preachers
that were connected with them, finally led to Martin
Luther's Ninety-Five Theses, so that one could say that
the cardinal played an indirect role in bringing about

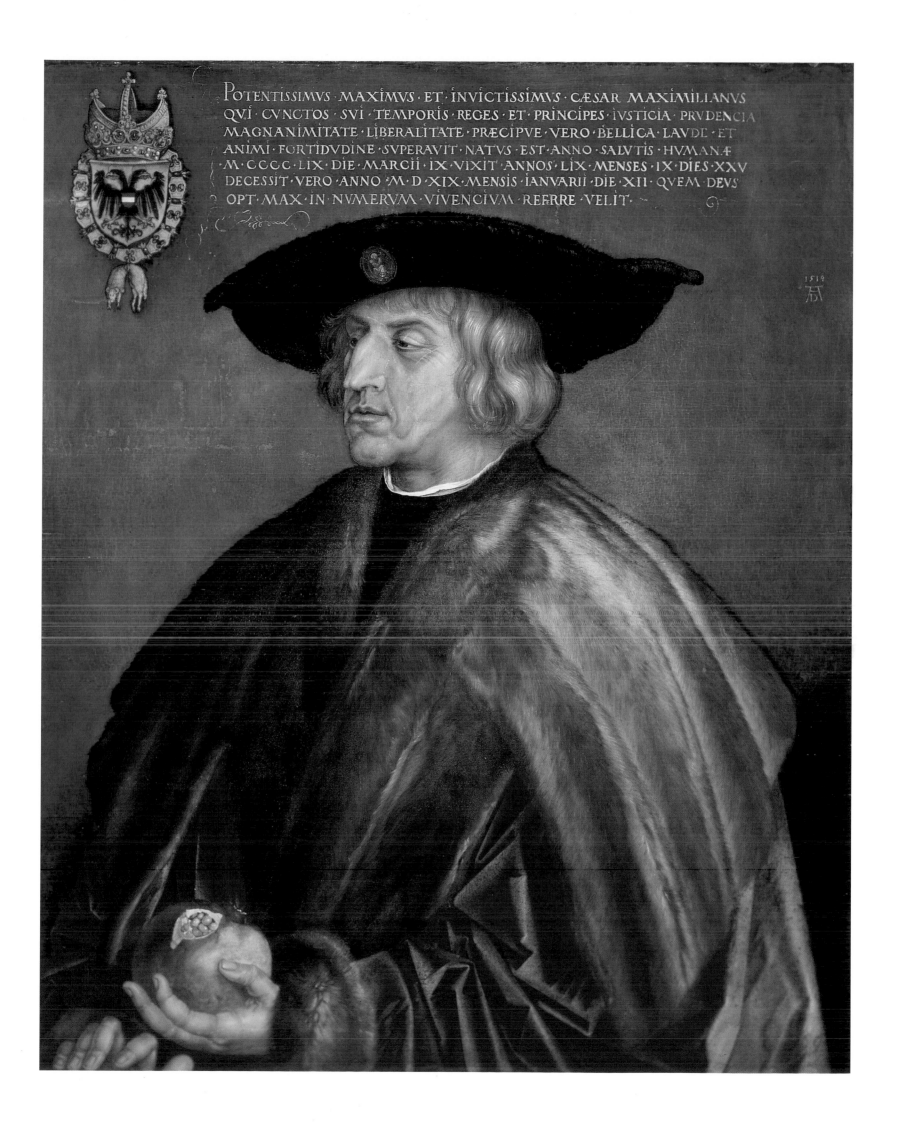

ALBERTVS·MI·DI·SA·SANC·
ROMANAE·ECCLAE·TI·SAN·
CHRYSOGONI·PBR·CARDINA·
MAGVN·AC·MAGDE·ARCHI·
EPS·ELECTOR·IMPE·PRIMAS·
ADMINI·HALBER·MARCHI·
BRANDENBVRGENSIS

101 *Cardinal Albrecht of Brandenburg,*
(Small Cardinal), 1519
Copper engraving, 16 x 11 cm
Kupferstichkabinett, Staatliche Kunsthalle, Karlsruhe

This engraving is one of six copper plate portraits of
Cardinal Albrecht of Brandenburg, one of the most
influential representatives of the empire. The portrayed
man is placed before a screen. His erect posture, diagonal
line of sight out of the picture, the coat of arms and the
two inscriptions all emphasize the official nature of the
portrait.

102 *Willibald Pirckheimer*, 1524
Copper engraving, 19.2 x 12.7 cm
Kupferstichkabinett, Staatliche Kunsthalle, Karlsruhe

The copper plate portrait of the famous humanist
Willibald Pirckheimer (1440–1530), one of Dürer's
closest friends, is an example of the new portraits he
created using printed graphics. The bust is placed, like
a monument, above an inscription that reads like an
epitaph. It refers to the contributions and character
of Pirckheimer, and in translation reads: "Portrait of
Willibald Pirckheimer in the 82nd year of his life.
The creative spirit will live, the rest will fall prey to
death. 1524. A.D."

the Reformation. Apart from his significance in the
history of religion, Albrecht of Brandenburg was one of
the most important princely patrons in Germany next
to Emperor Maximilian I and Elector Frederick the
Wise. His interest in art and desire to create the right
public image are manifested in a copper engraving
created in 1525 by Lukas Cranach (1472–1553),
showing him as St. Jerome in his Study in imitation of
Dürer's copper engraving of 1514 (ill. 95).

The copper plate portrait produced by Dürer was
used by the cardinal as the frontispiece in his *Hallesches
Heiltumsbuch*, published in 1520. This proves the high
propagandist status such graphic portraits could
achieve when ordered in high print runs.

In the engraving, the cardinal is looking out of the
picture in a serious and dignified manner. A dark
screen provides an effective backdrop to his figure. The
coat of arms beneath the cardinal's hat shows the three
crosiers of the bishoprics subordinate to him, Mainz,
Magdeburg and Halberstadt. The inscription indicates
his status: "ALBERTVS. MI(sericordia). D(e)I.SA(cro).
SANC(tae)/ROMANAE. ECCL(esi)AE. ZI(tuli)
SAN(cti)./ CHRYSOGONI. P(res) B(ite) R.CAR-
DINA(lis)./ MAGVN(tinensis). AC. MAGDE(burgensis).
ARCHI=/EP(iscopu) S. ELECTOR. IMPE(rii).
PRIMAS / ADMINI(strator). HALBER(stadensis).
MARCHI(o). /BRANDENBVRGENSIS" (Albrecht,
through the mercy of God, cardinal priest of the Holy
Roman church in the church of St. Chrysogonus,
Archbishop of Mainz and Magdeburg, Elector, Primate
of the Empire, administrator of (the bishopric of)
Halberstadt, Margrave of Brandenburg).

The inscription beneath the picture confirms that
the portrayed man was 29 years old when the work was
created, and this emphasizes his official religious and
political status. In 1520 Dürer sent 200 copies and the
original copper plates to the cardinal. There is a later
portrait of the cardinal dated 1522 and preceded by a
silver point drawing. As before, Dürer sent his client
500 copies and the original copper plate.

Dürer was a great supporter of the Reformation
which had begun when Luther published his Ninety-
Five Theses in Wittenberg in 1517. There is a letter
dating from 1520 in which Dürer openly admits to his
admiration of Martin Luther. Although both had
taken part in the Imperial Diet in Augsburg, the artist
and reformer did not meet. In his letter to Georg
Spalatin (1484–1545), the court chaplain and secre-
tary to the Protestant duke Frederick the Wise, Dürer
expressed his hopes that he would meet Luther, who
he would also have been honored to portray: "and if
God helps me to meet Dr. Martin Luther, I will
portray him with skill and engrave him in copper so
that the Christian man who has helped me leave great
troubles behind shall have a lasting memorial. And I
would ask Your Honor, wherever Dr. Martin is doing
something new that is German, to tell me about it in
return for my gratitude."

Official portraits commissioned for public reasons
contrast with portraits that were created for private
reasons. The latter stand out due to their perceptible

emotional immediacy and merciless naturalism, such
as the famous charcoal *Portrait of the Artist's Mother* (ill.
105) created in about 1514. The inscription reveals
that Dürer drew the old woman two months before
her death, aged 63: "1514 an oculy Dz ist albrecht
dürers/mutter dy was alt 63 Jor," and after his mother's
death he added in ink that she had died on a Tuesday
in the Week of the Cross at two o' clock at night: "vnd
ist verschiden/im 1514 Jor – am erchtag vor der
crewtzwochen/um zwey genacht." Dürer wrote in
detail in his commemorative book about her long
illness and death, which shattered him. Twelve years
earlier in this same book he had also recorded the
death of his father. Comparing it with Dürer's first
painted portrait of his mother dating from 1490 (ill. 8)
makes it clear how the intervening time had affected
both the portrayed woman and Dürer's artistic devel-
opment. Dürer recorded her features meticulously in
the charcoal drawing and included a degree of human
expressiveness and heartfelt sympathy that was previ-
ously unknown in portrait art. Here for the first time,
the face of a careworn old woman upon whom life has
left its mark, who gave birth to 18 children of whom
only three survived and who had experienced "great
poverty, derision, contempt, mocking words, fears and
great offensiveness," is not shown in the traditional
sense as equating ugliness with evil and death.
Although Dürer produced the drawing as a private
work, the picture continued to have an effect in works
where his students depicted unattractive, old women.
The self-portraits and portraits of close family
members and friends that Dürer drew and painted at
various points in his life are linked to a point in the
text of his planned treatise on painting in which he
stated that portrait art had a particular role to play:
"Awch behelt daz gemell dy gestalt der menschen nach
jrem sterben" (The art of painting […] preserves the
image of people after their death).

It is uncertain whether the death of his mother,
which Dürer describes so movingly in his commem-
orative book, led to the graphic prints depicting Mary
which link up with the series of woodcuts showing the
Life of the Virgin; while they present the Mother of God
in accordance with iconographical tradition as a figure
we can appeal to, in the sense of "compassio," (compas-
sion with Christ), they appear more human, natural
and emotional than the earlier woodcuts. The copper
engraving dating from 1520 showing the *Madonna and
Child* (ill. 104) is a good example of an almost genre-
like approach to the theme. The body position of the
sleeping Christ Child, however, also reminds us that
this is a reference to Christ's Passion.

The portrait dating from 1516 of his master Michael
Wolgemut (ill. 106), who was 82 at this time, displays
how Dürer, ten years after his second Italian journey,
was achieving increasingly profound and incomparably
psychological character portraits. This was also not
a commissioned work, but was created for private
reasons as is clear from the inscription: "Albrecht Dürer
made this likeness of his master Michael Wolgemut in
1516." Michael Wolgemut died three years later and

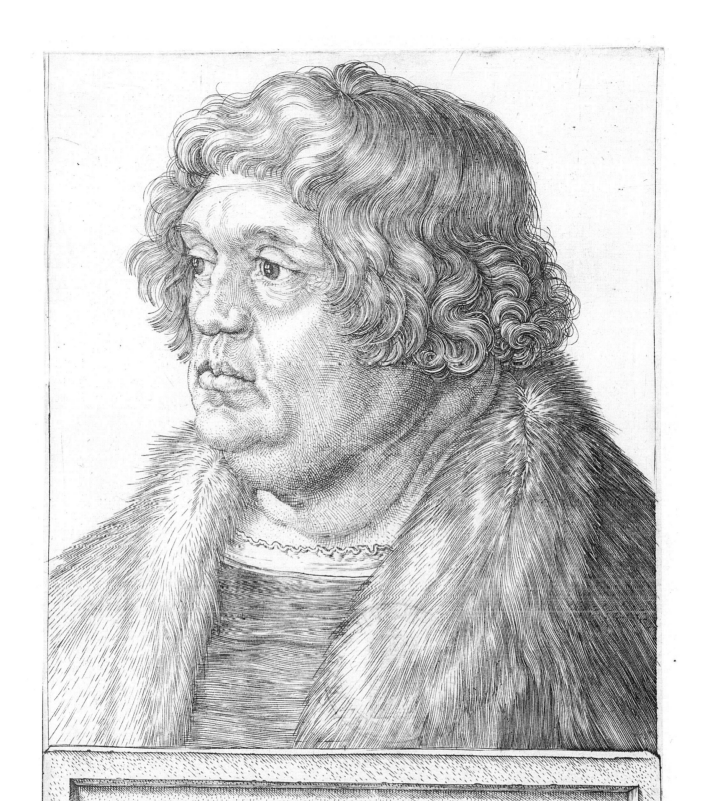

BILIBALDI · PIRKEYMHERI · EFFIGIES
AETATIS · SVAE · ANNO · L · III ·
VIVITVR · INGENIO · CAETERA · MORTIS ·
ERVNT ·
M · D · XX · IV ·

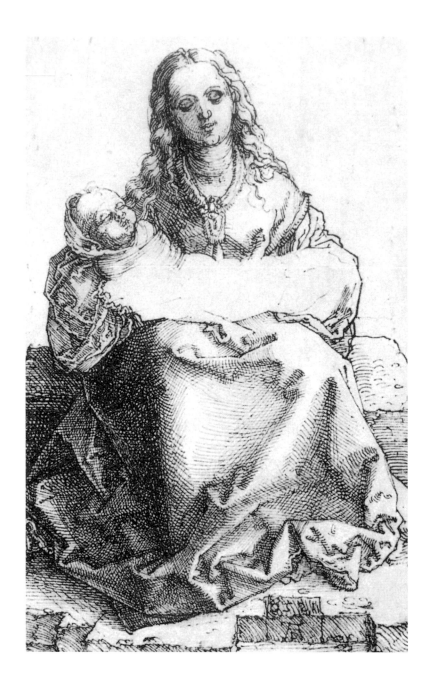

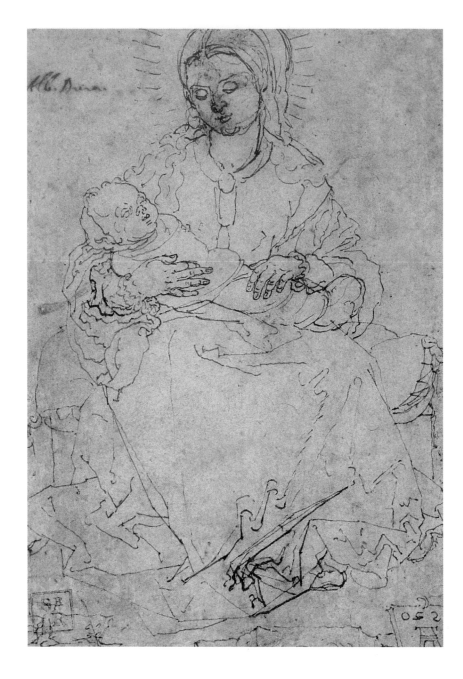

103 *Madonna and Child on a Stone Bench*, 1520
Pen drawing, 135 x 87 cm
Pushkin Museum of Visual Arts, Moscow (present location)

This pen drawing is a preliminary study of the group of figures in ill.
104, and while it shows the Madonna with her hair down, the babe
in arms and folds of her garments are already very similarly depicted.
The background landscape shown in the copper engraving is still
omitted here.

104 *Madonna and Child*, 1520
Copper engraving, 14.4 x 9.7 cm
Kupferstichkabinett, Staatliche Kunsthalle, Karlsruhe

This late depiction of the *Madonna and Child* is almost genre-like.
Only the halo indicates the holy nature of the group of figures. A
human attitude is expressed in the loving way the mother is turning
to her child, and this was intended to give the observer an emotional
understanding of the Christian doctrine of salvation by encouraging
"compassio," sympathy with the sufferings of Christ.

105 *Portrait of the Artist's Mother*, 1514
Charcoal drawing on paper, 42.1 x 30.3 cm
Kupferstichkabinett, Staatliche Museen zu Berlin – Preußischer
Kulturbesitz, Berlin

Two months before his mother's death, Dürer recorded her features
in this famous drawing. The extreme naturalism of the portrait is a
reference to the hard life the depicted woman had endured, for she
had suffered from various illnesses and had given birth to 18
children, only three of which survived. While in the Middle Ages
ugliness was equated solely with evil or death, here its function is
mainly as a private record.

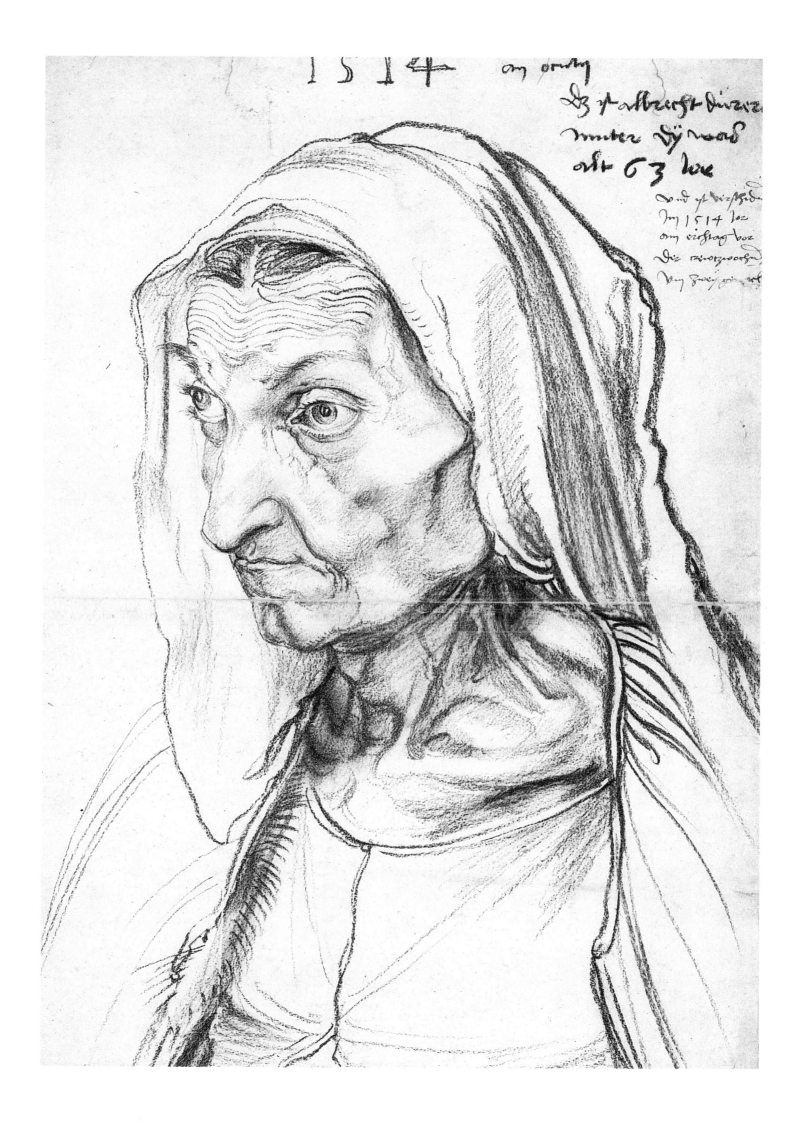

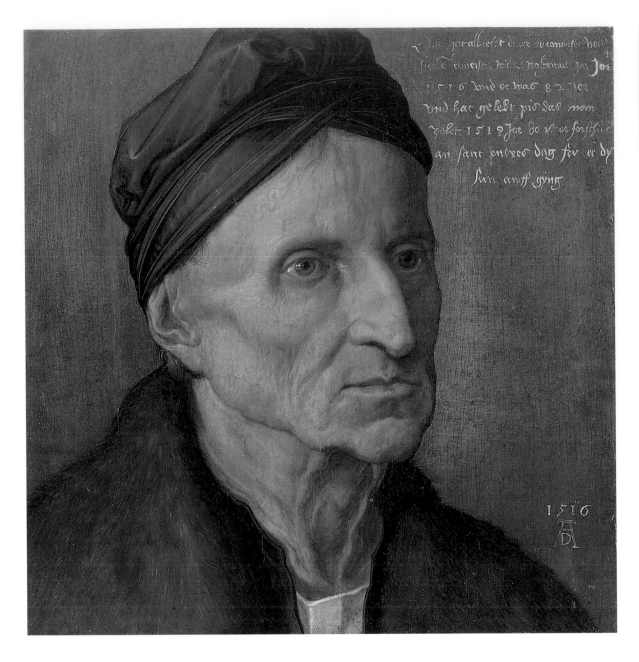

107 *Agnes Dürer as St. Anne*, 1519
Brush on gray primed paper, 39.5 x 29.2 cm
Graphische Sammlung Albertina, Vienna

This portrait drawing of Agnes Dürer was used as a preliminary study for the painting (ill. 108), and she is already depicted in the same posture and gestures. The area around the head is depicted in more detail while the lower part of the drawing is left open.

106 *Portrait of Michael Wolgemut*, 1516
Oil on panel, 29 x 27 cm
Germanisches Nationalmuseum, Nuremberg

The fine portrayal and psychological characterization of the 82 year-old Michael Wolgemut, Albrecht Dürer's old master, is the focus of the artist's interest here. Despite the merciless way in which his age is portrayed, including the depiction of numerous wrinkles and veins, the subject's clear and penetrating gaze presents us with a forceful and mentally alert old man whose physiognomy testifies to a lifetime of work.

108 *Virgin and Child with St. Anne*, 1519
Oil on panel transferred to canvas, 60 x 49.9 cm
The Metropolitan Museum of Art, Altman Collection, New York

The painting of the *Virgin and Child with St. Anne*, which the Nuremberg patrician Leonardo Tucher commissioned from Dürer as a devotional picture, was preceded by several preliminary studies. The picture became very famous and in later centuries was copied a total of seven times. The monumental main figure of St. Anne is a portrait of Agnes Dürer. Together with Mary – wearing the costume of a Nuremberg citizen – and the sleeping Christ Child, she forms an acute-angled triangle. St. Anne's pensive gaze and the figure of the sleeping boy refer to the Passion of Christ.

Dürer recorded the precise date in an additional inscription, just as he had in his mother's portrait: "And he was 82 years old and lived until the year 1519 and then he died on St. Andrew's Day before sunrise."

The finely executed portrait of the depicted man stands out effectively against the monochrome green background. The old master is wearing the black cap customary in workshops, as it was intended as a form of protection against paint splashes. The smart fur coat is an expression of the prestigious requirements typical of portraits. The most significant feature, however, is the precise recording of his physiognomy, reproducing the signs of old age such as his wrinkled neck and the bony face which is covered with many small wrinkles, testifying to a long life full of hard work.

In contrast to the public portraits commissioned by the upper classes and aristocracy, which were of a more official nature, Dürer used portraits of his close family for other purposes. His wife Agnes, for example, was his model for the painting of the *Virgin and Child with St. Anne* (ill. 108). Together with Mary and the Christ Child she forms an acute-angled triangular composition. The painting was preceded by a detailed individual study of St. Anne (ill. 107). Anne, a mature matron, appears pensive in her knowledge about Christ's Passion. She is consolingly placing her hand on the shoulder of Mary, who is praying to the sleeping Christ Child. Christ is bedded on the right edge of Anne's headscarf, a premonition of his Passion. It is not by chance that the position of his body and the cloth showing beneath his body remind us of pietà scenes. The picture is tightly framed and the group of figures is moved right into the foreground, so that the observer is being directly appealed to express their sympathy for Christ's sufferings in their worship. The human, emotional and natural conception of the individual figures, dressed in contemporary garments, heightens this intention.

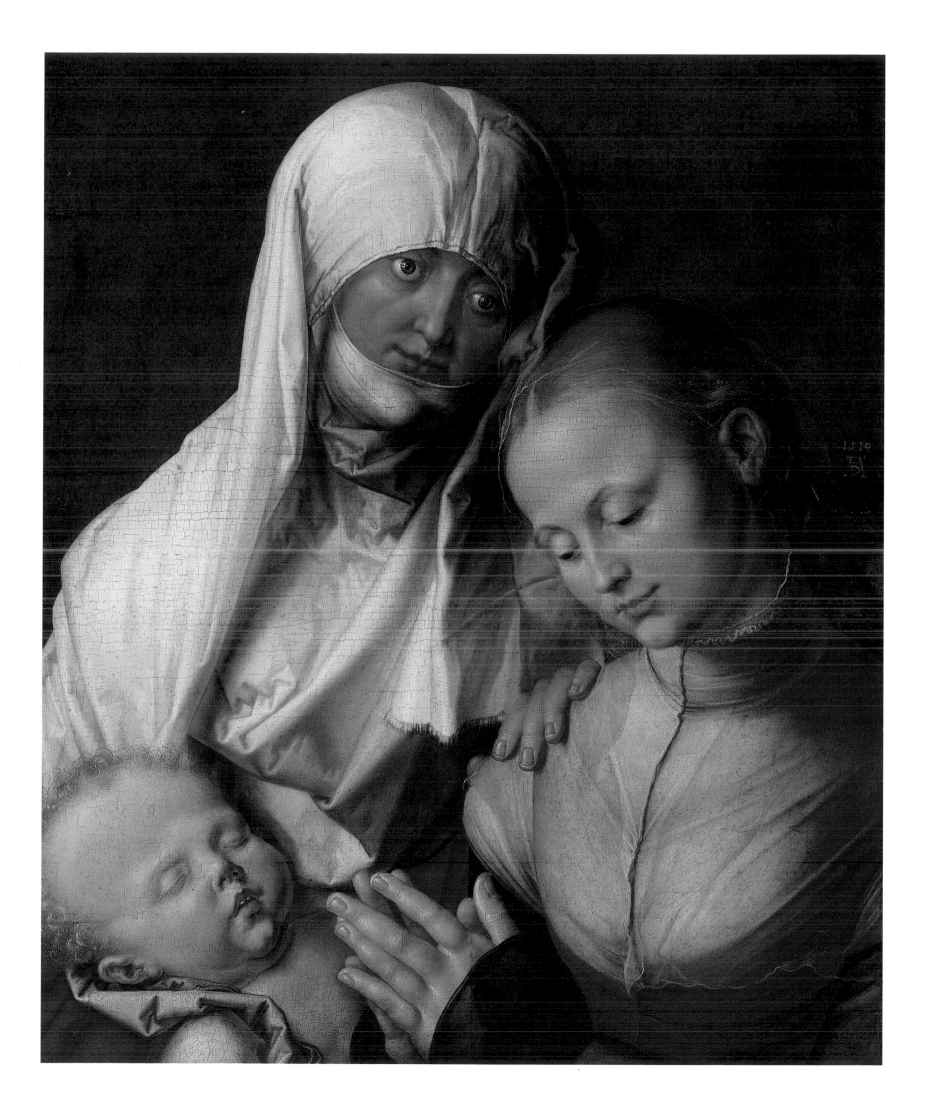

109 *Ship of Fools* by Sebastian Brant, Basle 1494
Chapter 48: A Ship of Journeymen
Woodcut, c. 16.3 x 10.4 cm
Germanisches Nationalmuseum, Nuremberg

The *Ship of Fools* by the famous humanist Sebastian Brant (1471–1521) is an allegorical work in 113 chapters which presents the reader, in an analogy to the dance of death in a procession of fools, with a depiction of human stupidity and vices and their consequences. The work was published in 1494 by Johann Bergmann von Olpe in Basle, and became an internationally famous folk book, mainly once it was translated into Latin and as a result of its illustrations. Chapter 48 describes the miserable career conditions of the journeymen. This full-page title woodcut is unusual compared to the woodcuts in the rest of the book which contain the chapter title and a motto in verse.

During Dürer's time, important humanists, scientists and great minds who were in contact with each other lived in Nuremberg, the center of German humanism.

German humanism had originated in Italy. Based on the study of the writings of classical authors, philosophers and artists, the desire was to create a revival, a spiritual rebirth which could lead to a life of peace and liberty in social harmony. The return to the classical world was seen as providing an ideal model for a new society and culture. Almost all the German humanists had studied at Italian universities and were in active contact with circles of Italian humanists, including scholars such as Angelo Poliziano (Politian, 1454–1494), Marsilio Ficino (1433–1499) and Pico della Mirandola (1463–1494).

Willibald Pirckheimer (ill. 111), who is considered to have been one of the most important of German humanists, studied music, classical philology and jurisprudence for seven years in Padua and Pavia and, upon his return to Nuremberg, became a close adviser of emperors Maximilian I and Charles V.

Due to their profound knowledge of classical language and classical writers, poets and philosophers, humanists such as Pirckheimer influenced the learned themes of the fine arts. It is characteristic both of him and other German humanists that the classical world and theology were the two cornerstones of his erudition. Pirckheimer, for example, did not only translate Greek texts but also translated the writings of the Fathers of the Church from Hebrew into Latin. Like the Augsburg humanist Konrad Peutinger, he was a diplomat and promoted the humanist movement by allowing all interested people, including Albrecht Dürer, to have access to his extensive library. Although he had not studied at university, Dürer took part as an equal in the learned discussions held by the circle of Nuremberg humanists. His work demonstrates the influence of humanist intellectual trends on the new themes in contemporary art.

The spreading use of book printing created the opportunity to exchange the most up-to-date humanist writings north and south of the Alps. Humanist erudition, linked to the study of the classical languages, led to innovations in all areas of society. For example, the famous Reformation theologian and humanist Philipp Melanchthon (1497–1560, ill. 110) reorganized the colleges and teaching of Latin, and the number of schools he founded gained him the honorary title of "Praeceptor Germaniae" – teacher of Germany. The extent of his academic work is an example of the enormous achievements of a humanist scholar who combined theological and universal erudition. In addition to standard works on Greek and Latin grammar, rhetoric,

Greek and Latin classics, physics, geography and psychology, he also wrote biblical commentaries, special theological pieces of research and catechisms, professions of faith and ecclesiastical rules.

Humanism and the Reformation went hand in hand to the extent that they had a stimulating effect on each other. Erudition prepared the way for religious renewal.

This connection between religious thoughts on reformation and the humanist body of thought was typically expressed in the writings of the secular priest Jacob Wimpheling (1450–1528). According to him, "the study of the heathen authors is not detrimental to Christian faith; it can only create damage if we possibly misunderstand them and make incorrect use of them." His famous treatise, the *Defensio theologiae*, was accepted as the German Christian humanists' program. Writers such as the legal scholar Sebastian Brant of Strasbourg (1457–1521, ill. 109) were primarily criticizing the behavior of the ecclesiastical ranks in their moralizing and socially critical poetic works.

Each of these learned humanists was also an *uomo universale*, a universally learned and interested person. When the Swiss reformer Ulrich Zwingli (1484–1531) asked Erasmus of Rotterdam whether he would like to become a citizen of Zurich, the latter replied that he preferred to be a citizen of the world. This is an example of the cosmopolitan attitudes of the humanists with regard to theological, social and spiritual matters.

In 1516, Erasmus of Rotterdam published the first textually critical Greek and Latin edition of the New Testament, the *Novum Instrumentum*, and it was greatly admired in scholarly circles. By publishing the New Testament he soon became the embodiment of humanist and theological erudition in the best scientific sense. Luther drew ideas for his own translation of the Bible into German from the second edition of the work, published in 1519.

There was widespread sympathy for Martin Luther and the Reformation in humanist circles. In their writings, the humanists took a lively interest in, and had an influence on, discussions about reformation. The Augsburg scholar Konrad Peutinger was particularly enthusiastic about Luther's early writings and invited him to his home in 1518. Willibald Pirckheimer was also a supporter of Luther's for some years, but before his death in 1520 returned to his former faith.

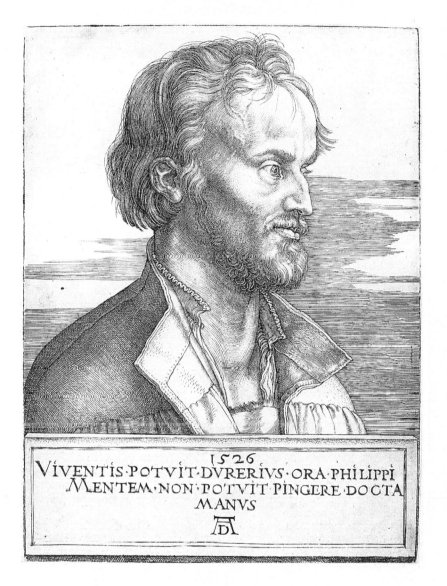

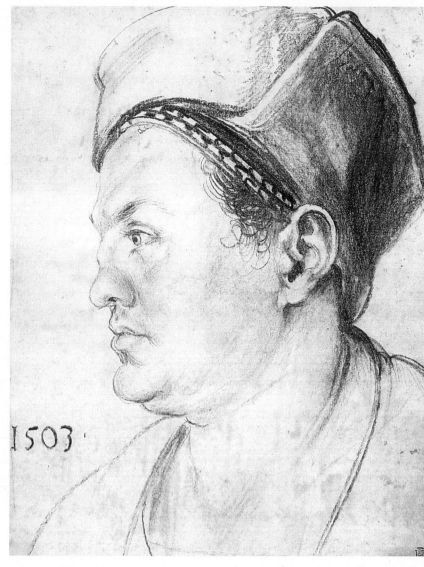

110 *Philipp Melanchthon*, 1526
Copper engraving, 17.5 x 13 cm
Kupferstichkabinett, Staatliche Kunsthalle, Karlsruhe

Philipp Melanchthon was one of the great humanists of his age. He
was a supporter of the Reformation and a close friend of Martin
Luther's. After studying in Heidelberg and Tübingen, he taught as a
professor in Wittenberg. The main emphasis of his research was on
theology, philosophy and rhetoric. Melanchthon is facing to the
right in a striking three quarter profile. The epitaph-like Latin
inscription refers to the humanist discussion Melanchthon led on the
portrayability of the human character: "1526. Viventis potuit
Dvreris Ora Philippi Mentem non Potuit Pingere Docta Manus"
(1526. Dürer was able to draw the features of Philipp from life, but
his expert hand could not capture his spirit. A.D.).

111 *Willibald Pirckheimer*, 1503
Charcoal drawing, 28.1 x 20.8 cm
Kupferstichkabinett, Staatliche Museen zu Berlin – Preußischer
Kulturbesitz, Berlin

In the portrait drawing of Willibald Pirckheimer, seen in profile
looking to the left, Dürer was making use of a silver point drawing
and "refined his friend's features without flattering him," as Panofsky
stated. The famous humanist was a close friend and intimate of
Dürer's. It is possible that Dürer was stimulated to produce this
profile portrait by ancient imperial coins, though it is also possible
that the drawing was used as a pattern by a medal maker.

The Results of Free Vision.
The Journey to the Netherlands

A silver point portrait, depicting the Dutchman in fine lines, testifies to the encounter of Dürer with the famous painter Lucas van Leyden during his journey to the Netherlands. The portrayed man, who soon became a friend of Dürer's, is gazing out of the picture alertly. The drawing was used in 1572 as a model for the engraved portrait of Lucas van Leyden in Hieronymus Cock's portrait series *Pictorum aliquot celebrium Germaniae inferioris effigies*, confirming the identification of the portrayed man.

"And when I was led to table, the people were standing on both sides just as if a great lord was being brought in …" (Dürer in his journal recording his journey to the Netherlands)

The outward reason for Dürer's journey to the Netherlands was secular in nature.

Emperor Maximilian I died on 12 January 1519, and he had promised Dürer an annual pension of 100 florins to be paid by the Nuremberg town council.

In order for this payment to continue, it had to be ratified by Duke Charles of Burgundy (1500–1558), the grandson of Maximilian I, who had been chosen as the new emperor of Germany; for this reason, accompanied on this occasion by his wife Agnes and maid Susanna, he traveled to the Netherlands. As the Bamberg bishop Georg III Schenk of Limburg (1502–1522) had given him traveling license and letter of recommendation, Dürer got through all the border controls without a problem. Dürer had paid for the license with a picture of the Madonna, since lost, and two of his large books of woodcuts. After he had taken part in a pilgrimage to Vierzehnheiligen in Franconia, he traveled by boat via Bamberg, Frankfurt and Cologne to Antwerp, where he stayed for a year with the innkeeper Jobst Planckfeldt (died 1531). From there he traveled to Bruges, Ghent, Mecheln, Brussels, Aachen and Cologne. During his one year stay in Antwerp, Dürer, who was already an internationally renowned artist, was received like a lord and showered with invitations and presents wherever he went. He stayed in Mecheln on several occasions with the imperial governess of the Netherlands, Margaret of Austria (1480–1530). In 1520 he witnessed the imperial coronation of Charles V in Aachen, whom he also met in Mecheln. After producing a charcoal drawing, he portrayed the Danish king Christian II (1481–1559), who paid him a princely sum and whose beauty and manliness Dürer admired.

Dürer met many of the great minds of the age, became acquainted with Erasmus of Rotterdam for the first time, sketched Sebastian Brant (ill. 113) and met important foreign government representatives and merchants. He became acquainted with the most important artists of his age such as Jan Gossaert (c. 1478–1533/1536), the Mecheln court painter Barend van Orley (1492?–1541) and the Antwerp stained glass artist Dirck Vellert (1511–1544), in whose art the influence of Dürer's printed graphics immediately showed itself. Dürer became friends with Lucas van Leyden (1494–1533), the "kleine männlein" (small man), who from then onwards adopted Dürer's style (ill. 112). He was invited to the wedding of the respected landscape painter Joachim Patinir (c. 1480–1524), the "gut landschafft mahler" (good landscape painter), and the well-known painter Jan Provost (c. 1465–1529) traveled specially from Bruges in order to meet him.

But Dürer did not only meet the most famous living artists: he also studied the most famous artists of the past. He viewed Michelangelo's Bruges Madonna, the "alabaser Marienbild, das Michelangelo von Rohm gemacht" (the alabaster Madonna which Michelangelo of Rome made), and was filled with enthusiasm for the old Dutch painting of artists such as Jan van Eyck and Rogier van der Weyden, and their portrait paintings influenced his late style in this genre. His host Jan Provost showed him the most famous paintings of the city, the *Death of Mary* by Hugo van der Goes (c. 1430/1440–1482) and Jan van Eyck's *Madonna with Canon van der Paele*. He got to know Jan van Eyck's *Wedding of Arnolfini* when staying with the governess of the Netherlands, Margaret of Austria. In the Ghent cathedral of St. Bavo he admired Jan and Hubert van Eyck's *Ghent Altarpiece*, "a most exquisite, very understandable painting." In Cologne he viewed the panel by "Master Steffan," which earlier researchers have identified as Stefan Lochner's main altar in Cologne Cathedral. Here too his annual pension was ratified by the emperor. Dürer had brought numerous printed graphics with him which he handed out as gifts or sold. His journey only lasted about a year, and despite this numerous drawings and several paintings show how intensively he worked during this time. Only one page still remains of the original manuscript of his journal: a tailor's sketch for Dutch ladies' coats. We are familiar with the text from two slightly diverging copies dating from the late 16th or early 17th centuries.

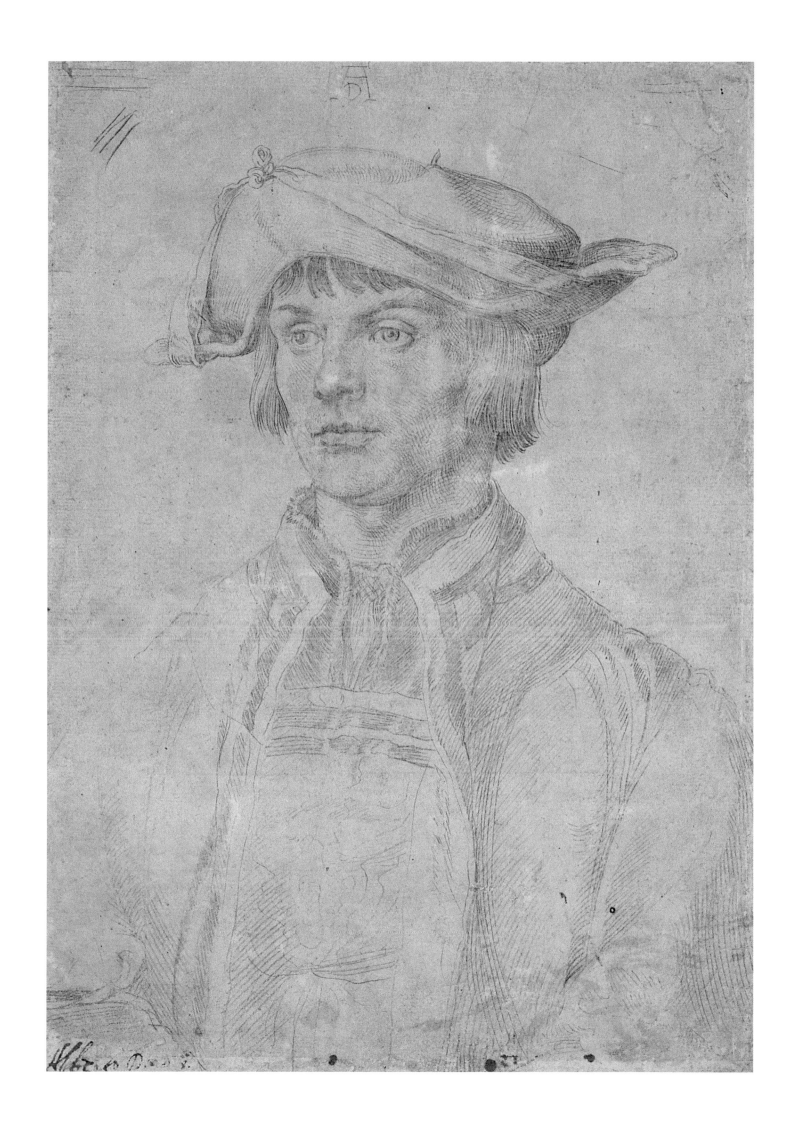

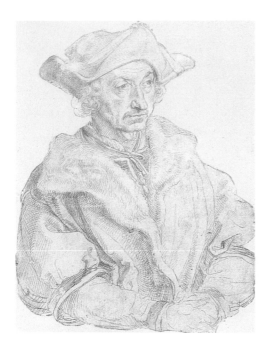

113 *Sebastian Brant (?)*, c. 1520
Silver point on paper, 19.4 x 14.7 cm
Kupferstichkabinett, Staatliche Museen zu Berlin –
Preußischer Kulturbesitz, Berlin

The silver point drawing presumably contains a portrait of
the Basle legal scholar and humanist Sebastian Brant,
created during the journey to the Netherlands. Brant, who
had been Dürer's sponsor and client during his stay in
Basle, was staying in the Netherlands at the same time as
the artist in order to represent the city of Strasbourg at the
court of Emperor Charles V. Seen in a three-quarter profile
looking to the right, he appears to us as a critical, older
gentleman. Though his arms and hands are only sketched
in, Dürer concentrated particularly on creating a natural
depiction of the face. In about 1520, when the portrait
must have been produced, Brant had already gained
international fame through his moralizing and satirizing
poetic work, the *Ship of Fools*.

114 *The Negress Katherina*, 1521
Silver point drawing on paper, 20 x 14 cm
Gabinetto dei Disegni e delle Stampe, Galleria degli Uffizi,
Florence

Dürer drew the Negress Katherina, the servant of the
Portuguese factor João Brandão in Antwerp, when she was
aged "20 Jar," according to the handwritten note. The
portrait drawing is part of a group of works that were
created for reasons of personal interest. The portrayed
woman is gazing directly at the observer. The curves of her
face are modeled with fine lines and cross-hatchings.

In this journal, Dürer recorded his business income
and expenditure in detail. The costs of food and
lodging are also mentioned there, as are exchange
values, such as when Dürer exchanged prints for an art
object in which he was particularly interested. His
handing out of gifts is also recorded with the precision
of a bookkeeper. In addition to this primary function
of bookkeeping, however, the journal also reveals
Dürer's attentiveness to people that he encountered on
his journey, and interest in the curious and rare objects
and natural phenomena that he recorded in numerous
drawings and sketches. We can read here of the
Mexican treasures exhibited in Brussels Castle and of
the sudden storm and distress that Dürer experienced
on Zeeland. Within the entire sober report, there is
only one point where the tone becomes emotional, and
this is when he heard of Luther's unexpected death
which he lamented at length. This entry in the journal
once more clearly shows Dürer's positive attitude to the
Reformation and the respect he had for Martin Luther.

While Dürer had already been concentrating on
painting portraits during the years before his journey
to the Netherlands, it was during his journey that he
developed the entire breadth of his ability in this genre.
Dürer records portrait drawings almost every day in his
journal. About 40 still survive of the 150 that we know
of in this manner. In addition to the printed graphics
which Dürer had brought along to sell, these portrait
drawings were one of his main sources of income to
finance his journey. On most occasions, however, it is
likely that Dürer gave the sheets away, confirmed by
the frequently personal inscription. He also, indepen-
dent of financial need, sketched characters and people
who were particularly interesting to him, such as the
female servant of the royal factor of Portugal, João
Brandão (1514–1521), the *Negress Katherina* (ill.
114). Therefore, the distinction between commis-
sioned pieces and portraits created of his own free will
also applies to these portrait drawings. Clients liked to
be depicted as a bust in a three-quarter profile in a
tightly framed picture, as this increased the self-deter-
mined and self-assured aura of the subject. Gazing into
the distance, together with the splendid fashionable
garments, emphasized the prestigious character of the
works. Magnificent accessories such as broad, fashion-
able caps advantageously underlined the physiogno-
mies which were depicted full of character. The portrait
drawings, carried out in charcoal or silver point with
sweeping lines, display rich nuances in the depiction of
light and shade. Nonetheless, it is also the case here
that the importance of dress, as a prestigious frame-
work to emphasize a character head, can come second
in the finished work as it does in the *Portrait of a Young
Man* (ill. 115), whose identity has still not been estab-
lished beyond doubt. Not all portraits have the same
painterly and psychological fullness, which was
frequently explained by Dürer's different personal atti-
tudes to the people he was portraying. In addition to
the drawings, Dürer mentioned 19 oil paintings in his
journal of the journey to the Netherlands, and they
were probably only a portion of the paintings created

during this time. Three oil paintings were created in
rapid succession: they were *St. Jerome* and the portraits
of *Rodrigo Fernandez de Almada*, the first secretary of
the Portuguese consul, and the Danzig merchant
Bernhard von Reesen (1491–1521). *St. Jerome* (ill. 118)
is the only religious painting that we know he created
during the journey. Dürer created this *memento mori* as
a free composition commissioned by Rodrigo
Fernandez de Almada. Dürer prepared the picture care-
fully in several large format brush studies which he
then combined in the painting. The saint is visible in a
tightly framed scene, as a half-length figure gazing
pensively towards the observer. His left hand is
pointing to the skull and behind him a crucifix is
hanging on the wall. In front of him, open on a lectern
with books piled beneath it, lie the Holy Scriptures
which St. Jerome had translated from the Hebrew. The
skull, a symbol of earthly transitoriness, is connected to
the Crucified Christ, representing the hope of salvation
of faithful Christians, by a diagonal line leading
through the saint. The combination of the intense
realism, and impressive interpretation of the theme of
the picture caused a stir and it was considered to be a
forward-looking work; few paintings were ever copied
as frequently.

A 93 year-old man whom Dürer had met in Antwerp
was the model for St. Jerome. The journal informs us
of his fee, three pennies. The posture and gestures of
the old man are considerably more natural in the head
studies than they are in the painting (ill. 117). The
brush drawing in the Albertina, which depicts the old
man at a moment of mental concentration, is in its
sweeping lines and plastic modeling a high point
recording a physiognomy full of character. Wölfflin
even considered the brush drawing to be the start of a
new stylistic phase in Dürer's work.

The portrait of the Danzig merchant *Bernhard von
Reesen* (ill. 116) is one of the few painted portraits
remaining from the journey that demonstrate the
influence Dutch portrait art had on Dürer. Here the
picture is not framed so tightly as in his portrait draw-
ings and the hands are visible in the picture. In this
type of portrait, Dürer was imitating contemporary
Dutch artists such as Jan Gossaert or Quentin Massys
(1465/66–1530).

In addition to numerous portraits, pictures of
animals, costume studies and vedutas testify to Dürer's
continuing interest in anything unusual. He also
collected "Naturalia" and "Artificialia," in other words,
the products of nature and art: a parrot, the shell of a
fish, horns and claws, a tortoise shell, Chinese porce-
lain, expensive textiles and furs. His hosts reinforced
his passion for collecting by giving him valuable
presents. His landlord Jobst Planckfelt, for example,
gave him an "Indian nut" and the Portuguese ambas-
sador João Brandão gave him "cloth from Calcutta
[…], a green jug with mirabelles, …, and a branch
from a cedar tree."

Dürer's particular interest in local costumes is docu-
mented in several drawings that were produced in
Nuremberg and Venice. During his journey to the

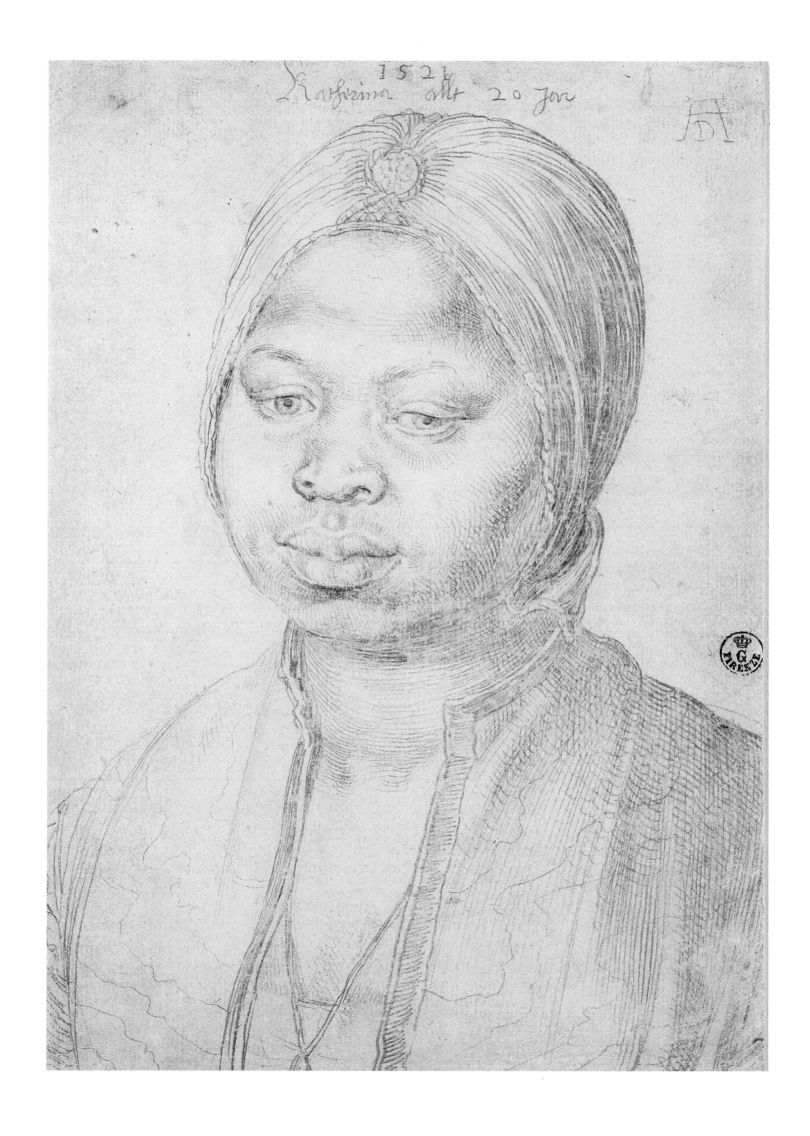

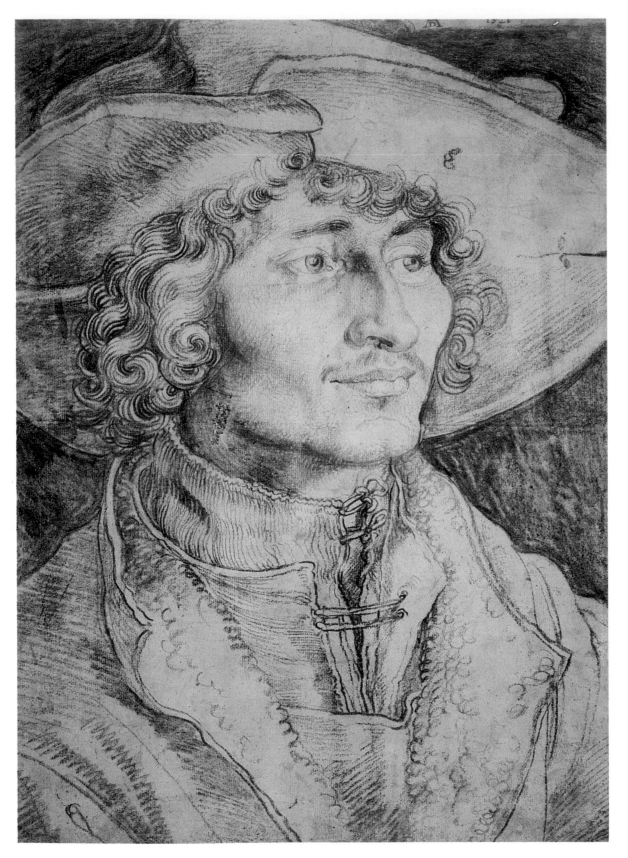

115 *Portrait of a Young Man*, 1521
Charcoal drawing on paper, 37.8 x 21.1 cm
The British Museum, London

One of the portraits drawn sweepingly with charcoal
during the journey to the Netherlands is this portrait of a
young man whose identity has not yet been established.
The scene is tightly framed, the bust of the portrayed man
is moved right into the foreground, causing the wide cap
to be cut off by the edges of the picture. His fashionable
hat shows off to advantage the character head with the
broad cheek bones and sensuous lips, which are depicted
with great precision and delicacy.

116 *Bernhard von Reesen*, 1521
Oil on oak panel, 45.5 x 31.5 cm
Staatliche Kunstsammlungen, Dresden

Dürer noted in his Netherlands journal that he had
completed the portrait of the Danzig merchant Bernhard
von Reesen, who was to die of the plague in the very year
the painting was created. The portrayed man is depicted in
a narrow picture detail in a three-quarter profile. His
smart, dark clothing contrasts effectively with the shining
red background against which his shadow is falling as if it
were a wall. The picture was influenced by Dutch portrait
art, shown by the fact that the man's hands are included in
the scene; they are holding a letter which begins "dem
pernh …" The lighting emphasizes the characteristic
features of the subject in that the left half of his face is in
shadow below the protruding cheekbone.

117 *Study of a Man Aged 93*, 1521
Brush drawing on gray violet primed paper
41.5 x 28.2 cm
Graphische Sammlung Albertina, Vienna

Dürer prepared the painting of *St. Jerome* (ill. 118) in
several sketches. His model was a 93 year-old man from
Antwerp. In this naturalistic brush drawing, the old man is
already leaning his head on his hand, but in contrast with
the painting is engrossed in his studies. In a handwritten
note above the picture Dürer informs us that: "The man
was 93 years old and still healthy."

118 *St. Jerome*, 1521
Oil on oak panel, 59.5 x 48.5 cm
Museu Nacional de Arte Antiga, Lisbon

St. Jerome is the only religious picture that Dürer painted
in the Netherlands. St. Jerome appears as an old man
wearing his cardinal's hat, right in the foreground of a
tightly framed picture. He is leaning his head on his hand
in melancholy and gazing towards the observer. The
diagonal line of composition leads from the skull, to which
the saint is pointing, up to the crucifix, so that earthly
transitoriness is being contrasted with salvation through
Christ. The open book and pile of books beneath the
lectern are on the one hand symbols of *vanitas*, but in
connection with the writing implements also refer to the
saint's erudition and translation of the Bible.

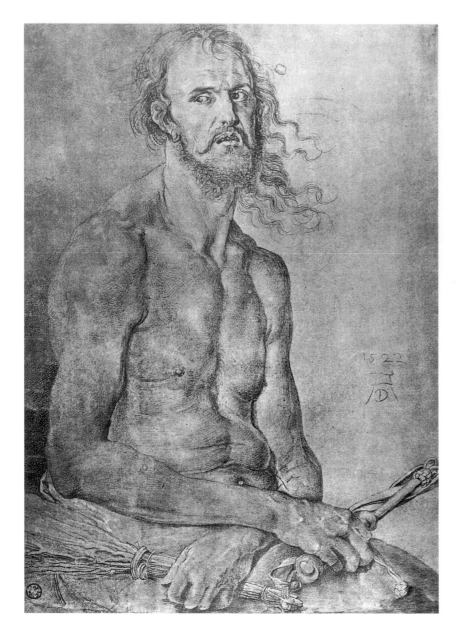

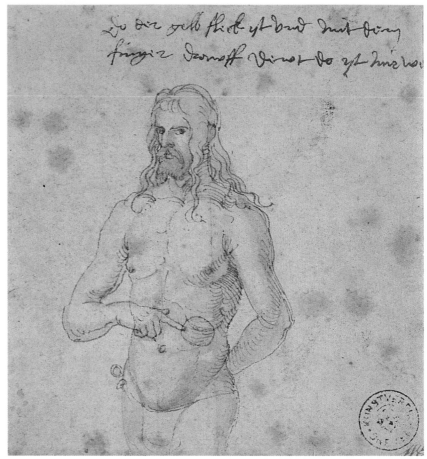

119 (above left) *Self-Portrait as the Man of Sorrows*, 1522
Drawing with lead pencil on blue-green primed paper,
40.8 x 29 cm
Kupferstichkabinett, Kunsthalle, Bremen (destroyed in war)

The *Man of Sorrows* is generally considered to be a self-portrait of Dürer created during his journey to the Netherlands. Semi-naked with a sunken chest and lips parted in pain, the man is gazing very naturalistically out of the picture. His crossed arms and the Instruments of the Passion such as the scourge and fasces remind us of Christ's sufferings.

120 (above right) *Self-Portrait*, 1521
Colored pen drawing, 12.7 x 11.7 cm
Kupferstichkabinett, Kunsthalle, Bremen

During his journey to Zeeland, Dürer contracted a malaria-like infection from which he would never recover. This is the context within which this small drawing, a self-portrait, was presumably created, for the artist is pointing to a painful spot. The inscribed comment, "Do der gelb fleck ist und mit dem finger drawff do ist mir we" (This is the yellow spot and when I press my finger on it, it hurts) suggests that the sketch was intended to be sent to a non-local doctor for his diagnosis.

Netherlands, he created colorful studies of curious Estonian and Latvian female costumes which, apart from the historical and artistic aspects, also demonstrate Dürer's interest in ethnology. In Brussels town hall, Dürer very much admired the gold which Hernando Cortés (1485–1547) had extorted from the Aztec ruler Moctezuma II (c. 1466–1520) in Mexico. He wrote enthusiastically – quite in contrast to the normally dry style of his journal – about a golden sun and a silver moon as well as two chambers full of armor and curious objects: "all the days of my life I have not seen anything that brought as much pleasure to my heart as these objects."

On a journey to Zeeland, Dürer wanted to see "the big fish" at Mittelburg, but "Fortuna washed it away again." He had been going to see a beached whale, but it was washed back into the sea by the rising tide. A *Walrus* (ill. 121) that was captured in the North Sea was recorded in a drawing by Dürer just as meticulously as he depicted two lions, animals that had already fascinated him during his first stay in Venice. Despite all the personal interest that Dürer may have

had in these natural phenomena, he also used them as free study material. The preliminary drawing for a Madonna which he did not produce shows that the drawing of the *Walrus* was also intended to be a preparatory sketch for a painting.

On his journey to Zeeland, Dürer contracted a strange fever that was to be his downfall. The journal mentions several medicines which the artist bought or was given. In a *Self-Portrait* (ill. 120) from this time Dürer is pointing to a painful spot at the side of his abdomen. The sheet was presumably sent to a non-local doctor for diagnosis. Due to the small drawing and symptoms described, malaria was diagnosed, since this causes a painful swelling of the spleen. A *Self-Portrait as the Man of Sorrows* (ill. 119), dating from 1522, shows how much Dürer suffered as a result of the illness.

On 17 May 1521, Dürer heard that Luther had been arrested. The false report was circulated in order to distract attention from the fact that the Protestant sympathizer, the Elector Frederick the Wise, had taken Luther into his own protection in the Wartburg.

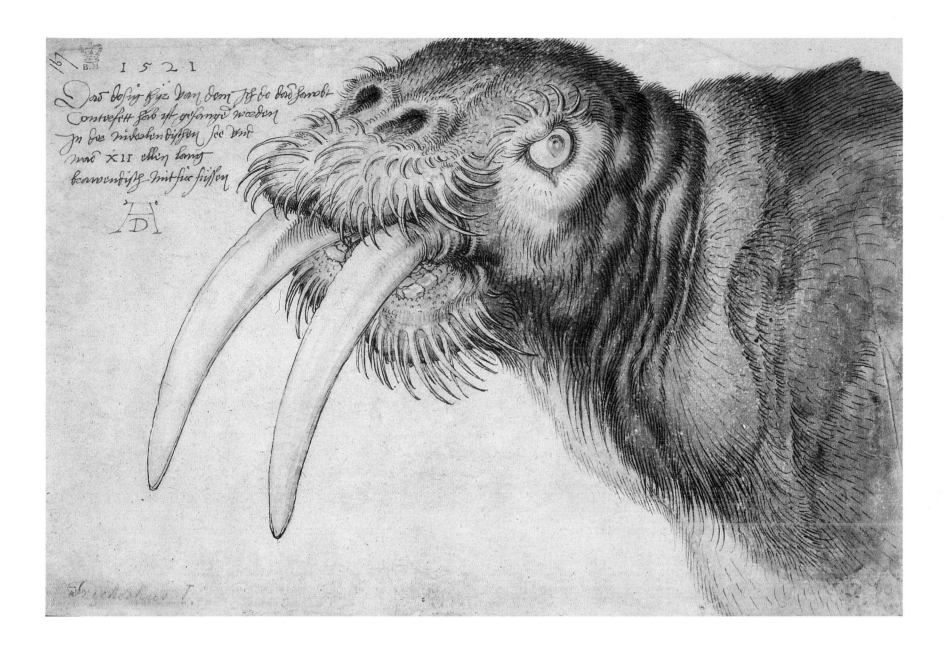

The wording in the journal of his journey to the Netherlands is rather dry and factual most of the time, and becomes emotional when Dürer writes of the supposed assault on Luther's freedom. These lines once again inform us about Dürer's positive attitude to Luther and the Reformation. At the same time, the text in Dürer's journal is also a desperate prayer in which he begs for Luther to be set free and for his ideas of reformation to be recognized; he also expresses his admiration of Luther.

Dürer knew all of Luther's writings, and was in close contact with the councilor Lazarus Spengler who later introduced the Reformation to Nuremberg. He also met Erasmus of Rotterdam on several occasions, though he criticized him to the effect that he showed so little courage and willingness to assert himself in matters to do with the Reformation.

By the end of the journey, the artist had made a loss where financial matters are concerned; he wrote that: "I have not been paid for the majority of my work […]. In all my deeds, provisions, sales and other dealings I have been at a disadvantage in the Netherlands." He

had, however, achieved his actual goal, which was for his annual pension to be ratified. In addition, he had gained deep impressions in all areas of life and was no longer a receiver, but much more of a giver of knowledge, a celebrated and admired artist who was capable of entering into direct interchanges with his artistic colleagues. The Flemish and Dutch artists celebrated Dürer as a prince of painters. In addition, he was courted by diplomats, princes and scholars. The municipal authorities of Antwerp had even proposed to him that he remain in the city. But after he had portrayed King Christian of Denmark in 1521 (?) in Brussels, Dürer, his wife and maid started on their homeward journey, via Leuven, Jülich, Aachen and Cologne, one year after he had left Nuremberg. The journal ends here.

121 *Walrus*, 1521
Pen drawing with watercolors, 20.6 x 31.5 cm
The British Museum, London

Throughout his life, Dürer was interested in oddities of nature. The walrus has pushed the front half of his body into the picture and is looking at the observer with his peculiarly glassy gaze; this has led to the suggestion that Dürer created the study from a chopped off walrus head or stuffed animal, and completed the rest from his imagination. The study was to be used as a detail in the altar painting of an enthroned Madonna and Child surrounded by eight saints and angels playing instruments, but this work was never produced. At the top left Dürer wrote: "Das dozig thyr van dem ich do das hawbt conterfett hab, ist gefange worden in der niderlendischen see und was XII ellen brawendisch mit für füssen" (The animal which I have drawn this picture of was captured in the Dutch Sea and was twelve cubits in size with four feet).

"THEN TRULY, ART IS PRESENT IN NATURE." THE LAST YEARS OF HIS LIFE

122 *St. Apollonia*, 1521
Chalk drawing on green primed paper, 41.4 x 28.8 cm
Kupferstichkabinett, Staatliche Museen zu Berlin –
Preußischer Kulturbesitz, Berlin

The chalk drawing was an individual study for a planned monumental Madonna with saints, of which six preliminary drawings exist. The figure of St. Apollonia appears on two of these studies. The drawing depicts a moment of spiritualization: St. Apollonia is portrayed as a young woman who appears to be imbued with inner concentration. She is portrayed in so individual a style that it is still disputed whether Dürer used a model or created an ideal figure from his imagination.

"Dann warhafftig steckt die kunst inn der natur/wer sie herauß kann reyssen dr hat sie" (Then truly, art is present in nature, and whoever can rip it out has got it; Dürer in his *Four Books on Human Proportions*)

At the beginning of August 1521, Dürer, his wife and maid returned to Nuremberg. The works created during the following final years must be considered as part of the same group of works as those pieces created during the journey to the Netherlands. Dürer brought some drawings back from the journey which are thought to have been preliminary studies for religious paintings. They include studies for a Great Crucifixion and for a Madonna and Saints, a monumental altarpiece which, according to Winzinger, "would probably even have put the *Feast of the Rose Garlands* in the shade." The latter painting, however, was never produced. An individual study still exists in the form of *St. Apollonia* (ill. 122). It appears in other preparatory studies together with her attributes, a pair of pliers and a tooth. In late summer, on 11 August 1521, the Nuremberg council decided to commission Dürer to produce the designs for a program of frescoes for the council chamber with a mythological and allegorical theme. The frescoes were produced by Dürer's students Georg Pencz (c. 1500–1550) and Hans Springinklee. In addition to the *Calumny of Apelles*, the chamber already contained the *Triumphal Chariot* of Emperor Maximilian I (ills. 88–91), which had been transferred from the woodcuts to the wall. The original decorations were destroyed during the Second World War.

During the following years, Dürer once more worked on a series of engraved portraits and continued to develop new types of pictures. For example, in the *Large Cardinal* dating from 1526, which is a second copperplate portrait of Cardinal Albrecht of Brandenburg, the subject appears in profile and his shoulders are slightly slanted, giving him a more three-dimensional appearance. Dürer also managed to develop new forms in his painted portraits, a large number of which have survived from this period. The manner so typical of the Netherlands of letting the subject's hands appear in the picture is now abandoned, in favor of pure bust portraits. Portraits such as those of

the two Nuremberg patricians *Hieronymus Holzschuher* (1469–1529, ill. 124) and *Jakob Muffel* (1471–1526, ill. 123) are examples of this type of portrait which is also characterized by the illusionistic reproduction of material details. There is one point in Dürer's *Four Books on Human Proportions*, in which he claims that it is necessary to execute all the elements in a portrait in the most thorough detail, which almost reads like a commentary on them: "That the very smallest things are made skillfully and in the best manner, and these things should also be done in the work in the purest and most diligent way possible, not omitting as much as a vein …" Despite the small format, the position of the two portrayed people in the pictures gives them a monumental appearance. The torso and shoulders serve as a base for the character heads.

The year of 1526 was another highly important one in Dürer's creative work, for in addition to his theoretical written works and engraved portraits, he also produced one of his major late works. The *Four Apostles* (ills. 125, 126), in their role as Reformation professions of faith, are a new pictorial creation. Dürer was a very pious person who repeatedly reflected on his faith. An ardent admirer of Luther's, he joined the so-called "Soldatitas Staupitziana" which had gathered around the Augustinian monk Johann von Staupitz (c. 1428–1524). Staupitz belonged to the same order as Luther and was the great reformer's pastor in Wittenberg as well as his predecessor in the chair of biblical theology at Wittenberg University. Dürer, Pirckheimer and other reform-minded individuals were dismayed by the fanatical and sectarian behavior of some groups. These were the circumstances under which the two panels with the figures of the Apostles were created, and together with the accompanying biblical texts they denounced the excesses of the Reformation, which had also been criticized by Luther. Examples of these excesses were the Peasants' War which broke out in 1524 and the trial, in 1525, of the three "ungodly painters," Dürer's student George Pencz, Barthel (1502–1540) and his brother Hans Sebald Beham (1500–1550). In 1525 the city of Nuremberg joined the Reformation: the form of church services was altered, the abolition of annual

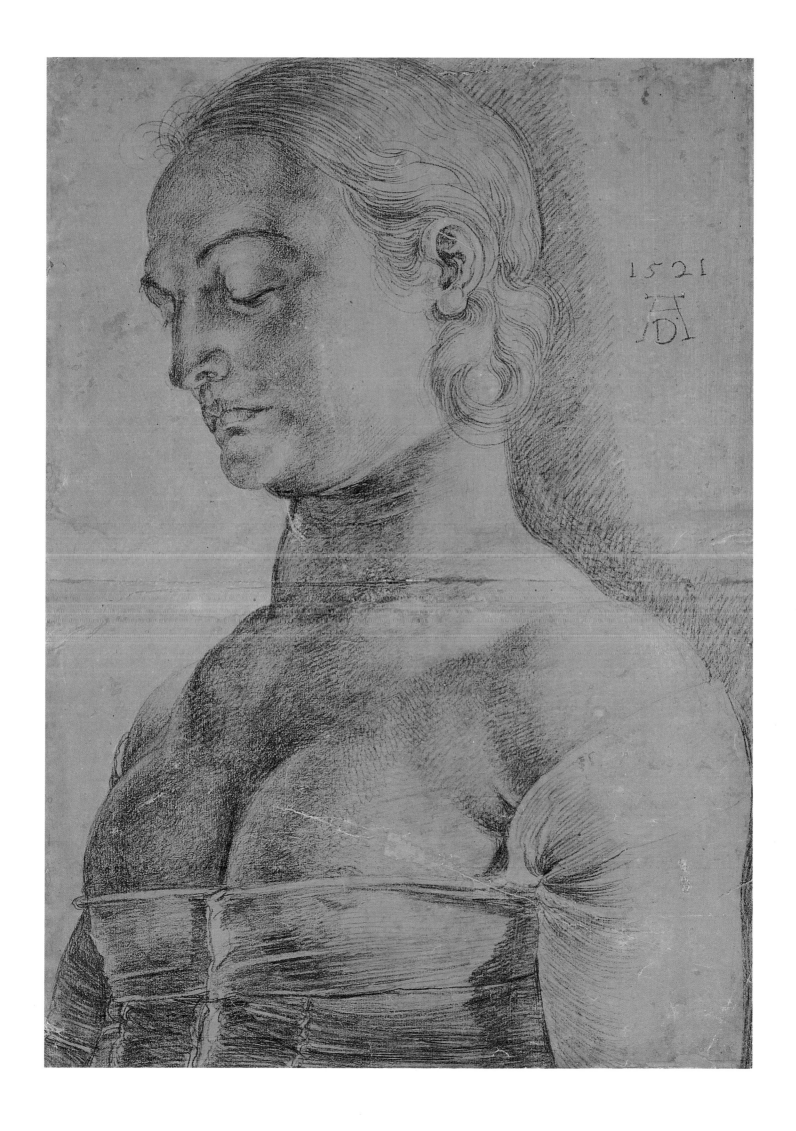

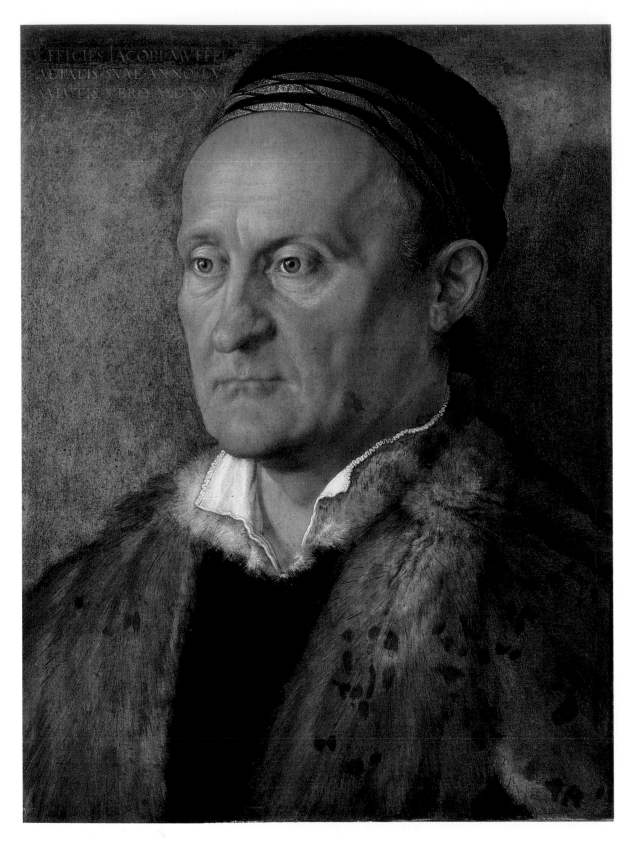

123 *Portrait of Jakob Muffel*, 1526
Oil on panel, transferred to canvas, 48 x 36 cm
Gemäldegalerie, Staatliche Museen zu Berlin –
Preußischer Kulturbesitz, Berlin

Like Hieronymus Holzschuher, Jakob Muffel
(1471–1526) was one of the dignitaries of the city of
Nuremberg and was a friend of Albrecht Dürer's and
Willibald Pirckheimer's. He had been a councilor since
1502, and was the "Alter Bürgermeister" (Old Mayor) in
1514 as well as being one of the city's septemvirs. The goal
in this portrait is not to idealize him but to produce a
character portrait that was painted with the highest
possible degree of naturalism. Details such as the fine
wrinkles on his forehead, rosy flesh tones and subtle
differentiation of the materials of his garments display
a highly cultured style of painting.

124 *Portrait of Hieronymus Holzschuher*, 1526
Oil on lime panel, 48 x 36 cm
Gemäldegalerie, Staatliche Museen zu Berlin –
Preußischer Kulturbesitz, Berlin

Hieronymus Holzschuher (1469–1529) had been a
councilor in Nuremberg since 1499, and was the "Old
Mayor" in 1509 and 1520. In contrast to the style of
portraits influenced by the Netherlands (cf. ill. 116), a
view of the bust alone is chosen in the late portraits and
the hands once more disappear from view. There is a vivid
sense of presence about the subject, probably a result of his
intense gaze and his format-filling position in the picture.
His character is recorded with fine brushstrokes, and
details such as the silvery shimmer on his hair and the fur
collar which frames his shoulders are subordinate to the
overall psychological effect of the figure.

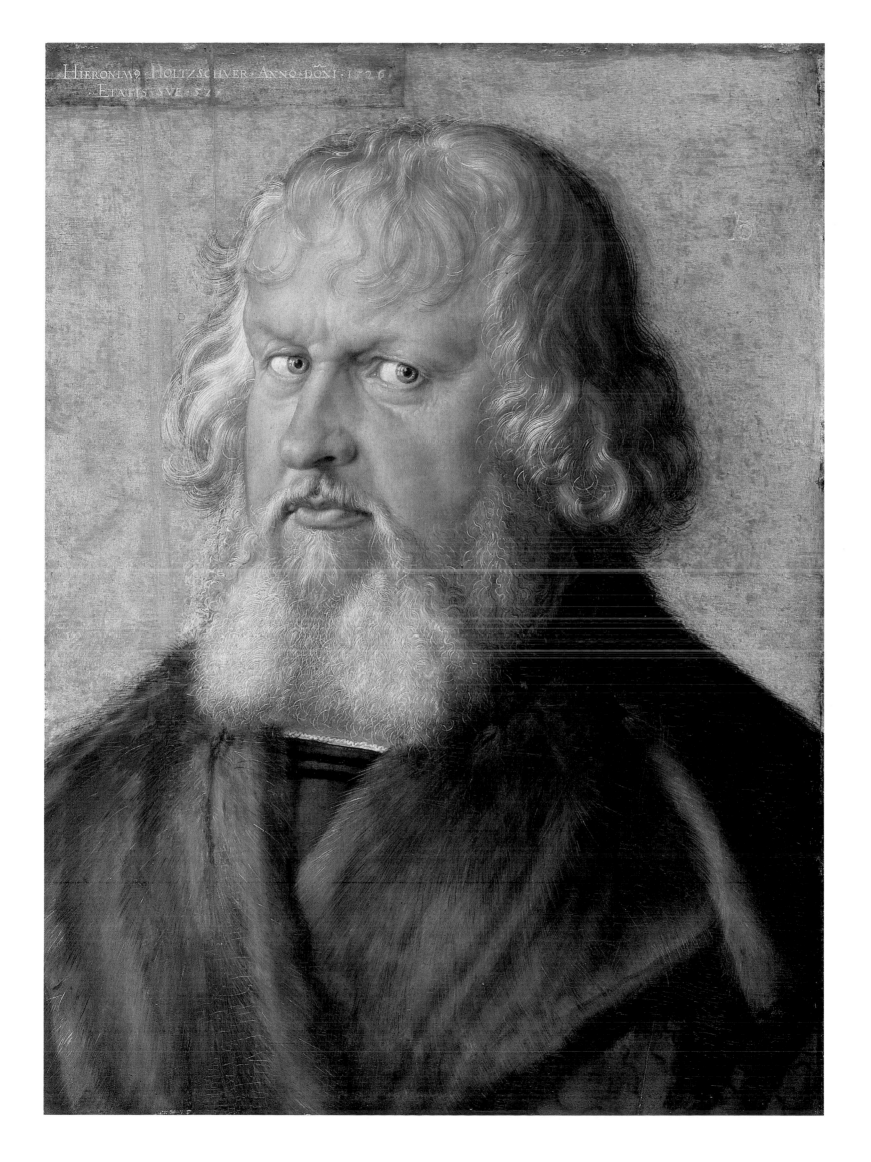

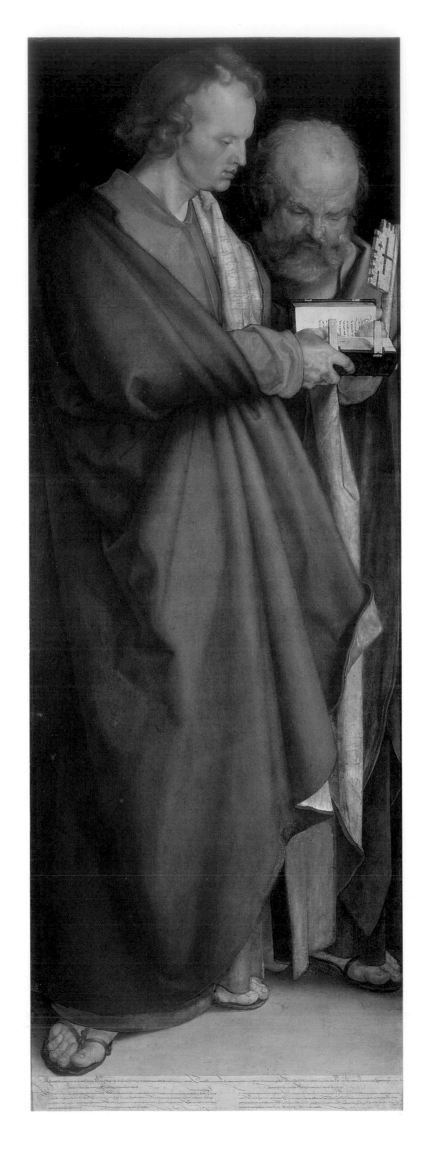

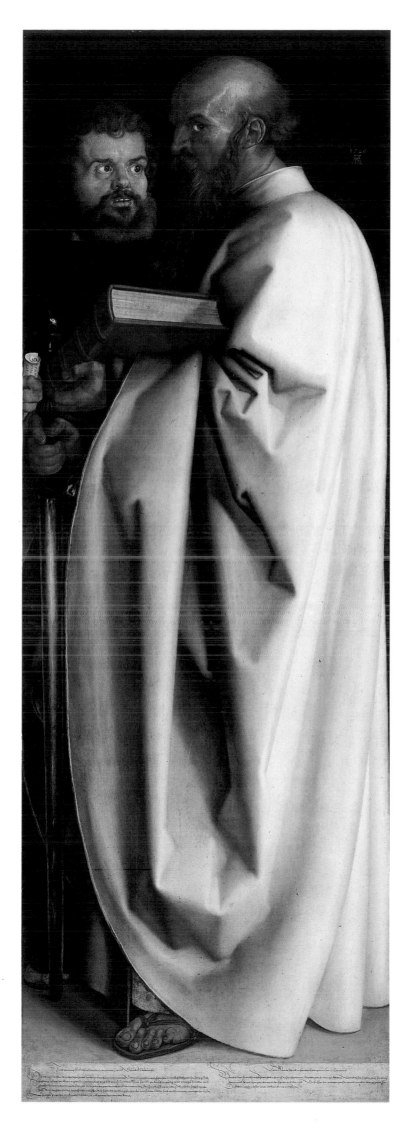

125, 126 *The Four Apostles*, 1526
Oil on panel, two Linden panels, each 215 x 76 cm
Alte Pinakothek, Bayerische Staatsgemäldesammlungen, Munich

Four saints are standing, arranged in pairs, opposite each other in
two panels. Three of the men are clearly identified by their attributes
and the inscriptions at their feet; they are the apostle St. John,
reading his Gospel, St. Peter with the key, and, in mirror symmetry
on the other panel at the front, St. Paul with his sword and book. St.
Mark, behind him, was one of the four Evangelists, not one of the
twelve Apostles. The saints are also depicted at various points in life
and represent the four humors. The inscriptions confirm the panels'
function as a profession of faith in the Reformation and a warning to
the town council of Nuremberg not to diverge from Luther's
teachings. The inscriptions are not arranged directly beneath the
appropriate apostle, but appear in the order in which they were
written by the apostles. The first we read is not St. John's, but St.
Peter's New Testament text. The inscriptions emphasize both the
arrangement of the figures on a rectangular ground plan and the
equal value of the depicted people. The texts from the Holy
Scriptures were written by the calligrapher and artists' biographer,
Johann Neudörffer (1497–1563). In 1627, when the original panels
were taken to the Catholic city of Munich to form part of the art
collection of the Bavarian Duke Maximilian I, the "offending" pro-
Reformation inscriptions were sawn off and added to copies that
were brought to Nuremberg. Not until 1921 were the original
inscriptions finally reunited with the original paintings.

127 *Four Books on Human Proportions*
from Book I: *Rear view of the female head type 7*
Staatsbibliothek, Bamberg

The basic measurement in the female nude depicted from the rear is her head, and here the addition of seven lengths completes the length of her body. In his visual and theoretical explanations, Dürer created variations of a variety of basic types in order to make it easier to give them individual features. The figure's left arm is held in front of her body to make the illustration clearer.

memorial services for the dead was demanded and the monasteries were dissolved. This was the context within which Dürer offered, in a letter dated 6 October 1526, to present them with a gift of two panels, each containing two standing figures of saints, to be housed in the upper regimental chamber of the Nuremberg town hall. Dürer received a hundred florins as an "honorary gift," his wife a further twelve.

The panels are in keeping with the familiar tradition for the interior furnishings of town halls, intended to portray the city's exercise of power and jurisdiction, but they go beyond this in their demand for reformation and Dürer's individual intention for them to be a warning. The work's title, *The Four Apostles*, is not strictly accurate as St. Mark the Evangelist was not an apostle. The monumental conception and coloring of the four standing saints shows the influence of the altar paintings by Giovanni Bellini. They are standing opposite each other in pairs in two panels, similar to vertical altar wings, and are identifiable solely by the iconographical, traditional depiction of the apostles and their attributes. On the left, St. John the Evangelist and St. Peter with the key are gazing with concentration at a book, and in the right panel St. Paul with the book and sword and St. Mark with the scroll are both gazing at the observer. The four men are standing firmly on the ground, and this is a reference to their steadfastness as teachers of the New Testament. The heavy cloaks support the monumental character of the figures. The sandals on their feet are an allusion to a point in the Gospel of St. Mark (Mark 6, 7–9) in which Christ sent them out in pairs to fight unclean spirits. They were supposed to wear sandals to carry out this task. The choice of saints was no accident in the context of a profession of faith in the Reformation: St. John was the Evangelist and apostle Luther regarded most highly, though his theology had developed from the writings of St. Paul.

There are inscriptions along the bottom edge of the picture (ill. 126), which are to be interpreted as warnings to the observer. The words are addressed to those who deny Christ, false prophets and sects who have contaminated the belief in reform. The biblical texts were written by the Nuremberg master calligrapher and artists' biographer Johann Neudörffer (1497–1553). They match Luther's translation of 1522, and a suitable passage is selected for each apostle. St. Peter, for example, is railing against false prophets (2 Peter 2, 1–3), St. John against those who deny the incarnation of Christ (1 John 4, 1–3), St. Paul, who is gazing warningly at the observer, against high-minded and unholy behavior (2 Timothy 3, 1–7), and St. Mark, finally, against scribes (Mark 12, 38–40).

The inscriptions, reinforce the importance of the work as evidence of Reformation attitudes. At the same time they represented a warning to the town council of Nuremberg to continue on its present line with respect to matters of faith, regardless of sectarians, fanatics or false prophets. Subordinate to this is the link between the four religious messengers and the four human humors, as Johann Neudörffer reported in his "Information about artists and artistic matters" in 1546. This was an arrangement dating back to medieval teachings about the humors; St. John was the sanguine, St. Mark the choleric, St. Paul the melancholic and St. Peter the phlegmatic man. However, the reference to the four humors was also an indication that the harmony of the soul could be destroyed if any one humor stood out; thus, the picture is also urging the observer to display "Temperantia," restraining one's own temperament in keeping with the intentions of the picture. The ages of man and four seasons were also linked to the four humors. St. Peter is an old man and represents winter, St. Mark is at his prime representing summer, St. John, who seems older in Dürer's picture, is a young man representing spring and St. Paul represents autumn. The panels were preceded by drawn studies which researchers have categorized in various ways, including as possible portrait studies. In the context of the religious and political meaning of the work, the *Four Apostles* represent something like the four new Fathers of the Church; St. Paul and St. Mark, the earliest witnesses and members of the early Christian community, are following St. John and St. Peter as the preachers of the gospel and, therefore, stand behind them in a figurative sense.

Both the *Four Apostles*, the drawing for a painting of the Madonna and Saints, and a Bearing of the Cross carried out in grisaille suggest that Dürer's religious painting was on the threshold of a new stylistic stage which would combine simple forms with a powerful expression of the contents. Altogether, relatively few works were created during the last seven years of his life, but they stand out due to the exceptional way in which they were depicted and their innovative power. Dürer's death on 6 April 1528, probably as a result of the illness contracted in the Netherlands, prevented him from proceeding with this new approach.

During his final years Dürer endeavored to support practice with theory. He had already prepared the first two volumes of his treatise on proportions before his journey to the Netherlands, and he continued working on them after his return (ills. 127, 128). Due to the numerous geometrical drawings and illustrations needed to serve his didactic purposes, and the necessary study of classical sources, the completion of the work on proportions was delayed. Since his first stay in Venice, Dürer had worked on the theory of the ideal human proportions. Dürer linked the depiction of body types with differing proportions to the teaching of the four humors, and as such was the first to indicate the connection between build and character. The first volume dealt with basic geometrical terms such as the point and line, the second dealt with surfaces and bodies, and the third and fourth volumes were dedicated to both the ideal depiction of bodies and the construction of columns, letters and sundials. In the appendix, the reader, artist and craftsman can find a short treatise on perspective and instructions for the use of drawing equipment. The treatise on proportions was published posthumously by Willibald Pirckheimer and Dürer's wife Agnes.

128 *Four Books on Human Proportions*
from Book I: *Side and frontal view of the female head type 7*
Staatsbibliothek, Bamberg

The insights regarding measure and numbers which Dürer had gained from his lifelong study of the ideal proportions of the human body was summarized in his *Four Books on Human Proportions*, which was published posthumously. The head was used as the comparative yardstick for measuring the other parts of the body.

In 1527 Dürer published his book on the fortification of towns and castles which he dedicated to King Ferdinand (1503–1564), the brother of Charles V, who was fighting the Turks. This book was divided into six chapters dealing with various fortifications, military defenses of buildings, cities and open areas. Dürer's theory of fortifications is related to those of Italian architects and treatises such as those of the architectural theoretician and architect Alberti (1404–1472), Filarete (c. 1400–1469), Bramante (1444–1514) and Leonardo da Vinci (1452–1519). It is not certain however which of these treatises Dürer knew. These theoretical treatises were the first publications on such themes in the German language. They were used for generations as standard textbooks.

In the "aesthetic digression" from the treatise on proportions, Dürer wrote his much quoted sentence in which he stated the necessity of comprehending the nature's by reducing them to basic mathematical and geometric principles: "Dann warhafftig steckt die kunst inn der natur/ wer sie herauß kann reyssen der hat sie/ vberkumbstu sie/ so wirdet sie dir vil fels nehmen in deinem werk vnd durch die Geometria magstu deins wercks vil beweyssen." (Then truly, art is present in nature, and whoever can rip it out has got it; if you overcome it, will take away much that is false in your work and through Geometria you will be able to prove much with your work.)

"Dürer is Dead – Long Live Dürer." Dürer Revivals from the 16th to the 20th Centuries

129 Lock of Dürer's Hair
Kupferstichkabinett der Akademie der Bildenden Künste, Vienna

The lock of Dürer's hair that his student Hans Baldung Grien cut off on the second day after his death has come to be venerated almost as a relic over the centuries. Our knowledge about its origins is unbroken. To begin with, it was owned by Dürer's student, Hans Baldung Grien, and then passed to the artist Nikolaus Kremer, who administered Baldung's estate in 1545; in the 17th century it was owned by the art collector Balthasar Künast. Heinrich Sebastian Hüsgen (1745–1847), who published the first list of Dürer's printed graphics, accepted the "relic" which eventually, after being kept in various places in the 19th century, passed into the ownership of the Nazarene painter Eduard Steinle (1810–1886). He gave it to the collection of the Akademie der Bildenden Künste in Vienna, where it has been kept to this day.

130 Giulio Campagnola, *Sposalizio della Vergina*, c. 1506 (detail), portrait of Dürer
Fresco
Scuola del Carmine, Padua

Giulio Campagnola's (1482–1515) portrait of Dürer is an example of the fact that Dürer was already famous while he was alive, even as far afield as Italy. In the scene from the Marriage of the Virgin, the artist is standing amidst the crowd of spectators, looking towards the observer. He is dressed as a smart gentleman wearing a long coat and a broad cap. The portrait brings to mind the point in Dürer's letter dated October 1506 to Willibald Pirckheimer in which he wrote: "Oh, how I will freeze after the sun. Here I am a gentleman, at home a sponger."

There is probably no other artist in German art history who has remained as celebrated and venerated, right to the present day, as Albrecht Dürer.

When Dürer was 30 years old, he was already being described as a second "Apelles" by the Nuremberg theologian and legal scholar Jacob Wimpheling (1450–1528) in his *Epithoma rerum Germanicarum*, which was published in 1505, and equated with "Parrhasius"; these were two famous classical artists from the fourth century before Christ. While Parrhasius was known for his use of proportions and the deceptive realism of his pictures, Apelles became famous as the portrait painter at the court of Alexander the Great (336–323 B.C.). The illusionism in Dürer's method of painting, however, is also a reference to the competition between Parrhasius and the famous painter Zeuxis (active c. 424–421), which is described by the classical writer Pliny: Zeuxis painted grapes that were so realistic that birds tried to eat them, but Parrhasius painted an illusionistic curtain that his colleague tried to remove. Dürer continued with these games. The humanist Christoph Scheurl wrote in an account that Dürer's dog had tried to greet the image of his master in the *Self-Portrait in a Fur-Collared Robe*, able to reach it as it had been put to one side to dry. The comparison of Dürer to the classical artists shows the degree to which both his printed graphics and paintings came to be highly valued shortly after 1500. On his second Italian journey, which took him to Venice and Bologna, Dürer was also greeted and celebrated as a new Apelles. Evidence of this contemporary high regard is Giulio Campagnola's (1482–1515) portrait of Dürer (ill. 130) in the fresco of the Marriage of the Virgin in the Scuola del Carmine in Padua. It depicts Dürer in the crowd of spectators, as a smartly dressed gentleman.

Marcantonio Raimondi first got to know Albrecht Dürer's printed graphics in St. Mark's Square in Venice, and was so overcome with enthusiasm that he added Dürer's monogram to his own engraved copies; this led to the first copyright trial in Western art history. In order to protect himself from forgeries, Dürer prefaced his books of the *Life of the Virgin* and the *Apocalypse* with a firm warning to the robbers and thieves of other people's work that they would have to reckon with the necessary sanctions. Even before 1500, painters, engravers and ceramists were already imitating Dürer's engravings because of their compositions and the finely executed "natural" background landscapes. At the beginning of the 16th century, a large range of Dürer graphics found their way into French illuminated manuscripts, where mainly Parisian illustrators produced scenes from the Life of the Virgin and the Passion.

Shortly before 1600, the demand for Dürer's prints was so high that the market was flooded with a range of engravings and other copies. This copying continued almost without interruption until the 18th century. The plates passed from hand to hand, and the engravings and other copies were frequently used to illustrate prayer and devotional books.

Shortly after Dürer's death, a positive personality cult flared up. After two days, the famous lock of hair was cut off and treated as a relic worthy of reverence by various artists and collectors – from Hans Baldung Grien (1484/85–1515), via Goethe's friend Heinrich Hüsgen (1745–1847), who published the first list of Dürer's printed graphics, to the Nazarene artist Eduard Steinle (1810–1886) – before being brought to the Vienna Academy in a silver "reliquary" in 1873 (ill. 129). Three days after his funeral, the grave was opened in order to make plaster casts of his face and hands. Until the 17th century, the death mask was owned by the Dutch painter Frederik van Valckenborch (1570–1623), who collected Dürer's works and was an ardent admirer of him. They were presumably destroyed in 1729 when the palace in Munich, where they had been part of the collections of the Bavarian Duke Maximilian I, burnt down.

The imitation of the graphic and painted works of Dürer continued through the following centuries. As early as the late 15th century, starting with the invention and availability of printed graphics, a private circle of collectors and admirers of the young Dürer's art had formed. The functional changes in graphics and the high print runs that were introduced by Dürer increased the interest of collectors even further. Printed graphics were increasingly being seen as an artistic genre equal to that of painting. This created considerable demand which also explains the copying

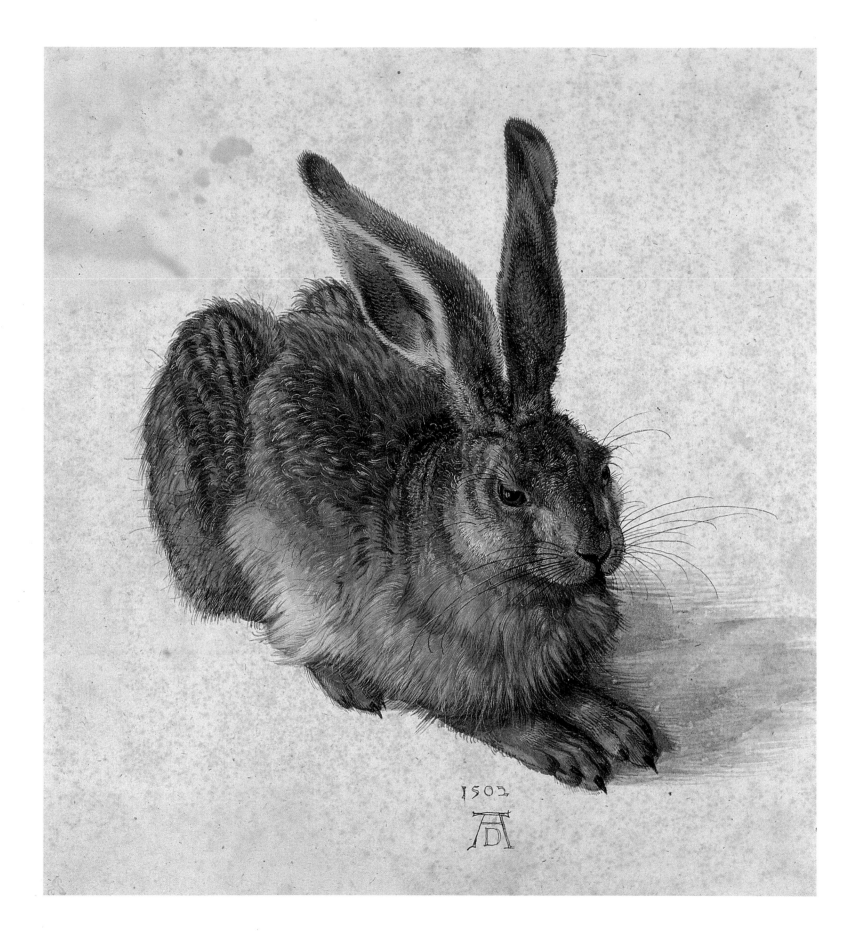

131 *Young Hare*, 1502
Watercolor and gouache on paper, 25.1 x 22.6 cm
Graphische Sammlung Albertina, Vienna

The famous watercolor of a hare was presumably painted from a living model; it became very popular and, together with the *Praying Hands* (ill. 78) and *Piece of Turf*, has been reproduced on a massive scale in the twentieth century. The important new feature of this study is the lifelike depiction of the animal. The hare's fur is depicted in delicate gradations and shades with a variety of brushstrokes. The mullion and transom of a window are reflected in its shining eye – the mirror of the soul. Dürer's ability to give an animal portrait such an individual expression presumably contributed to the considerable imitation of the work.

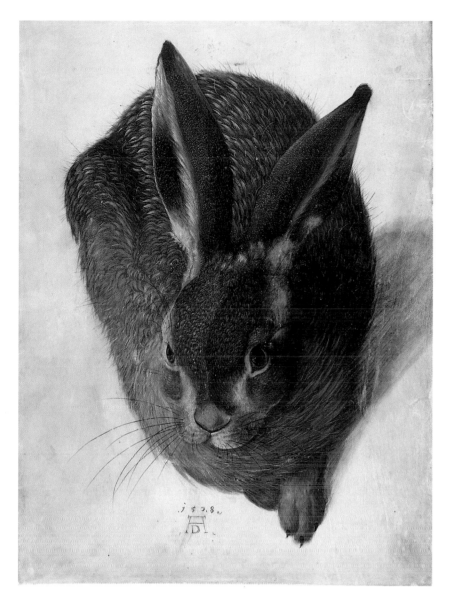

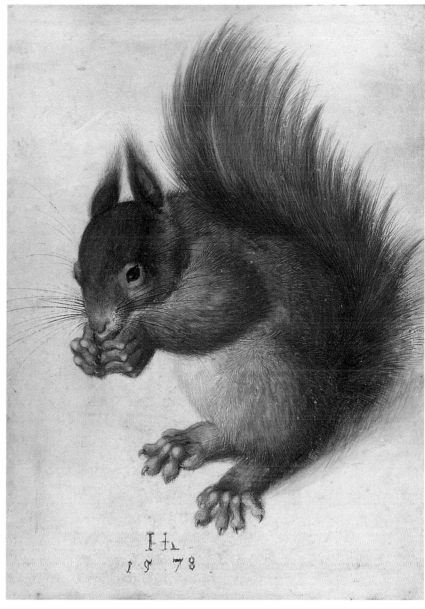

132 Hans Hofmann, *Hare*, 1528
Watercolor and gouache on parchment, 32.5 x 25.6 cm
Kupferstichkabinett, Staatliche Museen zu Berlin – Preußischer
Kulturbesitz, Berlin

One of the best-known imitators of Dürer's works, in particular
of his animal studies, was the Nuremberg artist Hans Hofmann.
From 1582 he was the court painter of Emperor Rudolph II, a great
admirer and collector of Albrecht Dürer's work. The depiction of a
hare from above, based on a lost original, bears Dürer's signature.
But its date, the year of Dürer's death, suggests that this sheet is
not authentic. The formulaic brushstrokes in the hare's fur and
the dotted strokes on its ears are characteristic of Hofmann's
method of painting.

133 Hans Hofmann, *Squirrel*, 1578
Watercolor and gouache on parchment, 25.1 x 17.7 cm
National Gallery of Art, Washington, D.C.

Hofmann's squirrel nibbling at a hazelnut is thought by various
researchers to derive from a lost work of Dürer's in which the squirrel
at the front was joined by a second one in a *profil perdu*. It is possible
that the artist saw the original study by arrangement with the
Nuremberg Imhoff family, who owned numerous works by Dürer
and were eager to lend them to him for his studies. In contrast to his
study of a hare in imitation of Dürer (ill. 132), Hofmann identified
the sheet with his own monogram and the date. The technical
perfection and fidelity with which the study is carried out are
hallmarks of the Mannerist style. Hofmann made use of copies
of Dürer's *Lions* in his depiction of the fur.

134 Hans Hofmann, *Wing of a Roller*
Watercolor and gouache on parchment, mounted on paper, 19 x 20.9 cm
Musée Bonnat, Bayonne

Although it bears Dürer's monogram, this sheet is considered to be a copy of Dürer's work by Hans Hofmann. The colors are duller, the changes in color less organic and the position of the feathers less exciting than in Dürer's sheet.

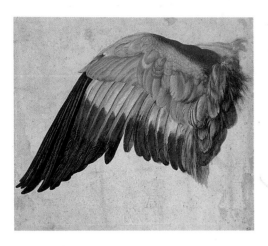

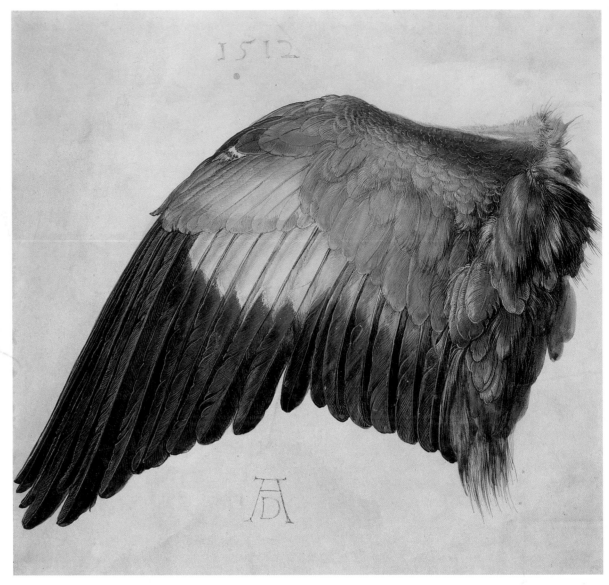

135 *Wing of a Roller*, 1512
Watercolor and gouache on parchment, 19.7 x 20.1 cm
Graphische Sammlung Albertina, Vienna

Amongst Dürer's studies of birds, it is this depiction of the wing of a roller that has been most frequently imitated. In accordance with the example of Leonardo da Vinci, Dürer produced studies of a variety of animals from different perspectives, and used these as free study material. The roller was found in Franconia during Dürer's time. The top of its left wing is depicted in magnificent colors. There is a three-dimensional quality to the feathers with their varying shades of blue, green and brown. The shining red at the bottom and top left indicates the bloody point where the wing was torn off. This wing was used in a broader sense by Dürer, as a model for angel wings. The fine, detailed lines are related to Dürer's line technique in printed graphics. In its painted technique, this study is half way between a panel painting and a drawing.

and imitation, directly upon publication, of Dürer's prints both north and south of the Alps. There were imitators, copyists and forgers at work in almost every sphere of Dürer's printed graphics and paintings. Dürer's extensive studies of animals and plants, for instance, were widely imitated in the 16th and 17th centuries.

Two artists in particular, both working at the court of Rudolph II, stand out as a result of their "imitatio" of Dürer; they were Hans Hofmann and Georg Hoefnagel (1542–1600), who drew numerous nature studies, now and then based on the same work. They even forged his monogram, examples of which can be seen in the studies imitating Dürer's hare and the *Wing of a Roller* (ills. 132–134). Towards the end of the 16th century and during the 17th century, the rising demand for works by Dürer even led to numerous of his secular and religious works being turned into sculptural works (ill. 136). In the mid-17th century, anonymous artists incorporated his copperplate portraits into portrait medals, and engravings such as the *Prodigal Son* and individual sheets from the *Engraved Passion* were imitated in relief form using materials such as ivory and wood.

The inflationary imitation of Dürer towards the end of the 16th and beginning of the 17th centuries was also linked to Emperor Rudolph II's (1552–1612) fanatical enthusiasm for Dürer, and he endeavored to collect his works in the way others collected religious objects and relics. The emperor worshipped Dürer in an almost religious sense, culminating with the procession-like transfer of the *Feast of the Rose Garlands* from Venice to Prague. Every respected art chamber and courtly collection owned prints by Dürer. By 1600, the aristocratic collecting mania had created some extensive and high-quality collections, the most outstanding being those of the Bavarian Duke Maximilian I and Emperor Rudolph II.

At the beginning of the 19th century the Nazarenes, who had a romanticized view of the art of the Middle Ages and Renaissance, started up the first regular Dürer celebrations. The celebration of the 300th anniversary of his death attracted thousands of visitors in 1828. This was the age of monuments to Dürer. Idealizing monuments immortalizing Dürer as the famous prince of painters and "most German of all German artists" were created by sculptors such as Christian Daniel Rauch (ill. 4), Franz Xaver Reich (1815–1881) and

137 Paul Klee, *detailed Passion* or *Dürer's Mother*, 1940
178 (R18), thick chalk (Zulu brand) on Japan papier (Bambou
Japon Leysse brand), with glue on cardboard, border below on
cardboard in ink, 29.5 x 21 cm
Paul-Klee-Stiftung, Kunstmuseum, Berne

Dürer's portrait drawing of his mother was used by Klee as the basis
for his famous line drawing which is a universally valid symbol of old
age, suffering and decay, and in that respect has distanced itself from
the personal dimension of Dürer's drawing.

138 Klaus Staeck, *Zur Konfirmation*, 1970
Silk screen in two colors, 73 x 50 cm

Klaus Staeck's poster *Zur Konfirmation* (On your Confirmation) was
his reply to the distorting, hyper-German and kitschy interpretations
that were made of the *Praying Hands* (ill. 78) through mass
reproductions and their use as wall decorations in middle-class
homes. He referred to the "thumbscrews," the violence being done to
Dürer, and symbolically fastened the praying hands together with
two screw clamps.

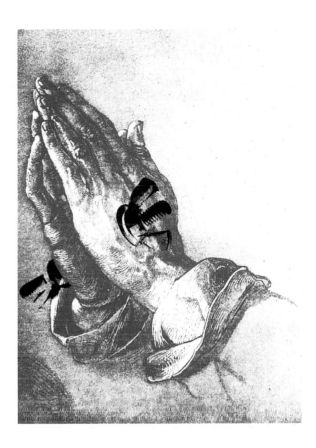

136 Anonymous, *The Prodigal Son*
Germany, 17th century
Relief, boxwood, 11.2 x 13.9 cm
Kunsthistorisches Museum, Vienna

An example of the wide-ranging imitation of the copper
engraving of *The Prodigal Son* (ill. 38) is this boxwood
relief dating from the 17th century. While the central
scene of the prodigal son amidst the swine still relates
directly to the original, the landscape background is
constructed more freely. Compared to the copper
engraving, this copy in the form of a relief loses vividness
and even appears flatter than the original.

many others. It is in this way that Dürer's work found
its place in the earliest German museums.

However, Dürer and his work were also used to make
ideological interpretations. Since the Romantic era and
period of Dürer revival, he has been regarded as the
epitome of the German artist, and this interpretation
was taken to extremes in the 1930s. His prints were
republished in the "Reichsdrucken" (prints from the
3rd Reich) by means of a photographic process that
was projected onto copper plates. The *Praying Hands*
(ill. 78), a preparatory study for the *Heller Altar*,
entered German homes in just as many different repro-
ductions as the *Young Hare* (ill. 131) and the *Large Turf*
and, detached from their context of meaning, fell prey
to hyper-German kitschiness. This was also echoed in
the art of the 20th century, an example being Klaus
Staeck's silk screen *Zur Konfirmation* (ill. 138), which
was created in 1970; in it, the praying hands are
clamped together, questioning the ideological manner
in which Dürer has been regarded. Even the classic
modern artists, from Corinth to Klee, have created
numerous variations on works by Dürer. Paul Klee
(1879–1940) was so fascinated by the charcoal *Portrait
of the Artist's Mother* that he produced a drawing in

response to it (ill. 137). The Swiss sculptor Alberto
Giacometti (1901–1966) and the Surrealist André
Masson (1896–1986) adopted Dürer's graphic prints
and reworked them in their own drawings. The
number of more and less well known 20th century
artists that have dealt with Albrecht Dürer in their own
way is considerable. In Dürer's anniversary year in
1971, artists such as Alfred Hrdlicka (born in 1928)
and Victor Vasarely (1908–1997) made statements
on their own relationship to Dürer. Even in the
Eighties, artists continued to tackle the problem of
Dürer's works. Sigmar Polke's (born in 1941) *Acht
Schleifenbilder*, which were created in 1986 within the
framework of his design of the German pavilion at the
XLIII Biennale in Venice, were a reflection of Dürer's
Triumphal Chariot. In an ensemble of eight pictures,
analogous to the eight sheets of the woodcut, Polke
reduced the personifications of the Virtues to the bows
on their banderoles which, mere ornamentation in
Dürer's woodcut, gain a central significance in this
case. The sculptor Jürgen Goertz (born 1939) was still
working on the "icons" of Dürer in the late Eighties
and created humorous parodies of the *Praying Hands*,
the *Large Turf* and *Young Hare*.

CHRONOLOGY

1471 21 May: Albrecht Dürer is born, the third of eighteen children born to the goldsmith Albrecht Dürer the Elder (c. 1427–1502) and Barbara Holper (c. 1451–1514).

1484 First surviving work: *Self-Portrait at 13*.

after 1485 Apprenticed as a goldsmith in his father's workshop.

1486 30 November: Dürer starts as an apprentice in the workshop of the Nuremberg painter and entrepreneur, Michael Wolgemut.

1489 He completes his apprenticeship toward the end of the year.

1490 On 11 April (shortly after Easter): Dürer leaves on his journeyman travels. It is not known where he went during the first two years.

1491/1492 Visits the brothers of Martin Schongauer in Colmar. Travels on to Basle, and works there as a graphic artist for woodcuts.

1492/1493 Period in Strasbourg.

1494 In the spring, working as a journeyman in Strasbourg. Returns to Nuremberg on 18 May (shortly after Whitsun) and marries Agnes Frey. In the autumn, travels to Venice via Innsbruck.

1495 In late spring, returns to Nuremberg via Trent, Lake Garda and the Brenner Pass.

c. 1495 Initial work as a copper engraver.

1498 Publication of the *Apocalypse*, some sheets from the *Great Passion* and other single-leaf prints.

1500 20 April: meeting with Jacopo de Barbari in Nuremberg. He encourages Dürer to study proportions.

1503/1504 First woodcuts from the *Life of the Virgin*. Dürer dated the copper engravings from 1503 onwards.

1504 Copper engraving of *Adam and Eve*.

1505–1507 Second Italian journey. Commission in 1505 to paint the *Feast of the Rose Garlands*.

1506 Completion of the *Feast of the Rose Garlands*. Journey to Bologna.

1507 Upon his return to Venice, travels back to Nuremberg via Augsburg.

1508/1509 Works on the *Heller Altar* and completes the painting of *The Martyrdom of the Ten Thousand*.

1509 Purchase of the house by the Tiergärtner Gate. Completion of the *Heller Altar*.

1511 Publication of the book editions of the *Great* and *Small Passions*, the *Life of the Virgin* and the second edition of the *Apocalypse*. Working on the *Adoration of the Trinity*.

1512 Emperor Maximilian I stays in Nuremberg. Dürer starts work on the *Gate of Honor*.

1513/1514 The master engravings of the *Knight, Death and the Devil* (1513), *St. Jerome in his Study* and *Melencolia I* (1514) are created.

1515 6 September: during a stay in Nuremberg, Emperor Maximilian I grants Dürer an annual pension of 100 florins.

1517 Journey to Bamberg. Visits Bishop Georg III of Limburg.

1518 Present at the Imperial Diet in Augsburg as a member of the delegation from the city of Nuremberg.

1519 12 July: death of Emperor Maximilian I in Wels. The Nuremberg council refuses to continue paying Dürer's annual pension without written confirmation from Emperor Charles V.

1520/1521 Journey to the Netherlands. Dürer writes his journal about the journey to the Netherlands.

1522 The city of Nuremberg pays Dürer a fee of 100 florins for his designs for wall paintings in the council chamber.

1525 Publication of the treatise on perspective, *Manual of Measurement*.

1526 Dürer donates the *Four Apostles* to the town council of Nuremberg as a memorial to himself.

1527 Publication of the treatise on fortifications.

1528 6 April: Dürer dies in Nuremberg. His major theoretical work, the *Four Books on Human Proportions*, is published posthumously.

GLOSSARY

Allegory (Gk. *allegorein*, "say differently"), a metaphorical illustration which represents abstract concepts or ideas in the fine arts and literature, either by means of human figures (personification) or scenes.

Altar Painting, Altarpiece (Lat. *altare*, "sacrificial table"), in the Middle Ages, altars were frequently decorated with sculptures. At first these were goldsmith's pieces or sculptured figures, though later on altar paintings came into use; they can have one or several panels. They were usually placed behind the altar or above its rear side in the form of retables.

Antique, Classical World (Lat. *antiquus*, "old"), the classical age of Greece and Rome began with the Greek migrations of the 2nd millennium B.C., and ended in the West in 476 A.D. with the deposition of the Roman emperor Romulus Augustulus (c. 475 A.D.); in the East it ended in 529 A.D. when the Platonic Academy was closed by Justinian (482–565 A.D.).

Apelles (c. 330 B.C.), Greek painter. Renaissance painters made attempts to reconstruct some of his pictorial compositions, known only through written sources.

Apocalypse (Gk. *apokalyptein*, "reveal"), the Revelation of St. John, the last book of the New Testament. The wrath of God descending upon the earth is depicted in three visions; in the form of terrible natural catastrophes, in the battle between the forces and good and evil, and in the union of a new Heaven and new Earth in the Heavenly Jerusalem. The announcement of the Second Coming of Christ at the end of the world was intended to console the persecuted Christians and also prepare them for the horrors connected with the event.

Apocrypha (Gk. *apokryphos*, "hidden"), Jewish or Christian additions to the Old and New Testaments excluded from the Canon.

Apostle (Gk. *apostolos*, "messenger"), one of the twelve disciples of Jesus, chosen personally by him from amongst his large crowd of followers in order to continue his work and preach the gospels.

Ars Moriendi (Lat. "the art of dying well"), a small book on death; Late Medieval devotional tracts which described the battles between Heaven and Hell for the souls of the dying and recommended to Christians the proper way to behave at the hour of their death.

Attribute (Lat. *attributum*, "added"), a symbolic object which is conventionally used to identify a particular saint or deity, usually portraying a significant moment from the person's life.

Baldachin. A canopy over an altar or other sacred object. It may be carried in processions, fixed by supporting columns or suspended from the ceiling.

Baldachins with twisted columns and fringed canopy became popular in Baroque churches.

Cardinal Virtues (Lat. *cardinalis*, "hinge"), the four principle virtues of Temperantia (Temperance), Fortitudo (Fortitude), Prudentia (Prudence) and Justitia (Justice) that were adopted from Plato (427–347 B.C.) in Christian ethics. Gregory the Great (540–604 A.D.) added the three so-called Theological Virtues of Fides (Faith), Spes (Hope) and Caritas (Love/Charity). At the height of the Middle Ages, this Christian system of Virtues was further extended.

Central Perspective (Lat. *centralis*, "in the center", and *perspicere*, "see clearly"), a scientific and mathematical method of three-dimensional representation developed by Filippo Brunelleschi (1376–1446) at the beginning of the 15th century. Relative to the observer, all the converging lines lead toward a single vanishing point at the center of the composition. An illusion of depth is created on two-dimensional picture surfaces by precise foreshortening and proportioning of the objects, landscapes, buildings and figures that are being depicted, in accordance with their distance from the observer.

Clair-obscur (Fr. "light-dark"), woodcut technique based on the reproduction of light and dark in drawings, where the effect depends on using the base of the drawing in the design of the image. In clair-obscur prints the light areas are carved out of the printing plate, in order to allow the white of the paper to take effect. In colored prints the colored areas are printed with clay plates, the black contours usually with a special line plate, except in cases where – as in Italy – these were dispensed with.

Copper Engraving, the oldest form of intaglio printing. When the print is made, the lines engraved into the copper plate appear on the print. The term was originally used for all manually produced prints.

Diptych (Lat. *diptychum*, Gk. *diptychos*, "folded twice"), in classical times folding writing tablets made of wood or metal. In the Middle Ages, an altarpiece comprising a pair of panels hinged together (with either sculptural or painted decorations) and lacking a central section.

Dominican Order (Lat. *Ordo Fratrum Praedictatorum*, "Order of Preaching Brothers"), order of beggar monks founded by St. Dominic (1170–1221) in Toulouse in 1216, to spread and extend the faith by preaching and teaching. In 1232 the pope put the Dominicans in charge of the Inquisition, the Church's court for trying apostates.

Engraving, the process of making an ornamental design by cutting into the surface of metal or stone.

Epitaph (Gk. *epistaphion*), an inscription on a tomb; a memorial plaque with an inscription inside a church; a funeral oration.

Eschatology (Gk. *eschaton*, "last", and *logos*, "word"), the science of the end of the world and beginning of a new world, and of the last things, death and resurrection.

Four Horsemen of the Apocalypse, the Four Horsemen in the Revelation of St. John (Rev. 6, 2–8), which contains the description of the end of the world and the Second Coming of Christ. The Horsemen personify the disasters about to happen to mankind, such as plague, war, famine and death. Their attributes are the bow, sword and set of balances. In some sculptures the first rider is identified as Christ by a halo. The color of his horse is white, that of the others red, black and dun.

Genius, in classical Rome, a person's invisible tutelary god. In art from the classical period onwards, the low-ranking god was depicted as a winged, usually childish figure.

Glaze paint applied so thinly that the base beneath it is visible through the layer.

Golden Fleece, the Order of the Golden Fleece, an order of aristocratic knights, founded in 1429 by Duke Philip the Good of Burgundy in honor of St. Andrew to protect the Christian faith and defend the church. The insignia of the order, based on the legend of the Argonauts, was a golden ram's fleece drawn through a gold ring.

Grisaille (Fr. *gris*, "gray") painting in gray monochrome, a type of painting that deliberately omitted colors and only used stone colors, shades of brown or gray. It was often used in paintings to imitate stone sculptures.

History Painting (Lat. *historia*, "history"), genre of painting whose subject is the depiction of religious or historical events.

Hortus Conclusus (Lat. "enclosed garden"), a motif of the Middle Ages in which the Virgin and Child, sometimes accompanied by a group of saints and angels, are depicted in a garden which is fenced off from the outside world and full of flowers, representing her purity.

Humanism (Lat. *humanus*, "human"), philosophical movement which started in Italy in the mid-14th century, and which drew on antiquity to make man the focal point. In humanism, the formative spiritual attitude of the Renaissance, the emancipation of man from God took place. It went hand in hand with a search for new insights into the spiritual and scientific workings of this world. The humanists paid particular attention to the rediscovery and nurture of the Greek and Latin languages and literature. To this day the term denotes the supposedly ideal combination of education based on classical erudition and humanity based on observation of reality.

Icon (Gk. *eikon*, "likeness"), a small, portable painting in the Orthodox Church. The form and colors are strictly idealized and unnatural. The cultic worship of icons was a result of traditionally prescribed patterns of representation in terms of theme and form, for it was believed that icons depicted the original appearances of Christ, Mary and the saints.

Iconography (Gk. *eikon*, "likeness", and *graphein*, "description"), originally the study and identification of classical portraits. In art history, refers to the systematic investigation of the subject-matter and symbolism of images

Insignia, the distinguishing marks or symbols of state or personal offices or honors.

Legenda Aurea (Lat. "Golden legend"), a collection of legends about saints collected by the Dominican Jacobus de Voragine (1228/29–1298). From the Middle Ages onwards, the *Legenda Aurea* was an important source text in Christian art.

Man of Sorrows, an image of the suffering Christ, showing the wounds of his martyrdom.

Martyrdom (Gk. *martyrion*, "witness, proof"), the sufferings, torture and death inflicted on a person on account of his faith or convictions.

Mother of Sorrows, Mater Dolorosa (Lat. "sorrowful mother"), a representation of the Virgin in mourning because of the sufferings of Christ.

Naturalism (Fr. *naturalisme*), a method of depiction in the fine arts and literature in which reality as the result of sensory experience rather than theory is represented as realistically and scientifically precise as possible.

Nazarenes, a group of German Romantic painters who were attempting to bring about a renewal in religious paintings by imitating the young Raphael, Perugino and Dürer. The outstanding figures were Franz Pforr (1788–1812) and Johann Friedrich Overbeck (1789–1869); they founded the Nazarenes in Vienna in 1808 and moved to Rome in 1810.

Nimbus (Lat. "aureole"), the disc or halo, usually golden, placed behind the head of a saint or other sacred personage to distinguish him or her from ordinary people.

Oil Paint, a paint used in art that consists of drying oils, other substances and color pigments that will not dissolve in the oil. The main drying oils used to bind the color pigments were linseed, poppyseed, and walnut oil.

Parrhasius (c. 420 B.C.), Greek painter of the late classical period (c. 400–300 B.C.), and with Zeuxis (c. 425 B.C.) and Apelles (c. 330 B.C.) one of the most famous artists of the classical age.

Patrician (Lat. *patricius*, "father"), originally a member of the ancient Roman nobility; from the Middle Ages onwards a term for a noble, wealthy citizen.

Pendant (Fr. "hanging"), one of a pair of paintings that are interdependent in theme or style.

Personification (Lat. *persona*, "person", and *facere*, "make"), an imaginary person conceived as representing a thing, concept or deity.

Perspective (Lat. *perspicere*, "see clearly"), the method of representing a three-dimensional object on a flat or nearly flat surface. Objects and figures are depicted as much as possible in accordance with the optical conditions in which they are actually seen by the observer.

Physiognomy (Gk. *physis*, "nature", and *gnomon*, "interpreter"), the external appearance of a person, in particular the face.

Pietà (It. "compassion, pity"), depiction of the Lamentation over the Dead Christ with the body of Christ shown lying in the arms of the Mother of God.

Pluvial (Med. Lat. *pluviale*, "rain cloak"): a long cloak in the shape of a semicircle which is open at the front, where a pectoral is used to close it. It is worn by bishops and priests as a ceremonial vestment on occasions other than mass, such as processions and consecrations.

Profil Perdu (Fr. "lost profile"), refers to a head or other object when more than half of it is turned away from the observer.

Proportion (Lat. *proportio*, "evenness"), in painting, sculpture and architecture, the ratio between the respective parts and the whole work. The following are important: 1. the Canon of Proportion, a mathematical formula establishing ideal proportions of the various parts of the human body. The unit of measurement is usually the relationship of the head to the torso (1:7 or 1:10); 2. the golden section, a line C divided into a small section A and a larger section B, so that A:B are in the same relationship as B:C; 3. the quadrature, which uses the square as a unit of measurement; 4. triangulation, which uses an equilateral triangle in order to determine important points in the construction; and 5. harmonic

proportions, an analogy with the way sounds are produced on stringed instruments, for example an octave = 1:2 (the difference in pitch between two strings, one half the length of the other), a fifth = 2:3, a fourth = 3:4.

Putto, Putti (It. "boy"), the figure of a usually naked, childlike angel.

Relic (Lat. *reliquae*, "remains"), part of the body of a saint or object owned by a saint that merits particular worship.

Sacra Conversazione (It. "holy conversation"), a representation of the Virgin and Child surrounded by saints in a dignified grouping within a unified space. The term is misleading, as an actual conversation is not normally taking place.

Septemvir (Lat. *septem*, seven and *vir*, man). One of the group of seven leading patricians governing Nuremberg in the 15th and 16th centuries.

Signoria (It. "lordship"), from the late Middle Ages, the governing body of some of the Italian city states, usually presided over by individual families.

Single-leaf Woodcuts, the earliest works in linear book printing which were produced between 1400 and 1550 as single sheets with black lines in high relief. They first appear in alpine monasteries, were at first used to spread information of all sorts and were later used as leaflets and visual polemics.

Tempera (Lat. *temperare*, "to mix in due proportion"), a form of painting in which the color pigments are combined with a paint medium such as egg, glue or casein (the protein in milk). Compared to oil painting, the paints dried rapidly so that it was not possible to paint wet-in-wet. For that reason, fine graduated tones were achieved by adding several layers of lighter or darker dots or lines to an area of dried paint. Because the colors of wet and dry tempera paints were different, it was difficult to achieve the same shade when overpainting.

Trinity (Lat. *trinitas*, "threefold"), in Christianity, the term used for the existence of one God in three persons: the Father, the Son and the Holy Spirit.

Triptych (Gk. *tryptychos*, "threefold"), a picture consisting of three panels, a central panel and two movable side wings, in particular a medieval winged altarpiece.

Uomo Universale (It.), the Renaissance "universal man," a many-talented man with a broad-ranging knowledge of both the arts and the sciences.

Vanishing Point, central point in a perspectival composition upon which a set of lines, which are actually parallel, appear to converge.

Vanitas (Lat. "vanity, transience"), complaint about transience and, hence, the triviality of all earthly things which was derived from the Old Testament phrase "vanitas vanitatum" (everything is futile). The saying was a particularly popular subject of pictures during the Baroque period, especially in combination with the warning "memento mori" (remember you are mortal). Typical symbols of Vanitas include the skull, hourglass and burning candle.

Veduta (Italian for view). A primarily topographical representation of a town or landscape that is depicted in such a life-like manner that the location can be identified.

Wood Block Carvers, craftsmen who carved the work into the wood block according to the design drawn on it. While they are not usually identified by name in the early period and are difficult to distinguish from the artist producing the design, they were responsible for the artistic quality of the print.

Woodcut, a printing process in the graphics arts. The wood block carver, who is not necessarily identical with the artist who designed the woodcut, cuts part of the surface of the block of wood away leaving the design standing proud; this is the part that will be visible in the final print.

SELECTED BIBLIOGRAPHY

Anzelewsky, Fedja: *Albrecht Dürer. Das malerische Werk*, 2 vols., Berlin 1971, 2nd ed. 1991

Anzelewsky, Fedja: *Dürer. Werk und Wirkung*, Stuttgart 1980 (Fedja Anzelewsky, Dürer: *His Art and Life*, London 1980)

Bailey, Martin: Albrecht Dürer, Phaidon 1995

Dürer, Albrecht: *Von menschlicher Proportion, Hierin(n) sind begriffen vier bücher von menschlicher Proportion, durch Albrechten Dürer von Nürenberg erfunden vnd beschriben, zu nutz allen denen, so zu dieser Kunst lieb tragen. M.D.XXVIII.* Facsimile edition of the original edition, Nuremberg 1528, Nördlingen 1980

Dürer, Albrecht: 1471–1971, exhibition catalogue, Nuremberg 1971, Munich 1971

Eichenberger, Dagmar and Zika, Charles (eds.): *Dürer and his Culture*, Cambridge University Press 1998

Goldberg Gisela, Heimberg Bruno and Schawe Martin (eds.): *Albrecht Dürer. Die Gemälde der Alten Pinakothek*, exhibition catalogue, Munich 1998

Hütt, Wolfgang: *Albrecht Dürer. Das gesamte graphische Werk*, I. Handzeichnungen, II. Druckgraphik, Munich 1970/1988

Hutchison, Jane Campbell: *Albrecht Dürer: A Biography*, Princeton 1990

Krüger, Peter: *Dürer's Apokalypse. Zur poetischen Struktur einer Bilderzählung der Renaissance*, Wiesbaden 1996

Kutschbach, Doris: *Albrecht Dürer: Die Altäre*, Stuttgart/Zurich 1995

Mende, Matthias: *Dürer – Bibliographie*, Wiesbaden 1971

Panofsky, Erwin: *The Life and Art of Albrecht Dürer*, Princeton 1955

Perrig, Alexander: *Albrecht Dürer oder die Heimlichkeit der deutschen Ketzerei*, Weinheim 1987

Rupprich, Hans (ed.): *Dürer. Schriftlicher Nachlaß*, vol. 1, Berlin 1956, vol. 2, Berlin 1966, vol. 3, Berlin 1969

Strieder, Peter and Schönberger, Arno (eds.): *Vorbild Dürer*, exhibition catalogue, Germanisches National museum, Nuremberg 1978

Strieder, Peter (ed.): *Dürer*, Königstein/Taunus 1981; new edition Augsburg 1996 (Peter Strieder: Dürer, Danburg CT 1984)

Winkler, Friedrich: *Die Zeichnungen Albrecht Dürers*, 4 vols., Berlin 1936 ff.

Winzinger, Franz: *Dürer*, Reinbek 1971

Wölfflin, Heinrich: *Die Kunst Albrecht Dürer's*, Munich 1963 (first edition, ed. Kurt Gerstenberg 1905); (Heinrich Wölfflin: *The Art of Albrecht Dürer*, London 1971)

PHOTO CREDITS

The publishing house and publisher wish to thank the museums, collectors, archives, and photographers for permission to reproduce the works in this book. Particular thanks go to the Scala photographic archive for their productive cooperation.

ArchiTektur-Bilderservice Kandula, Witten (9, 80); © Archivi Alinari, Firenze (131); © Arquivio Nacional de Photografia- Instituto Português de Museus, Lisbon (119); Artothek, Peissenberg (8, 52, 55) – Photo: Blauel/Gnamm (63); © Ashmolean Museum, Oxford (26 left); Bayerische Staatsbibliothek, Photostelle, Munich (21 top, 34 top, 35); © Biblioteca-Pinacoteca Ambrosiana, Milan (94); Bildarchiv Preußischer Kulturbesitz, Berlin (25, 27, 39 left, 50 left, 53, 67 left, 79, 107, 123, 124, 125, 133 left) – Photo: Jörg P. Anders (36, 111 right, 114); © The British Museum, London (26 right, 34 bottom, 116, 121); Doerner-Institut, Bayerische Staatsgemäldesammlungen, Munich (62); Edition Staeck, Heidelberg © VG Bild-Kunst, Bonn 1998 (135 right); © Elke Walford, Hamburg (30 left); Germanisches Nationalmuseum, Nuremberg (14, 21 bottom, 41, 68, 90, 110); Graphische Sammlung Albertina, Vienna (11, 23, 24, 61, 69, 74, 77, 82, 108 right, 118, 132, 134 right); Kunsthalle, Bremen (120); © Kunsthistorisches Museum, Vienna (71, 81, 83, 103, 135 left); Kunstmuseum, Bern © VG Bild-Kunst, Bonn 1998 (135 Center); Kunstsammlungen der Veste Coburg, Coburg (86); Kupferstichkabinett, Akademie der bildenden Künste, Vienna (130); The Metropolitan Museum of Art, Bequest of Benjamin Altman, 1913. (14.50.633) Photograph © 1989 The Metropolitan Museum of Art, New York (109); Öffentliche Kunstsammlung, Basle – Photo: Martin Bühler (17); The Pierpont Morgan Library/Art Resource, New York, purchased in 1910. I,257 d. (67 right); Pushkin Museum der bildenden Künste, Moscow (106 left); © RMN, Paris (28) – Photo: Gérard Blot (32), J.G. Berizzi (29), R.G. Ojeda (134 left), Quecq d'Henripret (113); Rheinisches Bildarchiv, Cologne (100); Scala, Istituto Photografico Editorale, Antella/Firenze (10, 15, 18, 33, 50 right, 51, 56, 72/73, 76, 84, 85, 89, 101, 108 left, 115, 126, 127); Staatsbibliothek, Bamberg (73 top, 102, 128, 129); Staatliche Kunsthalle, Karlsruhe (31, 37, 38, 39 right, 40, 42, 44, 45, 46, 47, 48, 64, 65, 66, 87, 92, 93, 95, 97, 98, 99, 104, 105, 106 right, 111 left); Staatliche Kunstsammlungen, Dresden – Photo: © Klut (54, 117); Städelsches Kunstinstitut, Frankfurt a. M. (30 right); Universitätsbibliothek Erlangen-Nuremberg, Erlangen (16); Woodner Family Collection © 1998 Board of Trustees, The National Gallery of Art, Washington D.C. – Photo: Richard Carafelli (133 right).